# CELTIC FOLK SOUL

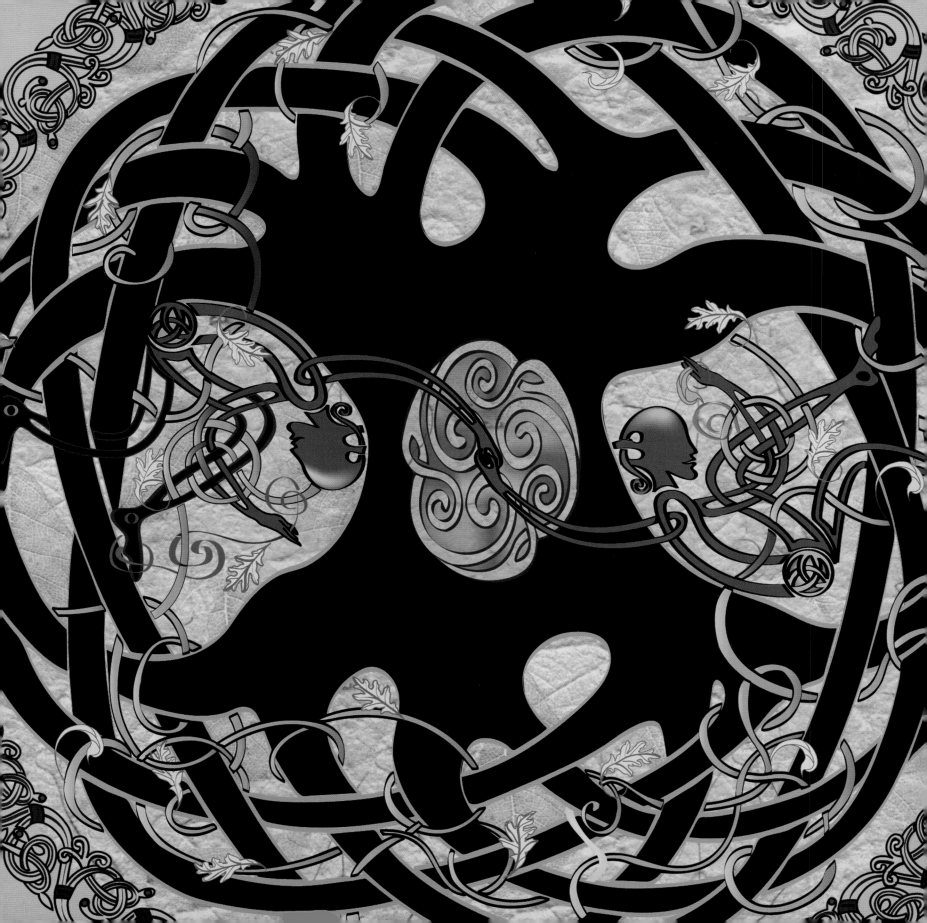

Jen Delyth

# CELTIC FOLK SOUL
## Art, Myth & Symbol

Amber Lotus Publishing
Portland, Oregon

Published by Amber Lotus Publishing
PO Box 11329, Portland, Oregon 97211
800.326.2375 • www.amberlotus.com

Amber Lotus Publishing first edition copyright © 2008
Text and Illustrations © 1990–2008 by Jen Delyth
www.celticfolksoul.com, www.kelticdesigns.com

Permissions notes:
Davies, Oliver, and Fiona Bowie. *Celtic Christian Spirituality—An Anthology of Medieval and Modern Sources*, 1995.
    Reprinted with permission of The Continuum International Publishing Group.
Evans, Dyfed Lloyd. "The Drowning of Gwyddno's Realm (Seithennin),"
    http://www.celtnet.org.uk/texts/llyfr_du/seithenin_eng.html, 2005. Reprinted with permission of Dyfed Lloyd Evans.
Farren, Robert. "The Mason," *The First Exile*, 1944. Reprinted with permission of Sheed & Ward, an imprint of Rowman &
    Littlefield Publishers.
Graves, Robert. *The White Goddess*, 1948. Reprinted with permission of Carcanet Press.
Jackson, Kenneth. *Studies in Early Celtic Nature Poetry*, 1935, 1995. Reprinted with permission of Llanerch Press.
Pennar, Meirion, trans. *Taliesin Poems—New Translations*, 1988. Reprinted with permission of Llanerch Press.
Pennar, Meirion, trans. *The Black Book of Carmarthen*, 1989. Reprinted with permission of Llanerch Press.
Thomas, R. S. "The Minister," 1953. Reprinted with permission of Bloodaxe Books.

Amber Lotus Publishing first printing: 2008
10    9    8    7    6    5    4    3    2    1
Printed in Korea

Library of Congress Control Number 2007942675

Author Photograph: Jenny Lemper
Book Design and Jacket Design: Jen Delyth and Leslie Gignilliat-Day
Editorial Services: Meadowlark Publishing Services, www.larkonline.net
Pronunciation Consultant: Peter N. Williams

Amber Lotus first edition ISBN: 978-1-60237-116-3

for my parents,
## Mair and Fred

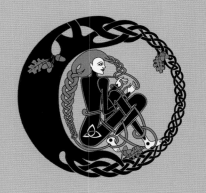

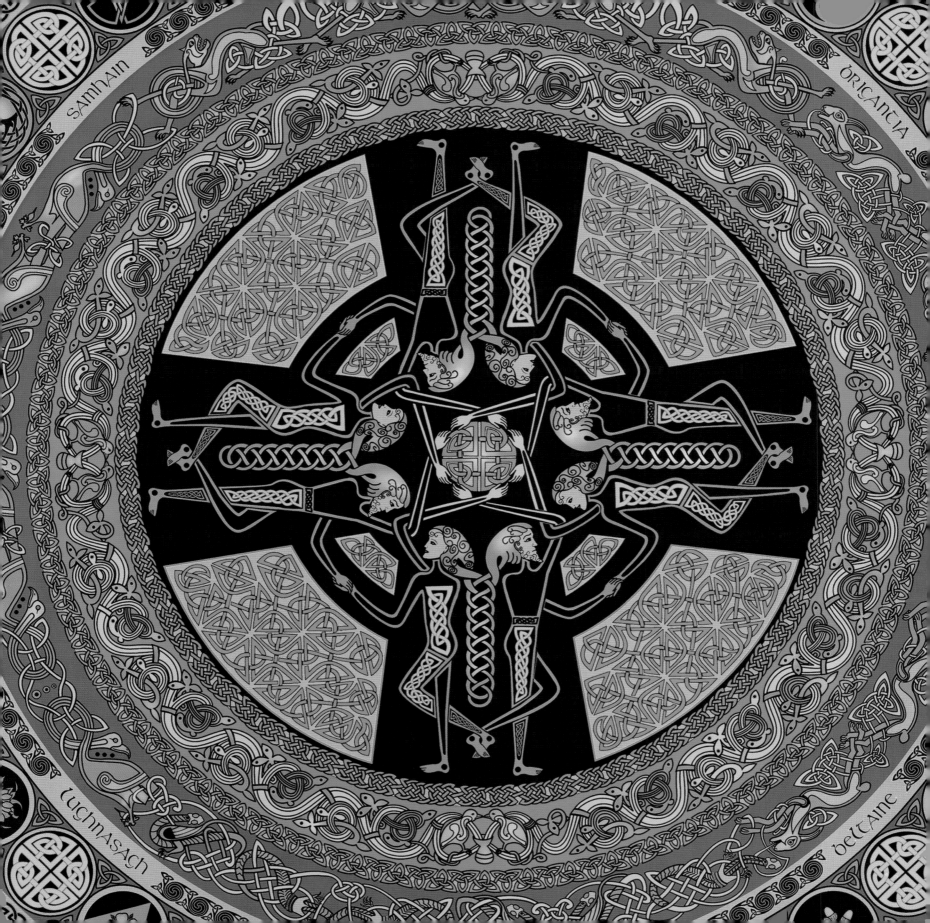

TABLE of CONTENTS

# CELTIC FOLK SOUL
## Art, Myth & Symbol

by JEN DELYTH

# FOREWORD

Here in Jen Delyth's book you'll find a wonderfully comprehensive, panoramic overview of the Celtic tradition in legend, art and symbol.

By way of a foreword, I'd like to contribute these few words. The Celtic tradition is certainly one of the most diverse and beautiful of the world's legacy. Celtic stories weave and wind like Celtic knotwork patterns, like nets, like shields, like portals, like maze-treadings, like dance steps, like tunes. They are many-layered like branches of ancient trees shadow-cast by moonlight. They are the wealth of the poor, the food of the hungry, a gift given to shorten the road—voices of many mouths, the work of many hands.

But not all of this tradition has been passed on to us as an oral heritage. It has reached us also by way of texts scribed by monks of the early church a thousand years or so ago— a thousand or so years after the apparent setting of the tales they tell. The texts recount the deeds of semidivine ancestors, faithfully but cautiously, as the deeds of kings and queens, wizards, giants, male and female warriors and women of power. The tradition—very much alive—has reached us also by way of carved stones, standing stones, painted vellum and gold beyond price cast into rivers, wells and lakes as offerings to the eternal.

In common with all human cultures, the Celtic culture has its own perspective on the human predicament: born from a mystery, living in a mystery and proceeding inexorably toward the mystery of death. But the Celts have an ongoing yearning for worlds beyond.

No matter where you encounter this vast inheritance of story, music, visual art and symbol—no matter where you enter the Celtic tradition—you will find yourself upon a path. If you are encountering the tradition at all, it is because it has relevance to who you are. It has something to teach you.

In the forty-something years I have been traveling about the world singing and telling stories, I have come to this conclusion: the material you need will find you when you are ready for it—when you need it enough.

The stories keep reminding us of certain truths: the Earth, our Mother, is worthy of respect, the haughty and proud are not favored by luck, generosity of spirit is rewarded. The stories say that instruction, in the form of inspiration, comes to us from the invisible realm that surrounds us—which the Welsh call Annwn, which the Scots and Irish call Tír na nÓg, the land of the ever young.

May you yourself find the gateways to your own story, and may you find inspiration in your journey through life.

May you travel in joy!
—Robin Williamson, Cardiff, Wales, 2007

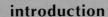

# FOLKsoul

For all poetry is in a sense memory:

all art, indeed, is a mnemonic gathering

of the innumerable and lost

into the found and unique.

—Fiona MacLeod,
*From the Hills of Dream*, 1901

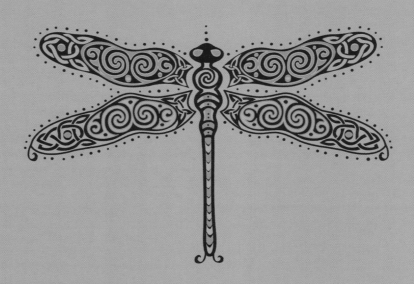

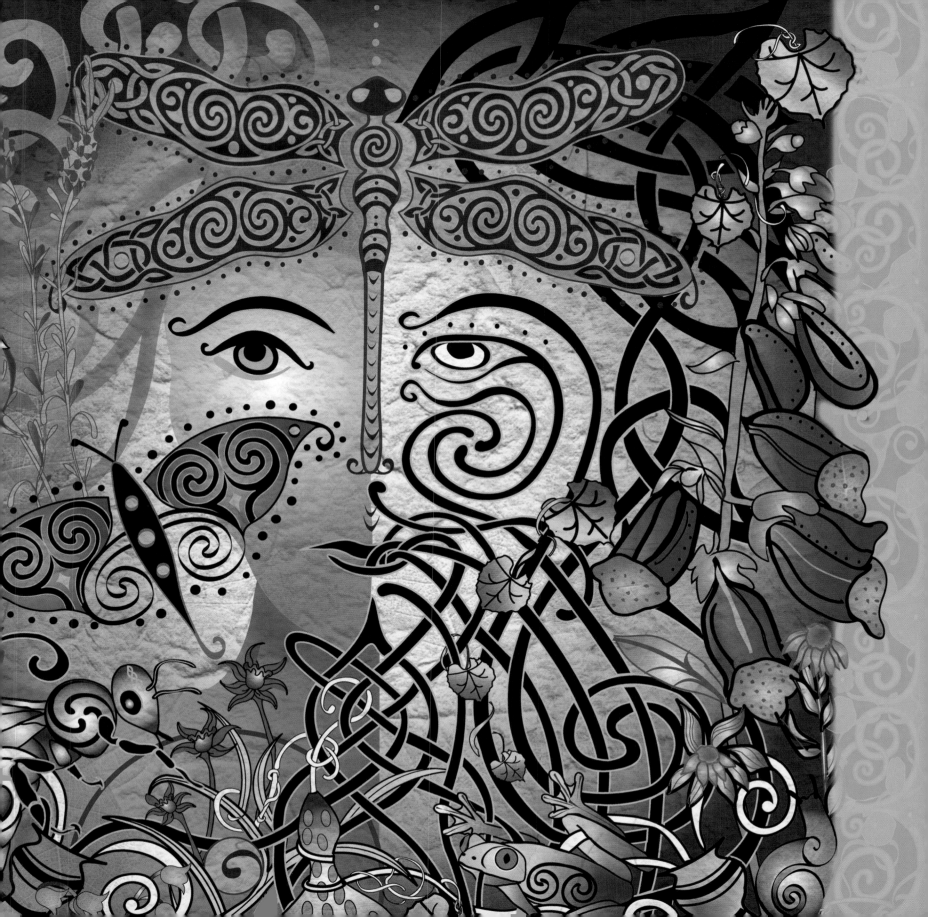

# FOLKsoul

**T**his is a book about the beauty, power and spirit of nature expressed through the ancient language of Celtic art and symbol: the voice of the Folk-Soul.

**The Celtic Folk-Soul** dances at the heart of a living tradition, representing the vitality of her people, their stories, their land and their memories, from the early tribes to us today. An ancient thread weaves back through art, myth and poetry connecting us to a complex mysticism that expresses the interconnection and balance of all things.

**Celtic Art** speaks to us through an intricacy of symbol and form that enchants while it mystifies, and yet is somehow the perfect way to talk about that which is abstract, sometimes invisible and yet essential.

    Throughout the many challenges and migrations of the Celtic people, the Folk-Soul sings of the beauty of life, even within the darkness—perhaps particularly then. This is the language, the poetic key to the Mysteries, that is the source of my inspiration and journey as an artist.

**The Voice of the Folk-Soul** is articulated through artists, poets and storytellers: it is they who channel the knowledge of our ancestors. The old memory is kindled through the songs and prayers of the fishermen and farmers, mothers and weavers, the priests and the poets.

    This symbolic language contains the seeds of articulation from the first people, and continues to evolve into our time. Through the motifs of myth, the deeper truths are illuminated, leading us intuitively into the otherworldly realms of our psyche.

    Through the abstract patternings and enigmatic riddles of ancient metal-smiths and medieval monk scribes, we glimpse the complexity of the Celts, whose connection with the elemental beauty and wisdom of nature speaks to us still. Intricate spiral and interlacing patterns convey the oneness of life within all forms, the visible and the invisible.

    Exploring the roots of ancient art-forms gives us insight into the heart of the culture from which they are drawn. Mythic tales and images contain primal archetypes that inform our collective consciousness and affect the deepest levels of our experience.

> I have been a sow, I have been a buck,
> I have been a sage, I have been a snout,
> I have been a horn, I have been a wild sow,
> I have been a shout in battle.
> I have been a torrent on the slope,
> I have been a wave on the shore.
> I have been the light sprinkling of rain,
> I have been a cat with a speckled head on three trees.
> I have been a circumference, I have been a head.
> A goat on an elder-tree.
> I have been a well filled crane, a sight to behold.

—Attributed to Taliesin. "Song of the Horses" from *The Four Ancient Books of Wales*, 1858. Translated by W. F. Skene.

**O**rganic elements and concepts form the foundation of this book. Each chapter evokes pivotal Celtic themes and the symbols and archetypes that represent them. My intention is for *Celtic Folk Soul* to be enjoyed primarily on a visual level, with the text accompanying the artwork rather than the designs simply illustrating the written word.

Each of the nine chapters contains original artwork and explanations of the symbolism found within it, with poetry and text giving additional support to the theme of each section. Chapters are represented by organic symbols paired with core concepts that define significant Celtic elements: Stone—mysteries, Wind—journey, Seed—fire.

I have chosen these integral themes to evoke the colors and textures of the art, myth and poetry, exploring those symbols that continue to resonate for us today. Each element within the book opens a window into the Celtic Folk-Soul—the door is our own imagination and creative experience.

**C**eltic artwork is rhythm, and it is this rhythm we feel interacting with the ancient patterns—the cadence and language of the Earth.

The sacred Spiral and her triple manifestation symbolize the ancient Earth Goddess and her seasonal cycles. The labyrinth and key-patterns speak of the ancient journey to the center and out again. The Tree of Life celebrates the verdant force of nature, the fruitful vines of growth and sustenance, and the sacred animals are totemic archetypes representing their qualities of strength, fertility and intelligence.

The patterns reflect the beat of the earth, the movement of the moon across the sky that draws the sap of the plants—the growth and waning of our lives, and that of the seed to the sapling to the tall tree and all back to the earth again in a great circle.

Celtic artwork describes this rhythm at the heart of

things. The elements within the designs are rooted in a far more ancient culture, where the language of the artists was directly connected with the Earth Mysteries. Sacred patterns within the Gavrinis chambered cairn in Brittany (dating back to 3500–4000 BC) and the megalithic passage tomb at Newgrange, Ireland (3200 BC), are good examples of this.

The characters of myth and memory spiral, meander and weave through time, which echoes with their riddles and contradictions. To know them, we must accept some of what we do not always understand, and allow the mysterious to speak in its own enigmatic way, feeling our path to the center—to the still heart of the turning triskele.

At times we may lose our orientation of time and place, travel between this world and the Otherworld, this moment and one long past. As we follow the Folk-Soul back through the ages, we will visit many places, some with curious and strange-sounding names, in every corner of the Celtic world—Wales, Ireland, Scotland, Cornwall, Brittany and beyond.

Like the complex patterns of Celtic art, in the telling of the tales and traditions we will encounter repeating motifs and figures, which reflect the circular rhythm and cadence that pulse through the Celtic culture. Elemental characters may appear often, representing primary archetypes on behalf of the many more who are not illuminated, or who are hidden from us by the veil of history.

**In Celtic mythology,** a well-known figure may appear with differences of name, attributes and lore in Irish, Welsh and Scottish variations. Welsh *Lleu Llaw Gyffes* is connected to the Irish *Lugh*, and both have their own stories to tell. However, both are connected with solar symbolism and are skilled warriors. They are both probably related to a far older deity of the sun—a mighty force of light and strength in the cosmos.

Illustration: *Aois Dana—the Poets*

"In some of the old nursery stories told in various parts of Wales,
a beautiful clear fountain was described, the waters of which arose
at the sound of singing, and fell when silence succeeded the song."

—Marie Trevelyan,
*Folk-Lore and Folk-Stories of Wales*, 1909

## AOIS DANA

The Aois Dana are the Poets.
They guard the fountain of knowledge, which is fed by the five streams of the senses.
These wise Poets drink from both the five streams (representing the senses)
and the fountain of knowledge (which represents intellect).
It is the folk of many arts who drink them both, and these are the Aois Dana.

The source of the River Boyne in Ireland is described as: "… a shining fountain, with five streams flowing out of it. … Nine hazels grew over the well. The purple hazels dropped their nuts into the fountain, and five salmon severed them and sent their husks floating down stream. The five streams of the senses are these, through which knowledge is obtained. No-one will have knowledge who drinks not a draught out of the fountain itself, and out of the streams."

—T. P. Cross and C. H. Slover, *Ancient Irish Tales*.
Arranged by John and Caitlín Matthews.

Illustration facing page: *Aois Dana—the Poets*

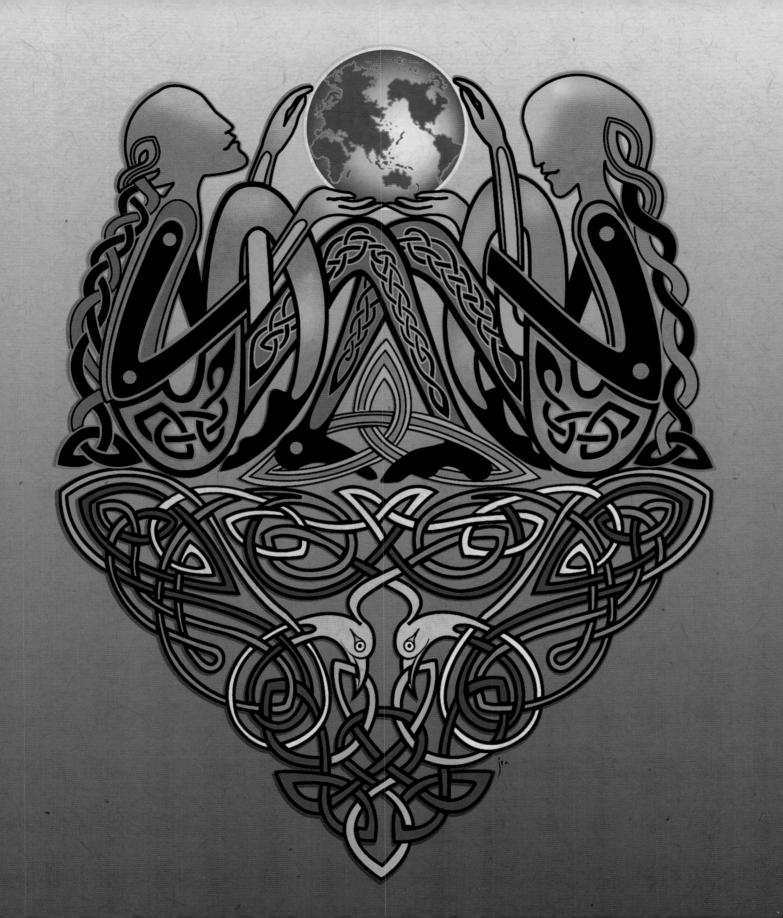

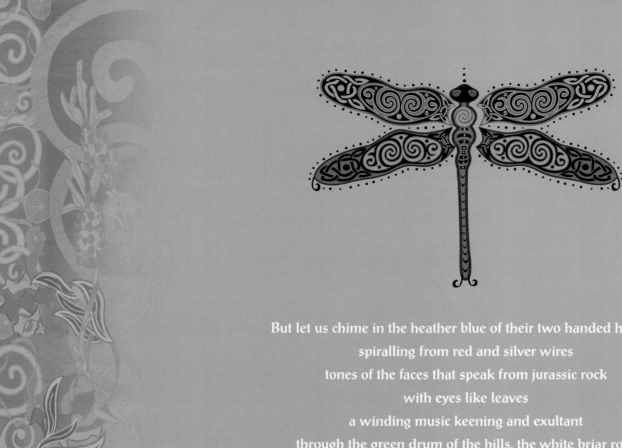

But let us chime in the heather blue of their two handed harpers

spiralling from red and silver wires

tones of the faces that speak from jurassic rock

with eyes like leaves

a winding music keening and exultant

through the green drum of the hills, the white briar rose

and the long dance of the horses cantering in threes

high and lonesome reel that galloped in the duple hoofbeat

sharp as the blade of January and soft as snow, their minstrelsy

that kissed

and parted

and found rest in journeying

they rode and billowed in the days of old.

worshipping across the world a music

that nests in bird song, insinuates in river babble

sings in the soft south wind and burns in the burning flame

to lay a burden and a turn that catch still at the heart

and descant yet

to the echo of that oldest tune of all, that stirs the bold

and I will not forget.

—Robin Williamson,
excerpt from "Five Denials on Merlin's Grave"

Language of symbols can be understood and recognized on many different levels: visual, contextual, mythic and philosophic. Although much of the esoteric tradition was kept hidden by the priestly class of Druids, the artists and the bards—poets, musicians and storytellers—wove mystical elements within their words and images.

Well-crafted images communicate the Mystery that is life, spirit within form. Authentic symbols can be experienced on both conscious and unconscious levels, through instinctual as well as intellectual understanding. To perceive more deeply we can learn the language, but more importantly, symbols are felt through the heart, and experienced through the soul.

This opens the communication of ideas on a non-verbal level to all people throughout history, including the majority who could not read or write, but who could relate to and draw from this visual tradition. The symbol may be complex, yet there is both a conceptual and intuitive vocabulary at its foundation.

Oghma is the Celtic god of language and communication who created the Ogham alphabet. The Celts curiously imaged him with finely crafted chains connecting his tongue to the ears of his smiling people. The power of eloquence binds us to the mystical persona; compelled, we hear his secrets whispered through the long chain of years.

The artwork and design language of the Celts communicate ideas of a more fluid relationship between things. At the heart of the imagery is a sense that all is multidimensional and interconnected, that there is a mystical and colorful spiritual world beyond the hardships of everyday life.

This is an art form that embraces creative interpretation, has affinity for ambiguity and profundity. It always intrigues, suggesting something of that which we cannot always see, but can often feel within the complexities of the world: the Mystery of a world that is alive, from which we come, and to where we return.

## Mythic archetypes

of Poet, Warrior, Plant, Beast, Land, Sea and Sky—all connected by the intertwining thread of the endless knot—are essential elements working through the Celtic imagination, rooted within an organic wisdom tradition.

The first people are our Ancestors. They lived close to the earth and wove their fabric of reality through Tree and River, Dragonfly and Wild Boar, with tales from the beginning of time intertwined with the brilliant colors of their fertile imagination.

Represented in this book are illustrations inspired by essential Celtic archetypes: the Tree of Life, the Triple Goddess, Taliesin the shaman Poet and Manawyddan Lord of the Sea, with animal and nature symbols such as Raven and Stag, Moon, Stone and Water.

Archetypes are instinctual patterns that communicate on a primal level. They may appear in dreams, trigger memories or work within our collective consciousness or community. Through studies of dreams, art, religion and mythology, influential thinker and psychologist Carl Jung realized that a universal symbolic language represents primal, and most significant, innate elements of our psyche.

Archetypes and symbols may continue to communicate with a fertile potency within modern cultures, surviving centuries of invasion and global change. Contemporary people can continue to find relevance within the language of the ancient world.

> **What we call a symbol is a term, a name, or even a picture that may be familiar in daily life, yet that possesses specific connotations in addition to its conventional and obvious meaning. It implies something vague, unknown, or hidden from us. … As the mind explores the symbol, it is led to ideas that lie beyond the grasp of reason.**
>
> —Carl Jung, *Man and His Symbols*

**M**yths give articulation to the heart and soul; they can act as guides within the lives of both ancient and modern people.

Mythologist Joseph Campbell reveals multi-layers of significance and meaning in world mythology and folklore, illuminating symbols that represent often complex abstractions that explain the organic principles of the Mystery of life—such as our journey from birth to death, the shifting realities of time and space. These are wisdom teachings that expose the human condition in all its tragedy and beauty.

The Celtic Folk-Soul is informed by the Western tradition. The story begins with the Hunter Gatherers, and the mystery deepens during the time of the Great Megalith Builders. With the brilliant warrior tribes of Europe,

reproduction illustrations that are representative of Celtic works of antiquity, but all other pieces are original.

With a dedicated intention to not simply reproduce the ancient artists' creativity, I remain inspired by their visual and mythic language. The challenge is to create a personal, individual style, crafting new patterns and designs while honoring the tradition. By adapting the authentic design vocabulary, and sometimes using new tools and mediums that were not available to the first Celts, symbols and elements are illustrated that continue to hold meaning.

In this spirit, the traditional Celtic elements and motifs (such as spirals, triskele, key-fret and interlace patterns) are integrated into compositions that reflect a personal vision, rooted within both a historical and contemporary cultural framework.

> Myth is the secret opening through which the inexhaustible energies of the cosmos pour into human manifestation.
>
> —Joseph Campbell, *Hero with a Thousand Faces*

the mythic narrative is manifest in a vibrant outpouring throughout every aspect of daily life. It then journies through the remote monasteries of the early Celtic Church and thrives within a renaissance of Celtic culture that continues to develop through art, poetry and mythology to fuel our imaginations today.

**This is a living tradition** with ancient roots reaching back to the first people. As a fluid and yet strongly characteristic style, Celtic art continues to change and develop—most important to those who continue to adapt and keep the tradition alive.

The images in this book focus on inspirational concepts that, while essential within the Celtic tradition, also speak to us today. Most of this artwork is conceived through the eyes of a contemporary artist. When discussing the arts and crafts of history, I have included a few

**Creativity and insight** are the gifts of the Aois Dana, the Poets who guard the fountain of knowledge. The Celts honored their poets and bards, their artists and storytellers as the keepers of memories. It is they who manifest the essential wisdom of the tribe, which is woven through their complex tales and tellings.

Celtic art, music, poetry and dance, and the spoken languages themselves, reflect this creative, organic form— the intertwining expressions of the Folk-Soul.

I grew up in Wales, where the language itself is ancient, where indeed many of our places—river, lake and mountain—still have the living folk memory known to them, often connected to their names. Although the Old Ways and communities that kept this knowledge for many centuries have changed in the modern world, some of the ancient artwork, poetry and folklore remain to inspire us.

We will never know exactly what our ancestors thought, believed or experienced in their time, as they would not comprehend much of what we have become. We may seek different insights within the compelling tales and visions from those intended by the ancient folk who fashioned them; however, it is this very richness of organic imagery and abstract allusion that continues to create new meaning.

In our world today, where environmental concerns are crucial, the balance not only between man and nature, but within our own psyche, is becoming increasingly complex. We have shifted from an earth-centered perspective to a more intellectual theology centered on man. Many today are redefining their spirituality, developing new perspectives to understand our place in the world within a living Universe.

Elements of the traditions of those who lived in comparative balance with their environment may infuse us with their perspective and insight.

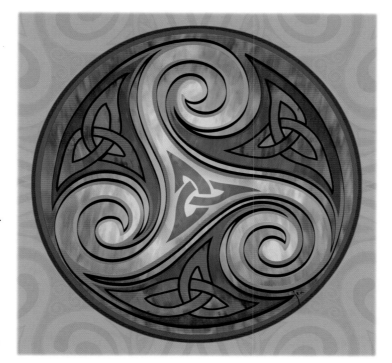

### The Mission of the Folk-Soul.
Eleanor Merry wrote her curious book *The Flaming Door: The Mission of the Celtic Folk Soul* in 1936. As a theosophist she has some deeply esoteric ideas about spirituality and the Celtic Mystery tradition, drawn from her research into comparative mythology and religion.

Merry introduces a compelling vision of a *Mission* of the Folk-Soul, which is to seek the keys of initiation, knowledge and wisdom within its legends and mythology. She begins *The Flaming Door* with these words:

*We shall, I believe, never fully understand our evolution, nor see in the glimmering light about us the sign-posts that point the way into the future, unless we recognize the greatness of our spiritual heritage.*

As a response, this book continues her challenge to seek inspiration and motivation through the mystical arts of those people who lived connected with the natural world, who recognized the Spirit within all things.

### The Celtic Folk-Soul
dances with unique rhythm and cadence in our culture today. Its intricate wit and joy playfully acknowledge as part of the natural cycle the darkest aspects of a difficult life of challenge and hardship. As we continue to explore our connection to the world and to find anchor within the sometimes strange sea of human existence, the voice of the Folk-Soul gives direction and insight.

As a living memory, this interchange of ideas explores the mysticism of the trees, the waters, the air that we breathe—and all that lies in between. This is a creative and vital energy that has crossed the oceans with her people and continues to thrive in the new places, as in the old.

**For we live** in a great story, and the Folk-Soul knows this well and delights in taking us on an ever-unfolding journey.

Illustration: *Triskelion*

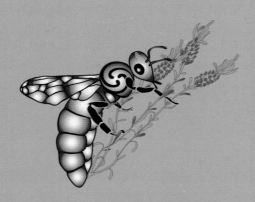

# THE GARDEN

The Garden is a perfumed sanctuary of flowering beauty
and green verdant life. Her creatures are the Butterfly, the Bee, Frog,
Dragonfly and Snail. The Butterfly's painted wings reflect the vivid colors
and patterns of the flowers and herbs she visits. The Bees gather their sweet
nectar from the lavender to create golden honey for their Queen.
Dragonfly, master of illusion, is shaman of the air, as the Frog is of his watery
pond among the rushes. The humble Snail carries the sacred spiral symbol upon
his back. His is the shady realm of undergrowth and tender shoots.

The Green Man and his Bride watch over the Garden.
He is of the earth—the green vines spill from his mouth, taking root in
the fertile soil. She is Blue Mistress of the flowers and winged creatures.
Together they dance in the Garden of creative possibilities.

Illustration facing page: *The Garden—Green Man/Woman*

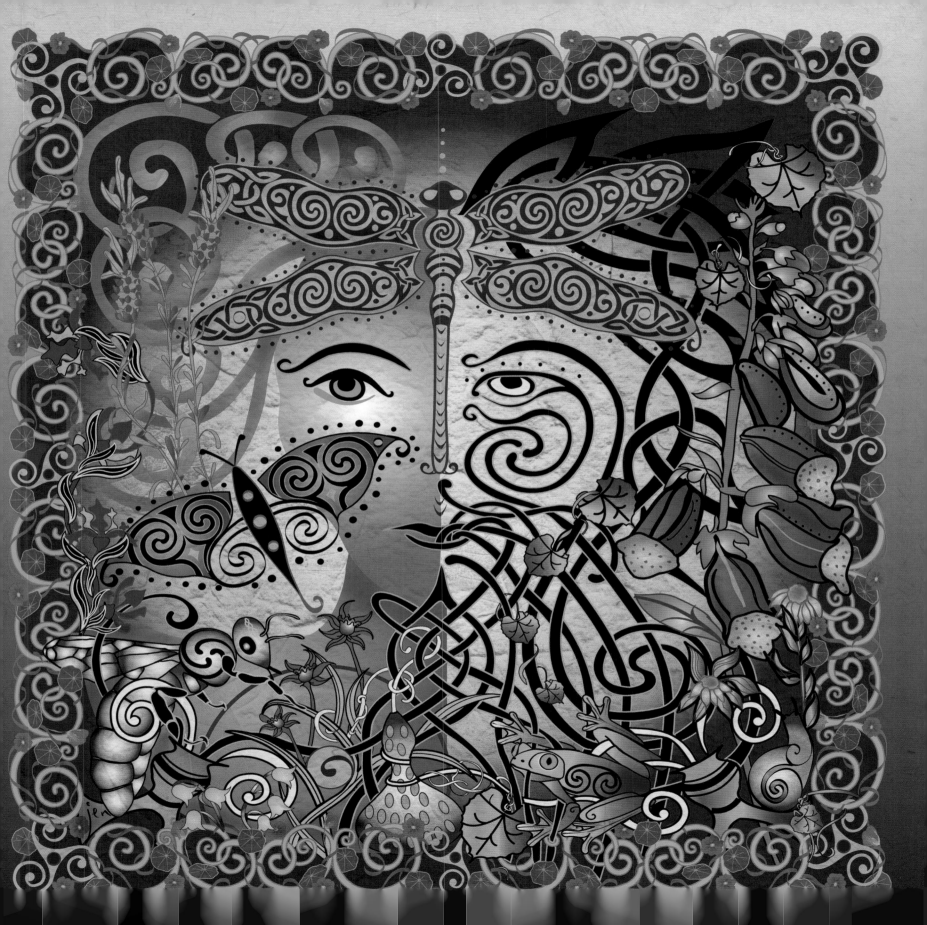

# ROOTS
## elements

The second time I was charmed

I was a silver salmon,

I was a hound, I was a stag,

I was a mountain buck.

—Taliesin, sixth century,
translated by Meirion Pennar

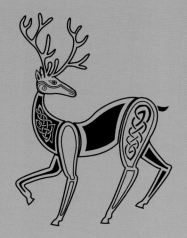

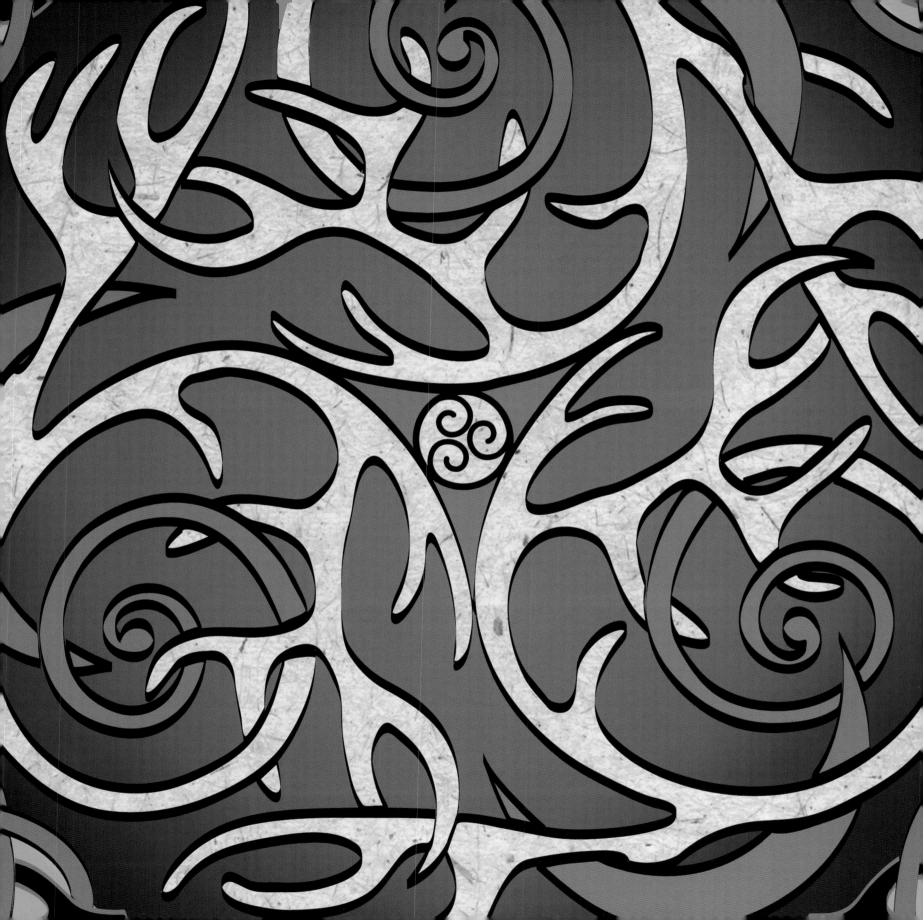

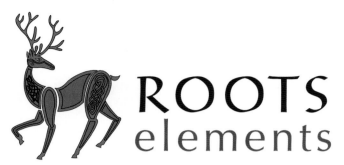

# ROOTS elements

Imagine the Folk-Soul as a giant tree with sturdy roots spreading deep into the ancient soil and the stony layers of the earth. Her trunk is thick and round, deeply ringed with many years' growth. She has beautiful bark and spiraling knots. Her wood is dense, but the sap runs clear and strong, drawing energy up into her expansive branches.

Her boughs reach skyward and then, heavy with fruit, bend down again to the earth, seeking connection with the tributary of roots below.

**The Roots of the Folk-Soul** go back to the first peoples, who lived close to the natural world. Through their daily existence and religious rituals, they were intrinsically connected to the cycles of life and death, light and darkness, to the turning of the great wheel of the seasons. The lives of the pre-Celtic peoples of the shadowy Megalithic culture of the Great Mound Builders were centered within a primal living Universe. They have woven their wisdom into the deepest roots of the Folk-Soul.

Our *Cro-Magnon* ancestors lived during the Ice Age. They hunted and were hunted, and they painted their powerful visions deep in the caves of the earth. It was there, close to the Otherworld, that the animal spirits were conjured from the rock by the shaman artists, brought to vivid life with charcoal, ochre and ground minerals in the light of simple lamps made of carved stone or bone that burned animal fat.

Although the Paleolithic people lived many thousands of years before the Celts, they are their ancestors, and there is a connecting thread between their paintings and the shape-shifting, mythic animal world of the Celtic imagination. Their art is a whisper within Celtic folk memory—the first voice of the people.

Hunter Gatherers lived in Europe during the Old Stone Age, the late Paleolithic period that stretched from 30,000 BC until the end of the last Ice Age around 8000 BC. They used chiseled stone tools, fishing nets and the bow and arrow, and domesticated dogs for hunting and protection to alert their communities to danger. They ritually buried their dead using red ochre (a natural earth pigment) to rebirth them in the womb of the earth.

These early people had not yet learned farming or animal husbandry, and their tools were simple. They were dependent upon the bounty of the world and were immersed in its Mysteries.

Small communities followed the herds, which led them in their seasonal migrations. The animals gave the people sustenance, their skins offered clothing and shelter, and they were valued for their mystical power and beauty.

In the psyches of the people, the lives of the animals were deeply interconnected with their own. The archetypal qualities of tenacious strength, speed and pride within the herd reverberated in the primal psyche of the Hunter Gatherers.

**The stories they painted** on the cave walls tell of the herds, the hunt, the Mysteries of life and death and the spirit world. The Hunter Gatherers were not builders, and we do not know what language they spoke or the names of those they worshipped. But their shamans have left us their stories upon the rocks. They found their communion with the spirit world in the darkness of the caves through paintings and engravings of animals and abstract patterns—and these are their only enduring legacy.

Our ancient forebears have left us with mere fragments of their long existence upon the earth, but their ancient dance within the Folk-Soul continues, inspired by their primal, earth-centered spirituality. Within the animist religions of the Bronze and Iron Age warrior tribes, many of their revered symbols continue to have power and relevance—the primeval Mother Goddess, the Stag, the Horse, the Bull and the elemental creatures of the water, air and the underground realms: Fish, Birds and Reptiles.

Caves were natural sheltering places, used for communal gatherings, but the archetypal animal figures painted high on the ceilings of the deep chambers were often difficult to reach, suggesting more ritual significance.

**M**other Goddess first emerges during the Paleolithic era: figures of pregnant, large-breasted women such as the Venus of Willendorf are our best-known early images of a human being. Dating back to 28,000–22,000 BC, this icon of prehistoric art was carved from oolitic limestone and found covered with a thick layer of red ochre, symbolizing the red blood of the Earth Mother.

Female animals and women were powerfully connected through the Mother Goddess, the primal archetype of fertility. The blood Mysteries of pregnancy and birth connected women with the cycles of the moon, as we see in the Venus of Laussel, an eighteen-inch-high bas-relief sculpture of a woman holding a curved bison horn that represents both the crescent moon and the universal vulva, the source of all life. More than 21,000 years old, our earliest Moon Goddess was found on a sheltered wall of limestone in the Dordogne Valley of France.

These natural archetypal symbols of fertility are profound Mysteries that continued to have deep meaning for the later agricultural communities and tribal peoples of Europe. Anu the ancient Earth Mother births new life, feeds her young at her breast and fiercely protects her children from harm.

**P**rehistoric Art in Europe is among the oldest of symbolic human expressions. Cave paintings and carvings made of rock, wood and bone tell the stories of the early people who came before us, who wove their presence into the roots of the Folk-Soul. Although the early people did not yet read, write or build, their sophisticated paintings reveal a shaman culture that was nurtured deep within the darkness of the caves. There, they painted animal forms that revealed themselves upon the undulations of the rock surfaces, bringing them to vivid life. These powerful images describe their encounters with the animal spirits in the trance-inducing darkness of the underground chambers. They used ritual paint such as red ochre and carefully placed their offerings of carved bones and teeth in hidden crevices, where they would whisper their secrets to the archaeologists who found them 30,000 years later.

Illustration: *Yggdrasil—World Tree*

**S**hamanism can be found in every hunter-gatherer culture around the world. The shaman is a priest, a healer and a magician—a link between the living and the Ancestors, this world and the Otherworld. Shamans journey to the spirit world in altered states of consciousness, seeking transformation and healing as intermediaries for the tribe.

The typical half human, half animal painting of an antlered man from Les Trois—known as *The Sorcerer*—is our earliest rendition of a shaman. He is an ancient example of the transforming and shape-shifting that appear later in Celtic mythology.

This figure of Cernunnos (center) is from the Gundestrup Cauldron, a votive object found ritually dismantled in a peat bog near Gundestrup in Denmark in 1891. Made around the second or first century BC by the La Tène–period Celts, this richly decorated silver bowl is covered in beautifully crafted images that relate to Celtic rituals and deities—including the antlered man, whom we first encountered upon cave walls more than 10,000 years earlier. He is depicted with magical plants, which were perhaps used as ritual medicine to aid in his journeying.

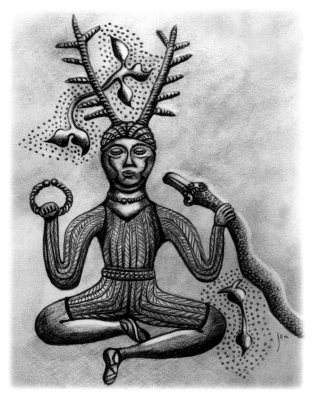

### Shape-Shifting

and journeys to the Underworld, introduced long ago by the first people, are powerful currents within the Celtic psyche. The most potent experiences of a shaman vision quest often include a personal transformation—shape-shifting into the animal itself.

In Celtic mythology there are many descriptions of such experiences. The Morrigan shape-changes into the Raven upon the battlefield, the Children of Lir become lonely Swans and women transform themselves into the Selkie seals of Manawyddan's Land under the Sea. In Welsh folklore—the *Mabinogi* stories—Pwyll, Lord of Dyfed, hunts a white stag in the forest with his hounds when he encounters Arawn, Lord of Annwn. They exchange places, and Pwyll lives in the Underworld for a year and a day as part of an agreement to balance his transgression of hunting a magical White Stag of Arawn.

### Taliesin

is a seer and shape-shifter, expressing the cycle of forms through the magical animals of the Celts: all is interconnected. The metaphysical, totemic relationship between man and the animals has long been expressed by Celtic shaman artists and poets such as Taliesin and Amergin, for whom creativity is the sacred language of the Mysteries. They describe many transformations through successions of totem animals and elements, representing the cycle of life and the ancient knowledge inherent in the spirit of nature.

The Druids may have believed in the transmigration of souls, reincarnation through animal to human forms. The Poet does not necessarily describe a literal transformation, but a more deeply symbolic one between both mythic and spiritual aspects of the totem creatures and the psyche of the Poet himself.

### Sympathetic Magic

between the hunter and the hunted is considered one interpretation of Paleolithic art. The paintings seem to represent the drawing of power from the animal to the shaman, who negotiates with the spirit world on behalf of the tribe. The paintings have been seen as an

Illustration: *Cernunnos—Gundestrup Cauldron, second or first century BC*

offering back to the Underworld to ritually rebirth the creatures that were an important source of food.

In the Chauvet cave in France are powerful thirty-two thousand–year-old paintings of animals such as bison and deer, depicted as pregnant and fertile. Creatures that are half human and half animal embody the sympathetic relationship between hunter and hunted—the shaman transforming or shape-shifting into the animal figure. However, many paintings do not depict creatures as being hunted, rather as revered for their qualities of power, grace and beauty, such as the herds of wild horses upon the cave walls.

P aleolithic Cave Painters carved and painted powerful images of their revered animals. Although some creatures were clearly important as food sources, they were also sacred figures within the people's spiritual traditions.

Lascaux in southwestern France has some of the most beautiful painted Paleolithic caves in the world, containing the earliest known art, dating to between 13,000 and 15,000 BC (or as far back as 25,000 BC). Haunting paintings of horses, bulls and stags, depicted with spiritual strength and character, tell animated stories of the hunt. Great bulls and many red and black cows cover the cave walls. An inspiration for people since the earliest times, the Bull symbolizes male strength and power, virility and stubborn tenaciousness.

Pech Merle in the Languedoc region of France is home to a magnificent labyrinth of caves filled with colorful paintings and engravings—some incorporating the natural forms of the cave walls. The spotted horses and the artists' handprints found there are most magical. Radiating dots and lines around and inside the animal forms release

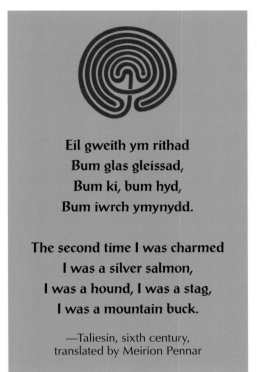

Eil gweith ym rithad
Bum glas gleissad,
Bum ki, bum hyd,
Bum iwrch ymynydd.

The second time I was charmed
I was a silver salmon,
I was a hound, I was a stag,
I was a mountain buck.

—Taliesin, sixth century,
translated by Meirion Pennar

their spirits from within the living rock. Deep in this spirit realm, the shaman artists conjured these sacred animals both literally and metaphorically out of the Underworld.

At the center of an enormous chamber at Pech Merle, surrounded by hanging stalactites, natural stone forms the head of a horse. The rock itself seems to open to the animal's spirit emerging from its rough surface. For the ancient Hunter Gatherers, as for the tribal Celts, there is no real boundary between the material world and the spirit world. Celtic folklore tells us that at certain times in the wheel of the seasons when the veil between the worlds grows thin, such as at *Samhain—Hallowe'en*, the door opens to the spirits coming through from their dark Underworld.

**Since we first walked the earth** human beings have entered into ritual trance states, experiencing hallucinations as part of our spiritual traditions. For Paleolithic people caves were both literal and figurative entrances into the Underworld. In the tunnels and chambers of the subterranean places, the shaman artists could enter into trance hallucinations, which they manifested or re-created with finger tracings, engravings and paintings.

Through ritual chanting, drumming and dancing, through extreme pain or sensory deprivation (as is found in the darkness of the caves) and sometimes with plant medicines—entheogens—human beings have the potential to experience alternate perceptions that share some common visual and emotional expressions. Their visual interpretations of these altered states offer an inspiring glimpse into the beginnings of the animist Old Religion that developed over many thousands of years to evolve with the tribal Celts, as they continued to feed the fertile roots of the primal Mysteries of the Hunter Gatherers.

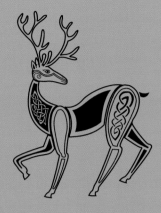

## In the Beginning

In the beginning was the three-pointed star,
One smile of light across the empty face;
One bough of bone across the rooting air,
The substance forked that marrowed the first sun,
And, burning ciphers on the round of space,
Heaven and hell mixed as they spun.

In the beginning was the pale signature,
Three-syllabled and starry as the smile;
And after came the imprints on the water,
Stamp of the minted face upon the moon;
The blood that touched the crosstree and the grail
Touched the first cloud and left a sign.

In the beginning was the mounting fire
That set alight the weathers from a spark,
A three-eyed, red-eyed spark, blunt as a flower;
Life rose and spouted from the rolling seas,
Burst in the roots, pumped from the earth and rock
The secret oils that drive the grass.

—Dylan Thomas

# AWEN–INSPIRATION

Awen is Welsh for *poetic inspiration*. A flowing essence, this spiritual illumination is known in Irish as the Imbas. Awen is the spark of life, creativity, inspiration and wisdom, the living principle.

The Hand image represents this creative principle of life, representing the great artistry of creation. It is an echo of the magical handprints of the shaman cave painters who honored the spiritual essence of the animals—the hunters and the hunted—and manifested their forms in the Otherworld, deep in the darkness of the caves.

In the illustration on the right, we see the totemic animal symbols of the Celts: the Horned Stag, the earth Serpent, the wise Crane, the Solar Horse, the loyal Hounds of Culcullain, the Salmon of wisdom, the Hare—totem of the Earth Goddess—and the Boar of valor, Twrch Trwyth. Also depicted are the symbols of sun and moon. In the palm of the hand, Awen is symbolized as three rays emanating from three small dots, symbolizing truth, the balance of life and existence. This symbol is described in Dylan Thomas's poem: "In the beginning was the pale signature, Three-syllabled and starry as the smile."

Bards and Poets revere the mystical divine knowledge of the Awen. According to the ancient Welsh tales of the *Mabinogion*, Bard Taliesin, meaning *Radiant Brow*, receives Awen with gifts of knowledge, prophecy and poetry from Ceridwen's cauldron.

Awen is the breath of the god Dagda, who bestows this gift of power and knowledge upon the Chief Bard of the Druids. Twelfth-century poet Llywarch ap Llywelyn (c. 1173–1220), known as the *Poet of the Pigs*, says, "The Lord God will give me the sweet Awen, as from the cauldron of Ceridwen."

Illustration facing page: *Awen—Inspiration*

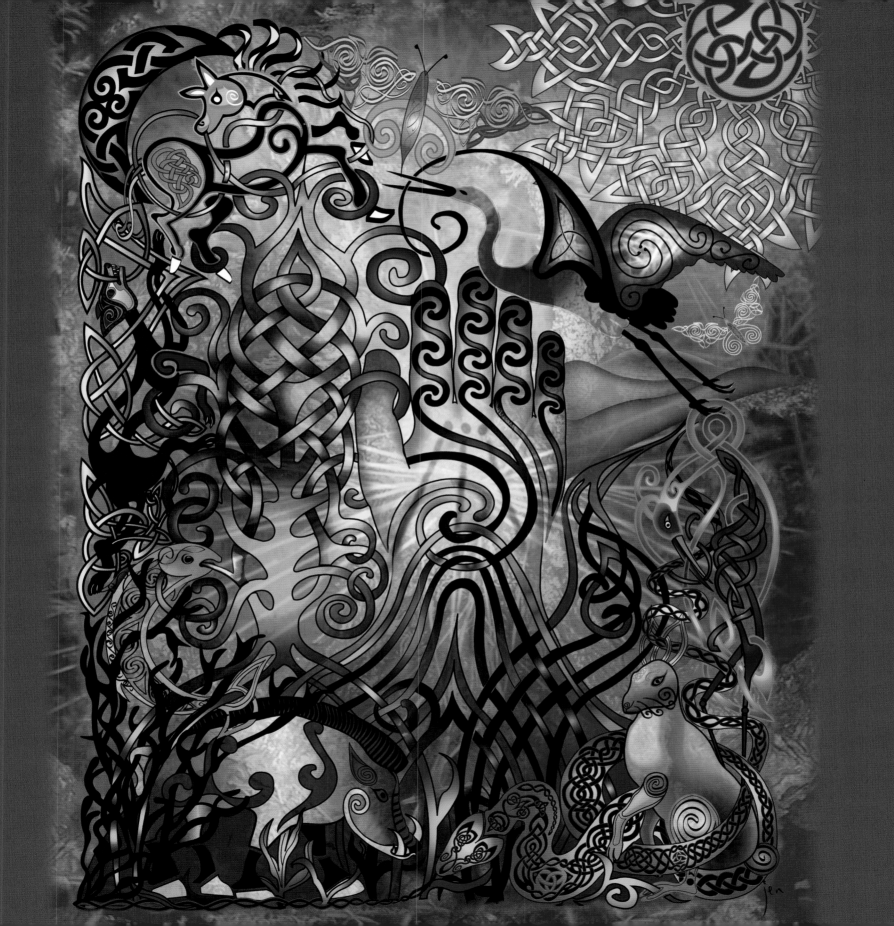

**T**rance Patterns are commonly occurring visual experiences that are characteristic of the markings and images we see in ancient cave paintings. Abstract patterns such as dots, signs and geometric and arrow shapes are not merely decorative—they represent ritual and mystical experience. Interestingly, these visual elements that are experienced during trance have been developed intuitively in later folk-art motifs such as the key-knot or chevron patterns, and the dotted outlines we continue to see in the artwork of the medieval manuscripts.

When the artist moves from trance to deeper hallucination, natural forms can reveal themselves through the fabric of the environment. For the cave painters, the sacred animals may have seemed to emerge through the natural forms of the rock walls and fissures, brought to life in the flickering light of their torches— the cave itself only a thin membrane between the artists and the creatures of the Underworld.

Handprints were left on the cave walls 20,000 years ago. The artists left their mark as both positive and negative stencil prints of their hands, around which they blew pigment. They did not necessarily create them as personal signatures, but as gestures—perhaps made in trance states during rituals— that fused hand with rock.

In this way, artists inserted their very presence into the mystical artwork. Although paintings of human figures from this time are rare, handprints are quite common, including those of children, perhaps apprentice shamans learning from their teachers.

**The First Artists** lived close to the natural world: the landscape, the animals and the seasons. They honored the creatures upon whom they relied for their survival, but they also revered them for their spiritual and physical qualities of strength, fertility and swiftness.

Perhaps the early artists who lived in different areas across many thousands of years had diverse reasons for creating their powerful paintings and rituals. We may never really know. However, there is a compelling relationship between the people and the animals that continues through the Iron and Bronze Age cultures of the tribal peoples—especially in the cults of the Horse, the Stag and the Bull. Other creatures that appear in prehistoric paintings, such as the mammoth, the auroch and the bison, were long extinct in Europe by the time of the Celts.

In many old Welsh stories, men are changed into a wolf or a hog, a raven, an eagle, or a hawk; while the women become swans, wild geese, serpents, cats, mice or birds. In the *Mabinogi* stories, Gwydion by means of magic, transformed Gilvaethwy first into a deer, then into a hog, afterwards into a wolf, and lastly back again into human form. In the story of Manawyddan, the wife of Llwyd, the son of Kilcoed, was turned into a mouse, and at his death King Arthur was transformed into the shape of a raven, for which reason the peasantry of Wales, Cornwall and Brittany will not kill that bird. Blodeuwedd, who was created from flowers as a wife for Llew, was changed into an owl for betraying her husband. From these ancient myths probably arose the belief in later ages that certain people could be transformed by magical aid into various shapes, or were directly descended from animals.

—Marie Trevelyan, *Folk-Lore and Folk-Stories of Wales*, 1909

The images and symbols of the Hunter Gatherers, the Neolithic megalith builders, and the warrior artist Celts of the Iron and Bronze Ages, form a continuum that invokes the sacred and connects the power in the world to the power within ourselves. This is the foundation of art and mythology within the Celtic Folk-Soul.

This artwork is a visual language that intuitively expresses the rhythms of the Mystery of life and the profound mystical connection between the inner world of the imagination and the creative power of the world in which we live.

## ROOTS OF CELTIC ART

The Development of Celtic Art began in the Bronze and Iron Ages, but it is the people who came before them who planted its seeds as the first animist artists. Their visual expressions of landscape, spirituality and rituals were powerful Mysteries that are rooted within the mythology and folklore of later Celtic culture.

The Language of Symbols was readily understood by the ancient people, whose lives were a continuum of religious expression communicated through visual images that held great power and significance. It is through the language of symbols that the Druid priests communicated the sacred to the people, who in turn expressed their intentions to the Gods.

The ancient artists created abstractions, rather than realistic depictions of the world, to honor the sacredness of Nature. This view, in which stylized figures are created to represent rather than copy the works of the Creator, is held by many cultures in the world.

Primitive Patterns carved into everyday objects of bone, wood and stone form geometric, stylized motifs that are still intrinsic to the vocabulary of Celtic art today.

The weaving of baskets and fishing nets, cloth and leather harnesses were among the first crafts of the early folk. A weaver takes one or many strands and creates a unique, solid pattern that *(continued on page 34)*

## RITUAL ART

The Red Man of Wales, discovered in one of the Paviland limestone caves in the Gower Peninsula of South Wales, is an almost complete Paleolithic human skeleton dyed or coated with red ochre and protected by an amulet of sacred sea shells. First known as the Red Lady of Paviland, and eventually identified as a man in his early twenties from 24,000 BC, his are the oldest human remains found in Britain.

Red ochre (the natural earth pigment) is often used as a ritual paint for Paleolithic people. It is the sacred color of blood and the earth, associated with the Underworld from which we are born and to which we return. In later Celtic mythology, red and white continue to be symbolic colors of the Otherworld, as we saw with the red- and white-eared Hounds of Annwn who encountered the magical Stag of Arawn.

Shamanic experiences of both ancient and contemporary tribal people are clearly connected with their forms of rock art. The first artists painted by spitting pigment—ground and mixed with saliva in their mouths—onto rock surfaces that were too uneven for extensive brushwork. (The Australian Aborigines still paint this way today.)

Imagine them breathing images onto the rock, shaping lines and tones with their hands upon the cave walls. Sometimes they used charcoal for underlying sketches. Their recipes for paint were mixtures of ground minerals: for red they used hematite, for black manganese dioxide, combining them with extender mixtures of biotite and feldspar ground together with quartz stones.

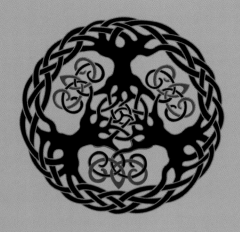

# YGGDRASIL—WORLD TREE

Trees are a profound symbol of the interconnection of all Life.
A Yggdrasil is the World Tree of Norse mythology, the
Giant Ash tree that links and connects all the known worlds,
the earth below and the heaven above. Also known as
the Tree of Knowledge, the Tree of the Universe and
the Tree of Fate, Yggdrasil is the axis, the center of the creation
of the Universe. Three roots connect the World Tree to the
three wells that flow beneath: the well of Mimir, whose waters
are the source of all wisdom; the Well of Fate—Urdarbrunnr—
guarded by the Norns; and the well of Hvergelmir—Roaring
Kettle—the source of many rivers that nourish life.
The World Tree is a symbol common to many societies.
Within Celtic tradition, the Great Oak tree is
most revered, and the Druids are said to have
worshipped among the ancient groves.

Branches reaching to the sun bend gracefully with the wind,
as roots are strong and seeking deep into the earth below.

Illustration facing page: *Yggdrasil—World Tree*

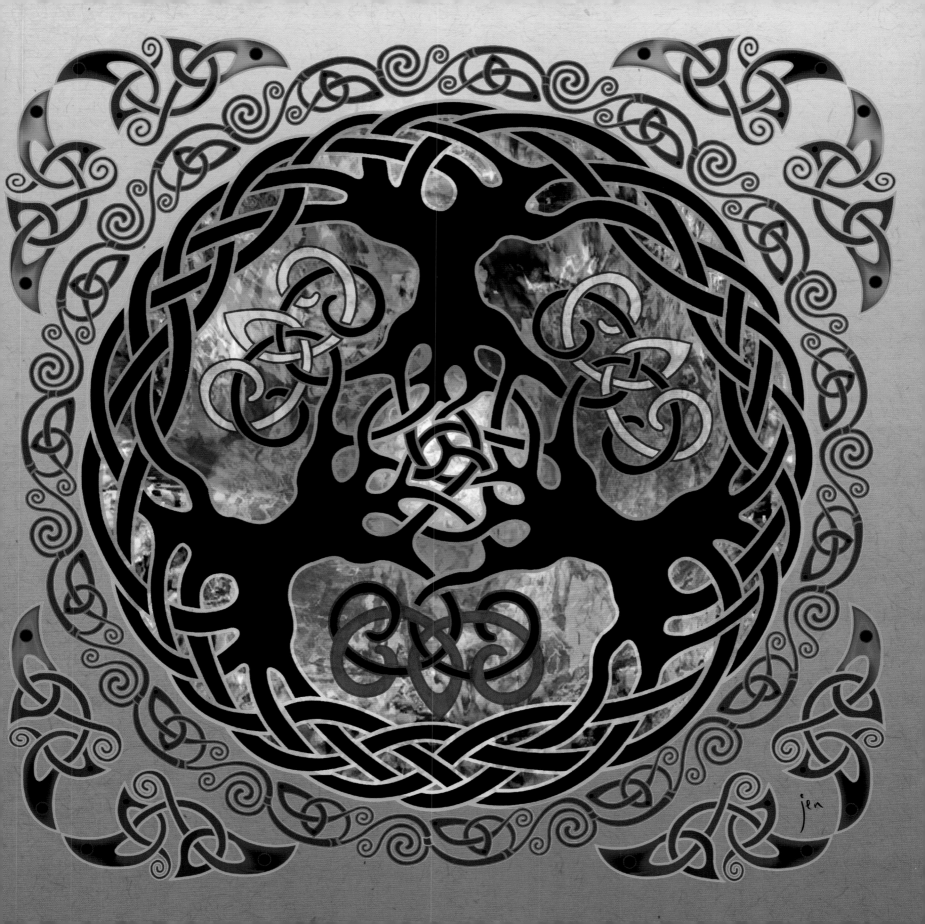

is at once balanced and flowing: *the many into the one, the one into the many.* These knottings and interweavings were pragmatic pieces that were essential to survival, but they also contributed to the development of abstract thought and mystical expression. In some ancient cultures, knotting and weaving were seen as protection from evil spirits, who could be caught and trapped within the complexities of the design.

The early artists translated these three-dimensional weavings into two-dimensional patterns, which they then developed into symbols representing more complex expressions of their religious beliefs.

**T**he Language of Celtic Art. An appreciation for sacred patterning reminds us that everything is in motion, and yet held in perfect balance. Celtic designs are limitless in their creative variation, with an energy that often flows outward from the center, unfurling in an infinite dance of possibilities.

These enduring designs continue to communicate ancient ideas of a more fluid relationship between things. At the heart of the imagery, and for the mostly illiterate folk who had direct access to folk-patterns and ritual art, is a sense that all is multidimensional and interconnected, and that there is a mystical and colorful spiritual world beyond the hardships of everyday life.

The following are a few examples of the symbol language that lies at the root of traditional Celtic Art including the elemental patterns the labyrinth (key and chevron patterns), the spiral and curvilinear forms, the interlace, the Tree of Life (vegetative plant vine motifs) and zoomorphic or animal designs.

**The Labyrinth,** maze and key-knot patterns meander into the center and out again, a metaphysical representation of the journey of life. Intricate networks of paths that

do not exist in nature except in the simplest spiral forms, they are an early example of the abstraction of pattern to express a metaphysical concept, to explain the mystery of life and death.

The labyrinth is one of the most ancient and sacred forms, created independently by people all over the world from earliest times. Some of the first examples of spiral maze patterns are ornaments created by the first Cro-Magnon artists from Mal'ta in Siberia (24,000 BC) and Mezin, Ukraine, (18,000 BC) engraved onto ancient mammoth ivories.

Mammoth icons of half-bird, half-woman figures are often found decorated with early ritual maze patterns. These first designs evolved from chevron (V-shaped) patterns, representing the flight of birds, or from the mark of the "pubic triangle" symbolizing the Goddess—the compelling theory of Neolithic and Bronze Age archaeologist Marija Gimbutas.

The chevron marks, along with the lozenge (diamond-shaped) symbol, are the basis of primitive geometric patterns. This primal language of chevron and spiral elements developed into the meandering zigzag designs, then transitioned into the labyrinth and key-knot patterns we later see in Cretan and Greek art (used often in mosaics), and was then adapted by the Celts.

A labyrinth pattern at its most elemental takes us on a spiral path through a passageway, a kind of ritual birthing into the center (womb) and out again. Associated with the ancient Goddess, it is a deeply profound ritual pattern, a primal archetypal symbol that people carved into rocks and painted on cave walls to express the complex experience of birth and death, the Journey through life.

**The Spiral,** or triskele, is a Celtic motif that is continually repeated in story, prayer and artwork patterns. In basic

form, it symbolizes the energies of change and regeneration, the dance of life.

The spiral is found everywhere in nature: snail shells, water swirls and eddies, tree knots, the curling growth of plant tendrils and vines. Spiral forms are the thumbprint of the universe, seen in massive galaxies and at the smallest cellular and atomic levels. Understood by the early peoples to represent the ebb and flow of life, the spiral is the key to the Mystery of the patterning of nature, its spiritual signature.

Taking this elemental spiral form and creating a triple-legged pattern is a leap of abstract expression. The early people could not yet read or write, but they were able to represent a metaphysical concept in this important motif, which symbolizes the three phases of life.

The spiral triskele designs, with their religious significance of sacred triplicity, have remained popular, especially in Wales, Brittany and Cornwall.

**The Eternal Knot** represents the interconnectedness of all things, and interlace patterns of complex knotwork are infinite in their variety. The basic ribbon patterns—under-and-over interlacing designs—are often used to fill a space with fluid symmetry and balance. These creative patterns are in constant motion; they weave into the center and out again, yet create a unified whole.

Playful rhythms utilize both positive and negative space to create balance and completion, while remaining meandering, spiraling, free and flowing. Patterns move outward and toward a center, but the center is also in constant movement, as we see expressed in the triskele symbol.

This organic fluidity reflects the persona of its craftspeople and is a visual representation of the culture that produces such imagery. The interlace patterns have no beginning and no end, representing at their most elemental the eternal quality of life with all its complexity, and yet balance.

**The Tree of Life**, a vegetative plant pattern, is a spiraling interlace form that usually climbs out of a pot and is often embellished with small birds and leaves. This motif represents verdant life emerging from the vessel or source—the grail, sacred container of life.

The first vegetative motifs appear in the La Tène Iron Age, and have been adapted from the more floral classical designs into a uniquely Celtic form.

Birds—which represent spirit through their gift of flight and journeys into the heavens—are often associated with the Tree of Life, from which they pluck the fruit of wisdom. This is a deeply esoteric philosophy common to many ancient cultures and religions.

The Tree of Life motif is not as early as the spiral or labyrinth, but was used in Egypt in 5000 BC and is an important symbol for cultures and faiths around the world. The vine motif, pot, and oval leaves with small eyes upon them symbolize all plant forms; at the same time, they represent the deeper philosophy of the Tree of Life.

In keeping with the respectful tradition of not copying but instead abstracting forms that represent nature, there are no images of actual trees or specific flowering plants in the Celtic art of antiquity. Those more lifelike interpretations of this symbol that we often see today in the work of modern Celtic artists are contemporary images—a perfect example of the evolution of the folk-art tradition that will continue into future times.

**A**nimal Beast and Bird designs intertwine with other elements and abstract patterns, hinting at the theme of shape-shifting that is intrinsic to the folklore of the Celts and expressing the imagination and wit of the artist. There is an often-dizzying interchange,

reflecting the shamanic movements between animal and human forms that we find in mythology.

In some early metal-works, simple stylized lines and curvilinear elements suggest faces of owls, cats, birds and strange divinities with *magic eyes* that peer through the vegetal-inspired motifs and spirals, inviting us into an otherworldly reality.

The same powerful creatures such as Horse, Stag and Bull that appeared in the cave paintings of the Paleolithic people are omnipresent in Celtic artwork. Otherworldly associations were common with these powerful totem creatures, including the Boar, who often appeared as a fierce symbol of valor.

The zoomorphic motif of a crouching animal looking over his shoulder, introduced much later, was adapted from the Scythian and Anglo-Saxon Germanic traditions. The Celts evolved this form, interchanging interlace, spirals and zoomorphic elements in incredible shape-shifting virtuosity. When we study medieval manuscripts such as The Book of Kells, we see many decorations of half bird, half beast, intertwining vines, creatures and saints throughout the vellum pages.

**The Bull** is revered by the Celts as Hu the Mighty, and he appears throughout their mythology with otherworldly significance related to the fertility of the land and the tribe. The mythic power of totemic beasts often relates to the forces of the land and the cosmos. In the Irish myth The Battle Raid of Cooley, Taín Bó Chuailgné, there is a supernatural battle for Ireland between the Brown Bull of Ulster, Donn, and the White Horned One, Findbennach, the Bull of Connaught. They lock together in terrible combat. Donn destroys the White Bull, and the Irish political landscape is established.

**The Stag** with his branching horns had mystical importance to the Celts, as he had for the Paleolithic people—an early depiction of Cernunnos, whose cult has stayed strong into our times. As we have seen, he appears in British folklore as Herne the Hunter. The hunter identifies with the stag, and the two are entwined in an ancient Mystery.

**The Horse** was clearly loved and worshipped by our most distant ancestors. Horses appear throughout the cave paintings as creatures of grace, intelligence and beauty: they are sometimes shown in herds, magnificent and free, not yet bound to the plough or the saddle. The spotted horses of Pech Merle are strikingly beautiful. Ten to twenty thousand years old, they are painted with radiating dots and other markings showing mystical significance.

The Horse culture of the Celts, as has been true for many tribal peoples around the world, was extremely important for warriors, who decorated their horses with fine bridles, harnesses and headwear. Horses also serve as solar symbols, embodying the sun's divine qualities of strength and fertility. Celtic coins were often minted with images of the Horse and solar symbols such as the wheel and the Boar.

The cult of the Sacred Mare developed over many thousands of years, until she became a fertile symbol of the sovereignty of the land for the Celts; she was known as Epona or Rhiannon.

The White Horse of Uffington is a stylized figure some 360 feet long. Gouged into the white chalk bedrock

three thousand or more years ago, she gallops across the Berkshire Downs. White Horse chalk carvings are the most poignant reminder of the importance of the Horse deity and her connection to the land itself.

**Symbols and Meanings** continue to evolve over time, but there is an underlying language—the relationship between man and nature—that continues to speak to us today. Most of the artwork in this book is original and contemporary. By using the traditional Celtic design language in new ways, and sometimes using new tools, archetypes and mythic elements are reinterpreted that still hold meaning and relevance many thousands of years later.

**O**ur lives may be quite different from those who painted in the caves twenty thousand years ago, but like them we still feel the power of life when we give birth to our children, bury our loved ones, watch Summer turn to Winter and celebrate with the return of Spring. We too, may appreciate the spirit of freedom, intelligence and grace found in a herd of wild horses running with the wind. Our early Ancestors are ancient whisperers within the shape-shifter Folk-Soul—their stories, born within their dark caves, are the roots of our ancient mythologies.

**The Celtic Folk-Soul** is richly colored by the archetypal visions of artists through the ages, from ancient cave painters to humble monks. This language that the Ancestors created in the fertile darkness of the Earth Mother endures within us: we are cave painters all.

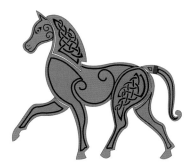

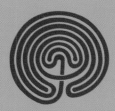

# HANES TALIESIN

I have fled with vigor, I have fled as a frog
I have fled in the semblance of
a crow scarcely finding rest:
I have fled vehemently, I have fled as a chain;
I have fled as a roe into an entangled thicket;
I have fled as a wolf cub;
I have fled as a wolf in a wilderness;
I have fled as a thrust of portending language;
I have fled as a fox,
used to concurrent bounds of quirks;
I have fled as a martin, which did not avail;
I have fled as a squirrel, that vainly hides;
I have fled as a stag's antler of ruddy course;
I have fled as iron in a glowing fire;
I have fled as a spear-head of woe
to such as has a wish for it;
I have fled as a fierce bull bitterly fighting;
I have fled as a bristly boar seen in a ravine;
I have fled as a white grain of pure wheat.
On the skirt of a hempen sheet entangled,
That seemed the size of a mare's foal,
That is filling like a ship on the waters;
Into a dark leathern bag I was thrown
And on a boundless sea I was sent adrift,
Which was to me an omen of being tenderly nursed,
And the Lord God then set me at liberty.

—Attributed to Hanes Taliesin, sixteenth century,
translated by Lady Charlotte E. Guest

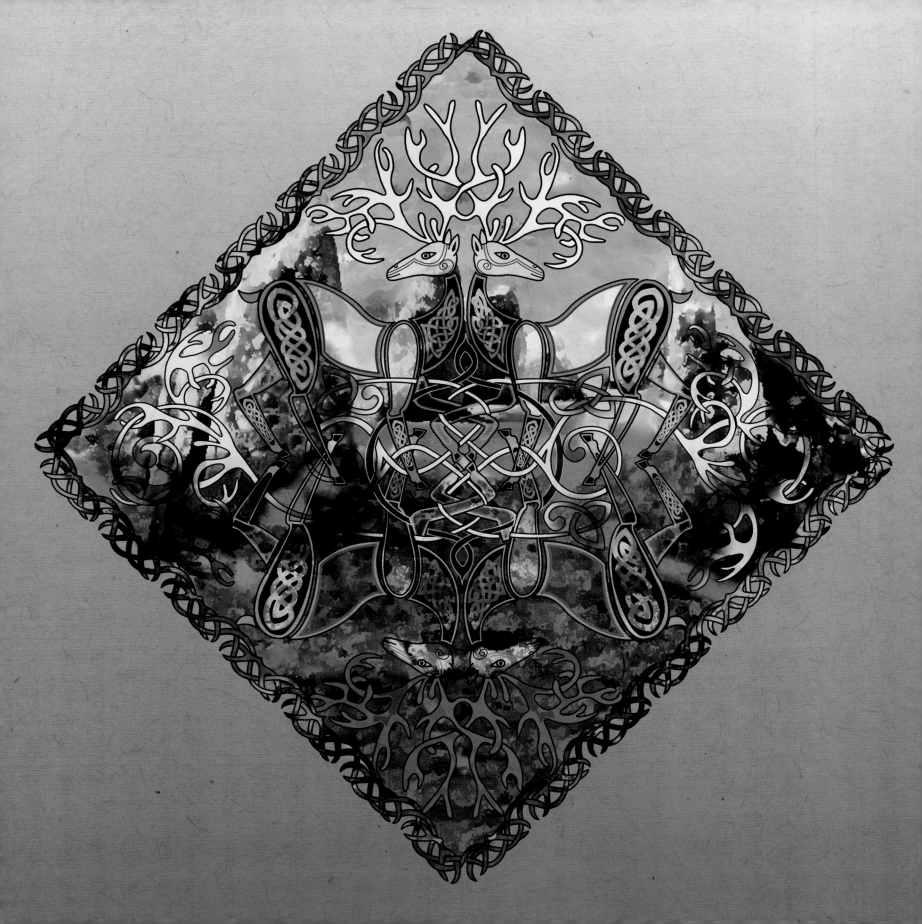

# TALE OF
# HERNE the HUNTER

**T**he Stag God is associated with Cernunnos, also called the Horned One or Lord of All Stags. He is lord of the horned and hoofed animals, and is associated with the wild hunt in which spirits of the dead are rounded up and carried to the Otherworld. Since the time of the earliest people, the Stag has been revered as a magical creature. The antlered shaman appears in the Paleolithic cave paintings at Les Trois-Frères in the French Pyrenees. Also known as The Sorcerer, the antlered man is an early manifestation of the Horned God, who appears in British folklore as Herne the Hunter. The hunter identifies closely with the stag: this is a very ancient mystery—hunter and hunted are one.

Tales of the Stag Hunter appear throughout European folklore. Herne, or *Cerne*, is the distant folk memory of Cernunnos—which translates as the Horned One. His cult was widespread across the Celtic world. On the silver Gundestrup Cauldron that was found in a peat bog in Denmark, we find him sitting cross-legged, wearing the sacred torc (Celtic neck ring) and holding a ram-headed serpent, which also represents fertility and strength.

Horned animals, especially stags, have long been associated with male sexuality and strength. To the Celts, the stag symbolized wild nature—he is Lord of the Animals. His alertness, speed, aggression and potency during the rutting season made him an object of reverence, while his spreading, tree-like antlers seemed to epitomize the forest. In mythology, the stag deity is often associated with the oak tree, a symbol of strength and wisdom.

Deer lose and regenerate their antlers each year and so are intrinsically connected to the Mysteries of seasonal regeneration and the cycles of death and rebirth.

Throughout Celtic mythology, both women and men shape-shift into Deer or Stag form, personifying the metaphysical elements of the animal spirit within their psyches. In the Fionn Cycle, Finn encounters his future wife, Sadbh, changed into a Fawn by the Black Druid *Fer Doirich*. Their son Oisín is later raised by his mother the Deer, and becomes part Deer himself.

Horns worn on the head symbolize the power and intelligence of the animal from which they come, and in many cultures the priest or shaman often wears the antlers of the Stag as he journeys between the worlds.

One of the earliest images of a horned Shaman figure comes from Val Camonica, a valley in the lower Alpine regions of Lombardy in northern Italy. There, two hundred and fifty thousand Bronze Age petroglyphs were carved by the Camunni tribe, some dating as early as 8000 BC. One of the most important of these figurative icons is a Celtic rock carving that depicts the Stag God wearing a long garment and a powerful magical-religious torc around his neck. Magnificent tall antlers grow from his head.

In the Welsh mythic stories of the *Mabinogi*, the Deer or Stag represents the boundary between the worlds. In one tale Pwyll, Lord of Dyfed, and his hounds become lost while hunting a mystical White Stag deep in the forest. In a clearing they meet a strange pack of red- and white-eared dogs (red and white are the colors of the Otherworld), the Hounds of Annwn—*Annwfn* in Welsh—the Celtic Underworld. They surround the noble Stag, but Pwyll drives them off and claims the quarry for himself.

Arawn, the Lord of the Underworld, suddenly appears—most angry that Pwyll has claimed the White Stag, who belongs to his realm. He demands that Pwyll

repair the insult by exchanging places with him, traveling to the otherworldly realm, and killing his enemy in Annwn. Although we do not encounter the White Stag again in this tale, he represents the journey to the Otherworld, where Pwyll and Arawn balance the cycle by exchanging places. Only after a sacrifice is made can Pwyll return.

Herne the Hunter figures in another tale of a shaman journeying to the Otherworld, a legend centered in the ancient Windsor Forest, one that is still remembered today. The local folk say that when the wind howls and storm clouds race across the darkened sky, the antlered man—Herne the Hunter—can be seen galloping with his spectral hounds, gathering lost souls for their journey to the Otherworld.

In the fourteenth-century version of the tale, Herne was one of King Richard's huntsmen. He was a true woodsman who knew every path and trail in the ancient forest and spent every day out hunting with his royal master. On one such morning, the dogs picked up the scent of a rare White Stag, and the chase began with a thundering of hooves and baying of hounds. The hunters crashed through the woods and leapt over streams, driven on by flashing glimpses of the noble animal darting between the ever-thickening stands of trees.

Herne rode at King Richard's side as they closed in on the Stag. An arrow had pierced its side, and the proud creature was cornered in a clearing deep in the forest, his magnificent antlers held high and his hooves angrily pawing the ground. Herne restrained the hounds, who were eager to move in for the kill: but this was to be an honor for King Richard alone. The king unsheathed his knife as his horse nervously edged toward their quarry.

> There is an old tale goes, that Herne the Hunter,
> Sometime a keeper here in Windsor forest,
> Doth all the winter time at still midnight,
> Walk around about an oak, with great ragg'd horns;
> And there he blasts the tree, and takes the cattle;
> And makes milch-kine yield blood, and shakes a chain
> In a most hideous and dreadful manner.
> You have heard of such a spirit, and well you know
> The superstitious idle-headed eld
> Receiv'd, and did deliver to our age,
> This tale of Herne the Hunter for a truth.
>
> —William Shakespeare, *The Merry Wives of Windsor*,
> Act 4, Scene 4

Suddenly, the Stag sprang forward and ripped open the king's horse with his fierce antlers. Herne instinctively threw himself between his king and the frenzied hart, thrusting his knife up and into the Stag's throat. He saved Richard, but not before he himself had been mauled by the great antlers and both man and Stag lay dying, their blood seeping into the earth.

It seemed that Herne was doomed, when out of the dark forest a stranger on a black horse appeared and asked to examine the wounded hunter. He was a local wise man, the magician called Urwick, and although the king's men feared him, they had no choice but to accept his offer of help. Urwick gave the men a strange order: "Remove the antlers from this noble stag, and fix them to Herne's head!" Though they distrusted the dark sorcerer, they did as he commanded, cutting the antlers from the dead Stag and binding them upon Herne's head. Then they carried him back to Urwick's hut, where he lay as if dead for many days and nights. The wise man fed him strange potions, herbs from the darkest depths of the forest, roots pulled by the light of the full moon and water drawn from an ancient spring. Herne slowly recovered his health, and Urwick removed the White Stag's horns from his head.

When he returned to the castle, Herne was rewarded for his courage and sacrifice with gold and a beautiful silver hunting horn from the king, who favored him above all his men. The other hunters soon began to feel jealous of the royal favors conferred upon the king's well-loved huntsman, and so they began to spread rumors that Herne was in league with the black magician and his dubious Arts. The king refused to believe the tales: Urwick was

indeed a strange recluse, but he was also a wise man and healer who used his powers for good, not evil.

The envious huntsmen hatched another plan to ruin Herne, planting three fresh deer skins in his hut and accusing him of being a poacher. Herne met them as they were leaving, and unaware of their intention, gave them a money purse to take to Urwick to thank him for his kindness and the gift of healing. But the men kept the money and instead went to the magician to claim that Herne was most ungrateful to him. Indeed, they said, Herne had often delighted in making fun of him to all who would listen, jesting about the sorcerer's ridiculous cure of putting antlers upon his head.

Urwick was furious and cursed Herne to the gods for his lack of respect and gratitude. The jealous hunters gleefully exacted further revenge by suggesting that, as punishment, Urwick should use his powers to take away Herne's hunting skills.

The next day Herne was out hunting as usual with King Richard. Much to their surprise, they failed to find a suitable quarry. After a few days of hunting Herne became frustrated over his repeated failures, and King Richard was puzzled. When the three poached deer skins were discovered in Herne's hut, Richard immediately dismissed him. His favorite hunter, Richard concluded, had been poaching by night and was simply too tired to successfully hunt during the day.

Herne was disgraced and went mad with grief. Overwhelmed by shame and desperation at the injustices done to him, he took his own life, and the next day he was found hanging from an oak tree in the center of the forest. Time passed and the hunting was never quite the same in Windsor Forest. There were no deer and no wild boar, not even many rabbits or fowl to snare for the royal table. The king was frustrated, and despite his anger at Herne, was sad to have lost his greatest huntsman.

One dark and windy night as Richard was returning from yet another disappointing day of hunting, a storm blew up and he took shelter beneath the same oak tree where Herne had died. A bolt of lightning struck the tree, revealing to the king the ghostly figure of Herne bearing the White Stag's antlers upon his head. He told the truth about the vengeful foresters and asked Richard to seek justice, to right the wrong that had been done to his honor, and so Richard ordered the two huntsmen hanged from Herne's Oak. Soon the deer and all the other game returned to the forest: balance was returned.

Many have claimed to have seen Herne, especially around Herne's Oak where he died. It is said that his ghost haunts the forest still, appearing as an antlered man riding his black horse with a horned owl upon his shoulder, his demon hounds at his feet and the wicked huntsmen following behind. He is said to claim the souls of poachers and all the damned souls of men as they chase the White Stag endlessly across the night sky. Herne's Oak can still be found within Windsor Forest, although it has been replanted and relocated several times throughout history. The original tree has long since gone, but the myth continues. When the wind howls and the moon is dark, it is said by those who remember the old tales that "the hunters are abroad."

In this myth, the deaths of the Stag and Herne are sacrifices at the sacred tree of the Celts: an initiation into the Mysteries of death and rebirth. The initiation is the fulfillment of the shamanic powers Herne received while mortally wounded, which were passed to him by his teacher, the Druid magician who placed the potent antlers upon his head.

The Stag appears in the earliest cave paintings, an icon of fleet-footed grace and noble bearing, keen of scent and quick to alert to danger—a magical creature of Celtic mythology and religion. His branching horns give power to the shaman, who is transformed by this Mystery. The hunter and the hunted are one.

# ANTLERS AND MOONS

Antlers are an ancient archetype representing male energy,

strength and fertility. The Horned God is a powerful

symbol to the ancient people. He is called Cernunnos, Herne

and Lord of All Stags. His great branching horns manifest

the Spirit of the Forest—the esoteric Mystery of the Tree of Life.

The growth and shedding of his antlers are seasonal

symbols of regeneration.

The moon is an ancient archetypal female symbol.

Arianrhod, the Welsh goddess whose name means

*Silver Wheel,* was worshipped as Priestess of the Moon.

She is mistress of the rhythms of tides (water, emotion, psyche)

and womb cycles (life, death, creation).

This weaving together of Antlers and Moons balances the

potent symbols of male and female energy. Both archetypes

represent rebirth and regeneration, and together they contain

the Mysteries of earth and sky.

Illustration facing page: *Antlers and Moons*

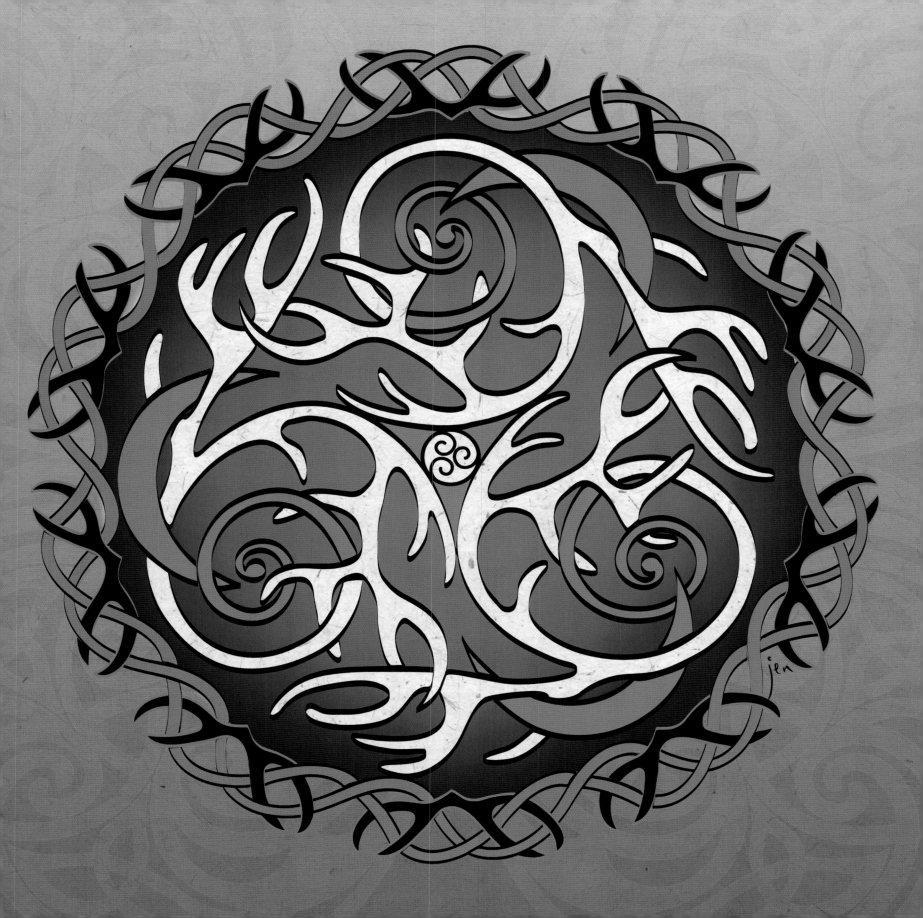

# STONE
## mysteries

And in the wood: by the grey stone on the hill
where the heron waits,
Can she not whisper the
white secrecies which words discolor?
Can she not say, when we would forget, forget,
When we would remember, remember …

—Fiona MacLeod,
*By Sundown Shores,* 1901

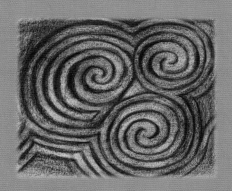

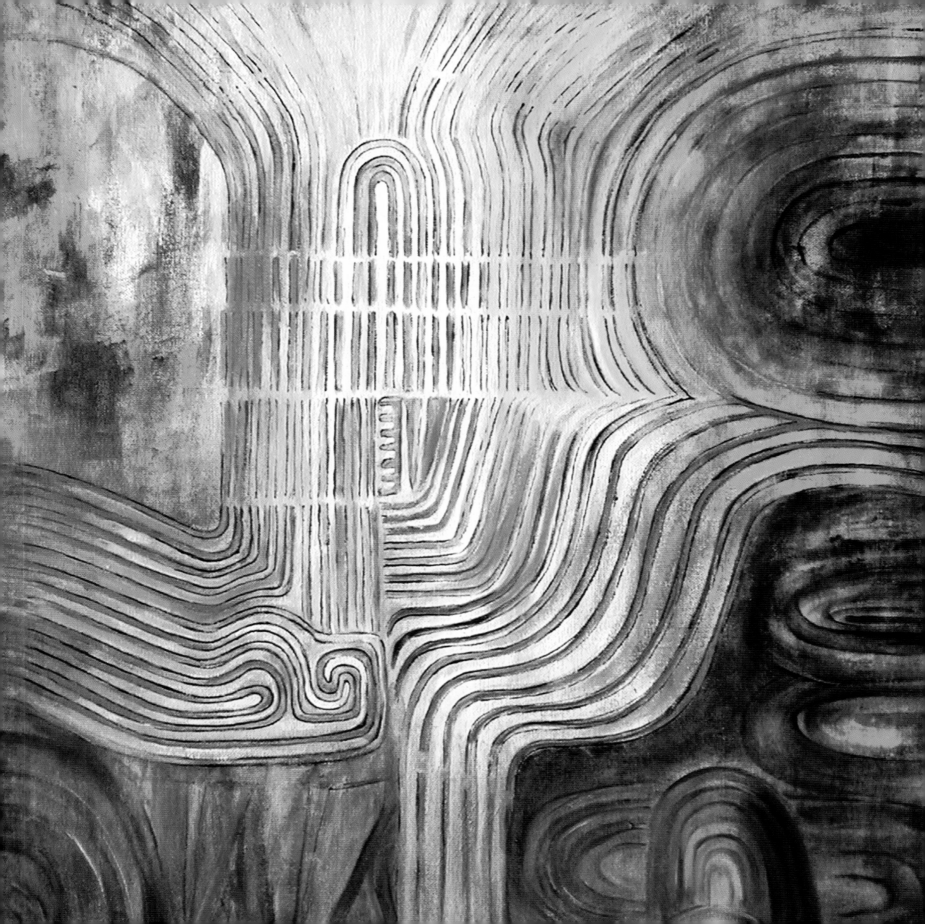

# STONE mysteries

**R**ocks and stones are the ancient bones of our natural landscape. For the early people, power adheres to the rocky places. Their great raised stones penetrate the earth, conducting the receptive energies upward and outward. Long-enduring features of the land, rocks are natural gathering places often known by name and endowed with spiritual and ritual purpose.

Mountains and hills connect the earth to the heavens; they are the body of the ancient Earth Goddess. The *Paps of Anu* in County Kerry, Ireland, are twin hills outlining the Mother's breasts, a prominent landscape feature that transforms the earth and rock into the body of the ancient goddess Anu.

Folklore and mythology surround the weathered outcroppings, the fossil- and quartz-embedded boulders that were tossed by giants and brought by magicians of old to their resting places.

**Dolmens and quoits** are the exposed lintels of the ancient covered cairns (mounds of stone). Menhirs are long, single unhewn or slightly sculpted stones, and cromlechs are great circles of menhirs. Today the ancient stones of the megalith builders remain permeated with mystery and the folk memories of many thousands of years. All of these stone forms—menhirs, dolmens, quoits, cairns and cromlechs—connect us with those who raised them, and the mysticism and ritual created around them.

Many races and cultures of people have come and gone in ancient Europe, some continuing the ancient traditions and others often reshaping the myths surrounding the sacred stony places that have seen so many seasons of rain, sun and wind. The megalithic monuments have inspired the folklore of the people through many thousands of years.

**E**arth is the ancient Mother, and the hills and mountains, the fertile soil and deep caves are her body. She is the rivers, springs and lakes—the waters emerging from the underground to fertilize the lands. Born from the belly of the mother, when we die we return to her. Animals, plants and the very nature of existence are subject to this profound circle of being.

For the Neolithic people this wisdom was profoundly connected with their newfound knowledge of agriculture: the growth of crops and the husbandry of animals the people depended upon. Dolmens and stones were often raised over springs or fissures, which are gateways to the subterranean depths of the Earth.

Five thousand years ago, the Neolithic communities built massive mounds so that they might enter into the earthwomb. Within the dark chambers of these cairns, they practiced rituals of burial, rebirth and journeys to the Otherworld.

**Mounds** are earthworks and burial graves, including immense round and long barrows and large, mysterious artificial hills like Silbury Hill, located just south of the village of Avebury in Wiltshire. Ancient people believed that we are reborn into an afterlife. They built the great mounds and barrows with stone and wood, and there

they laid out their dead with ceremonial ritual objects and animal totems to accompany them on their journey to the Otherworld.

The grave mounds are a visible reminder of the Ancestors, focal points in the landscape that have connected us to their beliefs throughout the ages. The mounds are still venerated long after the memories of those interred in them are a mere whisper within the Folk-Soul.

The ancient religion of the mound builders is intertwined with the beliefs of the Celts, who considered springs, caves and the mounds themselves to be entrances to the Otherworld. The Tylwyth Teg are the *Fair Folk* of Wales, the Tuatha dé Danaan are the *People of the Goddess Danu*. Their descendants are the Sidhe, *Shee—the People of the Mounds*, who were said to inhabit the magical places beneath such large mounds as Newgrange in Ireland.

**Earth Mysteries** for the early people and the later Celts include the idea that rebirth is a natural principle of life, part of the rhythm of growth and decay. For them, death is a natural stage in the cycle of existence. At important burial sites in Ireland such as Tara in Meath and Emain Macha in the north, the Celts held festive tribal gatherings around the graves of the divine Ancestors. Wells, springs or groves of trees near the mounds were seen as sacred points of connection with the mysteries of the Otherworld.

Night follows day, the movements of the sun giving birth to the seasons. The mystical wax and wane of the moon are connected with the fertility of plants and women. The moon pulls the tides of the oceans and rivers, the power and force of the waters, worshipped as divine qualities of Celtic goddesses such as Boann, Brigantia and Sinnan.

Neolithic people of Britain and Ireland lived around 4000 to 1500 BC. As the Ice Age receded, a new landscape of green fertile lands, lakes, forests and animals brought the Hunter Gatherers north, and new communities of simple farmers migrated west across the remaining land bridges, such as the Dogger Bank connecting England and France. Early mariners also came in simple boats across the narrow waters. Before the erosion of land and coast, there were islands in the southern part of the North Sea, and the early hunters, fishermen and traders would have experienced no difficulty in reaching Albion (the ancient name for Great Britain) and Ériu (Ireland).

The people began to grow crops and form small agricultural villages. They learned to domesticate cattle, sheep and goats, and weaving and pottery began. They refined the art of polishing and flaking flint, creating sharp-edged tools and stone implements that were technologically advanced for their time; they did not yet know the secrets of the metals. This was the age of the Great Stone Builders who raised the ceremonial menhirs, dolmens and cromlechs, and buried their dead in the mounds.

Stone is the bone of the world, under moor, under loam.
Under ocean and churchyard-corruption of buried bone;
Floor of the mountain, pound of the ocean, the worlds' cord.

—Robert Farren, "The Mason"

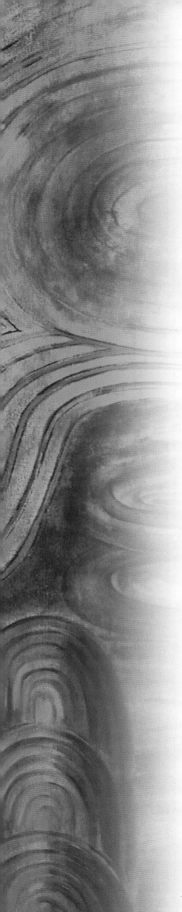

**T**he **Great Stone Builders** belonged to a civilization that spanned twenty-five hundred years, leaving little record of its existence beyond the remains of its ceremonial centers, gathering places and burial sites, and an ethereal presence in the mythology and religion of the tribal Celts.

The great stones and barrows were raised in the shadowy megalithic or Great Stone culture of the second and third millennia BC. There are many wonderful megalithic monuments in western Europe. Most of these are found in the more isolated Celtic lands of Wales, Ireland, Scotland and Brittany where they have survived through thousands of years supported by the culture and imagination of the people.

The raising of the huge stones for ritual or ceremonial gatherings seems to have been an intuitive impulse for man across the globe. Neolithic raised stones appear in different forms all over the world—in Asia, Africa and Europe—although we do not think they were created by a single culture or race of people.

The Neolithic village communities that cultivated the land and raised cattle had created a productive economy. They were becoming traders of such precious materials as gold, copper and pearls. Jet and flint were mined in areas such as Wales, Cornwall, Scotland and Brittany, places where we find the great stone circles and tall menhirs. The geologically complex islands of Britain and Ireland were particularly rich in ores, and being surrounded by the ocean they were easily navigated by the early mariners who were developing skills in boat building and sailing.

Some groups of Neolithic people, possibly connected with the new trading routes that stretched far to the east, developed skills in architecture and astronomy that were manifest in the raising of the cromlechs and menhirs. These huge structures visually channel the energies of earth and sky as they dominate the landscape, pointing to the mystery of the stars above. Neolithic priests or spiritual leaders learned how to channel the sun itself through the massive cairn chambers such as Newgrange and Gavrinis, and through the alignment of the stones at Stonehenge.

**Gavrinis and Newgrange** in Ireland are two of the largest and most inspiring examples of massive cairns that honor the Earth Mysteries. Both were built to welcome

but let us sing the skill of the master builders long ago
for it was no peasantry clodding after scrawny cows
who raised the hollow hills and henge stones
but calm and cunning wizards worked these wonders
continuing the snail line, dod flat at ring stand
ruling scribing and pegging out in granite
the windings of the dragon track
that writhes unhewn
in sward and marsh and moss and meadowland
that twines in stellar gravity among the eaves of the cubic sky
and poetry attests their artistry thus and otherwise
older yet and wiser far
and I will not forget.

—Robin Williamson,
excerpt from "Five Denials on Merlin's Grave," 1978

and encourage the return of the sun and honor the fertile forces of life, the movement from darkness to light: the great mystery of the wheel of the seasons, the cycle of life and death, the Mysteries of rebirth.

Gavrinis is one of the best preserved sites in Brittany and a most inspirational site for Neolithic art. It is not far from Carnac, a small town in southern Brittany that is surrounded by thousands of menhirs, dolmens and passage graves—and is one of the most important prehistoric areas in the world today. The stone alignments that stretch in long rows for over a mile or so were raised between 5000 and 2000 BC.

The Gavrinis megalithic temple on the Île de Gavrinis in the Golfe du Morbihan is dated around 3500 to 4000 BC. This ancient monument is built with a passage through which the winter solstice rays of sun fertilize the chamber beyond. The first rays strike upon deeply engraved patterns of spirals and key labyrinth motifs, awakening the power of the living earth.

It took many generations of sculptors with humble flint tools to chisel the significant markings that cover the hard stone walls: mystical symbols that include spiral, serpentine and downward-pointing triangle—*yoni,* motifs and whorls. This dedication over several lifetimes of carvers speaks to the profound importance of the symbols found within the womb of the great barrows and mounds created to honor the Earth Mysteries.

Opinions differ as to whether Gavrinis was a tomb or a temple, but there is no doubt of the profound spiritual energy you can feel in this incredible place. The inside of the raised cairn is deeply carved with beautiful patterns of rhythm and radiance—undulating curves and arcs that express the seasonal wax and wane of sunrises and sunsets.

The end chamber of the passage is carved with a radiant figure from which all lines flow outward. At winter solstice, sun rises through the dark passage to illuminate and fertilize the figure.

Some researchers suggest that the curved lines represent the feminine, and that this is a temple to the Earth Mother. Others that this is an incredible work of decorative art. No matter how we interpret this profoundly sacred place, the swirling, undulating rhythmic patterns, which are so full of energy, seem to speak of the beauty and power of life.

## GAVRINIS

I first heard about the Gavrinis passage grave from a sculptor friend who inspired my visit to this mystical place in Brittany. We had only minimal directions, but knew we could get there by taking a *bateau rouge,* red boat, from Larmor Baden Harbor near Vannes.

It was late on a misty October day when we found the harbor. There was only a small wooden booth to indicate that we were even in the right place—and that was closed. There was a poster of the Gavrinis on the door and some suggestion (in French) that there were trips at various times of the day during this season, so we decided to wait.

With nothing more than hope, and not much faith, we sat on the old wooden pier and watched for the bateau rouge that might or might not come to take us to the island. Just when we had decided that it was unlikely to ever arrive, we saw the small red and white craft (significantly, these colors represent the Otherworld in Celtic mythology) heading our way across the Golfe du Morbihan, and to our great relief and pleasure, were offered the last trip of the day to the Île de Gavrinis.

Arriving by boat at the small island was a special experience for us, and for the quiet French family who accompanied us and the guide. A small rabbit leapt out of the entrance of the giant cairn as we approached—a significant Celtic omen, as the Hare is totem of the Earth Goddess. Entering the dark, narrow passageway was an unforgettable experience. Flanked by marvelous slabs made by the Neolithic carvers over 5000 years before, it is deeply carved with spiraling patterns. On Winter Solstice, the passage channels a potent beam of sunlight to awaken a radiant figure on the back wall.

As we sailed back to the mainland, I was struck by similar patterns—the spiraling water currents of the bay, the salty tides swirling around the ancient rocks where a great civilization of people had once come to honor the Mysteries of Life.

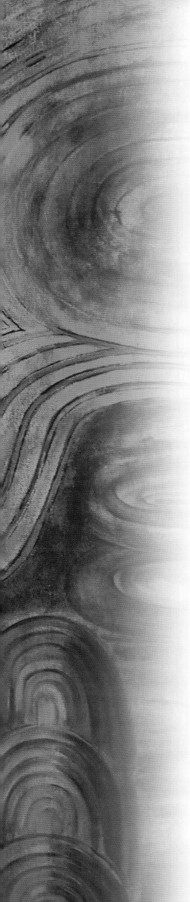

**N**ewgrange in Ireland is another magnificent megalithic tomb that channels the winter solstice sun through its uterine passageway. This place was connected with the sacred energies of the ancient Goddess long before the Celts arrived in Ireland.

Built about 3200 BC and known as Brugh na Boinne, *Bend of the Boyne,* the great circular mound of earth and stone sits astride an elongated ridge in a large curve in the Boyne River about five miles west of the town of Drogheda. The Boyne, said to reflect the heavenly river the Milky Way, is named for Boann, the Celtic river goddess. Newgrange has a facade of sparkling white quartz stones, is surrounded by giant standing stones and ninety-seven kerb stones, and is richly decorated with megalithic art. At dawn on the Winter Solstice, a shaft of light penetrates the long inner passageway and illuminates the inner chamber. The passageway calls the fertilizing powers of the sun into the womb of the megalithic mound on the year's darkest day.

The entrance stone is covered in carved spiral forms, including the significant triple spirals that are among the most sacred symbols of Neolithic Europe, and that are so well known to us today. They offer a beautiful example of an archetypal symbol that represents the infinite spiraling forces of nature. The design seems to symbolize the three patternings of life: birth, life and death; spring, summer and winter; the time before, the now and that yet to come.

This important symbol at Newgrange, which predates the Celtic people by thousands of years, links the ancient Neolithic culture with the sacred iconography of the Celts, who perceived the sacred triplicity in every aspect of their mythology, rituals and blessings: the Triple Goddess transforms between Maiden, Mother and old warrior Hag and appears as the triple Brighids, the Morrigan and the Matronae, *Divine Mothers.* The triplicity continues to have profound resonance within Celtic Christianity as the holy trinity; many prayers and blessings are woven through the theology of the sacred three.

The triple spirals at the entrance to the otherworldly realm of the Tuatha dé Danaan at Newgrange have become a contemporary icon of the Earth Mystery tradition, resonating deeply within the Celtic Folk-Soul.

How and why the stones were raised has produced many interesting and conflicting theories. Some archaeologists link the culture of stone raisers with a more sophisticated, mysterious people from the east, who came to exploit the natural resources of the simple Neolithic communities. The Irish myths tell of the invasions of the Fir Bolg—*the men with sacks,* and the Fir-domnann—*the men who deepened the earth—the diggers,* perhaps miners come from the Basque country, many of whom migrated to the western isles.

We may never know exactly whether the Great Stones were originally intended as astronomical devices or temples for sacrifices to the gods, whether they were built upon connections of *ley lines* (a theory explaining tracks or alignments between monuments) to channel the earth energies or as awe-inspiring architectural feats built to dominate the local landscape and its people. Often of extreme weight and size, and sometimes brought over large distances, the stones were certainly raised for profoundly important reasons considering the great effort expended using an ancient technology that astounds us still. Perhaps various elements of these theories were true for different peoples at different times.

Often built in open areas such as Stonehenge on Salisbury Plain, Carnac in Brittany or Castlerigg in Cumbria, they were most probably intended for community gatherings and used for ceremonial purposes.

  **STONE** mysteries

Illustration: *Carved Spirals on Newgrange Entrance Stone c. 3300–2900 BC*

Over time, the mysterious great stones of these enterprising Neolithic farmer-builders have inspired local folklore and superstition around the enduring pillars and lintels, craggy boulders and lichened stones.

**C**romlechs, circles of menhirs that held gatherings of people during rituals and celebrations, were ancient even to the Celts. While many stone circles and giant pillars have long since disappeared from our fields and woodlands, it is a wonder that plenty have somehow survived. Stories of Spirits and Faerie Folk associated with the stones may have helped to deter their destruction by local people over the centuries, although many were removed due to superstition, or sometimes used as handy building materials.

Some enterprising farmers, unable or unwilling to remove the extremely heavy stones from their land, have been known to integrate the large megalithic boulders into their buildings. One charming example in Brittany is of an ancient dolmen—once the ceremonial burial place of a Neolithic family—transformed into a makeshift chicken shed that was discovered in a farmer's yard!

It should be noted that in parts of Brittany, which was once the center of a massive civilization of stone builders, there are so many menhirs, dolmens, cromlechs and cairns scattered around the beautiful countryside that you nearly stumble upon them quite by accident.

It is possible to wander spontaneously, feeling the pull of the stones. A humble sign might point the way through a copse into an ancient grove off the usual tourist track, and there you may encounter megaliths in the natural landscape.

**T**he Hebrides and Orkney Islands in remote northern Scotland are also part of an enormous prehistoric ritual complex. Stone circles such as the Ring o' Brodgar are surrounded by water, built in the center of a natural basin formed by the surrounding hills. The land has vital spirit and wild beauty; the active forces of water, sky and rock animate the living landscape.

The Callenish Stones overlook the desolate moorland of the Isle of Lewis in the rugged islands of the Outer Hebrides off Scotland's west coast. They are tall and thin, piercing the sky of the wild and windswept landscape. There are many raised cromlechs and menhirs on these islands, which although isolated, were accessible to the early mariners, who traveled more extensively than was first realized.

It is here in the remote Hebrides centered on the island of Iona that Celtic Christianity flourished in the fifth century, founded by Columba, *Colm Cille*, among other early saints. In identifying the old religion of the earth with the new, Saint Columba is said to have first spoken the famous prayer "Mo Drui, Mac De"—"*My Druid, Son of God.*"

Three gigantic stones, called *Tre Greienyn*, are to be seen standing at the foot of Cader Idris. An old tradition says that these stones were three grains of sand which the gigantic astronomer Idris Gawr shook out of his shoes before he ascended to his stone chair or observatory on the top of the mountain. On the summit of Cader Idris there is an excavation in the solid rock which resembles a couch or seat. It is said that if anybody remained in the seat of Idris for a night, he would be found in the morning either dead, raving mad, or endowed with remarkable genius.

—William Howell,
*Cambrian Superstitions*, 1831

# GAVRINIS

The Gavrinis megalithic temple on the Île de Gavrinis, a small island at the
entrance to the Golfe du Morbihan in Brittany, is dated around 3500 to 4000 BC.
The stone slabs on the inside of this raised cairn are covered in deeply carved
patterns of rhythm and radiance: undulating curves and arcs that express
the seasonal wax and wane of sunrises and sunsets. At the center of the end
chamber of the passage is an abstract figure, created using flowing lines of energy
and rhythm. At the Winter Solstice the sunrise is channeled through the passage
and the figure is symbolically awakened. The Earth Goddess is fertilized by the
sun and the days grow long again. The serpentine markings represent
the coiled energy of the earth, the serpent itself representing rebirth. The
downward pointing triangle motifs, *yoni*, are female symbols of fertility and
birthing. Spiraling patterns represent the cosmos and are seen everywhere:
in the trails of stars, the ripples of water, our fingerprints, the ebb and flow of the
energy of the earth. This painting was inspired by the remarkable markings
and back wall figure of the Gavrinis Passage Grave.

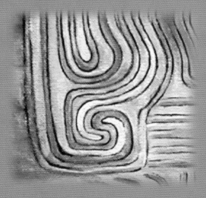

Illustration facing page: *Gavrinis—Winter Solstice*

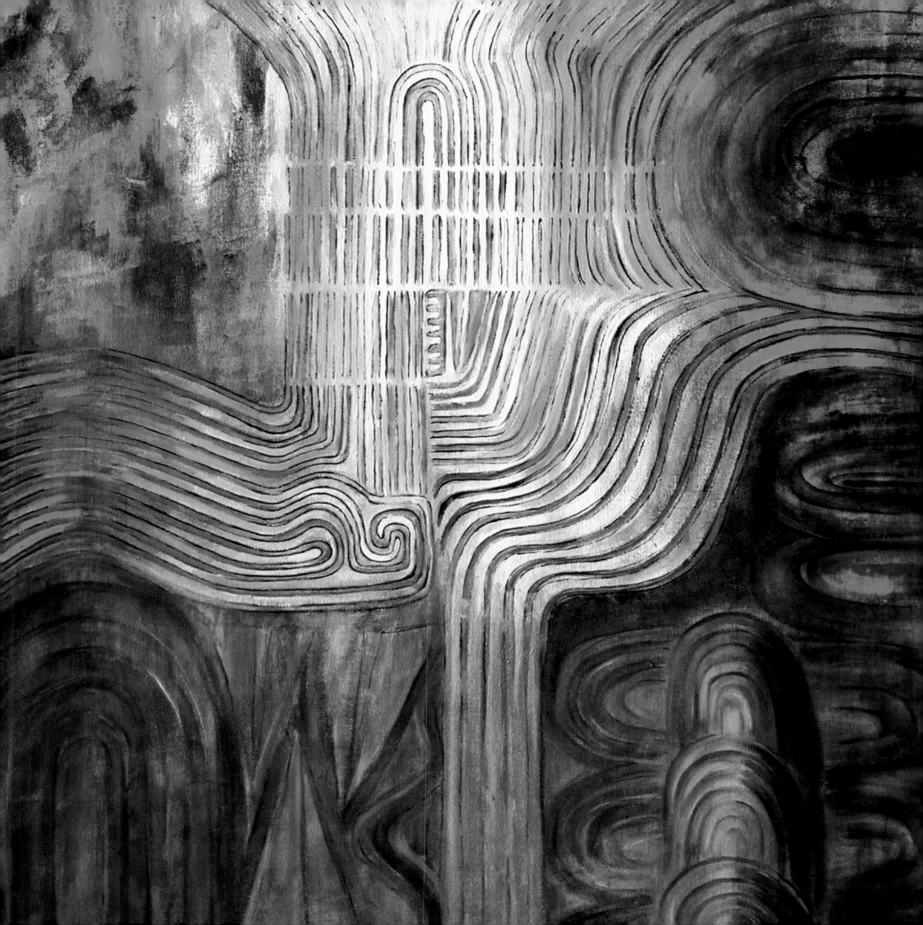

S tonehenge—the *Giant's Dance*—on Salisbury Plain in Wiltshire is the best known megalithic stone circle in the world. Possibly dedicated to the worship of sun, moon and stars, the stones align to the midsummer sunrise.

Built with wood set into holes dug with antler tools, the first Henge was built around 3100 BC. It was rebuilt with bluestones from the Presceli Mountains in Pembroke, South Wales—an incredible feat, as they were moved two hundred and forty-five miles over sea, river and land. Around 2300 BC, the third and final stage of Stonehenge began when giant sandstones, or Sarsen stones, were brought twenty miles from the Marlborough Downs.

**The early Druids** may have used the ancient stone circles for ceremonial gatherings, or perhaps for astronomical calculations, but their religion grew to be centered around the living trees, and their more secretive rituals were held in the groves and woods. Although the Celtic Druids were once thought to have built Stonehenge, and perhaps they did help to rebuild it, it is older than the tribal peoples of Bronze Age Europe.

The Ancient Order of the Druids was formed in 1781 as a secret society with principles of being *convivial, fraternal and philanthropic*. The druidic Grand Lodge visited Stonehenge for the first time in 1905, with much festivity and initiations for new members.

The last century was a turbulent time for the ancient Henge, with a military camp established there during the First World War, the creation of the Ancient Monuments Act, and the addition of an enclosure fence in 1901. There were formidable differences of opinion between the modern day Druids and the Office of Works in the 1920s, and the Henge has seen its share of struggles between worshippers and the establishment ever since.

**Summer Solstice.** For many years during the 1970s and 1980s, a Summer Solstice festival was held in a farmer's field across from the Henge. At dawn on the solstice, the modern-day Druids in white robes created a ceremony within the stone circle, a contemporary interpretation of the rites of the old religion which they continue to observe today.

The rising sun appeared above the Heel Stone on this, the longest day, thrilling the expectant crowds who gathered for this auspicious moment. After the serious business of seeing in the solstice was done and the Druids had left the stones, informal ceremonies of marriage, welcoming of new babies, blessings of new mothers and old fathers, and many other colorful events were conducted amid the music, singing and dancing: modern-day folk reweaving the fabric of gathering among the stones.

Sometimes, it must be said, it was raining. Typical British mist and low clouds prevailed, and no discernible sun was to be seen for days, including during the solstice sunrise. But there were other years where the day dawned perfectly upon the plains. Clear mornings brought the

---

From its earliest mention by twelfth-century historian Geoffrey of Monmouth, Arthurian legend tells that the monument was erected by Myrddin, *Merlin*, in memory of Pendragon, brother of Uther Pendragon, Arthur's father. It is said that Myrddin mythically built Stonehenge by himself in one night, calling all its massive stones from Ireland with his magic songs.

The Dragon symbolizes the natural energies of the earth. Stonehenge is built upon a powerful convergence of these geomantic forces—ley lines (the Chinese call them *Dragon Currents*)—which connect the whole earth by a network of energy flow. The Red Dragon of Wales is derived from the Great Red Earth Serpent.

**Y Ddraig Goch Ddyry Cychwyn!**
**Roughly meaning: The Red Dragon will rise again!**

**STONE** mysteries

sleepy-eyed out of their tents, caravans and makeshift shelters to join the motley group within the giant sarsens and ancient bluestones.

Sadly, the atmosphere at the monument is not what it once was. It is difficult to feel the numinous spark from outside the barrier fence that now surrounds the stones, and with the main road and busloads of tourists so close. There are many more inspiring circles that are less known—but not less powerful. Castlerigg, in mountainous Cumbria of northwest England, is one of them.

**C**astlerigg Stone Circle is one of the most beautiful, enigmatic stone circles in Britain. Sited on a high moor ringed by hills and fertile green valleys, the circle dates around 3000 BC and is one of the oldest stone circles in Europe.

Overlooked by Blencathra, Lattrigg and High Rigg Fells and with panoramic views all around, it is unspoiled—an utterly inspiring place set in the dramatic landscape. Old stone shepherds' walls run like streams through the stony heather, and a brooding mist hangs at the head of the mountain passes, giving atmosphere and gravity to the *Druid's Circle*, as it is known.

Since it is not easily accessible by tour bus, it is still possible to visit this powerful circle alone, or perhaps share the experience with small groups in muddy walking boots who also appreciate the beauty and age of this circle where Neolithic people once gathered.

This ancient circle of great stone menhirs continued to be honored by the Celts who populated the high land of rock and water. This area is not commonly associated with the Celtic heartland, but the north of Britain was home to the Celtic and Brythonic peoples who lived in its isolated valleys and hills. The Gododdin tribe—subject of the elegy poem by Taliesin praising its warriors who died in battle—lived in the north near the border of Cumbria.

Feted by the poets Wordsworth and Keats, this area of outstanding beauty is a complex geological land of ancient stone. Cumbria contains the highest mountains in England as well as most of the country's lakes, with volcanic peaks and glacial valleys rich in granite and shale.

Numerous ancient monuments can be found in this inspiring mountainous terrain, once home to over two hundred and fifty stone circles, but many of them are gone. While there are only fifty or so circles left, such as Castlerigg, Swinside and Long Meg and her Daughters, there are many smaller cromlechs that make Cumbria one of the most densely populated areas of stone circles in the world.

**W**elsh Folklore and legends have deep roots in pre-history. South Wales, which has a similar language and coastal environment to Brittany, was once a fertile home for the Paleolithic and Neolithic peoples. The coast and inland estuaries are rich in shellfish, and the climate, warmed by the ocean, is mild. There are many sheltering caves along its rugged coast, which continued to support the later Celtic people who arrived from the south and the east. Their culture is intertwined with that of the ancient Britons who lived before them.

There are still a great number of megalithic monuments in Wales, but many have disappeared, partly due to the attempts of the Church to quash the vestiges of the Old Religion—the folk superstitions and faerie lore connected to the ancient sites. It is a testament to the enduring nature of the old ways and the deep connection that many local people have had to them over many years that respect for the stones persists. Stories and myths about them have been preserved within folk memory for us to enjoy today.

Illustration: *Megalith—Stonehenge and Dragon*

**P**entre Ifan is one of the largest and best loved dolmens in Wales. In Pembrokeshire are the Preseli Hills, *Mynyddoedd Preseli*, a wide stretch of high moorland that holds many prehistoric monuments. Pentre Ifan is a graceful and simply powerful structure. Its giant capstone, weighing over sixteen tons, balances delicately upon three upright stones.

In 1911 in *Faerie Faith in Celtic Countries*, W. Y. Evans-Wentz wrote:

*Our Pembrokeshire witness is a maiden Welshwoman, sixty years old. She was born and has lived all her life within sight of the famous Pentre Evan Cromlech, in the home of her ancestors. She told me "My mother used to tell about seeing the 'fair-folk' dancing in the fields near Cardigan; and other people have seen them round the cromlech up there on the hill (the Pentre Evan Cromlech)."*

Dating back to about 3500 BC, Pentre Ifan—which means Evan's Village—was once partially covered by a great cairn used as a communal burial chamber. It was also known as *Arthur's Quoit*, after the legendary King Arthur whose numinous presence is everywhere in Wales. In the midst of lovely Welsh farmlands, this enigmatic dolmen overlooks the Nevern Valley, commanding extensive views. Carn Ingli, the mountain from which the Stonehenge bluestones allegedly originate, overlooks Pentre Ifan. The entire landscape is saturated in myth.

**T**he land speaks, or so it seems to the many peoples who have chosen to live in the wild rocky places, the mountains and windswept moors of Wales, Ireland, Scotland, Cornwall and Brittany. Today, we are drawn not only to the stones and their ancient history, but to the mysterious beauty and fertile power of the places in which they stand. We feel an intuitive sense of connection between the weathered lintels of an ancient burial site and the land that has held it for so long. Our experience of the megalithic monuments is colored by the imaginations of the folk who have lived close to their mysterious presence for many centuries.

It is interesting that the greatest concentrations of stone circles, menhirs and dolmens are in the more remote areas where they have become intertwined with the cultures of the folk who eventually settled there. Like the Neolithic people before them, the Celts have a deep affinity with the enduring nature of the ancient places, with the fertile memory of the Ancestors and with the earth herself.

**The ancient mounds and enigmatic stones** are bones within the landscape of the Folk-Soul. The early people are the mysterious cave dwellers and megalith builders whose ancient presence whispers through land and legend, with deep roots connecting back through the early communities. Their sacred places are their enduring memory, their wisdom the seeds for the tribes to come. They are the giants that fueled the Celtic imagination: the Tuatha Dé Danaan, the Tylwyth Teg, the Sidhe of the mounds.

**Theirs is the voice of the Folk-Soul,** and it speaks to us still.

---

## Standing Stone

The stone stores, transmits.
Against its almost-smoothness
I press my palms.
I cannot ask, having no word of power,
no question formed.
Have I anything to give?
My hands offer a dumb love,
a hope towards the day of the freed valley.
Flesh fits itself to the slow curve of dominating stone,
as prayer takes the shape of a God's will.
A mindless ritual is not empty.
When the dark mind fails,
faith lives in the supplication of hands
on prayer-wheel, rosary, stone.

—Ruth Bidgood, Welsh, *Selected Poems*

Illustration facing page: *Pentre Ifan*

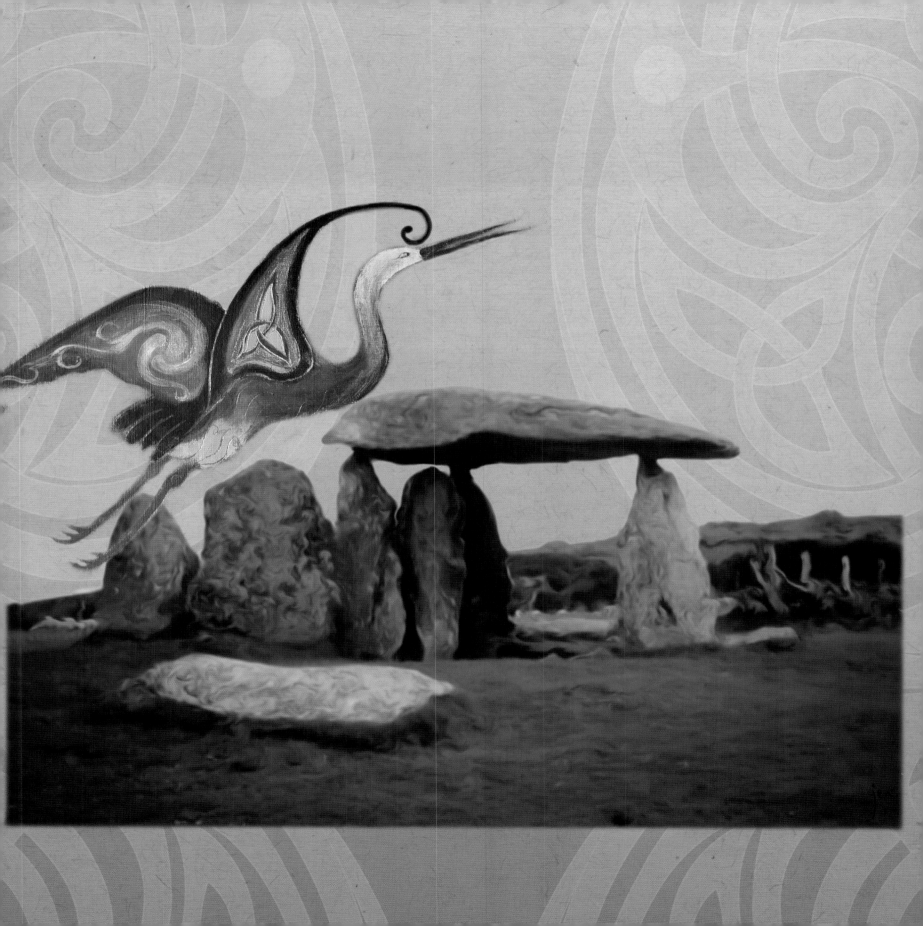

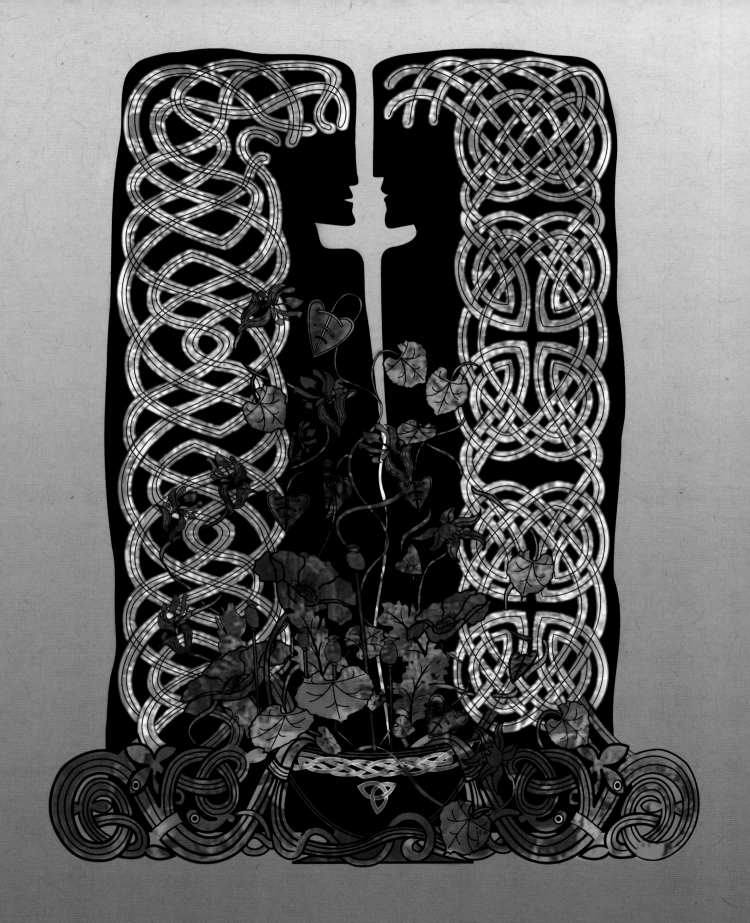

# TALE OF
# SPIRIT IN STONE

In the Celtic religion, everything in the natural world contains its own spirit. Each tree, spring, stream, mountain and rock possesses its own divine force. Standing stones are enduring symbols from the megalithic age when the dolmens, cromlechs and menhirs were raised at the sacred nodes of the living land. The ancient Mysteries are rooted in mythology, and legends tell of living beings magically turned into stone, their spirits alive but sleeping within the cold grey rock.

**The Cailleach Bheur** is a Celtic figure with roots in an ancient seasonal goddess. A Hag or Crone figure, in the Scottish Highlands she is known as the *Blue-faced Hag* and the *Queen of Winter*. She carries a magical staff that freezes the ground with every tap. There are many myths that tell of her turning to stone, such as on Beltain, the May festival of early Summer. She is reborn at Samhain—All Hallows Eve—and is the vigilant guardian of the animals throughout the long winter to come. Only when she again turns to stone on Beltain Eve can she rest from her labors.

A similar legend recalls how the Cailleach kept a maiden named Bride imprisoned in the high mountains of Ben Nevis. But her son fell in love with Bride and they ran away together. The angry Hag chased the couple through

the winter with many fierce storms. Then, when spring came again, she turned to stone, and so the lovers were free until the next winter season of the Cailleach Bheur.

Samhain and Beltain are the two gateways of the seasonal year, when the veil grows thin between the worlds and the spirits and the Sidhe come through to visit mortals. These are the changing times within the wheel of the seasons, observed with ritual and myth that have roots back to the first agricultural peoples.

**Long Meg and her Daughters** is a stone circle in Cumbria. Local legend claims that Long Meg was a witch who, along with her daughters, was turned to stone for profaning the Sabbath as they danced wildly on the moor.

The nineteen *Merry Maidens* near Land's End in Cornwall are similarly turned to stone for enjoying the rites of the Old Religion: these myths are warnings against neglecting the new Christian ways, the older associations with the stones often long forgotten.

Many menhirs are said to be the bewitched forms of women. These stories evolved during the Celtic Christian era, often melding aspects of the Old and New religions.

Breton myths tell of the magical transformations of men and women into the tall cromlechs and menhirs that are scattered around the Carnac region of Brittany in northwest France, where thousands of raised stones can be found. One tale relates that Saint Cornély, Carnac's patron saint, was attempting to convert a pagan tribe when he found himself surrounded by a hostile band of warriors. Cornély called upon his God and sent prayers to the heavens for support in his moment of need, and the pagans were turned to stone.

Another local legend about Saint Cornély, who is connected with an older figure as the Protector of Horned Animals, describes him being followed by Roman soldiers

> In Brittany, there is a tale of two lovers—Jean and Jeanne—who are turned into stone. Stones are also associated with fertility. The source of the greening vines—the Tree of Life—is the Celtic cauldron of rebirth, the Grail, representing healing and regeneration, symbol of the spirit forever renewing itself. Red poppies are associated with dreams, sleep and death. Red is the color of the Otherworld, and represents the supernatural.

on his way to Carnac, accompanied by two oxen. He hid in the ear of one of the animals before turning his pursuers into standing stones.

**T**he Rollright Stones in Oxfordshire are also called *The King's Men.* The tale is told that a king and his knights were about to make war on the King of England. But a witch made a bargain with the king, saying,

> *Seven long strides shalt thou take,*
> *If Long Compton thou canst see,*
> *King of England thou shalt be.*

The king thought this an easy bargain and, taking seven strides, he arrogantly replied:

> *"Stick, stock, stone,*
> *as King of England I shall be known."*

But the King's view was blocked by the mound known locally as The Archdruid's Barrow, and the witch cried out:

> *"Rise up stick, and stand still stone,*
> *For King of England thou shalt be none.*
> *Thou and thy men hoar stones shall be*
> *And I myself an eldern tree."*

And so it came to pass that the King and his men were turned to Stone.

—Arthur J. Evans, "The Rollright Stones and Their Folk-Lore," 1895

**F**ertility symbolism is profoundly important to all ancient cultures and is often associated with the Neolithic stones. Many stone circles or menhirs are erected over springs or underground streams; the tall stones conduct the receptive fertile energies of the earth upward. The individual pillars connecting earth and sky are also symbols of fertility. If they were not intended as such by the people who raised them, they were deemed so by future folk, who attached legends and significance to the mysterious stones left by the shadowy megalith builders of the Neolithic Age.

**Odin's Stone** is a favorite trysting place for lovers in the Orkney Islands, where there was once a tradition of *handfasting.* This ancient betrothal ritual centered around the stone circles of the Ring of Stennis, known as the *Temple of the Moon,* and the Ring of Brogar, the *Temple of the Sun.*

The young woman who was to be betrothed knelt before the Temple of the Moon and made her promises to her young man, who then pledged his faithfulness to her at the Temple of the Sun before the stone known as Odin's Stone. The young lovers then held hands through a hole in the stone, and their solemn commitment was made. This ceremony was held so sacred that anyone who broke a handfasting vow was exiled from the community.

Offerings of milk and honey and gifts of food were often left beside the stones, along with prayers for fertility or healing, and it was said that passing a child through the stone could cure it of the palsy.

**Men-an-Tol** is a circular holed stone north of Madron on the West Cornwall Moors that is said to cure ailments and promote fertility. As late as the 1800s, children were passed naked through the hole and drawn across the grass around the stone three times against the sun—*widdershins* (counterclockwise)—to obtain a cure for tuberculosis. Men-an-Tol was also associated with fertility, and bargains were sealed with a handshake through the stone, much like the handfasting ceremony at the Odin's Stone in the Orkneys.

**Maen Ceti**—or Arthur's Stone—on Cefn Bryn in the Gower Peninsula of South Wales is a dolmen dating back to 2500 BC. Its twenty-five-ton capstone is supported by upright stones to create a burial chamber that at one time was covered by a cairn of stones and earth. Legend says that Maen Ceti is named after King Arthur, who found a pebble in his shoe and threw it all the way from Carmarthenshire to Cefn Bryn.

Local folklore tells us that a young maiden could use the stone to test whether the man she loved would remain faithful to her: At the full moon she must bake a cake made from barley meal, honey and milk. After making her offering to Maen Ceti, she must then circle the stone three times on her hands and knees. If the man she loved appeared during her ritual dance, then she could be assured that he would be faithful.

**The Fishermen's Blue Stone.** There is a chapel dedicated to Saint Columba on the Fladda Chuan, *Fladda of the Ocean*, an island of western Scotland near Skye. The altar at the east end contains a round blue stone that is always moist. The local fishermen still practice an old custom of washing the blue stone with water if detained by a contrary wind, hoping a favorable wind will follow. The stone is also said to have healing powers, and the islanders respect the power of this stone so greatly that they swear decisive oaths upon it.

The Sleepers dwell within the rock below the earth. The Sleeping Lord—Arthur, *Pen Annwn, King of the Otherworld*—sleeps deep in a Welsh mountain, guarding the sacred vessel: the Grail. Legend tells us that when the world is in its gravest need, Arthur will be awakened by the music of a horn, and will return.

There is a story from Craig-y-Dinas in the Vale of Neath of a drover who is led by a mysterious stranger to an underground cavern beneath a large stone. It contains much gold, silver and metal treasure, which is guarded by sleeping warriors—King Arthur and his knights. The stranger tells him that he can take the treasure, but if he rings the bell by mistake and awakens the sleepers—who will then ask, "Is it day?"—he must reply, "It is not day, sleep on." The drover returns three times to bring home all he can carry from the glittering hoard. On two occasions, he accidentally rings the bell and makes the correct reply, but on the third day he forgets, and the sleepers awaken and beat him black and blue. He flees, and never finds the cavern or its treasure again.

# STONE FOLKLORE

Duffryn, near St. Nicholas in the Vale of Glamorgan, has druidical stones scattered about in various places. Some of these have stories attached to them. Old people in the beginning of the nineteenth century said that once a year, on Midsummer Eve, the stones in Maes-y-felin Field whirled round three times, and made curtsies. If anybody went to them on Hallowe'en, and whispered a wish in good faith, it would be obtained.

The great cromlech in the Duffryn Woods was an unlucky place to sleep in on one of the "three spirit nights," for the person who did so would die, go raving mad or become a poet.

On a certain day in the year the Dancing-Stones of Stackpool were said to meet and come down to Sais's Ford to dance. If anybody witnessed this performance, it meant exceptional good luck to him. The witches held their revels and the devil played the flute occasionally around the dancing stones.

On the summit and sides of Cefn Carn Cavall, a mountain near Builth in Breconshire, there are several cairns scattered here and there. It is said that when King Arthur was hunting the swine named Twrch Trwyth, Cavall his favorite dog impressed the stone with his footprint. The warrior king collected a heap of stones together and on the top he placed the curiously marked one, and called the mountain Carn Cavall.

Among the mountains called The Rivals in North Wales, is the beetling and furrowed Craig Ddu, *Black Mountain*, with its almost black rocky surface and inaccessible sides rising sheer against the sky. In the eighteenth century people said that the apparition of an old man with long white hair and flowing beard used formerly to be seen wandering down the valley, and pausing to mutter unknown words beside the Craig Ddu. Sounds of strange music were heard, and magic signs were made by the old man. If anybody fell asleep in the shadow of Craig Ddu he would sleep for ever, and be carried away by unseen hands so that his resting place could not be known.

—Marie Trevelyan, *Folk-Lore and Folk-Stories of Wales,* 1909

# Y TYLWYTH TEG

Much of the rich folklore of the Faerie Folk is connected to the memories and beliefs of the first peoples. They represent the personification of the living earth, creatures of the ancient world who continue to live within the imagination and psyche of the Folk-Soul. Many myths and legends have grown up around the mysterious mounds, including the idea of a supernatural race of divine beings— *Tuatha Dé Danaan*—living within them. The gods and goddesses of the pre-Celtic Irish who inhabited the land before the coming of the Milesians, *the Gaels,* live on as mythic memory, later becoming entwined with the beliefs of the Celts as the Faerie or fey. Small and dark, they live deep in the bowels of the earth; their spirits inhabit the land as they once did five to twenty thousand years ago. In Wales, the Fair Folk, or Fair Family, are *Y Tylwyth Teg.* The circles in the grasses of green fields are still called *Cylchau Y Tylwyth Teg*—faerie rings. Fairies were creatures under the earth; they were generally supposed to dwell in the lower regions, especially beneath lakes. The people of Pembroke imagined that they inhabited certain enchanted green isles of the sea.

A Mandala is a symbolic diagram, often viewed as a mystical map of the cosmos, usually circular, frequently referring to the cyclic view of life, nature, fate and time. This is a seasonal calendar that includes the solar Solstice and Equinox festivals and the four fire festivals, which marked the turning of the seasons and which were religious celebrations. Symbols for the four elements of Fire, Air, Water and Earth, and totem animals and plants, are placed according to their symbolic seasonal and directional positions within the Mandala wheel. Here the Celtic Folk are woven into the ancient symbol of the cross— the cross-quartered circle—representing the union of male and female energies. The cross represents the four directions, the four elements, the four corners of earth—*male energy.* The circle represents the Whole, the earth-womb—*female energy.*

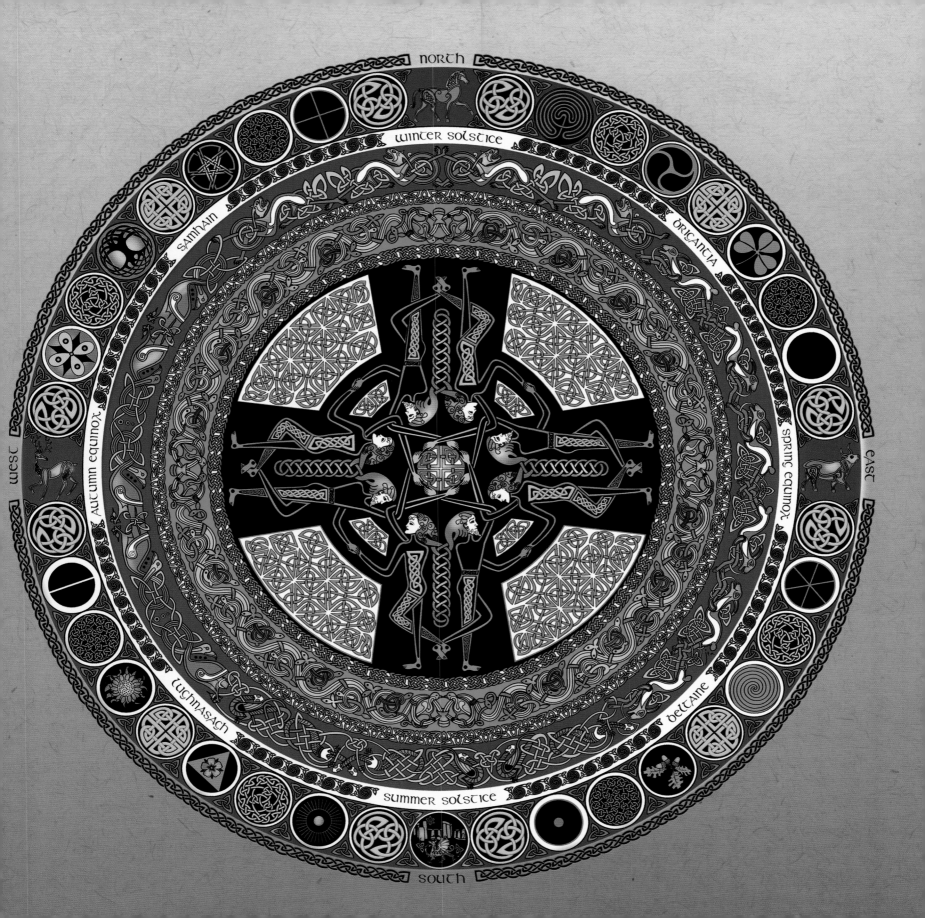

# WOAD
## tribal

restless in life and seeking no end in death

for breath of the ages in the face of the air

still ghosts to the vitality

of our most early and unwritten forebears

whose wizardry still makes a lie of history

whose presence hints in every human word

who somehow reared and loosed an impossible beauty

enduring yet

among the green islands of the grey north sea

and I will not forget.

—Robin Williamson,
excerpt from "Five Denials on Merlin's Grave," 1978

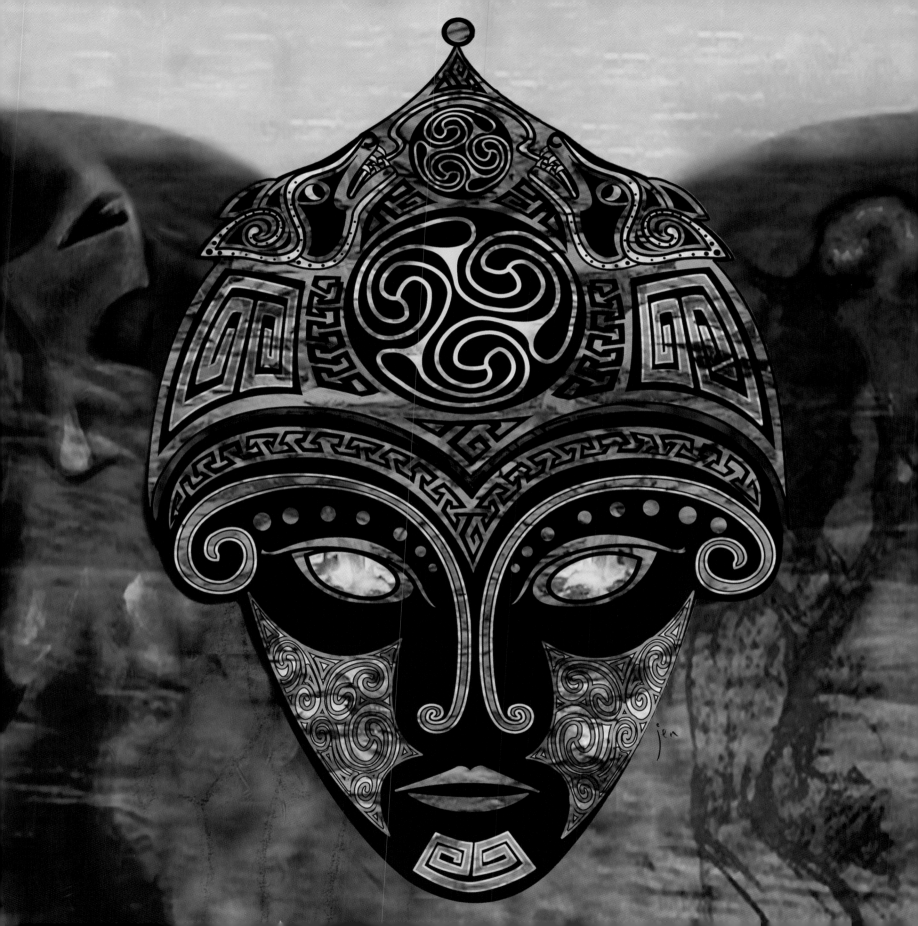

# WOAD
## tribal

**W**oad is the blue plant of the tribes. In modern folklore we imagine the ancient Picts and Celts as fierce, naked warriors, their bodies painted with blue spiral and animal designs. Some say woad was used as the ritual body dye of the Celts, and this native wild plant has been symbolically chosen to represent the color of the tribes.

Woad is the blue of the earth. It reflects the mystical color of sky, of the Otherworld that awaits great warriors who are honored in battle. The Brigantes of ancient Britain had blue shields, and blue was connected with the Celtic goddesses of war. It was also linked with the fertility of the earth, and blue was chosen as the good-fortune blessing color for women's clothing.

Woad is the common name of the flowering plant *Isatis tinctoria* in the family *Brassicaceae*. Cultivated throughout Europe since ancient times, it was used in northern Europe to produce dye for textiles and pottery until the stronger, more intense indigo—which was not native to the cooler climate—could be acquired through trade.

According to Julius Caesar, some Celtic—*Britanni*—tribes and northern Pictish warriors dyed or tattooed their bodies with blue decorations before battle (*Picti* means *painted people*). The Greek historian Herodian (AD 170–240) said of the inhabitants of Caledonia, "*They mark their bodies with various pictures of all manner of animals.*"

The body of the Iron Age Lindow Man was preserved in the peaty bog of Lindow Moss. Analysis of his skin revealed copper and iron (which can create a blue pigment) decorating his body. It is likely that woad was used for body painting as well, but according to some recent experiments by a twenty-first-century tattoo artist, it may not be a suitable pigment for tattooing.

**T**attoo art has grown increasingly popular in recent years, as has interest in other ritual and initiatory art forms of tribal people such as scarification, piercing and decorative body jewelry. For those seeking identification with their Celtic heritage, or who resonate with the mythic/symbolic art of an earth-centered tribal people, Celtic designs are often chosen as meaningful contemporary body art.

Throughout history people have used markings to represent their identities and indicate their territories or possessions. For primitive or tribal people, symbolic marks may be associated with initiation, personal life experiences or events within the tribe. Tattoos, body art, graffiti tags and even logos are recognizable symbols in our culture and have become popular as representations of our individual and group identities, and of personal expression or style.

Some ancient Celtic warriors painted or tattooed their bodies with symbolic designs, probably including images of their animal totems. The modern body art movement, however, does not necessarily seek to re-create the tribal customs of Bronze and Iron Age Europe. Contemporary Celtic tattoos are a decorative style that can connect us with ideas that are rooted in the age of tribal people, but that also resonate with meaning today.

**T**ribal—the very word evokes ideas of independence of spirit and community, honor and loyalty within the group. A tribe is governed from within, and is answerable to its own needs and rules.

Tribalism is a natural human trait. When in community, we are not so different from our dog/wolf friends who evolved to live in packs in order to survive, both socially and physically. In fact, the Celts and early tribes-people of Europe honored the dog as a symbol of tribal loyalty, faithfulness and fierce protection of their families and communities.

There is growing contemporary interest in tribal culture as a more conscious exploration of alternative expression. The Modern Primitive art and culture movement has developed from a growing interest in the cultures of so-called primitive peoples and includes body art as a creative post-modern response to our industrialized world. Today in the West, we do not seem to live in a particularly tribal society, yet we continue to naturally create our own cultural groups within the larger nations in which we live.

Ancient cultures often include elements of human experience, wisdom and knowledge that we have almost lost touch with in our modern world. Myth and ritual are important to the experience and understanding of being human. By exploring Celtic culture and tribal expression, we find a language of archetypes infused with mythic characters and powerful natural symbols that represent aspects of who we are, who we were and where we came from.

## The Book of Invasions—Leabhar Gabhála Éirean, written in Middle Irish—tells the story of how the Celtic tribes came to Ireland. This important folkloric document is composed and assembled from many sources, including fragments of Irish oral tradition and poetry, with much translation, reinterpretation and bardic embellishment.

Many of our favorite characters, such as the Tuatha Dé Danaan, Nuada of the Silver Arm, and the fierce Fir Bolg, fight their battles for the land of Ireland. It is a complex cycle of tales, beginning with Noah and the flood with *The Settlement of Cessair*. This is followed by *The Settlement of Partholón, The Settlement of Nemed, The Settlement of the Fir Bolg* and *The Settlement of the Chieftain Gods*, the Tuatha Dé Danaan. The last invasion was said to be by the Milesians, who may have been Iberian (from Spain).

**Banbha** is known as the Spirit of Ireland. She is one of a triad of goddesses, along with Fotla and Ériu, who represent the sovereignty of the land. Of the divine race of the Tuatha Dé Danaan, she is daughter of Fiachna— one of the three ancient Goddesses who inhabited Ireland before the coming of the Gaels, and she is wife of King Mac Cuill. Banbha is the first to greet the Druid Amergin as he leads the invasion force of the Milesians in a march upon Ireland. *The Book of Invasions* refers to Amergin as the first Druid of the Gaels. He promises to name Ireland after the three sisters, and after Ériu (Eire) she is still known, but the poets remember Banbha when they refer to the spirit of the *Emerald Isle*.

We no longer think that the Celts invaded Ireland or Britain in a series of massive invasions that directly displaced the people (an earlier, literal interpretation of *The Book of Invasions*). Instead, we believe it is a mythological cycle of tales that has evolved through oral tradition to explain, perhaps in a deeply symbolic way, the complex history of migrations and cultural influences evolving over thousands of years.

Woad is also an amazing astringent. The tattoo I did with it literally burned itself to the surface, causing me to drag the poor experimented-upon fellow to my doctor, who gave me a stern chastising for using inappropriate ink. It produced quite a bit of scar tissue, but healed very quickly, and no blue was left behind. This leads me to think it may have been used for closing battle wounds. I believe the Celts used copper for blue tattoos—they had plenty of it—and soot ash carbon for black. Unfortunately, we need more bog bodies to prove this point!
—Pat Fish, Celtic tattoo artist

**E**arly tribes of Britain and Europe developed their religion, their mythology and their culture throughout the Bronze and Iron ages, adapting the beliefs of the Neolithic cultures of the stone builders who came before them. Their profound certainty in an Otherworld, and deep respect for the numen—the sacred spirits of the land—continued to be revered at the wells, rivers and lakes, the rocks and ancient groves, the mounds of the Ancestors.

The tribal communities who developed their religion and culture in Europe and Britain during the late Neolithic and early Bronze ages, and who are the precursors of the Celts, are the Beaker Folk, the Battle Axe Folk and the Urnfield People. It is these Bronze Age metal-working tribes who developed many of the artistic and mythic ideas that were to flourish within the later Iron Age Celtic culture.

**Who were the Celts**, where did they come from and did they consider themselves to be a race or unified people? Those who we know as the Celts are the fiercely independent tribes that the Romans referred to as the Gauls, *Galli* and *Galatae*, and the Greeks named *Keltoi*.

Their brilliant boasts, riddled wit, generous insults and terrible battle screams haunt the mountains and rivers, the high hills and hidden valleys of ancient Britain and Europe. Something of their light and darkness lingers still within our veins, like the golden mead so favored by those warriors of life and death.

Theirs is an oral tradition, and although their enemies—the classical observers of Rome and Greece—often perceived them in less than flattering terms, we have today a more complex insight into their magical, mythic world through what they have left behind.

We must seek to find the Celts through their brilliant mastery of iron, gold and bronze, their weapons, coins, jewelry and horse bridles—all decorated in high style and with mythic profundity. Their finely crafted objects and wealth of materials reveal a technologically advanced people who traded successfully, and whose power and wealth in their time was related to their mastery of metals and their invention of agricultural tools.

The Celts were not a single race of people, but a tribal culture that spread as a vital force of ideas communicated through their mystical symbols. Masterful artists, they created images of deities for their shrines and crafted symbolic decorations upon everyday items of pottery, wood and leather. They designed richly decorated, intricate gold and bronze objects for the emerging class of aristocratic warriors and chieftains.

**Keltoi** is the Greek term meaning *barbarian*, or *foreigner*. The name was first ascribed to the Gauls and the European tribes, who would most likely not have recognized what it meant, and would not have used it to describe themselves. We have continued to know them—those people who are loosely defined by their language, religion, art and culture—as the Celts.

We have remaining to us mere snippets of knowledge and more legend, of the *Scordisci, Boii, Senones* and *Norici*, the *Iceni, Belgae, Parisi, Brigantes*: clannish tribes who fought each other as often as they battled with those who did not speak their common language or worship their Mysteries of the earth.

Boldly dressed and powerfully striking in appearance, they were considered fierce warriors who lived for the glory of battle with emphasis on personal bravery and honor to the tribe. They made war and conquest among other Celtic tribes and against the Etruscans, the Romans and the Greeks. The warriors of the ancient European Celts once

Illustration: *Tribal Heads—from a small silver phalera from Manerbio sul Mella (Brescia) dating to the first half of the first century BC*

threatened the might of Rome and the sanctity of Delphi, the sacred oracle of Greece. But it is in the islands of the Atlantic that their culture took root, continuing to evolve through their language and traditions to the present day.

**Their enigmatic mythic religion** was manifest in all aspects of their life, and their Druid priests were philosophers, astronomers and judges, who were highly intelligent and versed in knowledge, though mostly illiterate.

The spiritual qualities perceived by the Paleolithic people within the Stag and the Bull continued to be venerated, and as the warrior cultures grew stronger, the Horse and the Boar became extremely important to the Celts as symbols of valor and strength.

The magical birds who carry the secrets of the air and haunt the watery fringes of lake and marsh, such as Crane, Swan and Goose, are also essential mystical figures for the Bronze and Iron Age tribes.

The Cult of the Head was a widespread and quintessential aspect of the Celtic religion. Symbolic of divinity and otherworldly powers, the human and animal head appear as a constant motif in Bronze and Iron Age artwork and mythology, displayed on coins and votive objects, metalwork and decorative patterns.

Celtic iconography emphasizes the heads of birds, animals and humans as important decorative and mystical design elements. Some are expressive and some are caricatures, probably representing deities that are long forgotten.

Heads were also carved into stone as monuments at shrines, although the many wooden votives that must have once been there are long gone, save a few preserved in marshes or bogs. These are the symbols of the Celts, voiced by the artists upon the objects that they left behind them.

The head was venerated, considered the seat of the soul and the intellect. The severed head is of profound magical importance to the Celts. We are told by the Greek historian Diodorus Siculus (circa 90–30 BC) in his *Library of History*:

*"When their enemies fall they cut off their heads and fasten them about the necks of their horses."* They were then taken to be impaled and displayed triumphantly outside their houses. Further, he says: *"The heads of their most distinguished enemies they embalm in cedar-oil, and carefully preserve in a chest and these they exhibit to strangers"* … which they apparently would not sell for an equal weight in gold. Diodorus also comments:

*"They display a greatness of soul; for not to sell that which constitutes a witness and proof of one's valour is a noble thing."*

Classical observations of the warriors do not necessarily describe the character of the common people—the farmers, fishermen and weavers who venerated the heads of their favorite deities in wood carvings at their natural shrines of springs and wells. It is clear that some of the tribal beliefs, which may seem a little barbaric to us today, are based on a deeply mystical relationship with the power and spirit within both human and animals, and most especially within their heads!

Tribal Warriors often went naked into battle, adorned with heavy golden torcs, golden belts and armbands. Their hair was bleached white with lime water and spiked in coarse tufts. Some were bearded, and others were clean-shaven or wore bushy moustaches. They were distinctive and fierce looking, unafraid of death upon the battlefield as they fought for the glory of the spoil, for their hero's honor. *(continued on page 72)*

Illustration: *Tribal Owl Knot*

## Pangur Bán

I and Pangur Bán my cat,
'Tis a like task we are at:
Hunting mice is his delight,
Hunting words I sit all night.

So in peace our task we ply,
Pangur Bán, my cat, and I;
In our arts we find our bliss,
I have mine and he has his.

Practice every day has made
Pangur perfect in his trade;
I get wisdom day and night
Turning darkness into light.

—Anonymous, Irish, eighth century,
translated by Robin Flower

Sometimes called
"The Monk and His Cat,"
the poem "Pangur Bán" was written
by an Irish monk in the ninth or
late eighth century and discovered in
the margins of a manuscript in the
Monastery of Saint Paul, Carinthia, Austria.

# KATS-SIDHE
# FAERIE CATS

Cats were of great significance to the Celtic people. In Scotland the Stewart clan had the cat as a totem animal, and this totem covered the confederacy of a number of tribes, clans and families.

Kataobh (cat country), now known as Caithness, is named after a Pictish tribe, the Kati (cat people).

In one of the Irish Otherworld voyages, a little cat is encountered as a guardian of treasure; in maintaining its watch, it turns into a flaming form, and leaping its way through a potential thief, turns him to ashes.

The cat is usually a female totem, dating back to ancient goddess worship.

In this design, intertwined triple felines indicate the symbolically significant number Three, which represents the female principle and is most sacred to the Celts.

Illustration facing page: *Kats—Sidhe,
design adapted from The Book of Kells*

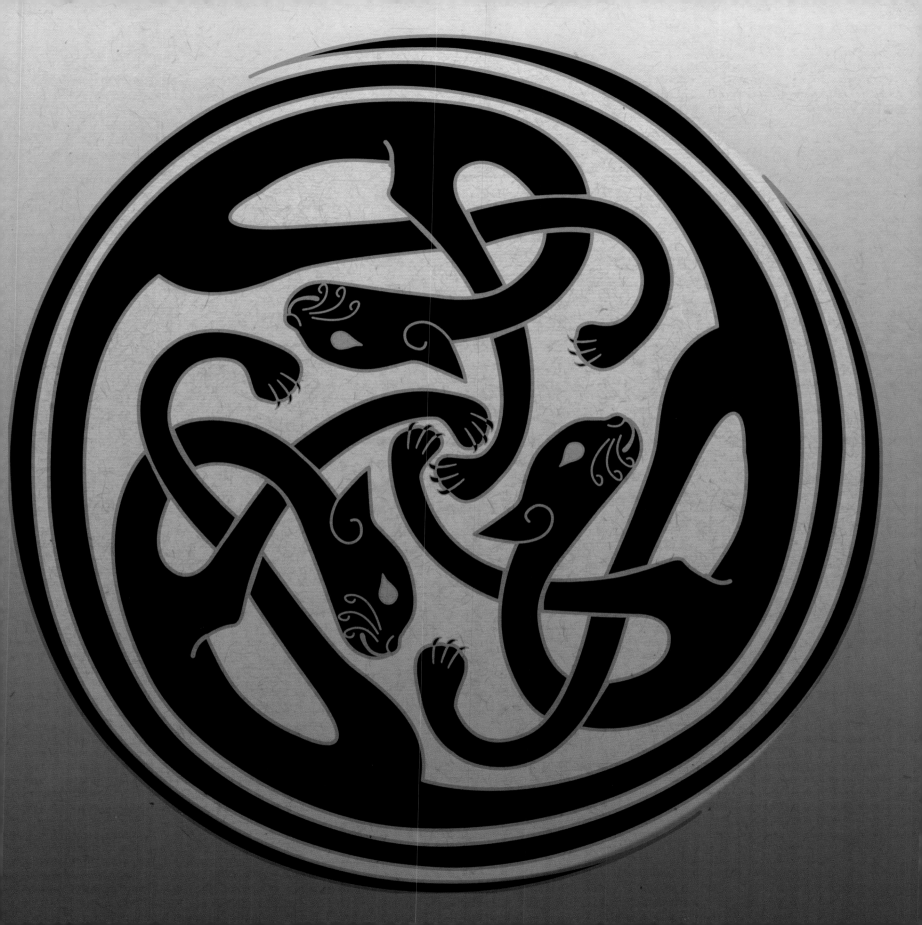

Their warrior culture, inspired by the teaching of the Druids that their souls were immortal and the Otherworld awaited them, expanded throughout Europe, Britain and Ireland, infusing their myths with a bloody passion for legendary battles between the gods.

**The Divine Warrior,** who protects the tribe and is glorified for his great endurance and courage, exists in all heroic societies. For the Celts, tribal honor is extremely important, and in mythology warriors become heroes and gain entrance to the Otherworld through mystical hunts of treacherous supernatural creatures such as *The Red Swine of Derbrenn.*

The Celts claim their descent from a divine ancestor. Nuada of the Silver Arm was a prophet and champion, and king of Ireland and of the Irish gods, the Tuatha Dé Danaan. His fearsome killing sword, Claíomh Solais, *the Sword of Light,* was one of the great treasures of Ireland. In Welsh mythology, Nuada is also known as Nudd and is a hero of the medieval tales. He is also associated with Nodens and Mars, the Roman God of War and healing who was also revered by the British Celts.

**L**ugh of the Long Arm, *Lugh Lamhfhada,* guardian of the magical spear of Gorias, uses magical skills rather than brute force. Also known as Lleu Llaw Gyffes, *Bright One of Skillful Hand,* he was considered a god of the Sun, a shining light, and was greatly skilled at all things. His feast day is the harvest festival Lughnasdh, August 1, usually celebrated with sports and games of skill in his honor.

Red is the color of the Otherworld and of the warrior gods. The Dagda, also known as Ruad Rofhessa, *The Red One of Great Wisdom,* figures as a mighty warrior in one early Irish tale, with a club that deals death out of one end and restores life with the other.

**The Cauldron of Rebirth,** which provided sustenance while restoring life to the dead, is a common motif in the iconography and mythology of the warrior Celts. As the horned gods are associated with both fertility and hunting,

so the warrior gods such as the Dagda, Mars, Nuada and Nodens are also gods of healing.

The club of the Dagda, chief god of the Tuatha Dé Danaan, symbolizes that life and death are an eternal cycle. The Dagda also possessed the Cauldron of Abundance, which has the power to heal and provides an inexhaustible source of food and poetic inspiration.

The Gundestrup Cauldron is a large silver Iron Age vessel recovered from a peat bog in Gundestrup, Denmark, where it was found purposefully dismantled and given as a votive offering to the watery bog. It is highly decorated with symbols of reincarnation, death, sacrifice and rebirth. There are images of the Horned God Cernunnos holding a ram-headed serpent and wearing the warrior torc of power and fertility.

A figure is shown thrusting a man into a large pot as a series of warriors approach carrying the Tree of Life upon their spears. This could be a literal illustration of a Druidic sacrificial rite, or a more symbolic metaphor that communicates a metaphysical connection between life, death and the ritual of the feast. It is a most powerful and significant piece of art, and although some interpret it as depicting the cruel nature of the Celts, it is a powerful example of the warrior myth and belief in the Otherworld that awaits them.

**The Hero's Portion** is traditionally related to the Chieftain's Feast. The consummate center of social activities within Celtic society, the feast is more than the source of both food and drink; it is symbolic ritual involving the slaughter of the boar and its cooking in the tribal cauldron. The Celtic feasting hall was an important and festive center within the tribal communities. According to their heroic merit, warriors receive their portions in strict and significant order, often contested with passion and sometimes violence.

The symbols of the ritual feast associated with the journey to the Otherworld can be seen in richly decorated grave objects. There are gold flagons with boar heads, and huge cauldrons that could contain many gallons of mead— the honeyed alcoholic drink of the Celts. Pig bones and joints of pork are buried with the chieftains for their ritual feasts in the Otherworld, boar being both the favorite meat of the Celts and symbol of the warriors.

**B**oar is a symbol of valor and ferocious strength for the warriors, one of the most popular animal symbols for the Celts. But unlike the Stag, the Bull and the sacred birds, the Boar was not particularly revered until the Iron Age Celts.

The Boar symbol appears as a crest on the helmets of the warriors, and Celtic coins feature the Boar as a universal symbol of strength and fertility—sometimes portrayed with triple horns and often associated with the Tree of Life.

Boars appear throughout mythology as magical, often destructive supernatural beasts. In the Welsh *Maginogi* stories, Gwydion tells Math, son of Mathonwy, of the arrival of strange creatures from the south called pigs—*hobeu*—belonging to Pryderi, who got them from Arawn, King of Annwn, the Celtic Otherworld.

The hunting of the Otherworld pigs is a favorite theme. The most legendary boar is Twrch Trwyth (Welsh) or Torc Triath (Irish): *The King of the boars from whom Magh Treitherne is named*. The great boar was once a wicked king. He and his followers were transformed into swine who laid waste to a third of Ireland. In the story of Culhwch and Olwen (the *Mabinogi*), Culhwch and Arthur are sent on a seemingly impossible quest to snatch the treasure of bristles from between the ears of the ferocious Twrch Trwyth.

In the battle of Mag Mucrime, pigs of magic, *mucca gentliuchta,* were said to come out of the cave of Cruachan, which is Ireland's gate of the Underworld, and the Red Swine of Derbrenn appear frequently in the early tales. Fenian warriors hunt the treacherous, powerful boars, who lead the heroes to the Otherworld.

**C**elts were fierce adversaries. Their belief in the Otherworld was absolute, not only manifest in the great wealth buried with their honored chieftains, but also observed in their sometimes extravagant battle lust.

Celtic warriors believed in an assured place in the afterlife if they lived and died well and with honor. Their Druids reassured them that their soul was immortal, and great glory awaited a brave warrior in the next world, or incarnation in the cycle of *(continued on page 76)*

Illustration: *Chieftan Head—Gold Slater (Celtic coin) minted by Parisii tribe, end of second, early first century BC*

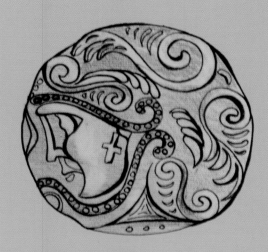

**Their aspect is terrifying. The Gauls are tall of body, with rippling muscles, and white of skin, and their hair is blond, and not only naturally so, but they also make it their practice by artificial means to increase the distinguishing color which nature has given it. For they are always washing their hair in lime-water, and they pull it back from the forehead to the top of the head and back to the nape of the neck ... since the treatment of their hair makes it so heavy and coarse that it is different in no respect from the mane of horses.**

**Some of them shave the beard, but others let it grow a little; and the nobles shave their cheeks, but they let the moustache grow until it covers the mouth. The clothing they wear is striking—shirts which have been dyed and embroidered in varied colors and breeches, which they call in their tongue bracae; and they wear striped coats, fastened by a buckle on the shoulder heavy for winter wear and light for summer, in which are set checks, close together and of varied hues.**

—First-century BC Greek historian and commentator Diodorus Siculus, *Library of History,* V: 28–30

**Among the Gauls the women are nearly as tall as the men, whom they rival in courage.**

—Diodorus Siculus, *Library of History*

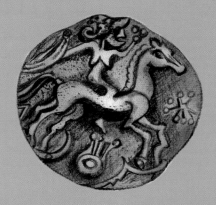

# BOUDICCA

I am she who loveth loneliness
And solitude is my breath.
I have my feet on graves
And the Resurrection of
the dead is my food.
For I am a Queen,
Queen of all things on
earth and in the sea
And in the white palaces of the stars
Built on the dark walls of time
Above the Abyss.

—Fiona MacLeod,
"The Gaelic Heart," 1900

Boudicca is the courageous Brythonic warrior queen of the Iceni tribes who united and led her people in a last massive revolt against the Romans who occupied her lands. When her husband Prasatagus died, Boudicca became queen by inheritance, but the Romans—in a ploy to take control of her land and people—refused to honor Celtic law, claiming that they only recognized the male line.

When Boudicca resisted, she was flogged and her daughters raped, and this terrible insult brought Boudicca and her people together in a massive uprising against the Romans. Boudicca rode at the head of her warrior army in her chariot, her long red hair streaming behind her and a heavy golden torc around her neck, fixing onlookers with a piercing glare. Said to have a small brown hare hidden in the folds of her cloak, she went riding against the powerful Roman military forces in defiance of their attempt to subdue her Celtic people. Boudicca means *victory*, and the rebellion began to gather force from other tribes who had been ill-treated by the Romans. The Celts were at first successful in causing much damage, destroying cities and wiping out entire Roman legions. The sack of Londonium, *London,* was particularly savage, perhaps in retaliation for the rape of Boudicca's daughters.

At their last stand at the edge of a forest near a narrow gorge, the Roman commander Suetonius and his legionnaires used their tactical advantage to crush the warriors and their families. Boudicca poisoned herself to avoid capture, a last act of defiance by the Celtic queen who believed that honor and freedom were worth the great sacrifice made by her people. Although the Celts were ultimately unsuccessful in their rebellion, Boudicca's name was never forgotten, nor was the pride of her people who resisted the great power of the Roman Empire. The battle was lost, but their spirit could not be broken.

Illustration above: *Boudicca—from Gold Slater (Celtic coin) minted by the Coriosolities tribe, first half of first century BC*
Facing page: *Boudicca*

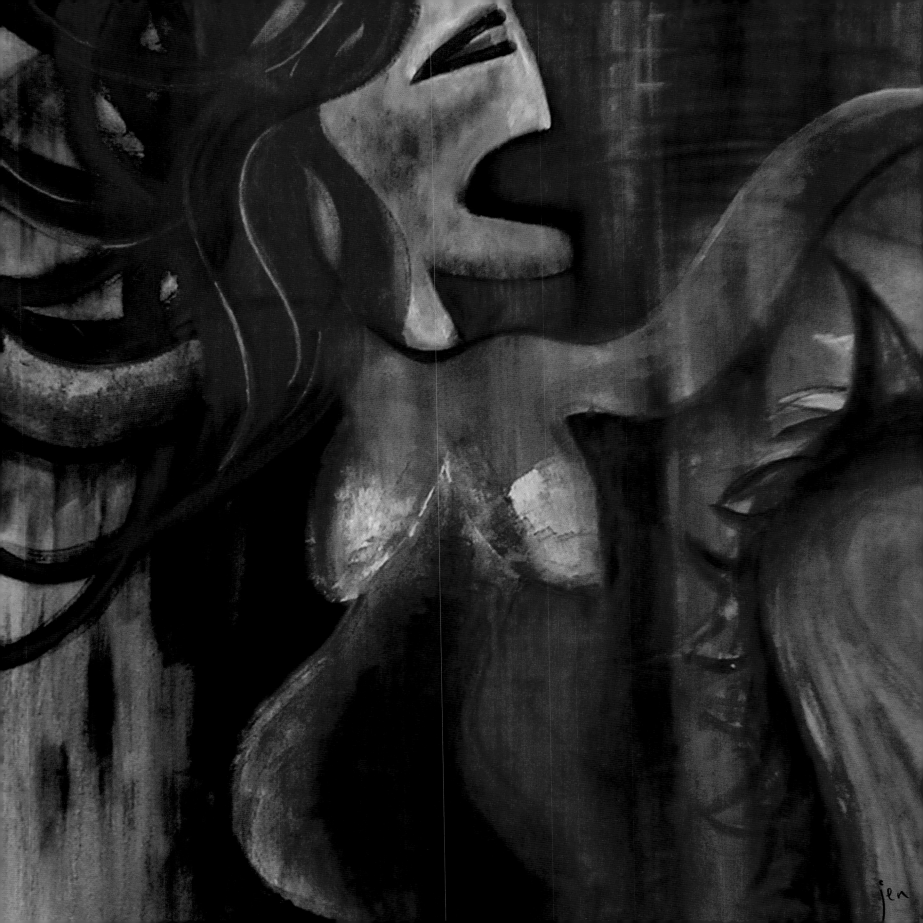

life (the transmigration of souls). The Romans were sometimes horrified by the hordes of wild, naked warriors who attacked them, their bodies painted with ancient symbols, seemingly unafraid upon the battlefield. While scorning their lack of military organization, they also admired their courage and pure fighting spirit.

Y Gododdin is the earliest poem in the Welsh language. In the sixth century, Welsh bard Aneirin tells of the fate of three hundred Celtic warriors in the great battle at Catraeth against the invading Angles. The band of men was wiped out by the great numbers of the English. They were Welsh-speaking tribes from a kingdom in the north of Britain, Brythonic people whose tribal capital was Din Eidyn: *Edinburgh*.

The poem is an elegy to the bravery of the slain heroes, who welcomed death as an honor. It is also a powerful testament to the history of enduring passion and resistance of the Celtic people against invaders.

## The Romans and the Celts

continued an adversarial relationship for centuries. In 390 BC in retaliation for an insulting political skirmish, the Celts sacked and besieged Rome. For seven months they harassed the city and only returned home after the Romans negotiated with the Celtic leader Brennus, who demanded his weight in gold as a tribute.

The sack of Rome would long be remembered by the Romans; some say they never forgave the Celts for this defeat that was finally avenged with Caesar's conquest of

Gwˆyr a aeth Gatraeth gan wawr
Trafodynt eu hedd eu hofnawr,
Milcant a thrychant a ymdaflawdd.
Gwyarllyd gwynoddyd waywawr,
Ef gorsaf wriaf yng ngwriawr,
Rhag gosgordd Mynyddog Mwynfawr.
Truan yw gennyf, gwedi lludded,
Goddesf gloes angau trwy anghyffred,
Ac eil trwm truan gennyf fi gweled
Dygwyddo ein gwˆyr ni ben o draed
Ac uchenaid hir ac eilywed.

Men went to Catraeth with the dawn
Their fears disturbed their peace,
A hundred thousand fought three hundred
Bloodily they stained spears,
His was the bravest station in battle
Before the retinue of Mynyddog Mwynfawr.
It is a grief to me, after toil,
Suffering death's agony in affliction,
And a second grief to me
To have seen our men fall headlong.
And long sighing and lamentation
After the fiery men of our land.
May their souls after battle be welcomed
In the lands of heaven, the home of plenty.

—Aneirin, sixth century, "Y Gododdin," translated by Professor A. O. H. Jarman

Gaul and the suppression of the uprising by the brave warrior queen Boudicca three and a half centuries later.

Boudicca was the queen of the Iceni tribes who bravely rose up against the great might of the Roman armies. She inspired the Celtic tribes of Britain to unite against their oppressors in a massive revolt that shall long be remembered. Although ultimately defeated by the more organized fighting tactics of the Romans, the Celts redeemed their pride and showed great courage in response to the indignities forced upon them. The tribes had their share of glorious victories, and also terrible defeats that eventually forced the Celts of Europe to submit to Roman government. But Rome could not completely control the wild tribes of Wales and Scotland. Boudicca is a symbol for the Celts who continued to resist many invaders over centuries of conquest and struggle.

Druid Priests nurtured the powerful bonds between the tribes, encouraging the ancient belief of rebirth in the Otherworld. The new family of gods, the Tuatha Dé Danaan, fought mystical battles in the Otherworld with the older Fir Bolg, but it was to the isles of the Great Stone culture that the European and Irish Druids came to seek the deeper and older wisdom of the ancient religion.

The Celtic culture did not arrive by invasion as was once thought, by taking over the tribes of the Atlantic islands during the Iron Age, but actually developed there

for thousands of years. Classical writers of the time such as Julius Caesar wrote that Druidism originated in Britain, which was indeed its center of power and (along with Ireland) the land of the well-respected teaching colleges.

The Druids of Britain integrated much of the ancient wisdom, lore and knowledge of the enigmatic stone culture, adapting and preserving the old mysticism of the early tribes: the people of the long barrows. They preserved their cosmology, their calendars of lunar and solar cycles, feast days and sacred shrines, and took over the organization of learning and religious ritual from the Neolithic Shaman megalith builders.

Over time, the Druids moved the centers of their power and ritual away from the great stone temples and circles of the Neolithic religion toward ancient natural shrines—the springs and groves—preferring to commune with their gods in nature among the trees. This power shift was also perhaps in response to the growing needs of the agricultural communities, who required more localized religious centers, and so their priests could continue to exercise their renewed power and authority over the people.

The living groves and numinous places were the centers of worship for the earth-centered spirituality of the Celts, but the ancient stones and the mounds of the ancestors continued to be respected as ceremonial gathering places.

**They kept their secrets close,** and their history and literature were preserved through a complex oral tradition: the Druids forbade their commitment to writing. Much knowledge was concealed by those cunning philosophers, the long-bearded priestly magistrates of the Celts. We see them described through the writings of their often contemptuous enemies, the Romans and the Greeks, and hear their whispers through fragments of songs and stories.

The Celts believed in an oral tradition, and their memory skills were highly cultivated—incredible in comparison to ours today. They sometimes trained for many years to memorize vast repositories of knowledge using the symbols and patterns found within poetry, song and mythology as mnemonic keys. Their teaching colleges were highly respected for their rigorous training. Twelve years of study were required for the bards, four more years for the Ovate priests or priestesses, and a further four years to become a Druid teacher/judge. Classical writers noted that students came from all over Europe to attend the colleges in Britain.

The Druids did develop a form of writing, called *Ogham*, which they sometimes used for recording important information. Some were versed in Greek, but they forbade writing their literary, political or religious knowledge, keeping their secrets close.

**R**itual Sacrifice of animals, and sometimes humans, was often an intrinsic part of religion, the offering of life to the elements perhaps interpreted as necessary rather than cruel. In some Iron Age communities, sacrifices

> The Druids attach particular importance to the belief that the soul does not perish but passes after death from one body to another; they hold discussions about the heavenly bodies and their movements, about the size of the universe and the earth, about the nature of the physical world, and about the power and properties of the immortal Gods, subjects in which they also give instruction to their pupils.
>
> —Caesar, *Gallic War* V. 1

Illustration: *Tribal Roots*

# FOLK FESTIVALS

In Wales, the May Day festivities were not complete without the customary fight between Summer and Winter. At the turn of the century around 1900, an aged Welshman described the battle conducted in South Wales in the following way:

*When I was a boy, two companies of men and youths were formed. One had for its captain a man dressed in a long coat much trimmed with fur, and on his head a rough fur cap. He carried a stout stick of blackthorn and a kind of shield, on which were studded tufts of wool to represent snow. His companions wore caps and waistcoats of fur decorated with balls of white wood. These men were very bold, and in songs and verse proclaimed the virtues of Winter, who was their captain.*

*The other company had for its leader a captain representing Summer. This man was dressed in a kind of white smock, decorated with garlands of flowers and gay ribbons. On his head he wore a broad brimmed hat trimmed with flowers and ribbons. In his hand he carried a willow-wand wreathed with spring flowers and tied with ribbons.*

*All these men marched in procession, with their captain on horseback heading them to an appropriate place. This would be on some stretch of common or wasteland. There a mock encounter took place, the Winter company flinging straw and dry underwood at their opponents, who used as their weapons birch branches, willow wands and young ferns.*

*A good deal of horse-play went on, but finally Summer gained the mastery over Winter. Then the victorious captain representing summer selected a May King, and the people nominated a May Queen, who were crowned and conducted to the village. The remainder of the day was given up to feasting, dancing, games of all kinds, until later still drinking. Revelry continued through the night until the next morning.*

—Marie Trevelyan, *Folk-Lore and Folk-Stories of Wales,* 1909

were thrown with votive offerings down a ritual shaft built within their wooden dwellings. Gruesome descriptions by classical writers spoke of a large wicker frame filled with living sacrifices to be burned alive, although we have no real evidence beyond the writings of these enemies to substantiate this.

**Cromm Crúaich,** *Bloody Crooked/Bent One of the Mounds,* is an ancient Irish fertility god—in Wales he is known as Pen Crug, *Chief of the Mounds.* A great gilded pillar stone dedicated to Cromm was said to be once covered in gold and silver. Surrounded by twelve smaller stones upon a mound in Magh Slecht, *the Plain of Protestations,* in County Cavan, Ireland, the great stone of Cromm demanded sacrifice of the firstborn to assure that milk, corn and honey were plentiful.

It is told in the Dindshenchas (place-lore) of the twelfth-century *Book of Leinster* that the Irish sacrificed their children to Cromm Crúaich up until the sixth century when Saint Patrick ended the ancient practice—although this could be a mythic misinterpretation of the ancient rites. It is also told that Saint Patrick struck the idol with his crozier, leaving its imprint upon the bare stone, causing them all to fall down and the gold and silver covering to crumble into dust.

Ritual sacrifice to appease the gods was common among animist pagan societies. Victims, believing a place in the Otherworld assured, may have sometimes gone willingly to their ritual death (as the sacrifice of the Lindow Man seems to indicate), although it is probable that others were more reluctant to become offerings to the gods—especially adversaries captured during battle!

The Lindow Man was ritually killed. An Iron Age man who has lain in the peaty waters of Lindow Moss for a few thousand years, he was well groomed, and his last meal of Druid's mistletoe and sacred grains implies his ritual sacrifice.

For the Celts, death was not the end of life, but a vivid aspect of reality. The otherworldly Tír na nÓg, Land of the Ever Young, was a welcome paradise for both warriors and common folk who lived a difficult life in

difficult times. Their religion accepted blood and death as part of the Mysteries of life, necessary for the sustenance of the earth.

Gatherings and Festivals with livestock trading, athletic competitions, horse races and religious ceremonies were centered around the seasonal year. Britain was a headquarters of Druidism, but once every year a general assembly was held in the territories of the powerful Celtic tribes the Carnutes—between the Sequana (*Seine*) and the Liger (*Loire*) rivers, considered the center of the Celtic world in the Iron Age. Two of the great Gaelic assemblies were known as Oenach Tailten, or *Tailtiu*, and Aenach Carmen, or *Carmain*.

The Ceilidhs, or gatherings for feasting, music, dancing and rituals, honored the harvest, the plantings and the times of change. These were important agricultural cycles of an agrarian people who relied upon the fertility and bounty of the land.

Many old customs and festivals are still enjoyed today, especially May Day and Samhain—best known as Hallowe'en. Old traditions that actively continued until the turn of the century in parts of Wales, Ireland and Scotland have their roots in the gatherings and rituals of the ancient Celts.

Midsummer fires and festivals were held around the Summer Solstice on Saint John's Eve. Fires were built from the charred remains of the previous year's ritual burn, with either three or nine different kinds of wood. Herbs were thrown into the fire, and girls with bunches of three or nine different flowers would jump over the midsummer fires holding the hands of their sweethearts, young boys wearing flowers in their buttonholes. Rites of fertility and the power of fire to purify and heal are celebrated with a night of wild and merry celebration.

**The Folk-Soul lives** within the heart of her tribe and celebrates with colorful Ceilidh gatherings. The tribe honors the courage of her warriors and the brightness of her young people who, leaping the tain-fire to fertilize their love, are inspired by what was, what is and what could be.

# THE MARI LLWYD

The Mari Llwyd tradition was celebrated in Welsh villages up until the 1900s, and is enjoyed again today in many parts of South Wales. It is a winter celebration traditionally held on the 12th night after Christmas. The ritual is a remnant of the ancient horse worship of the Celts, with the skeleton head, shoulders and skull of the horse accompanied by a festival procession of dancers, rhymers and mummers.

A light hearted contest of clever wit and rhyming skills this feast festival takes place at the dark time of winter. The old name of Marw Llwyd—meaning the Grey Death—was a symbol of the dying year. The Mari Llwyd was an exhibition made up of mummers dressed in all kinds of garments. The most prominent figure was a man covered with a white sheet. On his head and shoulders he bore a horse's head, fantastically adorned with colored ribbons, papers and brilliant streamers. Youths bearing burning brands, and small boys dressed up as bears, foxes, squirrels and rabbits helped to swell the throng.

The Mari Llwyd was always accompanied by a large party of men, several of whom were specially selected on account of their quick wit and ready rhymes. All doors in the village were safely shut and barred when it was known that the Mari Llwyd was to commence. When the party reached the doors of a house, an earnest appeal was made for permission to sing. When this was granted, the company began recounting in song the hard fate of mankind, and the poor in the dark and cold days of winter. Then the leading singer would beg those inside to be generous with their cakes and beer and other good things.

Then began a kind of conflict in verse, sung or recited, or both. Riddles and questions were asked in verse inside and outside the house. Sarcasm, wit, and merry banter followed, and if the Mari Llwyd party defeated the householder by reason of superior wit, the latter had to open the door and admit the conquerors. Then the great bowl of hot spiced beer was produced and an ample supply of cakes and other good things, and the feast began.

—Marie Trevelyan, *Folk-Lore and Folk-Stories of Wales,* 1909

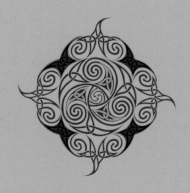

Listen! You can hear the dance
Starting on the kitchen floor.
They are learning the steps
Becoming the music
Reaching the skill, the fever,
Doing what I've always wanted.
Dancing though me, dancing their
beginning,
They are learning to be haunted.

—Brendan Kennelly, "House"
from *Breathing Spaces: Early Poems*

# CEILIDH–THE DANCE

In ancient and modern spiritual traditions, the Dance is a metaphor for life, an ancient choreography moving with the rhythm of the Earth to the music of the cosmos.

Within Celtic tradition the Ceilidh is a gathering: a celebration of music, storytelling and dance. Long winter nights are passed to the music of the fiddle and whistle, the beat of the bodhran drum. The traditional Celtic dances weave intricate patterns of circles, spirals and squares in arrangements of threes and fours—a dynamic expression of the eternal knot. In ritual dances such as the annual Beltain Maypole dance, men and women weave ribbons in ancient spiral patterns around the phallic tree to raise and manifest the fertile earth energies.

The Morris Dancers continue the tradition of the Shaman dances. They wear antler headdresses and costumes of red and white representing the colors of the Otherworld. Their clogs, sticks and bells stamp out rhythms in circle and square patterns on the earth in celebration of the ancient Horned God of fertility and strength. The Lord of the Dance is one of the oldest gods of the natural world, still honored as a powerful force at the center of our spiritual and metaphysical lives.

Illustration facing page: *Ceilidh—the Dance*

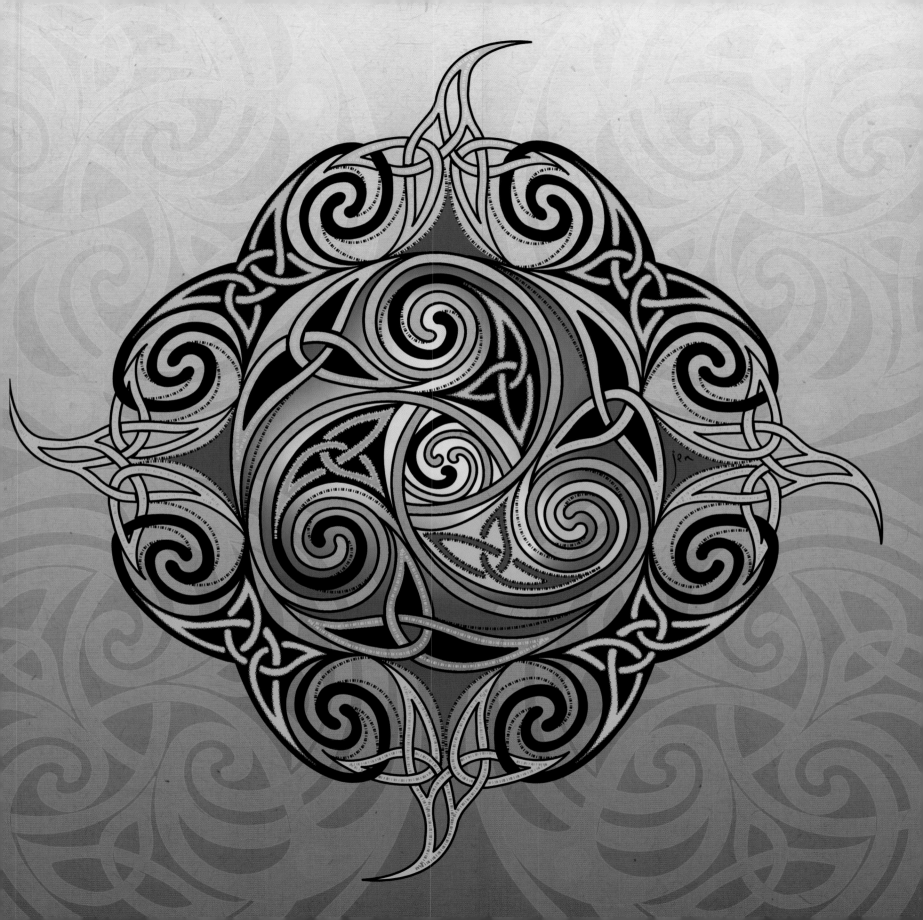

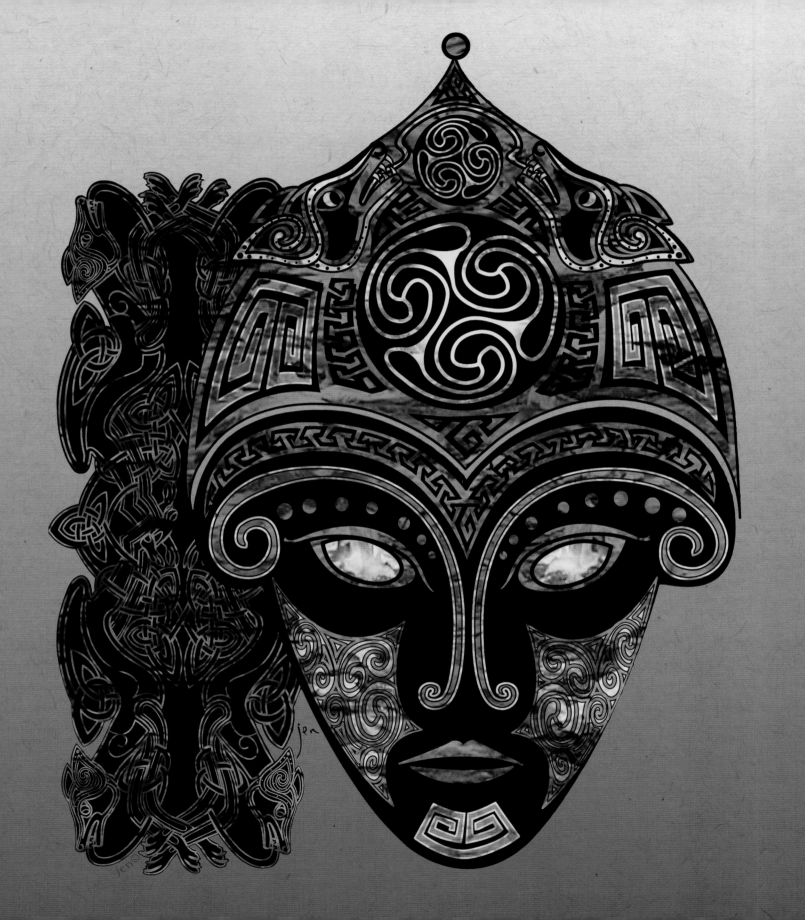

# TALE OF THE
# TÁIN BÓ CHUAILGNÉ
## CATTLE RAID OF COOLEY

**D**onn of Chuailgné—*the Brown One of Cooley*—is a magical Bull of the warriors, representing fertility, strength and the protection of the land: the sovereignty of Ireland.

The great bull Donn has been transformed many times since he was the divine swineherd. In bull form he had many magical powers and virtues, and was prized above all other animals, especially among the warriors and the pastoral tribes-people who fought to keep him, as described in the Old Irish epic *The Táin Bó Chuailgné*—the driving off of the Cattle from Chuailgné.

The most famous bull in Ireland, Donn was the property of Daire, a chieftain of Ulster. On his broad back fifty youths would gather every night to play games of draughts. Under his shadow he sheltered a hundred warriors from heat and cold, and no evil spirits dared to come near him. Donn was the magical protector of the tribe, ensuring the reproductive powers of the herds. His delightful, musical lowing every evening could be heard from the north to the south, from the east and the west of Chuailgné, and the sound put all the cows in calf.

In Ireland's greatest legendary epic battle, told in the *Táin Bó Chuailgné*, we hear the tale of the great cattle raid, the invasion of Ulster by the armies of Medb and Ailill, queen and king of Connaught, to acquire the Brown Bull of Chuailgné. This is a battle for the sovereignty of Ireland, and the Bull is a supernatural symbol of the struggle for tribal authority of the land and her people through the ownership of the powerful symbol of fertility and strength.

The Táin tells us that there were once two great bulls who were originally the magician swineherds of two gods:

Bodb, King of the Sidhe (*faerie folk*) of Munster, and Ochall Ochne, King of the Sidhe of Connaught. The two Druid swineherds were constantly fighting, bickering and challenging each other. They changed themselves into two ravens to continue their rivalry and battled without ceasing for a year.

Next, they transformed into beasts of the water and fought for another year in the river Suir, and the next in the river Shannon, tearing and devouring each other but with neither of them winning nor losing the fight. Their next shape-change was back to human form, and as warriors and champions the magicians fought each other bitterly but bravely, neither having the advantage over the other, matched in all skills and strength.

Their next transformation was into eels.

One went into the River Cruind in Chuailgné, Ulster, and was eaten by a cow belonging to Daire the Chieftan of Chuailgné, who gave birth to the Brown Bull of Ulster. The other slipped into the spring of Uaran Garad of Connaught, where Queen Medb's cow swallowed him and birthed the White-horned Bull of Connaught.

The White-horned Bull was too proud to belong to a woman, even though Medb was a powerful and wealthy queen. Well known to rule equally with her husband, Ailill, she was free-spirited and independent, taking her own lovers, and was respected as a strong leader of her loyal warriors and champions. But the White-horned Bull left her and joined her husband's herds.

This gave Ailill the advantage over his wife, who was equal in all other things: sheep, swine, horses, jewels and fine objects. The proud queen did not like having less than

her husband, for power within the tribes was measured by such worth, and the White-horned Bull was a greater treasure than any within her own herds.

When Medb heard about the great Brown Bull of Ulster, she began courting Daire with gifts and promises, hoping he would lend her his prized bull to balance her husband's wealth and power. Daire enjoyed the attentions of the queen and was preparing to lend her the Brown Bull when he overheard her messenger boasting (while drunk on his host's fine wine and hospitality) that if Daire did not freely give up the bull, Medb would take it from him by force.

Daire was angered by this insult and refused to hand over the great Brown Bull to the woman who had clearly wounded his pride and his honor. Medb was furious when she heard she was to be denied the Bull, and made good on her threat, assembling all the warriors of Ireland to battle with Ulster.

The armies of Ulster were at that time under the ancient curse of a Druidess who, in retaliation for an insult by one of Conchobar's ancestors, laid them under a spell of weakness that fell upon them from time to time during the year.

Medb and her army were confident of victory; still, she sought advice from her seers to auger the outcome of the war. "How do you see our enemy?" the queen asked her prophetess, who interpreted the sacrifices. "I see them bathed in red," she replied. "How do you see my fine warriors?" asked Medb. "I see them bathed in red also," was the puzzling reply. "*For I see a small man doing deeds of arms, though there are many wounds on his smooth skin; the hero-light shines round his head, and there is victory*

**Three Bull-protectors of the Island of Britain:
Cynfawr Host-Protector
son of Cynwyd Cynwydion,
Gwenddolau son of Ceidiaw
and Urien son of Cynfarch.**

**Three Bull-chieftains of the Island of Britain:
Elinwy son of Cadegr,
Cynhafal son of Argad
and Affaon son of Taliesin.**

Early Welsh Triads

*on his forehead. His appearance and his valor are those of Cúchulainn of Muirthemne, and all our army will be reddened by him. He is setting out for battle; he will hew down your hosts; the slaughter he shall make will be long remembered; there will be many women crying over the bodies mangled by the Hound of the Forge whom I see before me now*" (translated by Charles Squire, 1905).

The Hound of Chulainn was the greatest warrior of Ulster—the hero Cúchulainn. Although he was a young man, small in stature, when the battle fury was upon him he suffered *riastradh,* or paroxysm, transforming into a fearsome, wondrous being of sinew and muscle, his angry gnashing causing flakes of fire to stream from his mouth. He was much feared in battle for his frenzied courage, his powerful strength and his spear named the *Gáe Bulg*, which sang for the blood of his enemies.

Cúchulainn was not under the weakness spell as were the other champions of the Red Branch, and so it fell upon him to defend Ulster alone against the four provinces of Ériu. Thus began the most terrible battle of Ireland between Cúchulainn and the army of the proud Queen Medb for the Brown Bull of Chuailgné.

Cúchulainn fought in single-handed combat with each warrior, according to tribal tradition, and the blood of the brave men began to turn the earth red. They kept coming in an endless stream of warriors, but still the Hound of Chulainn cut them down with his fierce sword, his powerful sling and his ferocious battle strength as he slew his adversaries one by one. He killed a hundred men a day with his sling, and fought from morning until night against any who dared to face him on the field. Not one returned.

Medb, surprised and furious that her victory was not assured, gathered her best champions, sought the aid of her most powerful Druids and magicians and sent seductive invitations to the young hero, offering him gold, jewels and a place in her bed if he would forsake Conchobar; so determined was she to bring home the Brown Bull of Chuailgné. But Cúchulainn—happy as he would have been under other circumstances to accept her hospitality, drink her wine and enjoy her attentions—replied that he would remain upon the battlefield to uphold his fierce duty to the honor of Ulster.

Medb sent more messengers to Cúchulainn with offers of wealth, power and friendship in return for his sword, but this time—angered by her persistence—he sent back a dire warning that the next man to insult his honor would do so at his peril! Then Cúchulainn offered the queen a bargain. He would fight one man each day, allowing the main army to march on in safety for as long as the duel lasted, but they must stop when Cúchulainn had killed his man. Medb agreed, and offered her champions great rewards—including the hand of her daughter Findabair in marriage— for the death of the Hound of Cúchulainn.

Many great warriors fell beneath his sword, and Findabair died from a broken heart in seeing so many brave suitors lose their lives for her. Cúchulainn also slew the totem animals of Queen Medb with his sling—her dog, her bird and her squirrel; this loss filled her with grief and fury. While he was busy fighting off the best of Medb's men, she scoured Ulster for the Brown Bull, found him and stole him away to her camp.

Cúchulainn was now covered with wounds on every part of his body and so exhausted by the terrible battle and so many good warriors fallen that he cried from the killing of them. He knew that he could not last much longer and sent a message to the men of Ulster, rousing them to come to his aid. Even with the spell of weakness still upon them, their loyalty to Cúchulainn gave them strength and courage, and they joined him, meeting Medb's army face to face at last.

The battle for Ireland continued to rage, with so much blood spilled that soon neither side could remember what they were fighting for. Even the bards had exhausted their elegies to the bravery of the slain warriors, the sadness of their women and the blood that never stopped flowing. The black ravens of the war goddess Morrigan were also quiet now, waiting for the end of this most terrible battle of the Táin. Though the birds of the dark Morrigan possessed the gift of augury, even they could not see the outcome of this war.

Then the Brown Bull of Chuailgné and Ailill's White-horned Bull met upon the battlefield. The armies moved away from the terrible fight, which could be heard and felt all over the land of Ireland. It was a ferocious battle. The two bulls had fought through every form, but this was their first meeting as the horned beasts. They snorted fire and threw muscle against muscle, shaking the ground beneath them as their hooves scraped deep furrows in the earth.

Then the Brown Bull savaged the White-horned Bull, tearing him limb from limb upon his horns. He dropped his loins at Athlone and his liver at Trim, and when he returned to Chuailgné, he was maddened with rage—and some say grief for the slaying of his swineherd brother—and killed all who went near him. Then his heart burst with the effort, and he fell down and died. This was the end of the most deadly battle for Ireland, the Táin Bó Chuailgné, won at great cost by the Brown Bull of the Ulster.

**The horned Bull warrior god** is ancient protector of the people and their land, insignia of the warriors. Also associated on Celtic coins with the sun, the Bull shares the attributes of fertility and strength, supreme qualities of power for a pastoral people whose wealth is measured by the size of their herds.

This story is an interpretation from *The Book of the Dun Cow, Leabhar na hUidre*, a seventh-century ancient Irish manuscript telling the first-century Tale of Cúchulainn (translated by Charles Squire, 1905).

Sweet apple tree with flowers foxglove pink
that grows in secret in the forest of Celyddon,
and even though you look for it
it is all in vain because of its peculiarity
until Cadwaladr comes from his meeting of warriors
in Rhyd Reon—Cynan in response
setting out for the English.

The Welsh will win,
glorious shall their dragon be:
everybody shall have their rights,
the Brythons' morale will be high,
the horns of celebration will be blown,
the song of peace, of prosperity.

—Attributed to Taliesin. "Merlin's Apple Trees"
from *The Black Book of Carmarthen,* 1250.
Translated by Meirion Pennar.

# Y DDRAIG GOCH—RED DRAGON

The Red Dragon symbolizes the sovereignty of Britain and is the totemic beast of the greatest line of kings, the Pen-dragons. The Red Dragon—*Ddraig Goch*—is derived from the Great Red Serpent that once represented the old Welsh god Dewi, also associated with Wales's mythical patron saint David.

There is a legend that the British tyrant King Vortigern, who some say brought the Saxons to overrun Britain, was attempting to build a fortified tower—thought to be the hill fort of Dinas Emrys, *the city of Emrys*—in Snowdonia, north Wales. But the building was unstable, and the structure kept falling down.

A young boy was brought to be sacrificed in an attempt to save the tower. However, young Emrys had powers of prophecy—and he saw that two dragons, one red and one white, were fighting in an underground pool below the weak foundations.

Vortigern was afraid and listened to the boy, who lived—some say— to become Myrddin, *Merlin the Wise Man.* Emrys prophesied a long fight between the red dragon and the white dragon, who would at first dominate but eventually the red dragon would win. This victory would be, according to Welsh legend, brought about by *Y Mab Darogan*—the foretold son of Welsh and Cornish legend. Arthur, Owain Glyndwr and Henry VII of England were all thought by their followers to be *The Destined One* to force the Anglo-Saxons (English) out of Britain and reclaim it for its Celtic inhabitants.

Y Ddraig Goch Ddyry Cychwyn—*The Red Dragon will rise again.*

Illustration above: *Arthur's Knot—from Pen-Arthur Cross Slab, ninth century, Wales*
Facing page: *Y Ddraig Goch—Red Dragon*

# METAL
## art

I have been in many transformations

I have been a sword of enchantment

I have been the light of lanterns

I have created the feast

I have been a sword in the hand

I have been a shield in battle

I have been an enchanted harp string.

—Taliesin, sixth century,
adapted from "The Battle of the Trees"
from *The Four Ancient Books of Wales: The Book of Taliesin,*
twelfth to fifteenth century

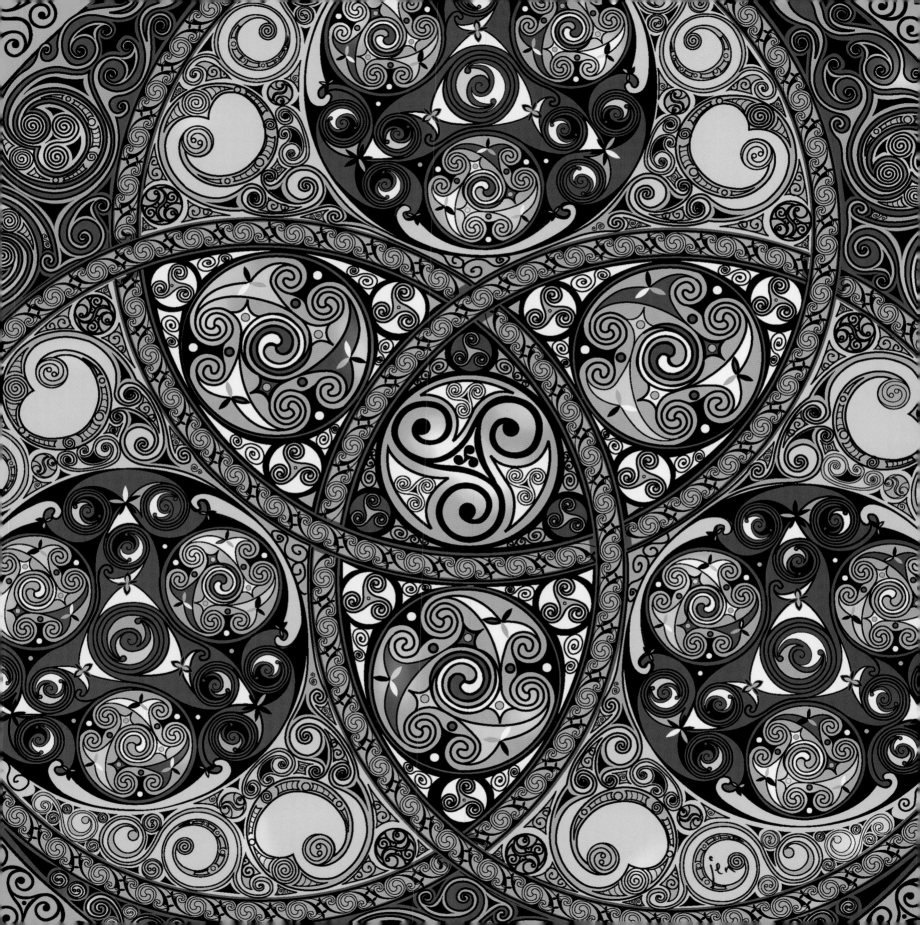

# METAL
## art

**A**rt has been a basic activity of people for thirty thousand years. We have a natural impulse to exercise skill, design and imitation in interpreting our world—both the natural world around us and that within our imagination. These skills reflect how we have evolved, how we communicate and differ from our animal cousins, representing innovative survival techniques and a compelling impulse to create and express both the visible and invisible.

Art is a language, a form of nonverbal communication that we receive on an intuitive as well as a more conceptual level. This language of shape, color, symbol and representation integrates the vocabulary of the artists, who draw from the ideas and perspectives of both the style and philosophy of their culture.

The Celts believed in an oral tradition, so their visual language is their clearest voice, the primary communication from the ancient people to us today. The most direct and fascinating connection we have with Celtic culture is through their arts and fine metal-works, which allow us to trace the movements of the early tribes through to the land of the Britons. The development of their techniques and artwork gives us insight into how they thought, worked and lived, how they moved and migrated, spreading the culture of the tribes with their trades and skills.

The Celtic Folk-Soul is shaped by the deeply symbolic art forms of the Celtic tradition. We may simply enjoy the images, resonate with their beauty, style and aesthetics. We can also interact with them as a more complex communication that reaches through time to many people— young or old, from different cultures perhaps speaking in different tongues. We may interpret this visual language through a deepening understanding of who the artists were and what various images may or may not have meant to them—their intention.

Especially with sacred or religious art, which is often based on ancient archetypes rather than personal expression, the images often draw from the language of nature herself, which is a vocabulary that continues to be accessible to all of us today.

**T**he Bronze and Iron ages were when the development of Celtic Art began. For the first Celts, as for the flint and stone carvers of prehistory, new skills represented the technological advances of their time. The knowledge of metal and the discovery of the raw materials necessary to create it fueled the brilliant warrior culture that produced the style we now know as Celtic Art.

Metal-work with intricate spirals and interlace patterns, and highly stylized curvilinear animal and vegetal forms, began to appear on iron weapons, tools and jewelry. The Iron Age Celts created golden torcs, bronze helmets and shields, horse trappings and intricate clasps called fibulae. We find finely engraved mirrors and heavy cast bowls, beaten metal shields, forged axes and swords—all highly decorated, some with enameling, amber and coral.

Their designs reflect a sophisticated mythological tradition and a strong belief in the afterlife, an otherworldly relationship between the mortal world and the divine force of nature. These early artists created an intricate and uniquely beautiful style of ornament and mystical expression that has continued to evolve through many centuries of adaptation and change into the Celtic Art tradition we know today. This was the artistry of the early Celts, and metal was their making.

**Celtic Art** continues to inspire us, but back in the Bronze and Iron ages it was a powerful expression of status, culture and mysticism that took root among the tribes of Europe, Britain and Ireland.

Because the Celts did not write down their traditions or ideas, we must instead find glimpses of the tribes through the reflected brilliance of their art and rituals, seek them through their abstraction of things, through the twists and turnings of their enigmatic riddles and patterns. Theirs is a visual language of stylized motifs and symbols representing the archetypes that form the heart of Celtic mythology and culture. Triskele whirligigs, interlaced knotwork, maze and key-fret patterns, with stylized animal and plant vine motifs, form the vocabulary of design. Curvilinear and S-patterns, chevron, lozenge, palmettes, trumpet and lyre loops, and the yin-yang motif are the grammar of Celtic ornament.

**K**nowledge of Metals—bronze and later iron— represented profound technological advancement for artists and craftspeople, and for the entire culture of those tribes we call the Celts.

Although the language and religion of the European tribes began to evolve with the earlier proto-Celtic communities such as the Urnfield folk, the knowledge of metal brought from the Mediterranean and Middle East quickly advanced the emerging culture of the Celts.

For the metal-smiths and -makers, this was a time of immense creativity. Their innovations in design and craftsmanship represented far more than their considerable decorative skills. They were creating wealth, status and military power for their people, and—leaving a most important record for us today—were channeling the powerful beliefs of the tribe through the symbols and patterns they engraved, cast, worked and shaped into new forms.

Bronze and Iron Age Celtic art is associated with two distinctive periods of Celtic cultural development and artistic style. These have been named after archaeological sites where large quantities of Celtic metal-works and artifacts were found. The Celtic Bronze Age is represented by Hallstatt, *Salt Town*, a village in Austria, and the Iron Age by La Tène, *the Shallows*, near Lake Neuchatel, Switzerland.

**C**eltic Bronze Age—the Hallstatt period (from the end of the eighth to the early fifth century BC)— represented great technological progress, creating immediate and rapid growth among the tribes of Europe. The ability to produce bronze from an alloy of copper and tin, and to make tools and weapons that were stronger than stone and could be shaped into any form, was revolutionary to those who had relied on flint and stone until then.

The new technology of bronze arrived in Europe around 4000 BC, although it took longer to reach Britain and didn't reach Ireland until 2000 BC. The tribes began developing sophisticated techniques to create new weapons and tools that were quickly adapted throughout the agricultural communities, spread by traders and traveling artisans who were highly respected and honored by the communities.

Areas of Europe that were found to be rich in the necessary raw materials such as tin and copper became strong tribal centers of trade. New tools improved agriculture and quality of life, creating a class of artisans and warriors who were sustained by their newfound prosperity. The new metal weapons gave strength to the warrior cultures that lived in the ore-producing trans-Alpine areas, increasing both their wealth and status. They developed their military focus and acquired more tools, weapons and metal objects through skirmishes with other tribes and raids upon the lands beyond.

> **A word or an image is symbolic when it implies something more than its obvious and immediate meaning. It has a wider unconscious aspect that is never precisely defined or fully explained … Because there are innumerable things beyond the range of human understanding, we constantly use symbolic terms to represent concepts that we cannot define or fully comprehend. This is one reason why all religions employ symbolic language or images.**
>
> —Carl Jung, *Man and His Symbols*

Celtic Iron Age—the La Tène period (beginning of the fifth century BC)—is when the true civilization of Celtic culture emerged. Mastery of iron created profound social change, prosperity and trade for those skilled in the new technology.

Iron smelting developed in the Middle East and Asia and spread to Europe through Greece, the Balkans and later Northern Italy, replacing bronze as the metal of choice for weapons and tools.

Wealthy tribes who became accomplished in the skill of metal-working developed aristocratic class systems and began to bury their dead in style. Their rich grave goods include some extraordinary examples of Celtic metal-smithing and artistic development. They tell us much about the beliefs of the people who prepared for a journey to the Otherworld with ritual food and drink, finely crafted adornments, highly decorated objects for feasting and chariots—some made of gold.

Celtic culture spread rapidly, not by massive invasion but by trade and migration throughout Europe, down into the Iberian Peninsula, and eventually across the ocean to the British Isles—the land of the Druid priests—there to make its enduring mark.

### The Divine Smith of Irish mythology is Goibhniu, called Govannon in Wales. Along with Creidhne, the god of metal, and Luchta, the artist-maker, the revered Smith fashioned the magical Otherworld weapons for the warrior gods. He made the sharpest blades for Lugh of the Long

Arm before the battle of Magh Tuiredh, and the skillfully crafted silver arm for King Nuada.

The metal-smith held the secrets of creating metal from the crude ores, a shape-changing technology that excited the artisans, who could now bend, mold and pattern ever-new, intriguing and mystifying forms, all in a strongly characteristic style that reflected the beliefs of the tribe.

Iron and Bronze Age artists were held in high esteem in Celtic society, and in the north of Britain Goibhniu was particularly revered. We find him depicted at his anvil wearing his belted tunic and strangely conical cap with tongs in one hand and hammer in the other. The masters of metals created useful tools and decorative objects, and brought wealth and honor to their tribes, to the chieftains and to themselves with their fine work and ingenuity of design.

Brighid is the patron of smiths, artists and bards. She is the mistress of all crafts, watching over the forging of metal-works and prized weaponry of the Celtic artists. She is goddess of the hearth and the smithy, associated with the forge of life as midwife of lambs, watching over mothers in childbirth and nurturing the fire of inspiration of the poets.

Votive offerings were given to lake, river and sea. Great ceremonial silver cauldrons, ornamented sword scabbards, golden shields and finely crafted torcs of exceptional quality, beauty and value were given in sacrifice to the gods in great quantities. It was said that the Romans sold off entire lakes for the potential hoards of gold and metal votive artworks that lay beneath the waters.

---

**In the Irish prose Dindshenchas, Len Linfiaclach was a craftsman of Sid Buidh. He lived in the lake and made bright vessels for Fland, daughter of Flidais (goddess of wild things). He was accustomed to cast his anvil each night eastwards as far as the grave mound and it used to cast three showers out—a shower of water, a shower of fire and a shower of purple gems. This was also practiced by Nemannach when he was making Conchobar Mac Nessa's cup.**

—Whitley Stokes, *The Prose Tales in the Rennes Dindshenchas*, 1894

Illustration: *Astrology Horse—from Gold Slater (Celtic coin) minted by the Parisii tribe, end of second, early first century BC*

# GRAMMAR of  CELTIC ORNAMENT

1

2

3

4

5

6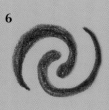

7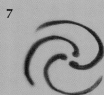

8

9

10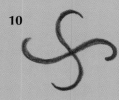

11

12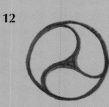

13

14

15 16

| | | | |
|---|---|---|---|
| 1 Trumpet | 5 Spiral | 9 S-Pattern | 13 Step or Key Pattern |
| 2 Lyre Loop | 6 Double Spiral | 10 S-Swastika | 14 Basket Weave |
| 3 Palmette or Mushroom | 7 Triple Spiral | 11 Yin Yang | 15 Double Strand Knot |
| 4 Double Palmette | 8 Pelta | 12 Triskele | 16 Four Strand Knot |

The elemental symbols are connected to mythology, spirituality and folk traditions, and have roots
going back to the Paleolithic and Neolithic peoples who first incised them on caves, rocks,
burial chambers and cairns. Some of these root elements have profound mystical significance
and were used to invoke the sacred and connect with the power of the earth.

Illustration: *Tan-Y-Llyn engraved bronze
shield mount, Gwynedd, Wales*

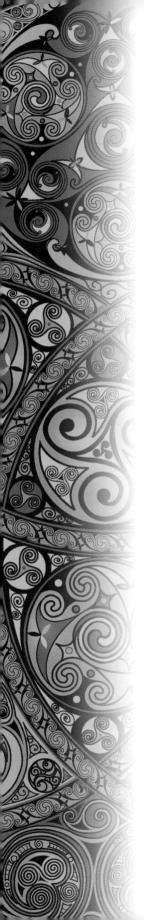

Artists of the Iron and Bronze ages were responsible for creating these fine objects not only for their patrons, but for the gods themselves, who were destined to be honored in the Otherworld. They created intricate gold, bronze and iron objects for devotional offerings and also for grave goods, making models of chariots and wonderful figures to accompany their king to his opulent life ahead.

The roles of artist, smith and metal-crafter included sacred responsibilities for the mystical needs of the tribe, as did those of poet and bard. During this time, artists are also a conduit for ideas. Their symbols are the visual language of a society without the written word, without books. The mythic images communicate on behalf of the people to the gods to propitiate for healing and prosperity, for their crops, animals and children. Visual expressions are not merely decorative but represent inherent power, absorbing and channeling mystical qualities within their very forms.

## CELTIC SYMBOLISM

Celtic imagery is complex; its patterning communicates on both material and spiritual levels. The fluid rhythms, twists and turns of labyrinth pathways resonate with the patterns of life. The interlacing ribbons create infinite loops without beginning or end. Spiral forms are a mystical sign of the universe seen everywhere in nature: in tree ring growth, snail shells, the patterns of wind and water.

Animal symbols include the Boar, who is the popular insignia of the warrior. We find this creature of valor upon the shields and helmets, the drinking flagons and great cauldrons of the feast. The cornucopia of the Celts—rather than the classical symbol of a bowl overflowing with fruit—is a magnificent golden flagon, cast in the shape of a fierce boar with three horns and filled with honeyed mead. It is offered to the gods as a gift of the feast, for the blessing of bounty and fertility of the tribe.

Birds such as the Raven—totem of the warrior goddess, the Triple Morrigan—Crane and the strangely popular Swan, which is intriguingly depicted wearing mystical silver or gold chains, have a particular mystic symbolism that we encounter in mythology. Their beaked heads peer out among the abstract patternings and swirls of the Celtic metal-workings.

The horned animals include the Stag and figures such as Cernunnos. The ancient Horned God represents the primeval powers of fertility and hunting, and continues to be an important figure for the Celts in the metal ages, as he was for the earliest Paleolithic shaman painters. Interesting combinations of horned birds and significant triple-horned bulls appear on Celtic coins and metal-works. Magical symbols, they combine the power of fertility associated with the Stag deity with the mysticism of the sacred triplicity, along with their virtues of spirit-bird flight or solar-bull strength.

Solar symbols are among the most powerful for the warrior Celts, associated with the Horse, the Bull, the Swan and the sun gods Lleu and Bel. The Horse as solar animal embellishes the coins, bronze mounts, harnesses and richly decorated grave goods that are destined for the Otherworld.

Coins provide some of our most interesting insights into Celtic symbolism and culture, since each tribe minted its own disks with sacred iconography including the heads of tribal kings and chieftains. Gold Celtic coins often feature the Horse, the Boar, the Raven and sun chariot wheels. The illustration on page ninety-two depicting a solar horse with dots and other strange marks may signify astronomical relationships.

The metals gold, bronze and iron are associated with the sun and with the warrior hero gods Lugh and Nuada. The Sun represents fertility, power and strength—the stuff of warriors—and the esoteric sun wheel symbol is frequently paired with animal and chieftain figures on Celtic coins, which are in themselves like small golden sun disks. These are powerful symbols associated with wealth, and through them the gods of the Iron Age Celts of Europe lent their favors to the tribes of the metal masters.

Abstractions of the natural world, rather than realistic, lifelike renderings, imply rather than depict a third-dimensional quality—which is our mythic-spiritual connection. This distinctive non-narrative art form illustrates a spiritual content, the unseen elements which peopled the natural world of the tribes.

Sometimes using only a minimum of lines, the heads of animals and humans, dragons and fantastic crested birds are integrated with magical vegetative motifs such as mistletoe leaves and yew berries within a fusion of abstract patterning that gives fluid structure to the overall design. Here and there we see a hint of an owl or cat face with magic eyes, or a Celtic warrior head suggested between the curvilinear lines. They reveal an enigmatic presence that is both charmingly playful and profoundly mystical, communicating a shape-shifting mythic quality through the intricate patterns. We can only guess at the layers of symbolism and complexities of meaning that were apparent to these people who were steeped in the rituals of their time.

Non-naturalistic imagery was a conscious intention of the Celtic artists, whose art is not imitative of nature but stylized, due in part to religious taboo. They represented the ideas of their community rather than their own personal interpretations, perhaps under the watchful eyes of the Druid priests.

Although they had contact with the more realistic figurative art of the Mediterranean, the Celts focused on communicating the unseen magical elements and symbolic qualities of nature, rather than the idealized but realistic depictions of the world of the Romans and Greeks. Their perspective reveals a more untamed attitude toward life. They are active participants rather than masters of the environment; they view the natural world as intrinsically sacred and powerful, to be respected and honored.

Unique style and innovation are the signatures of Celtic artists. One of the important strengths of Celtic culture is to adopt and utilize elements from the outside into its own characteristic style. The Celts were masters of adaptation with a strong sense of identity and individual expression. Although they borrowed freely from the Mediterranean and Asiatic traditions, Celtic artists transformed the adapted motifs in fascinating ways, fusing styles and elements together to create ambiguity and multidimensional symbolism.

The Bronze and Iron Age Celts learned from the people with whom they traded and fought, such as the Etruscans, the Greeks and the Romans, integrating new techniques, construction methods and materials into their own unique style and sophisticated craftsmanship. They loved to borrow ideas and concepts, but always adapted them into their own forms, choosing what suited them and leaving the rest.

They transformed their plunders and trades of coins, tools and precious objects, adding their own expressions of the mysterious world of animals and nature, tribal goddesses, stylized beasts and twisting, intertwined plants.

New interpretations of techniques were created, such as reversing the field of the design to incorporate the background areas—which further evolved patterns to balance negative and positive space. The Celts adopted Roman techniques such as enameling and millefiori, influencing the brilliant colors and the style of later illuminated manuscripts—a wonderful example of cross-medium as well as cross-cultural inspiration.

The introduction of the compass—a drawing tool used to create circles and curves—around the fifth century BC changed the way artists both (continued on page 98)

Illustration: *Boudicca—from Gold Slater (Celtic coin) minted by the Coriosolities tribe, first half of first century BC*

METAL art 95

# TRISKELION–TRIPLE GODDESS

The Triskelion is the triple-legged pattern, which invokes the mysticism of the sacred three-fold symbolism of life. Throughout Celtic mythology and folktales, Celtic goddesses appear in triple form, and from ancient times the Great Earth Mother was the Triple Goddess representing her three aspects, Maiden, Mother and Crone—Spring, Summer and Winter. For the Celts it is the philosophy of a triplicity rather than a duality that is seen reflected in the world as the organic principle. The triple form can be seen everywhere in the conceptual patterns of the world: ocean, earth and sky—roots, trunk and branches—birth, life and death—time before, the now and that to come.

Spirals are the design of nature, of our universe. Snail shells, water flows, star systems—our very DNA—are all patterned with the sacred spiral thumbprint of life, the Spiral Dance. They are among the most ancient symbols created by our ancestors: carved on bone amulets and cave walls, appearing on megalithic monuments and entrances to caves, at sacred places of worship, all over the Continent and the British Isles. These mystical triple patterns symbolized the womb, death and rebirth, and the coiled serpent or dragon, all regarded as sacred in the Old Religion, representing the Earth energies.

This original design is inspired by metal-work motifs
from the La Tène style, woven into a contemporary illustration
of the sacred triplicity of the Triple Goddess.

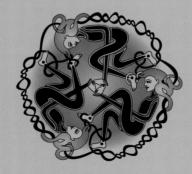

Illustration facing page: *Triple Goddess*

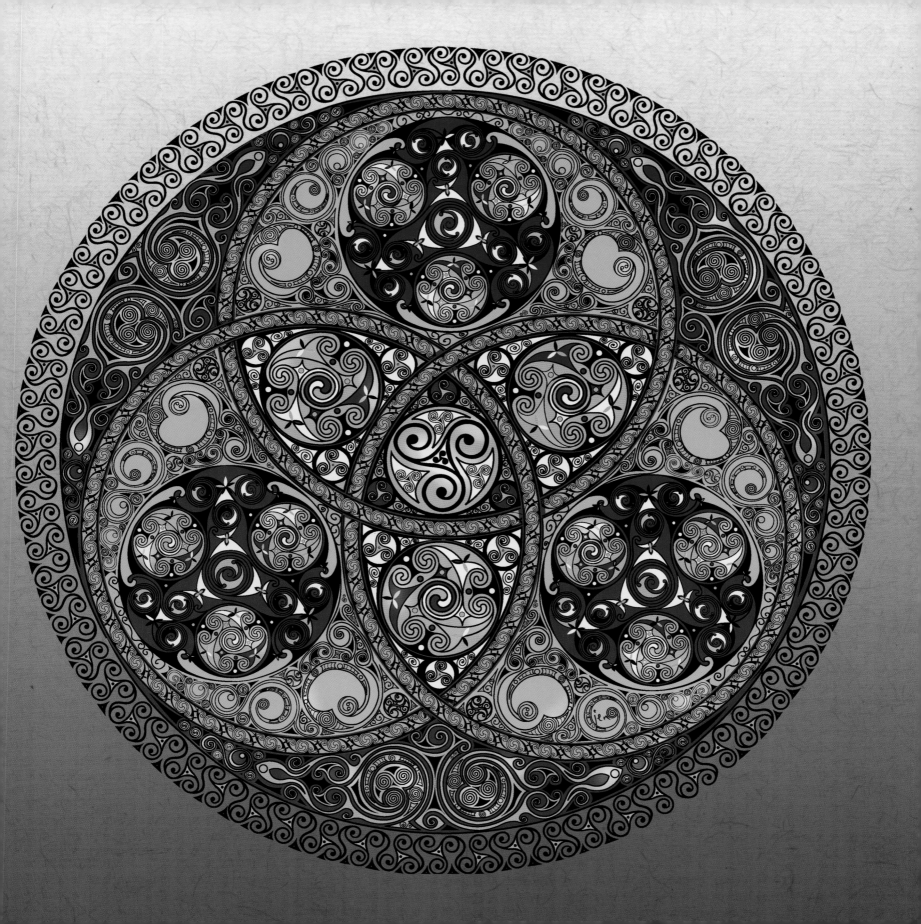

For they not only wear golden ornaments—both chains around their necks and bracelets round their arms and wrists—but their dignitaries wear garments that are dyed in colors and sprinkled with gold.

—Strabo, *Geography IV*

Each man's property, moreover, consisted in cattle and gold; as they were the only things that could be easily carried with them, when they wandered from place to place, and changed their dwelling as their fancy directed… They made a great point, however, of friendship; for the man who had the largest number of clients or companions in his wanderings, was looked upon as the most formidable and powerful member of the tribe.

—Polybius, *Histories II*

They carry shields as tall as a man, all decorated with individual designs. Some of the shields have bronze centerpieces shaped like animals that stick out from the front and serve as weapons themselves. The Gauls also wear helmets with figures on top that make the warriors look taller and even more fearsome. Some of these helmets have horns sticking out from the sides, but others have figures of animals on the fronts of birds.

—The Greek Posidonius, first century BC,
quoted by Diodorus Siculus in *Library of History*

rendered and conceived their curvilinear designs, creating geometric interplay, symmetry and balance. This important instrument continued to be essential to the development of Celtic Art through to the Middle Ages; it was perhaps the most significant creative tool for the metal-artists, and later for the scribes.

Some Oriental imagery and symbolism traveled via the Etruscans, such as the Tree of Life, represented by intertwining vines guarded by the birds of knowledge and wisdom. Although originally from Persia, these motifs reflected Celtic religious iconography, and so were adapted to become an important addition to their design vocabulary.

Celtic Art in Britain and Ireland, known as the *Insular Tradition*, developed with its own distinctive style in relative isolation throughout the early expansion of the Celtic civilization in Europe. The art, language and religion of Albion (Britain) and Eire (Ireland) were influenced by some trade links and migration from the continent; however, Insular culture developed in its own fashion, integrating the ideas and expressions of the earlier tribes.

The ancient traditions of the Great Stone Builders continued to influence the ideas of the slowly evolving Celtic culture of the islands of the Atlantic. The Old Religion, whose shrines were at the rivers and wells and at the old sacred places, continued to be honored through the Celtic Druids who were well established in Britain. Triskele designs, with their religious significance of sacred triplicity—as seen at the pre-Celtic Neolithic Newgrange passage grave in Ireland—remained popular, especially in Wales, Brittany and Cornwall.

After the Romans left centuries later in AD 400, Celtic art and culture continued, especially in the more remote and less Romanized localities of Wales, Scotland, Cornwall and of course Ireland, which had not been invaded. Although the great era of fine Celtic craftsmanship was stifled for a while by the domination of inexpensive Roman imports, Celtic artists continued to find patronage at the courts of the Celtic chiefs, who demonstrated their pride

and status by choosing traditional Celtic styles for items such as drinking flagons, bowls, brooches and swords. Even so, the glory days of the Celtic artist-makers were now over, until their reemergence centuries later under the patronage of the Christian monasteries.

After the great works of the illuminated manuscripts and richly decorated sacramental objects of the medieval church, there was not to be a revival of Celtic Art and culture again until the mid-eighteenth century. Today, at the beginning of the new millennium, there is renewed interest and expertise in both traditional and more contemporary interpretations of Celtic arts and crafts.

Over time, new influences helped shape the Insular Tradition. The animal patterns of the Germanic invaders were enthusiastically adapted into the Celtic art vocabulary. Pictish stone carvings were influenced by the Anglo Saxon bestiary; the Irish adapted the zoomorphic forms into their own style, and the Anglo Saxon artists were similarly influenced by Celtic art and techniques.

The form of a crouching creature looking backward (which is a more naturalistic but still highly stylized animal motif that can be traced back to the Scythians and the Euroasiatic tradition of the lands of the Russian steppes) appears in the Sutton Hoo metal-works and in later illuminated manuscripts such as *The Book of Durrow.*

With the retreat of the Romans, early Christianity took root, bringing new ideas and a shift from the mysticism of nature to a religion centering around man. However, the native Celtic expression still flowered, particularly in the monastic communities of Ireland and Scotland, developing a synthesis of traditions and styles in art and literature. It is in Ireland that Celtic Art again blossomed during a Celtic renaissance in medieval Europe, once more becoming an important source of cultural inspiration and influence.

**A**daptation is key to both the development and the survival of the Celtic culture and its art forms. As Irish missionaries traveled to Europe centuries after the Romans had lost their power there, elements of Celtic expression, which to some extent had been long forgotten in the lands of the early Halstatt and La Tène metal-artists, were reintroduced through the Irish arts and literary traditions—where they had first been conceived! The evolution of Celtic Art had come full circle.

The Celtic Folk-Soul has flourished despite many challenges. It is the vitality of symbolism within her art and mythology and an openness to adaption and individuality that are the secrets to the enduring nature of her culture.

Celtic Art renews our connection between past and present, the inside and outside, the seen and the unseen. The language of Celtic myth and symbol represents the beauty of nature, expressing the Mystery of Life and the interconnectedness and balance of all things.

Perhaps in future times, we too shall be examined through the eyes and hands of our artists, but for the Celts it is certainly their achievements through decoration and craftsmanship, their mythic expression and symbolism, to which we can relate most profoundly.

The rich, symbolic language of the Celtic Folk-Soul contains the seeds of articulation of the early first peoples, forged in bronze and iron, and continuing to evolve into our time. Through what they made and what they have become, we seek to find them, these people who fought and birthed, lived and died and loved so long ago.

Illustration: *Arthur's Knot—from Pen Arthur Cross Slab, Wales, ninth century*

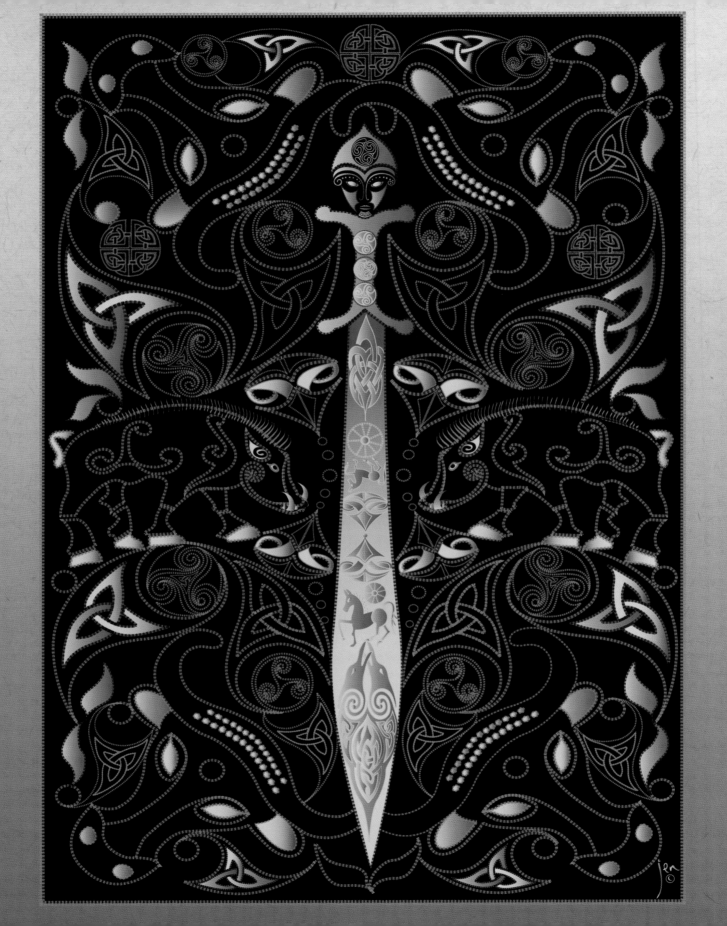

# TALE OF
# LUGH OF THE MANY SKILLS

Lugh—*Lleu Llaw Gyffes* in Welsh—means light or shining, and Lugh is associated with the gods of the harvest and of the Sun. He is a male counterpart to Brighid, who is patron of poets, smiths and midwives—the forging of words, metals and life within the womb.

Each year on August first, there was an agrarian festival called Lughnasdh, where athletic games, races, competitions and feasts celebrated Lugh of the Long Arm. He is also known as Lugh of the Many Skills, and—as an accomplished smith and bard, sorcerer and historian, as well as a skillful warrior—he is the Many Gifted One, *Samildanach,* Master of the Arts.

The story of Lugh begins with two sworn enemies, the Fomorians and the Tuatha Dé Danaan, both of whom, according to Irish mythology, inhabited Ireland before the coming of the Celts.

The king of the Fomorians was called Balor. His daughter Eithne fell in love with Cian, son of Dian-Cécht, the healer of the Tuatha Dé Danaan's chieftan king, Nuada of the Silver Arm. So angered was King Balor by his daughter's affair with an archenemy that he built a crystal tower to keep her locked away from him. The strangely beautiful prison had no entrance but a window high up in the smooth, steep walls, but Eithne sent messages to Cian with the birds that would visit her upon its ledge.

However, her lover was not to be thwarted, and Cian visited a Druidess who gave him the power to fly up to Eithne's crystal tower. Theirs was a joyful and passionate love, and soon she was pregnant, and then gave birth to triplets—two beautiful boys and a girl.

A prophecy foretold that Balor could only be killed by his grandson, so when he discovered the babies, the king flew into a terrible rage and stole the two boys away.

Ignoring his daughter's grief and her pitiful screams, he threw them into the sea to drown.

One of the brothers perished, but the sea god Manannán Mac Lir found the other—Lugh—and brought him to Tailltu, warrior queen of the Fir Bolg who became his nurse. Lugh was also fostered by the master metal-smith Goibhniu, who recognized his natural gifts and taught the boy many skills of the arts and crafts, the knowledge of the makers. Goibhniu is the Divine Smith, one of three craftsmen who represent the triplicity of artist gods known as *Na Tri Dée Dána.*

Even as a small boy Lugh was curious and ingenious. He quickly learned any task that was put to him: the arts of the warrior, of the poet, of music and of metal-craft. And so he became known as Lugh of the Many Skills, *Samildanach.*

Nuada of the Silver Arm, king of the Tuatha Dé Danaan, was secretly preparing a war against the Fomorians and Balor, their leader. Lugh decided to join the great company of warriors who were gathering within Nuada's fortress, but he needed to prove his worth before he could gain entrance and sit among them.

Before the Battle of Magh Tuiredh, Lugh went to Tara, where a marvelous banquet, a great warrior feast, was being prepared, but the gatekeeper would not let him join the court until he proved that his trade-craft was both unique and useful. Lugh had become master of all trades, and so he began naming his abilities: "I am a wright," he said, but the gatekeeper said there was already a wright among the warriors. "I am also a smith," said Lugh, but there was already an adequate smith within the keep. Lugh tried again: "I play the harp with the gift to enchant the company into dreams of the Otherworld!" But the gatekeeper was not convinced, and already liked the music of the court bard well enough.

*Illustration facing page: Warrior*

Lugh was not easily dissuaded. He explained that he was a warrior, a harper, a poet, a sorcerer, a craftsman and a historian. Although the gatekeeper was becoming more than a little impressed, he continued to shake his head, saying that all of those trades were represented by other members of the Tuatha Dé Danaan.

At last the clever Lugh asked him, "But do you have any person who is master of all the skills?" The Gatekeeper admitted defeat, that there was not one inside the court who possessed all the trades, and permitted him to enter.

When Nuada heard of the boy with the many skills, he invited him into his company, and Lugh took his place among the warriors of the Tuatha Dé Danaan. He became one of the greatest of them, possessing enormous strength and courage and having the advantage of being expert in all he did.

Lugh's foster father Goibhniu, the Divine Smith of Irish mythology, fashioned all the magical Otherworld weapons for the warrior gods of the Tuatha. Along with Creidhne, the god of metal and Luchta, the artist-maker, he worked to craft fine weapons that were said to always fly true and inflict fatal wounds.

Together they had created the silver arm for Nuada, who had lost his in battle. It was highly decorated with magical designs and expertly made with movement in every finger of the perfectly crafted hand. When fitted against Nuada's shoulder this was a better arm than the one that he had lost, and incredibly beautiful. Nuada of the Silver Arm was victorious in many battles until he met his match against Balor, who killed him at the battle of Magh Tuiredh. Balor was known as *Balor of the Evil Eye*, named for his terrible weapon, a deadly contraption made of iron that caused the death of many fine warriors upon the battlefield.

Meanwhile, the makers Goibhniu, Creidhne and Luchta made a powerful sword for Lugh, which was finely crafted and held all the sorcerers' symbols of the warrior. This magic sword was called *Freagarthach the Answerer*; it was fearless, invincible, and sought the blood of the enemies of any whose grip was strong enough to keep the sword from leaping into the fray with a battle lust all of its own.

The metal was forged in the heat of a lightning bolt and imbued with the ferocity of the Boar, the deadly knowledge of the Raven Morrigan and the golden strength of the Sun Horse. Lugh also possessed an invincible spear and a formidable sling: not one could escape its deadly aim.

When Balor killed Nuada of the Silver Arm, Lugh gathered his best warriors and took up his powerful sword, spear and sling to avenge the great chieftain king. At first Balor disdained the young warrior, who rode fearless upon his shining horse, decorated with all the symbols of the sun. "Who is this babbling youth?" he asked his wife, and she replied, "This is your grandson Lugh who is sworn to destroy you!" Lugh took aim at Balor of the Evil Eye with his great sling, killing him and all who were near him in a single blow.

After winning the battle and establishing the sovereignty of Ireland for the Tuatha Dé Danaan, who were to rule for two centuries, Lugh—now known as *Lugh of the Long Arm* for his victory with the sling—became king of Ireland and reigned for forty years.

> **I have been in many transformations**
> **I have been a sword of enchantment**
> **I have been a raindrop in the air,**
> **I have been the furthest of stars.**
> **I have been the words of the oldest book**
> **I have been the light of lanterns**
> **I have been a bridge over many rivers**
> **I have been a path, an eagle, a coracle in the sea.**
> **I have created the feast,**
> **I have been a sword in the hand**
> **I have been a shield in battle,**
> **I have been an enchanted harp string.**

—Taliesin, sixth century, adapted from "The Battle of the Trees" from *The Four Ancient Books of Wales: The Book of Taliesin,* twelfth to fifteenth century

Illustration facing page: *Macha—Celtic bronze fitting in form of horse's head, first century BC*

it is recounted with an absence of drollery
next came copper workers with wheels and carpentry
from the land of the Greeks, drunken by starlight
north through the Daneland heroing and charioteering
and breaking bones like crockery
with their brown swords.
but let us sing these rovers homesick for sights unseen
and sounding for the sake of the silence between the stars
and garnering an elder lore within their druidry
for so bore Nuada of the Silver Hand,
master of the elements
into Alba
into Erin
the quest of the Seat Perilous
and of the White Bull's Spotted Hide
to make and unmake the demons of the mind to fly
honouring the unvisionable Dagda
and Mananan of the Letters in the Craneskin
and shining Lug of the Ways
of the world
the garden
and carrying always within, as is fitting
the shadowlit
whispering
marefaced
catfaced
owlfaced
ageless huntress and thrice queen
who musing in the blood whistles and whirls
her hounds and ravens, beyond all sacrifice
craven and unrhyming, nailed in a blackthorn tree
lest horned eyes be blinded by the tomb of the lightlessness
in the charm of the halcyon dark.
on this, our grave and Christian clerics in alarm
avert their pens
womenless men crooked in the cloister of their age
but poetry declares it differently
older yet and lovelier far, this mystery
and I will not forget.

—Robin Williamson, excerpt from "Five Denials on Merlin's Grave," 1978

# TRIPLE MORRIGAN–THREE SISTERS

Celtic goddesses frequently appear in triple form in mythology and folklore.
The Triple Morrigan, *Great Queen*, also known as Badb, *Crow*, is the ancient Celtic
death goddess of victory, prophecy and battle. The Raven is her totemic bird.
In Arthurian myth she appears as Morgan Le Faye, King Arthur's witch half-sister,
as a powerful and dark influence. The Morrigan ruled the Fortunate Isles
with her nine sisters who are said to guard and tend the cauldron of rebirth in the
depths of Annwn, cooling it with their breath.

In Greek mythology, the divine sisters appear as the Muses, known as the three Graces,
or Fates. In Norse legends they are the Norns, who live near the Well of Urd at the
base of the tree Yggdrasil, which connects the nine worlds found in Norse mythology.

In Native American mythology, squash, corn and beans are known as the three sisters.
Often depicted as being clothed in the leaves of the crops over which
they are guardians, the sisters are also, in some legends,
the daughters of the Earth Mother.

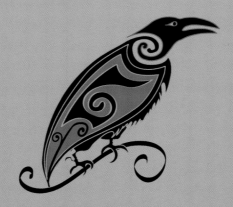

Illustration facing page: *Triple Morrigan*

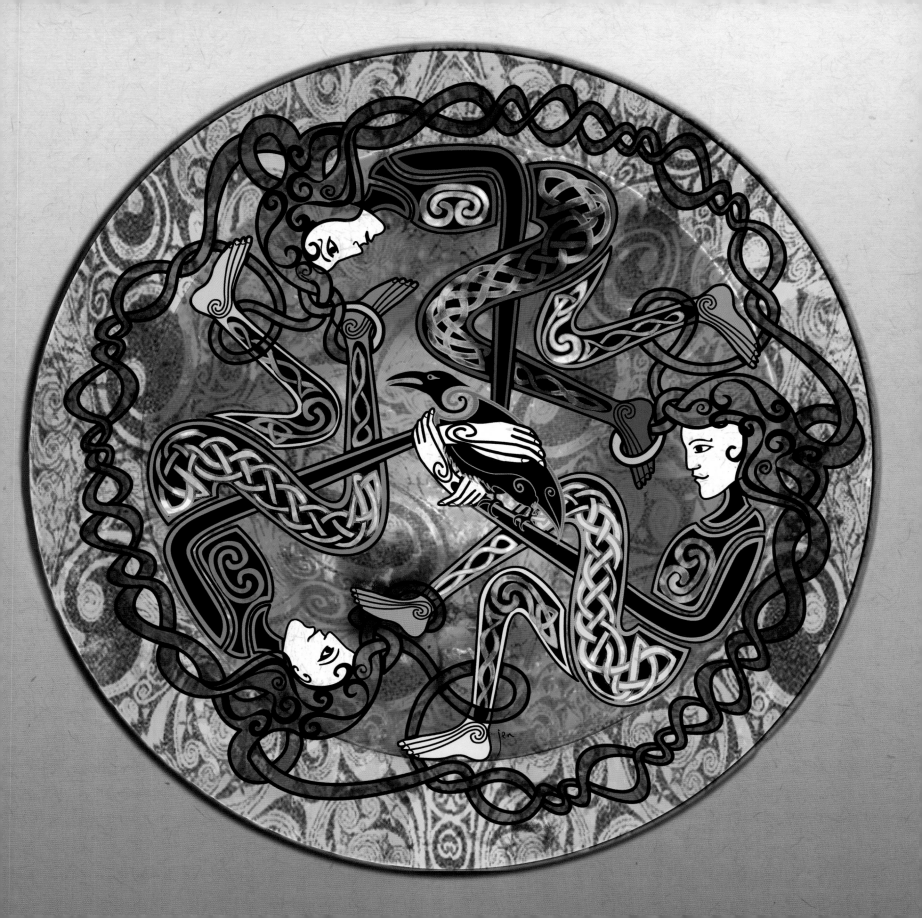

# SEED
## fire

The dew will come down to welcome
Every seed that lay in sleep
Since the coming of cold without mercy;
Every seed will take root in the earth,
As the King of the elements desired,
The braird will come forth with the dew,
It will inhale life from the soft wind.

—Alexander Carmichael,
*Carmina Gadelica—Ortha nan Gaidheal*

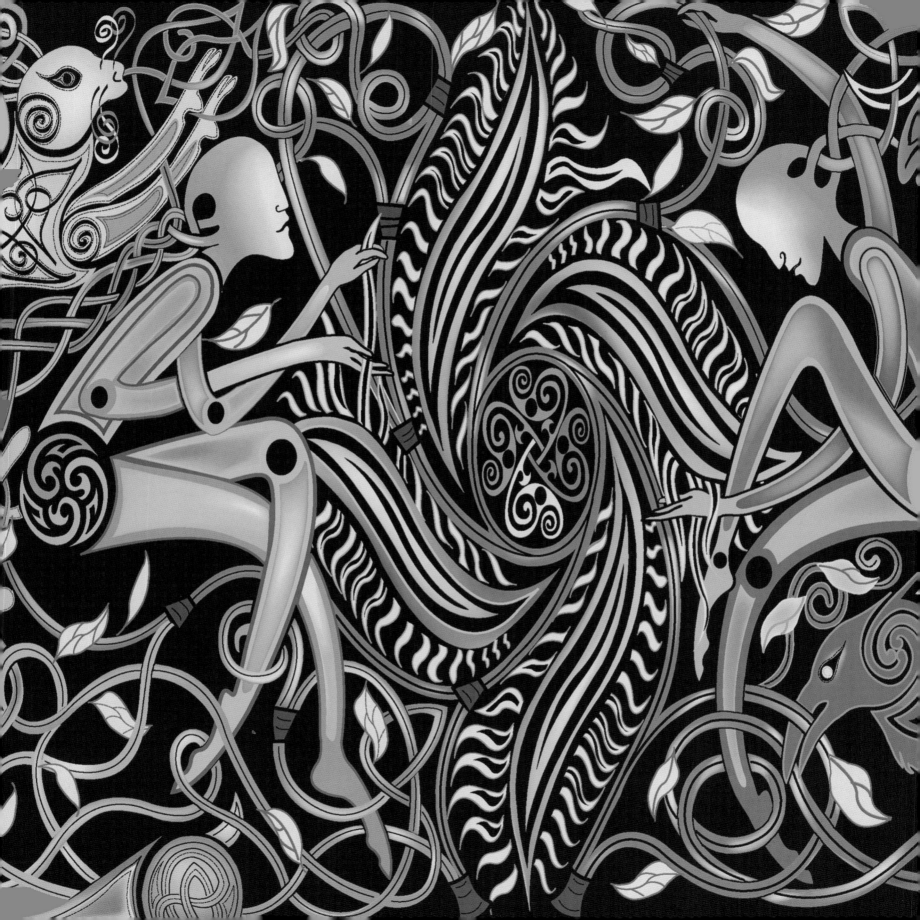

# SEED
## fire

**S**eed contains the great dream of being. Seed dreams of opening, becoming itself—a flower, a man, a great tree, an ancient poem that takes root in a future time.

**The Fire of Life** burns within the heart of the seed. The dry husk contains the dormant force waiting to be sparked into green life in the warm womb of the earth. The humble seed scatters to fall on stony ground or fertile soil.

The Green Fire calls the shoots toward the light to drink the fertile rays of the sun. It is the generating heat of the compost pit, the earth-oven transforming decay into nourishment.

> ### The force that through the green fuse drives the flower.
>
> —Dylan Thomas
>
> **Fire is an elemental and deeply spiritual symbol. Fire purifies, cleanses and illuminates the darkness. The dance of fire is inspiration, poetic and divine. The arousal of inner fire ignites mystical passion, kundalini energy, and is a metaphor for burning love and emotions. Fire is a supernatural force that can blaze brightly with golden life, or devour, destroy and consume. The rich ash of the burned fields fertilizes the soil, and fire sparks the life within the seed to germinate.**

A Red Fire warms the heart through our love and passion, and is also the fire of anger and rage. Color of blood, of red ochre with which the Ancients were buried, this is the fire of life and death.

The Yellow Fire represents the spirit, illustrated by the golden halos of the Saints in the ancient manuscripts. The shining sun fire is wise and illuminating, the source of strength and fertility.

The Blue Fire is cold, focused, the still power at the heart of the dancing flame. Fire of mind and intellect, color of the vast sky, blue is the fire of the bards and of the poets.

The White Flame is the mystical fire, color of the Otherworld from which we come and to which we return. The White flame is emptiness and fulfillment—the color of light, of everything and nothing.

**The Poet** nurtures the germinating seeds of insight called to life by the fire of inspiration and illuminated by the fertile sun of the intellect. This esoteric fire is known as *Awen* to the Druids—it is the creative spark of life.

The Celtic Folk-Soul is forged by this transforming element of fire. Dormant seeds sown by the ancient storytellers, poets and artists are brought to flower by the fire within—others may be destined to open in another time than this.

This is the creative process honored by the Celts, who understood that the Arts were close to the Mysteries of Life and gave their bards the highest respect and mythic honor.

**F**ire is one of the four root elements of matter. The lightest element, fire purifies, consumes and transforms organic forms back to their basic elements. Fire is honored universally as an inspirational spiritual element

Illustration facing page: *Tân—Earth Fire*

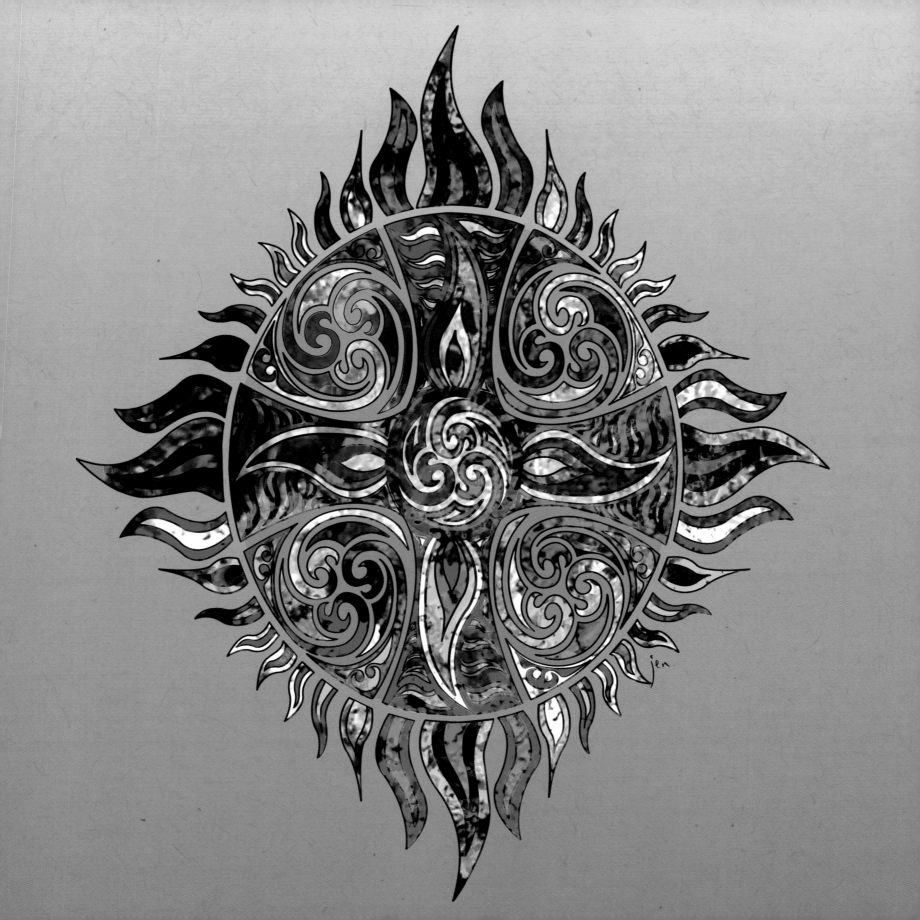

in our religious ceremonies and our homes. Our prayers often focus upon the small flame of a candle, and within its light we recognize the burning flame of our inner spirit manifest in the flickering form.

Ever since we discovered its secrets, fire has warmed the hearth at the center of our lives. We gather around fire and gaze into the dancing flames as we tell our stories and pass the long winter nights.

Fire is the stuff of alchemy—wood and bones burn down to ash, which fertilizes the earth, creating new growth. Fire in the capable hands of the metal-smith transforms the raw ore of the earth into beautifully wrought adornments and sturdy tools: this is the fire of the forge.

**B**righid, Keeper of the Flame, is daughter of the Dagda, the great god of Irish mythology, the ancient protector of the tribe. She is also a revered Christian saint and pagan goddess of healing, poetry, smith-craft and midwifery. At her monastery in Kildare, women took turns guarding and feeding the holy fire, keeping an eternal flame in the spiritual hearth.

Brighid is the smithy—patron of craftsmen and poets. Honored by metal-workers, whose intricately wrought gold, silver, copper and iron were so favored by the Celts, as midwife she is mistress of the forge of life itself. Substance is formed, glows soft in the fire, is crafted and then tempered in the cold waters of the world. She is mother to the bards and poets, whose inspiration is worked into finest form within her fire, as corn ripens and is forged by the fertile rays of the sun.

Midwife protector, Brighid is invoked by women in childbirth. Her festival is February 1st: the Feast of Imbolc at the time of the lactation of the ewes. In legend she was the midwife of Jesus and a friend to Mary. As a Christian saint, Brighid is known as Mary of the Gael, compassionate mother who the people continued to worship when Bride moved into the shadows of the Old Religion.

Brighid tends the fertilized seed as it divides into life, grows full and journeys out toward the light and air from the watery furnace of the belly of the Mother. She is loved and worshipped throughout the Celtic world and is still honored as the healer goddess of the creative fire of life.

**On the Eve of Brighid's Feast** young Celtic women make corn dollies—woven effigies of Brighid called the Brídeóg—by weaving sheaves of corn or husks of wheat, barley or oats into the likeness of a woman. They often weave straw from the sheaves of the last harvest into the new one; continuity and blessings are intricately entwined with the golden crop that embodies the fertile fire of the sun.

In parts of Wales the grain spirit was thought to hop from stalk to stalk as the sheaves were reaped, until she was in the very last sheaf, which was brought into the home, dressed and woven into the form of a woman. Sheltered for the winter, the corn or wheat spirit was then offered back to the land at planting time.

These are the ancient rituals of an agrarian people, continuing from mother to daughter, from father to son through the rhythm of the years, keeping alive the balance of nature and connection between the farmers and the land, between the spirit and the earth.

**The Art of Fire** began when our ancestors first learned to strike flint against tinder and kindle the small flame, gaining immense power and advancement. Fire provided warmth, was used to cook food and *(continued on page 114)*

Illustration above: *Blodeuwedd—Woman of Flowers*
Facing page: *Sheela-na-gig, inspired by Kilpeck stone carving, twelfth century*

# THE GAELIC HEART

I am older than Brighid of the Mantle, Mary.
I put songs and music on the wind before
ever the bells of the chapels were rung in the West
or heard in the East.

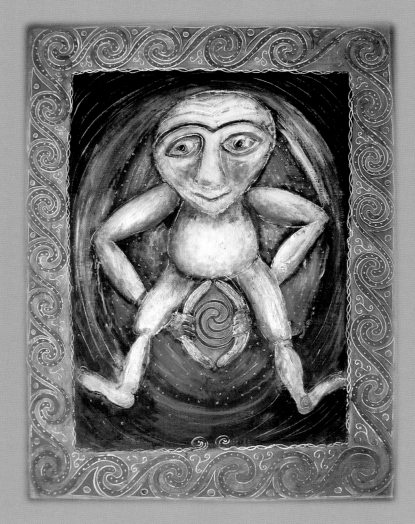

And I have been a breath in your heart.
And the day has its feet to it that will see me coming
into the hearts of men and women like a flame upon dry grass,
like a flame of wind in a great wood.

—Fiona MacLeod, "The Gaelic Heart," 1900

## GREEN MAN

The Green Man is a powerful archetype, an untamed mysterious figure often depicted with his semi-human foliate face entwined with plants and leaves—often growing out of his mouth. He is an ancient primeval character, representing the fierce verdant force of nature, of the woodlands and densely entwined thickets that once covered the land.

The Green Man was often included in stone carvings by the artists and stone-masons; his enigmatic image adorns the crevices and walls of medieval cathedrals and churches all over Europe. Similar images occur in many cultures, representing the vegetation deity, the spirit of the trees, plants and foliage. Our oldest Celtic example dates to the third century BC, where he appears on an Irish obelisk, perhaps the mythic *Derg Corra—the man in the tree*. He is well known throughout the British Isles by many names, such as *Green Jack, Jack-in-the-Green* and *Green George*.

## MYRDDIN WYLLT—Wild Man of the Woods

Myrddin Wyllt—*Wild Man of the Woods*—here represents an aspect of the Green Man archetype. This mythic figure also appears throughout Celtic tradition, such as in the story of *Suibhne Geilt*, Irish King of *Dal Araidhe*, who went mad during the battle of *Magh Rath* (AD 642), flew into the crowns of the neighboring trees and was known to utter poetic prophecies.

Myrddin Wyllt is a Welsh sixth-century bardic visionary, a mad wild man. He is both a historical and mythic figure who inspired many poems and prophetic legends from the Dark Ages onward. The life of Myrddin Wyllt became the basis of the great iconic magician Merlin who later figured in the romantic twelfth-century Arthurian legends.

It is said that Myrddin Wyllt, son of *Morgryn Frych, Prince of Gwynedd*, went mad when he witnessed the horrors of a terrible battle that wiped out almost his entire family and tribe, sometime in the sixth century. He fled to become a *Wild Man of the Woods*, where he shunned all people and lived in the caves of the woodlands on either side of the river Conway, surviving only off the wild cress and river water.

Between bouts of incoherent ravings and madness, Myrddin spoke prophesies of his people in poetry with powerful meter and rhythm, inspiring Poets and Storytellers through the ages. Although he hid from any who came too close, his sister Gwenddydd knew him well and would leave cheese, bread and ale near his secret places. She would wait patiently to hear his words of poetry, and write them down when she returned home.

Over time, the reputation of the visionary Myrddin Wyllt spread beyond the local people, and through the protection of his sister Gwenddydd, Myrddin would share his gift of inner sight and decipher the dreams of those who made pilgrimage to the *Wild Man of the Woods*.

Geoffrey of Monmouth wrote about Myrddin Wyllt in the twelfth century in his *Historia Regum Britanniae—History of the Kings of Britain*. He combined the stories of wild man Myrddin Wyllt with several historical and mythic figures, including *Aurelius Ambrosius*, a well-known war leader, to form the figure he called *Merlin Ambrosius*, who later became popularized as the great magician of the legendary King Arthur. In his work *Vita Merlini*, Geoffrey of Monmouth continued the stories of the original sixth-century wild man Myrddin with a poem in Latin that "prepares to sing the madness of the prophetic bard, with a humorous poem on Merlin."

Illustration facing page: *Myrddin Wyllt—Wild Man of the Woods*

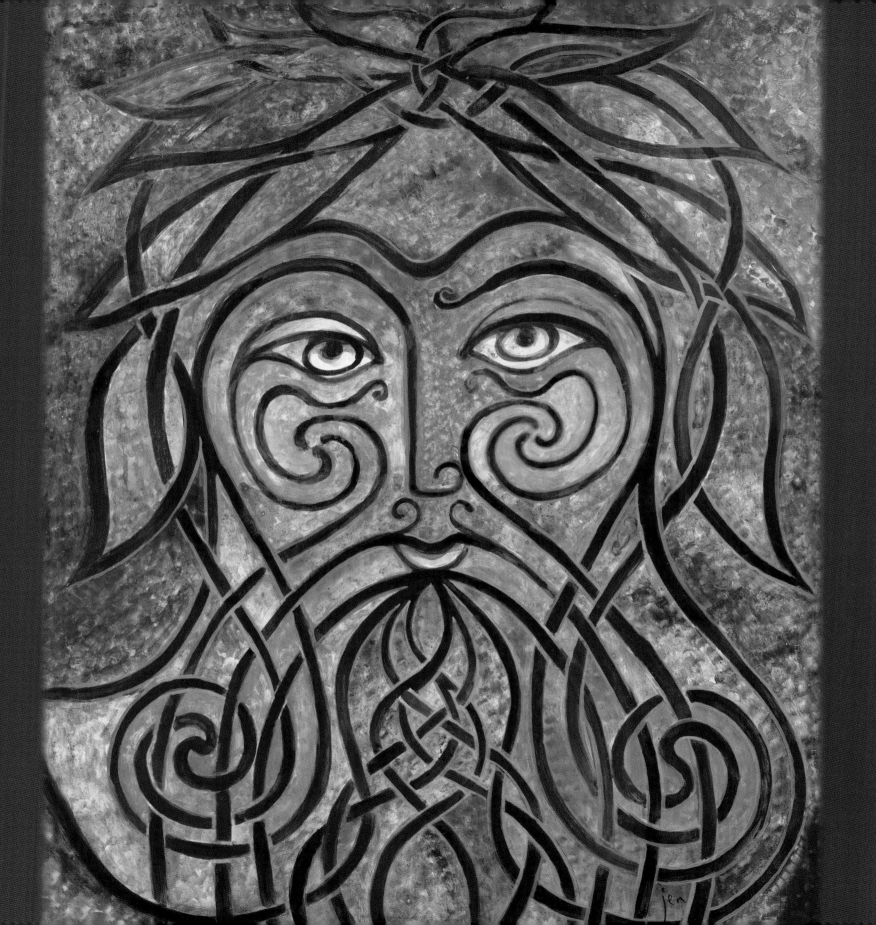

# BALTÂN–SACRED FIRE

The *Baltân*, the sacred fire of the Druids, was obtained directly from the sun, and all the hearth fires in Britain were rekindled from it. These fires were accompanied by feasts in honor of Bel, the Celtic deity of light, and in Druidic days they were carried out with much pomp and ceremony.

*The fire was done in this way; nine men would turn their pockets inside out, and see that every piece of money and all metals were off their persons. Then the men went into the nearest woods, and collected sticks of nine different kinds of trees. These were carried to the spot where the fire was to be built. There a circle was cut in the sod, and the sticks were set crosswise. All around the circle the people stood and watched the proceedings. One of the men would then take two bits of oak, and rub them together until a flame was kindled. This was applied to the sticks and soon a large fire was made.*

*Sometimes two fires were set up side by side. These fires, whether one or two, were called coelcerth, or bonfire. Round cakes of oatmeal and brown meal were split in four, and placed in a small flour-bag, and everybody present had to pick out a portion. The last bit in the bag fell to the lot of the bag-holder.*

*Each person who chanced to pick up a piece of brown-meal cake was compelled to leap three times over the flames, or to run thrice between the two fires, by which means the people thought they were sure of a plentiful harvest.*

*I have also heard my grandfather and father say that in times gone by the people would throw a calf in the fire when there was any disease among the herds. The same would be done with a sheep if there was anything the matter with a flock. I can remember myself seeing cattle being driven between two fires to "stop the disease spreading."*

—Marie Trevelyan, *Folk-Lore and Folk-Stories of Wales*, 1909

to light the way and was a powerful tool for land management and protection: fire gave us the means to survive.

Working with fire is also a mystical art, experienced both playfully and intuitively, sometimes dangerous and powerful.

**Folk rituals** involving fire have been practiced up to modern times throughout the Celtic world with daily prayers for the smooring, *smothering*, of the hearth-fire and the tending of the baking oven. Sometimes the flame was kept burning symbolically from the last log or peat to the next, day to day, season to season.

Traditionally in Wales each year, the folk brought fire into their homes as cinders or burning wood from the ritual Beltain fire, which the Druids would light from the heat of the sun, igniting a fire built with the wood of nine sacred trees: Alder, Birch, Elder, Hawthorn, Hazel, Rowan, Oak, Yew and Willow.

Some families still continue the tradition of keeping a portion of each year's Yule log to begin the fire of the next year, in recognition of the continuity of the ritual fire and its symbolic significance within their homes at the darkest time of year.

**Fire Festivals** on the highest hills marked the cycles of the year. Celebrated at night and during the full moon, fires were built upon the mountains, sending their high, bright flames into the dark night. With dances and gatherings around, and often through the ritual fires, the Celts marked the quarterly seasonal turning points of the year, calling the flame of fertility to the crops, livestock and to all of nature. Their fires ritually enact the rebirth of the seasons and of life itself.

The turning points of the solar year are between the solstices and equinoxes of the sun's highest and lowest positions. For the Celts, the points betwixt and between are important ritual times, marking the agricultural cycles and the essential fertility rites.

**Imbolc or Brigantia**—February 1st honors the goddess Brighid and marks the beginning of Spring and all new

beginnings. This is the festival of the lambs, the milk of the Mother nourishing the earth after a hard winter.

**Beltain or Brilliant Fire**—May 1st is a celebration of fertility, and the festival of Bel—*Bright One*—and his táin, or fire. May Day is still celebrated in many cultures around the world and is a festival of the green-budding, brightly blossoming new life that arrives each year with such beauty and vitality.

**Lughnasdh**—August 1st, when the turning point of the sun's journey is reached, the Feast of Lugh—*Shining One*—is celebrated at Lughnasdh or Lammas. This is the time of plenty, with gatherings and athletic competitions in honor of Lugh Long Arm—*He of the Many Skills*.

**Samhain**—October 31st is the Harvest Festival, with the Celtic New Year beginning on November 1st. Fires are lit for the dark Samhain, when Lugh's power wanes and winter, darkness, cold and hunger await. Samhain is the time when the veil between the worlds grows thin, when the door to the Otherworld is opened. We continue to celebrate Hallowe'en with its attendant spirits, witches and goblins, and although many do not remember the complex roots of Samhain, the Folk-Soul continues to resonate with this enigmatic, dark turning point of the year.

**B**urning the Wickerman. It was recounted with dark implication and possibly some exaggeration by the Roman Caesar that the Celtic Druids practiced animal and human sacrifice by burning live creatures inside a large woven wicker-work figure. However, this may be a misinterpretation of their rituals honoring the vegetation spirit.

The Celtic folk traditionally burned an offering of a woven man- or woman-shaped form, which was the last sheaf of the harvest dressed up in finery before being ritually consumed by fire—returned to the earth to celebrate the fertility of the personified corn spirit.

Although the Celts were known to ritually sacrifice people—usually criminals or *(continued on page 118)*

# FIRE LORE

**In connection with fire superstitions, there are many curious survivals. People in out of the way places, when troubled in mind, touch the stone over the chimney-piece, and afterwards throw a handful of dry earth into the fire. As it burns, they whisper the cause of their trouble to the flames, and this is supposed to avert any impending evil; or they kneel down beside a low-placed oven or stand by the high, old fashioned ones, and whisper any secret or trouble to the bottom of the oven.**

**When the fire under the oven hisses, there will be quarrels in the house. If sparks of fire fly from the candle when lighted, the person they go towards will get money that day. A crackling fire betokens strife; a dull fire betokens sorrow. When there is a hollow in the fire, people say a grave will soon be dug for a member of the family. When the fire is slow in lighting, they say "the devil is sitting on top of the chimney."**

—Marie Trevelyan, *Folk-Lore and Folk-Stories of Wales*, 1909

**When "need fires"—(new fires) were lit at Beltain festival (1st May),—"Beltain" is supposed to mean "bright fires or white fires," that is luck bringing or sacred fire—burning brands were carried from them to their houses, all domestic fires having previously been extinguished. The new fire brought luck, prosperity, health, increase and protection. Until recently, Highland boys who perpetuated the custom of lighting bon-fires to celebrate old Celtic festivals were wont to snatch burning sticks from them and run homewards, whirling the dealan-dé round about so as to keep it burning.**

—Donald Mackenzie, *Ancient Man in Britain*, 1922

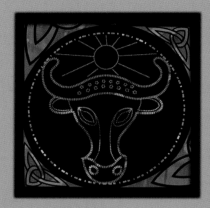

Brother to the silver
moon–lady of the night–the
sun brings us in a triple cycle
of Winter, Spring and then
Summer–the wheel of life and
death, moving as the shadow
of the simple sun clock gives us
our first divisions of the day.

# LUGH–SHINING ONE

Sun symbols are among the oldest of all representations that people have
carved on stones, rocks and bones.

The sun is the fire of our universe, the wise and fertile force that gives light to
the world. Sun is one of our most ancient archetypal symbols—powerful Fire
of the Heavens. To the Celts, the flaming gods of light are Lugh, *Shining One*,
and Bel, *Bright One*. The great Bull God Hu the Mighty is associated with the
sun, as is the Horse. Their coins, the golden disks that the Celts loved so well,
are struck with the fertile rays of the sun and with their sacred animals that
reflect their qualities of strength and fertility. The Solar Wheel as sun symbol
was worn as a talisman and buried with the dead. The Celts did not worship
the actual physical sun, which was not represented by any one particular god
or goddess. They venerated the spirit and power of nature in all things, and
many deities embodied the divine qualities of the sun—life, light, healing,
inspiration, strength, (inner) fire and illumination.

At the Summer Solstice—the longest day—the sun's powers are at their
strongest; and at the Winter Solstice—the longest night—the sun is at its
lowest ebb. The great stones of the early people have sometimes been raised
to focus the sunrise through their alignments as ritual to ensure the return
of the sun. At the solstices, the fertile rays pierce the central chamber of the
cairns, or are channeled through the precise arrangements of stones, in honor
of the mighty force of light and life.

The four great Celtic festivals, *Samhain, Imbolc, Beltain* and *Lughnasdh*, were
markers of the solar year, with fires lit at Beltain, *Bright Fire*, to mark the return
of the sun and encourage the fertile warming force. In this design, the twelve
fiery rays of the sun represent the modern zodiac. The circle with a center is
still used today in astronomical calendars as the sign for the sun. The double
spiral and rhomboid patterns are ancient dynamic sun symbols, representing
seasonal growth and then the waning of the sun's power. The chain of joined
rhomboids is the symbolic image of the ongoing chain of sun years.

Illustration facing page: *Lugh—Shining One*

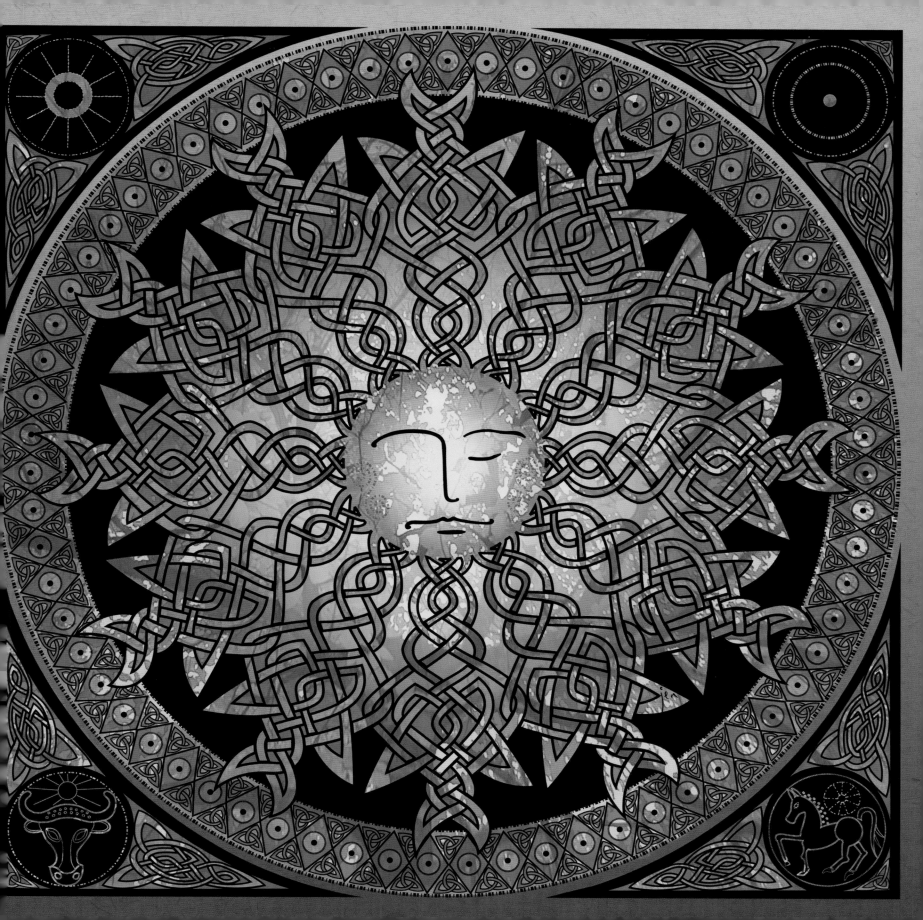

unfortunate prisoners—this was observed by Greek writers to be an infrequent practice done only as a last resort, such as after years of bad harvests or in other dire circumstances when serious measures needed to be taken.

However, for some tribes who practiced cremation rather than interring their dead, it has been recorded that faithful slaves, servants or wives would sometimes be sent to the funeral pyre along with their masters to join them in the Otherworld. A wife whose husband died from suspicious means was also offered up to the flames sometimes to bring justice to the family. These seemingly barbaric rituals are intended to restore balance, not as cruel punishment or spectacle, and are similar to the ancient practice of suttee in India, where to this day (even though the practice is outlawed) faithful wives may throw themselves upon the fires to prove their love and grief and follow their husbands into the next world.

**B**urning Man is the contemporary fire festival gathering in the desert of Nevada. This truly twenty-first-century phenomenon, although not self-identified as a Celtic-culture gathering of artists and adventurers, was first inspired by the ancient rituals.

The fertile seed—brought to dynamic life by fire—that has grown into this complex event was born out of the creative impulse of artist Larry Harvey. He was inspired to initiate a mythic act: to burn a wicker effigy in a traditional and yet intuitive ritual of regeneration.

Begun in 1986 in San Francisco when a wooden figure was burned upon the beach in honor of the Summer Solstice (to the considerable excitement of spectators), Burning Man festival developed into a large-scale, uniquely creative gathering and self-reliant artist community that resonates with our most ancient impulses to engage with fire, nature and art on a mythic level.

This futuristic-style festival celebrates art and

transformation with an intense exploration of fire as creative ritual. While not a religious festival, it is profoundly spiritual at its core, a celebration of the elements acted out with powerful drama through massive fire sculptures, fire dances and fire-breathing vehicles (funky, iron-clad Dragons!). The peak ritual, the burning of the massive man-sculpture, invokes the ancient transformative nature of fire.

Burning Man festival is an unforgettable experience for the many who brave the challenging elements of sun, wind and ancient lake-bed dust storms to participate in one of the most creative large-scale gatherings in the world.

This is at the heart a powerful expression of the Celtic Folk-Soul, though in a landscape far distant from the mountains and hills that held the first ritual Tain Fires!

**The Fire in the Head** is found in a line from the ancient poem "The Song of Amergin" from *The Book of Invasions,* 1500 BC. Shaman-poet Amergin says, *"I created the Fire in the Head."* The fire in the head represents a bardic flash of illumination, of ideas and inspiration that are both intellectual and spiritual. As poet Amergin brings the fire of inspiration into form, and as shaman he brings fire as a spiritual force to illuminate the mind, the psyche.

The human head was a potent symbol for the Celts. In Welsh and Irish mythology the heads of heroes possess magical properties, even after death. The head with the sun bursting through the crown represents Awen—spiritual and creative illumination flowing upward to the heavens through the mystical power circle of the torc, the Celtic ring worn at the throat.

**F**ire is the mysterious flaming light of inspiration that cracks open to new life the seeds cast upon its fertile ground—seeds of creativity to be awakened within the womb of the Celtic Folk-Soul.

Illustration: *Cross of Life*

## Beannachadh Smalaidh

Smalaidh mis an tula
Mar a smaladh Muire;
Comraig Bhride 's Mhuire,
Air an tula 's air an lar,
'S air an fhardaich uile.

## Smooring Blessing

I will smoor the hearth
As Mary would smoor;
The encompassment of Bride
and of Mary,
On the fire and on the floor,
And on the household all.

# CARMINA GADELICA
## Smooring the fire

Peat is the fuel of the Highlands and islands. Where wood is not obtainable the fire is kept in during the night. The process by which this is accomplished is called in Gaelic smaladh; in Scottish, smooring; and in English, smothering, or more correctly, subduing. The ceremony of smooring the fire is artistic and symbolic, and is performed with loving care. The embers are evenly spread on the hearth—which is generally in the middle of the floor—and formed into a circle. This circle is then divided into three equal sections, a small boss being left in the middle. A peat is laid between each section, each peat touching the boss, which forms a common centre. The first peat is laid down in name of the God of Life, the second in name of the God of Peace, the third in name of the God of Grace. The circle is then covered over with ashes sufficient to subdue but not to extinguish the fire, in name of the Three of Light. The heap slightly raised in the centre is called "Tula nan Tri," the Hearth of the Three. When the smooring operation is complete the woman closes her eyes, stretches her hand, and softly intones one of the many formulae current for these occasions.

—Alexander Carmichael, *Carmina Gadelica—Ortha nan Gaidheal*, nineteenth-century collection of folklore recorded during visits to the Highlands of Scotland

When
The wren
Bone writhes down
And the first dawn
Furied by his stream
Swarms on the kingdom come
Of the dazzler of heaven
And the splashed mothering maiden
Who bore him with a bonfire in
His mouth and rocked him like a storm
I shall run lost in sudden
Terror and shining from
The once hooded room
Crying in vain
In the caldron
Of his
Kiss

—Dylan Thomas, "Vision and Prayer"

Illustration facing page: *Fire in the Head*

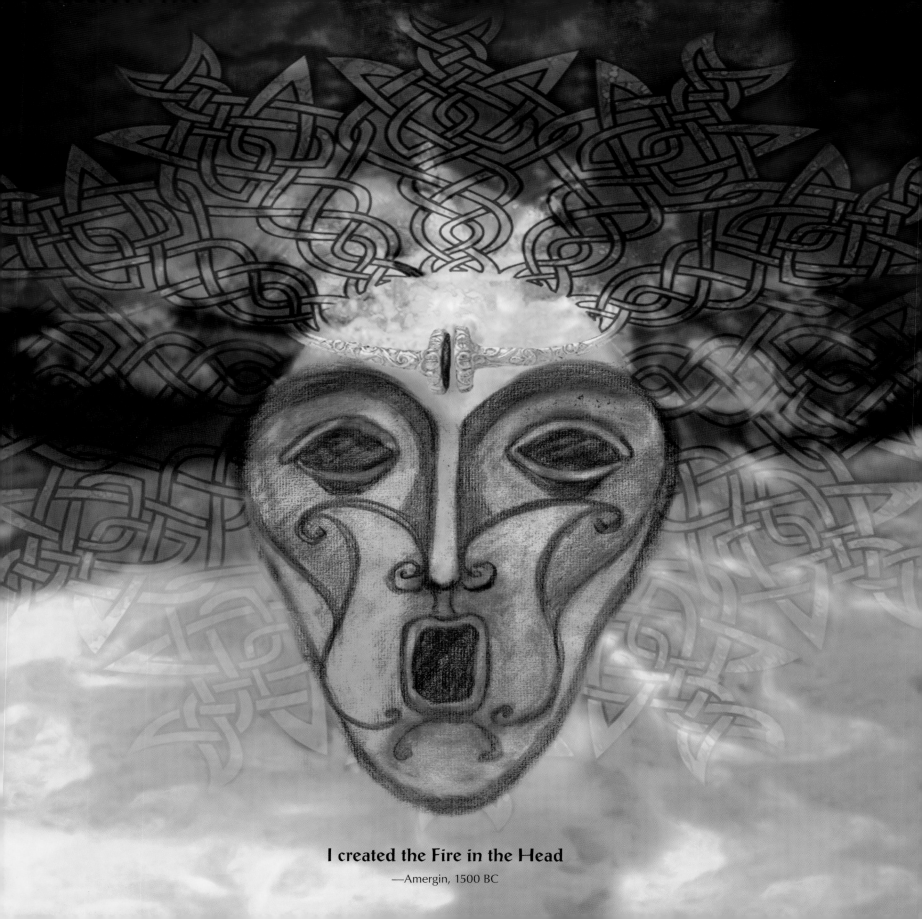

I created the Fire in the Head
—Amergin, 1500 BC

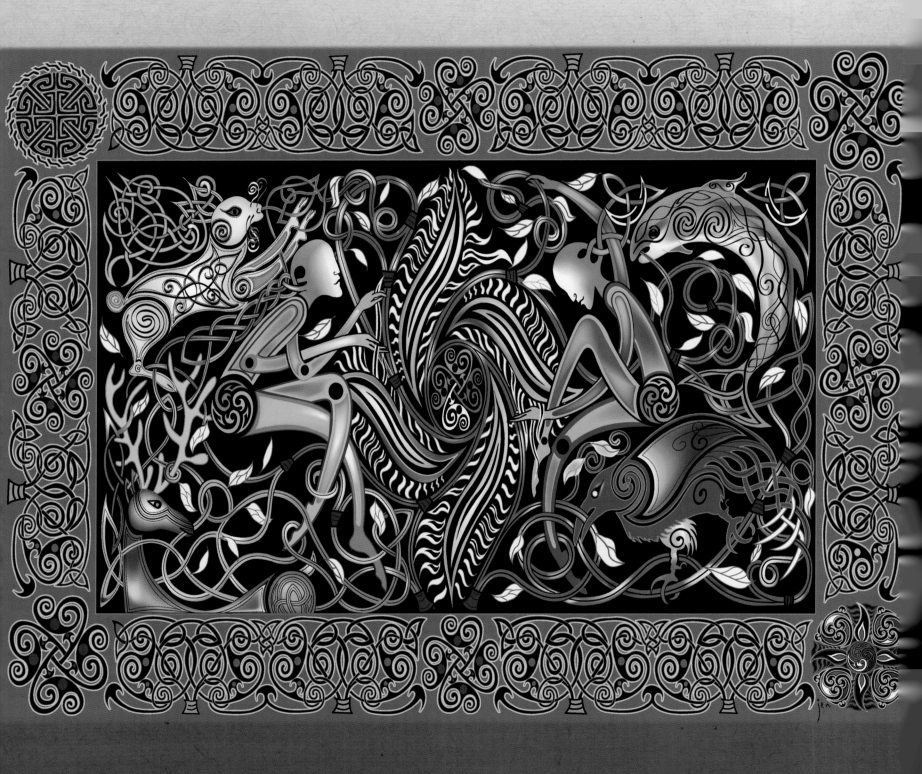

# TALE OF TALIESIN

**T**aliesin is the great Welsh bard, and a well-known mythic figure. His name means *Radiant Brow* and *Inspired One*. As Shaman he is awakened by a hot liquid drop of knowledge—the Awen—which he tastes from the Cauldron of Regeneration by accident.

Reborn as a seed of wheat in Ceridwen's womb, he is cast out upon the waters (representing spirit) to be discovered with the sacred Salmon of Wisdom, and is transformed into the great poet and prophet, a bard of the highest order in Celtic society.

In the Welsh myth, Ceridwen the ancient crone, or goddess of dark prophetic powers, is a powerful mother goddess. Her totem animal is the Sow. Her son Afagddu—also known as Morfan—was ignorant and ugly, so she created a potion of inspiration and divine knowledge in a large cauldron to empower him.

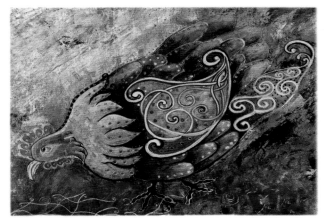

The cauldron is filled with all that is dead and all that is alive, and Ceridwen searches high and low for all the plants she needs. The magical brew was to be stirred for a year and a day. Only the first three drops of the elixir would contain the potion's wisdom; the rest would poison whoever dared taste it.

Little Gwion Bach, the child of a servant, is given the job of guarding the cauldron and stirring it three times between sunrise and sunset for a year and a day. A blind man named Morda—who possesses the inner vision, the wisdom of the flame—tends the fire beneath the large pot.

On the very last day, as Gwion is dreaming of escaping the drudgery of his long task, three drops fall out scalding hot onto his finger and—ouch! Gwion instinctively cools his finger in his mouth. And so it is by accident that he receives the magical properties of the potion.

Suddenly, a strange sensation moves through the young boy's body and into his mind—like a clear river, like a brilliant star beam, a field of flowers, a deep ocean of secrets. In an instant he is filled with all the knowledge of life, and beyond life, and becomes wiser than his years.

Ceridwen senses the magic taking hold of the boy and screams in rage: the spell was meant for her own son Afagddu! Gwion knows immediately that she is angry and runs away, and Ceridwen pursues him through a cycle of changing shapes (which correspond both to totem animals and to the turning of the seasons—as well as to the elements of creation).

Gwion with his newfound shaman knowledge changes into a hare, and Ceridwen chases him in the form of a greyhound. Gwion then changes into a salmon, she into an otter. He becomes a crow; and she is transformed into a hawk, giving him no rest in the sky. Just as she is about to stoop upon him, he sees a heap of winnowed wheat on the floor of a barn, and changing into a single grain, hides himself in the pile.

Illustration above: *Ceridwen—Great Green Hen*
Facing page: *Taliesin—Transformation*

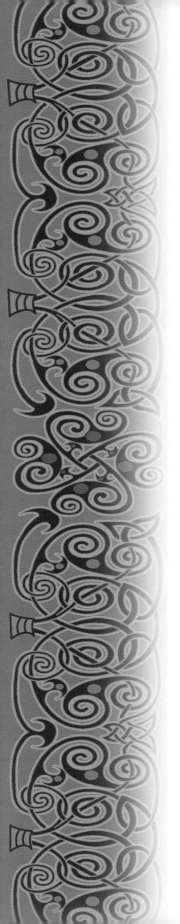

Now Ceridwen chuckles, knowing that she has him trapped. Changing into a high-crested black hen, she eats the pile of grains.

Now Gwion grows inside Ceridwen, transformed into a new life within her. For nine months he develops, learning the Mystery of the beginnings of life in the waters of the womb. Ceridwen is unforgiving and waits until the birthing time—and then he is born. She is the ancient Sow Goddess, who will eat her weak young to protect the strong ones; but once he is lying in her arms he is so beautiful that she cannot kill him as she had intended.

She gazes into the eyes of the strange child that is hers and yet not hers, and his look of deep wisdom and light penetrates her cold heart. So she wraps him in a bag and casts him out to sea, handing over his fate to the elements.

The bag floats for seven days and seven nights, and the waves bring Gwion in to shore. He is guided by the sacred Salmon of Wisdom into a salmon weir that is being fished by the young Elphin, a local prince who has been sent on a quest to catch one of the ancient fish.

Elphin pulls in his nets, hoping for a prize to take home to impress his father the chieftan, but instead of the great salmon he had hoped for, all he finds is an old sack. Disappointed, and worried that his day is not going so well, he opens the bag—and there to his surprise is a tiny boy, looking up at him as though seeing into his soul. The strangely beautiful child begins to speak with musical words of poetic prophecy, describing all that is worrying Elphin, and all that will happen when he returns home later with his mysterious catch. "Do not be troubled," the child says, "for your father will know that you have found something of great value—more than the fish he had hoped for."

As Elphin looks down at the boy, he sees a shining light emanating from his forehead and says, "Behold—a radiant brow!" And so Taliesin is named.

Elphin takes Taliesin home to his father, who at first is not very pleased to see a baby rather than the great salmon he had hoped for—but then Taliesin begins to speak with delicate beauty and profundity, and all are amazed. The chieftan decides to bring him up as his foster son—as was the Celtic tradition—and Taliesin grows to become a great magician, poet and prophet.

In the sixth century a renowned poet named Taliesin (circa 534 to 599) was associated with the mythical bard. He is the earliest poet of the Welsh language whose work has survived, including *Llyfr Taliesin—The Book of Taliesin*—a collection of sixth-century poetry written down in the Middle Ages. Taliesin Pen Beirdd, *Chief Bard,* was court bard to three kings and honored as the Chief Bard of Britain. In the sixteenth century, the mystical poetry of *Hanes Taliesin—the History of Taliesin*—was attributed to Taliesin, but probably written much later. The story of the initiation of Taliesin is authentic in the sense that it draws from a deep tradition saturated in ancient myth and enigmatic Celtic material.

This mystical story is repeated often throughout the Celtic tales in different guises, among them the Irish tale of Finn mac Cool, *Fionn mac Cumhail,* and the Salmon of Wisdom, representing bardic initiation into the Mysteries. The story of the mythical Taliesin, *Radiant Brow,* symbolizes the esoteric arts of poetry: to stir the cauldron of knowledge, to transform and move through the elemental forces, and finally to channel the gift of the arts into the world through rebirth in the waters of spirit. The Poet weaves wisdom and knowledge kindled by the flame of inspiration, which is manifest into the world through a fertile intellect and insight.

Illustration: *Emergence*

I was nine months almost
In the belly of the hag Ceridwen;
I was at first little Gwion,
At length I am Taliesin.
I was with my Lord
In the highest sphere,
When Lucifer fell into the depths of Hell.
I carried the banner
Before Alexander.
I know the names of the stars
From the North to the South
I was in the Firmament
With Mary Magdalene
I obtained my inspiration
From the cauldron of Ceridwen.

I was Bard of the harp
To Deon of Llychlyn;
I have suffered hunger
With the son of the Virgin.
I have been instructed
In the whole system of the universe;
I shall be till the day of judgement
On the face of the earth.
I have been in an uneasy chair
Above Caer Sidi,
And the whirling round without motion
Between the elements.
Is it not the wonder of the world
That cannot be discovered?

—Attributed to Taliesin.
From *Hanes Taliesin, History of Taliesin,* sixteenth century.
Translated by D. W. Nash.

# DRUID'S EGG

The World Egg contains the seed of life. Within the egg the golden yolk has
the properties of a Yellow Fire that feeds the fertilized seed. The thin eggshell
contains the life within—a fragile membrane—yet the oval-shaped egg has great
strength and is one of nature's most powerful Mysteries. Many world mythologies
speak of a cosmic egg—symbol of the primeval universe—and of the great
Mother who created it. Orphics said that Mother Night, the Great Goddess of
Darkness, first birthed the World Egg, which was identified with the moon.

The Druid's Egg, Serpent's Egg or Snake Stone was an object with powerful mystical
properties. On Saint John's Eve it was said that the snakes twisted and writhed in
a tangled knot, creating the glain. The egg emerging from the ball of vipers floated
mysteriously upward into the air, to be caught by the priests while it was in the act of
falling. It was said that the Druid who found himself the fortunate possessor of this
invaluable treasure would quickly escape by leaping upon a horse, not stopping until he
reached the other side of the first running water. The stream would stop his pursuers,
who could follow him no farther. Immense magical power and wisdom were believed
to be gained by the possessor of the Druid's Egg, although few have ever seen one.

Illustration facing page: *Druid's Egg*

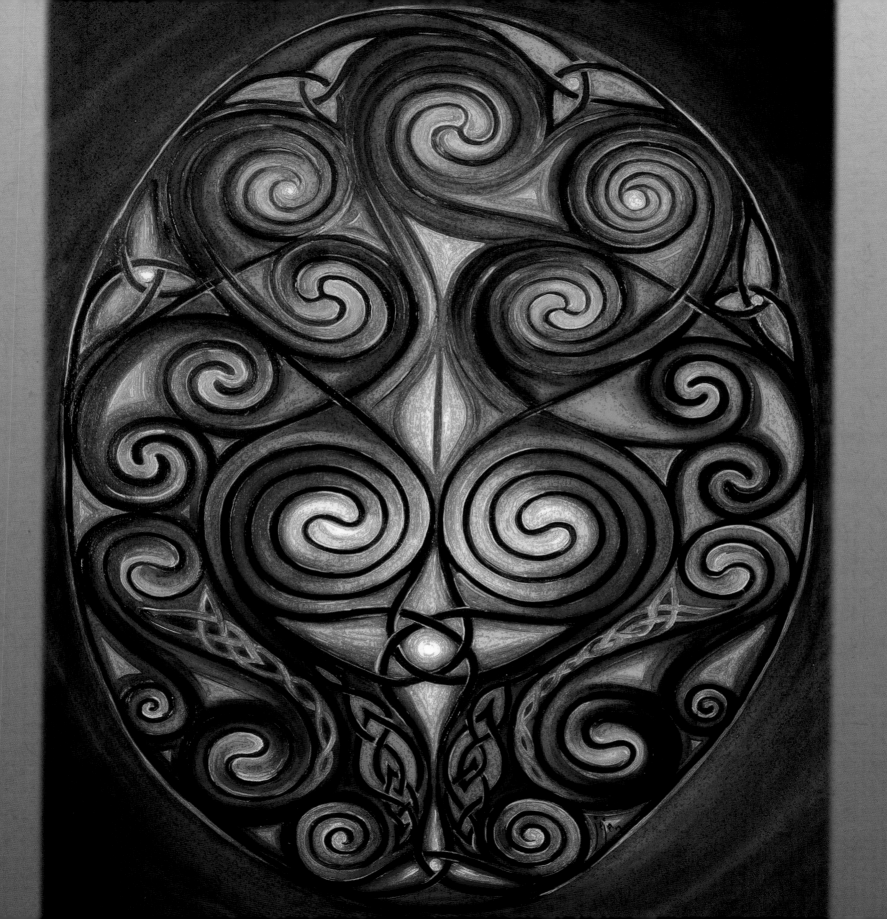

 WILDE
nature

I have been a blue salmon,
I have been a dog, a stag,
A roebuck on the mountain.
A stock, a spade, an axe in the hand.
A stallion, a bull, a buck,
A grain which grew on the hill.

—Taliesin, "Cad Goddeu," sixth century,
translated by John and Caitlín Matthews

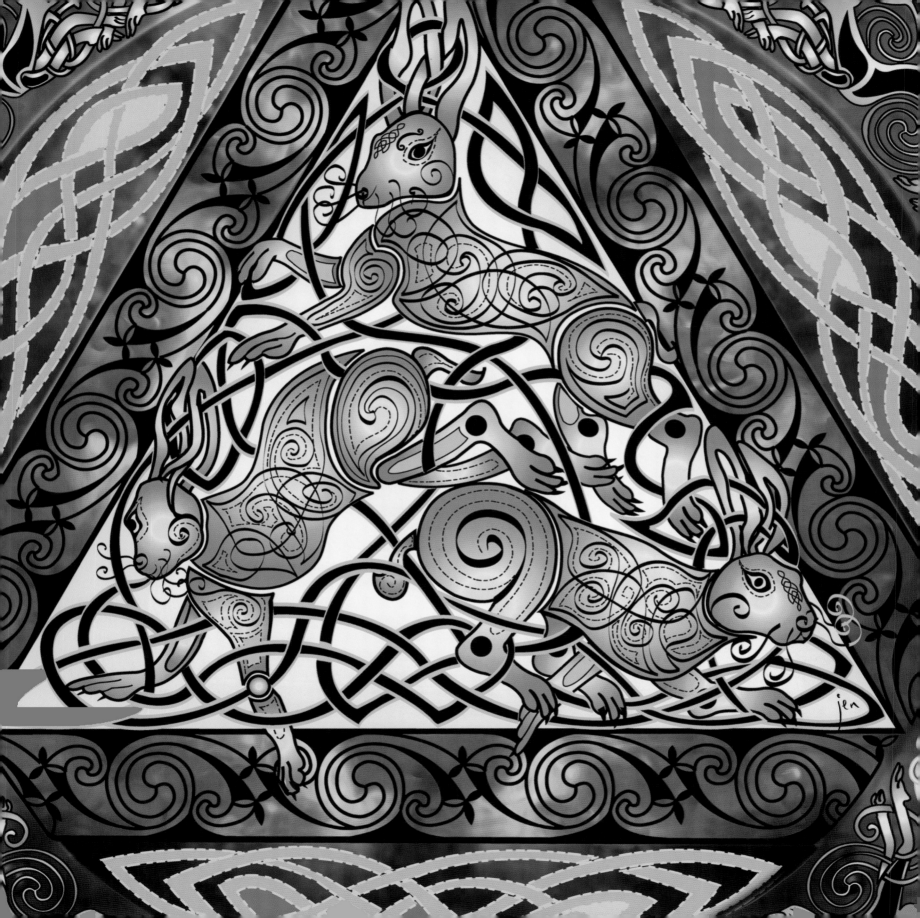

# WILDE
## nature

**T**he Wild Places—the dark untamed forests of wolf and wild boar, the great mountains of ancient eagle and bear, and the unfathomable deep lakes and oceans—were a primal landscape for pre-industrial man.

In an animist universe each rock, spring, plant, animal and star has its own powerful rhythm and symbolic resonance. Man is not separated from the creatures and landscape.

All living forms interconnect, indeed are created from a common source of energy and matter—this is a profound philosophy that was deeply understood by the ancient Druids. Through the Wild Places, the Celtic Folk-Soul draws her inspiration.

**The early folk** recognized the essential vitality of nature in their everyday lives and rituals. They were close to the natural world, utterly dependent upon the balance and fertility of the seasons, upon the crops and animals for food and comfort.

A source of inspiration and spiritual wisdom, nature is often dark and menacing, but always full of beauty and vibrant life. Celebrated through art, mythology and poetry, a deep love and respect for the Wild touches every aspect of Celtic culture.

**The Celtic Poets** describe the interconnectedness of nature and the mythic world of belief through personifications that are rooted in a deep, esoteric wisdom tradition. "The Song of Amergin" is one of the oldest, attributed to the ancient Irish poet Amergin when he first set foot on Ireland. Some say it is an incantation, others a prayer. It is the only surviving poem in colloquial Irish from the Old Goedelic.

This personal identification with animal, hill or *a wave from the sea* is common among the Celtic poets, and it is this flux between states, the merging of boundaries and forms as revealed through art, poetry and mythology, that is so essential to the character of the Folk-Soul.

The Poets are highly revered for their insight into the mystical aspects of nature, and are often associated with mythic shaman characters themselves, such as Taliesin and Amergin.

## The Song of Amergin

I am a stag of seven tines,
I am a wide flood, a wind on the deep waters,
I am a shining tear of the sun,
I am a hawk on a cliff.
I am fair amongst flowers,
I created the fire in the head,
I am a battle waging spear,
I am a salmon in a pool,
I am a hill of poetry,
I am a ruthless boar,
I am a threatening noise from the sea,
I am a wave from the sea,
Who but I knows the secret of the unhewn dolmen.

—Attributed to the ancient Irish poet Amergin. From *The Book of Invasions,* a medieval manuscript, 1500 BC. Rearrangement of translation by Robert Graves.

Robert Graves's translation of "The Song of Amergin" arranges the lines in a form that reveals a deep esoteric and mythic meaning: the transformative relationship between Poet and the power and strength of the natural world is both profound and beautiful.

**Taliesin and Ceridwen** enact a shamanic chase through many forms in the archetypal Welsh myth. Poet Taliesin, whose name means *Shining Brow*, shape-changes into a hare, a salmon, a crow and then a grain of wheat. The ancient Goddess Ceridwen pursues him as a greyhound, an otter, an eagle and then a hen. Ceridwen eats the pile of wheat and Taliesin grows within her womb to be ritually reborn as a bardic magician.

**In the Welsh** *Mabinogi* stories, written down in medieval times from a more ancient oral tradition, Lleu transforms into an eagle, and Blodeuwedd, who is magically created from flowers, is changed into an owl.

The powerful dark Morrigan is a Triple Goddess who shape-shifts into the Ravens of war, death and rebirth upon the battlefields, and the Children of Lir become swans, ever haunting the waters and skies with their plaintive calls.

Celtic deities are often associated with particular animals or with elements in nature such as mountains and rivers, sacred vital places of the land. This is an ancient Mystery tradition that has its roots in the beliefs of those who came before the Celts. Traditions merged, and respect for the ancient, numinous spirits of the land continued through the rituals of the tribes.

**Animals** are revered for their strength, intelligence, fertility and patience, for their distinctive abilities and personalities, their associations with their habitats and the seasons. Except in the mythic sense, animals are not worshipped as deities in themselves; instead, it is their qualities that are honored and seen as magical. There is no real separation between animal and human existence, and in mythology and folklore, shape-shifting between mortal and animal form is an everyday magical occurrence.

**From the earliest carvings** upon rocks and stones to the richly decorated manuscripts of the Christian Gospels, vibrant expressions of animals—hounds, birds, stags, boars, lions and fantasy beasts—tell colorful tales of magical creatures living in the forests and lakes, and within the wild universe of our fertile psyches.

Illustration: *Triple Morrigan—Ravens*

# HOUNDS OF ANNWN

Cwn Annwn—*the Hounds of Annwn*—are a pack of red-eared, snow-white spectral hounds from the Celtic Otherworld. Appearing in the medieval tale the *Mabinogi*, Pwyll, Lord of Dyfed, meets Arawn, Lord of Annwn—the Otherworld—with his fierce totem dogs, while both are out hunting. In Welsh folklore, Arawn rides with his pack of hounds through the skies in Autumn, Winter and early Spring. The Hounds of Annwn haunt the fringes of this world as the Wild Hunt, and are feared to be the Hell Hounds whose baying—like the wild geese—is heard on the howling winds.

Dogs have lived among people since the earliest times, and are protectors and companions within our communities. The Celts were well known for breeding exceptional hunting dogs of intelligence and skill, and their hounds were a favorite trade with the Romans, who valued them greatly.

# BEDDGELERT

Beddgelert is the Welsh legend of the faithful hound of Llewellyn, Prince of Wales. The trusted greyhound Gelert was left to guard the master's infant son, as he had done many times before. During the night, a hungry wolf stealthily crept into the chamber. He was about to attack the baby in his cradle when the loyal hound Beddgelert leapt upon the huge, mangy creature, and there was a savage struggle of sinew and muscle, fur and fang. In the fierce fight, the cradle was overturned and the infant fell underneath, safe but hidden from sight.

The prince arrived home, and seeing the empty cradle and carnage all around, he cried out in anguish! The wounded Gelert was covered in blood—exhausted, he lay at the foot of the cradle. Full of grief and anger, Llewellyn stabbed his loyal hound, sure that he had killed his son. Too late! He heard the plaintive cry, and found his baby safe beneath the cradle, near the lifeless body of the wolf. Llewellyn mourned his beloved dog, and never forgot the bravery and sacrifice of his most loyal companion. He honored Gelert with a tomb near the village of Beddgelert, *Gelert's Grave*, in Gwynedd, Snowdonia, which is still visited by appreciators of tragic stories, and canine lovers, today.

Illustration facing page: *Hounds of Annwn*

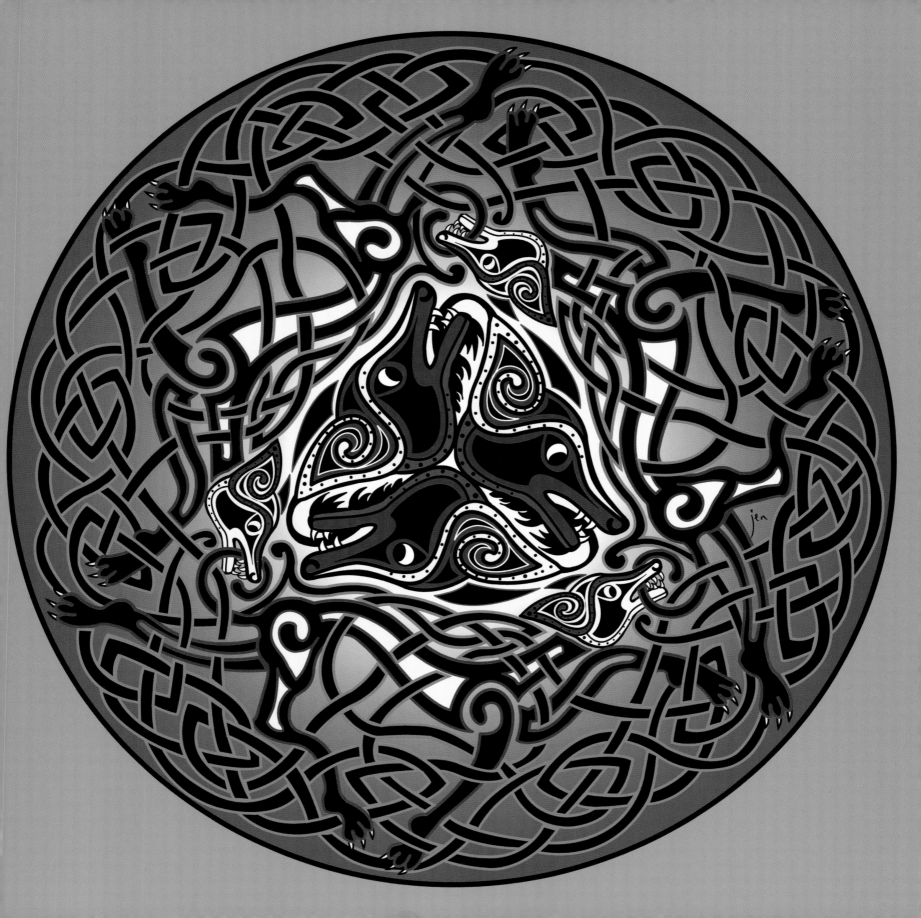

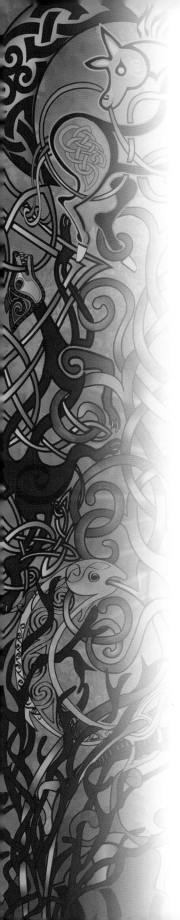

## ANIMAL TOTEMS

Totem Animals are connected with each divine or mythic character, including the Faerie creatures of folklore, and the numen—presiding spirit of the land. Shamans believe that animals are messengers of spirit and are to be respected for their elemental gifts of nature—their intrinsic power and intelligence, their innate wisdom.

## FEMALE TOTEMS

Female Animal Archetypes are the Raven, the Sow, the Mare and the Hare. All inspired enormous respect among the Celts as they had for the people who came before them. These are the creatures of the powerful Mother Goddess of Life and Death.

Ravens are totem birds of the dark Celtic goddesses—the Badbh and the Morrigan—who possess the ability to appear as one or three beings and to shape-shift into Raven form. Appearing throughout Celtic mythology, they are often featured in the Welsh stories of the *Mabinogi*.

The Druids predicted the future by studying the flight of birds, and Ravens are birds of omen. They are believed to possess oracular powers, and the distinctive harsh voice of the Raven prophesied the outcomes of battles. Carrion birds, they are associated with death. Celtic coins depict the Raven or Crow perched on the back of a horse symbolizing the war-goddess Badbh Catha, who could change shape from woman to death-crow in battle.

As death is closely intertwined with life, the bright-eyed Raven is also gifted with clear vision and is wise in the mysteries of rebirth and healing.

The Horse was of tremendous importance to the early nomadic Celts, a major symbol of energy, power and fertility. Representing the sovereignty of the land, the Horse was associated with royalty and kingship.

Epona, *Divine Horse*, is the White Mare Horse Goddess, also known as the more ancient horse goddesses Rhiannon in Wales and Macha and Etain in Ireland.

There are ancient large-scale carvings of the Horse upon hillsides, such as the famous 370-foot-long White Horse carved into the chalk at Uffington (in Berkshire). These carvings need continual tending to be seen: weeds and topsoil have no doubt hidden many others over the centuries. Thought to date back as far as 1000 BC in the late Bronze Age, these carvings continued to be honored by the Celts—such as the tribe of the Belgae at Uffington—as intrinsic symbols of the sovereignty of the land.

Irish kings in the eleventh century were still symbolically united with the White Mare. She represents the land of Ireland, whose fertility is assured by her union with the mortal king. Another relic of pre-Christian horse worship is the Morris Dancer's traditional horse-headed stick, or *hobby horse*, and the Welsh Mari Llwyd—*the Grey Mare* ritual, an active tradition into the 1900s that continues in parts of Wales today. A horse's skull dressed in white is carried from door to door, and a battle of wits and rhyming between the Mari Llwyd group and the villagers decides who will gain entrance to the home that loses the challenge, and be rewarded with ale and food.

**The Hare** is considered sacred in many ancient traditions, representing fertility and rebirth, associated with the moon and the festivals of Spring. The Hare was totem to the moon goddess Andraste, to Ceridwen and to the Earth Mother—since the Hare burrows into the ground. Renowned for her astounding fertility, the Hare is hunted by nearly every predator including man, yet continues to survive and prosper. Boudicca, warrior queen of the Iceni, was known to release a hare from within her cloak before battle as a good omen.

**The Sow**—Ceridwen, known in the Welsh tradition as the Great Sow Goddess Hen Wen, is the Old White One, the White Sow who went about Wales with gifts of grain, bees and her own young. She is the ancient fertility goddess whose tusks are crescent-shaped like the moon. A carrion eater, she holds the wisdom of life and death. She births many offspring and is their fierce protector. Ceridwen was the goddess of poetic inspiration and the mother of Taliesin, the legendary bard. Her name may derive from *cerdd*—song or poetry—and *gwen,* white.

## MALE TOTEMS

**M**ale Animal Archetypes have ancient associations with hunting. The male aspects of nature are represented by the Stag, the Dog, the Boar and the Bull.

**The Boar** represents war and hunting, hospitality and feasting, valor and strength. The Celtic boar is a creature of war and his image appears everywhere on Celtic shields, helmets, drinking vessels and warrior iconography.

Welsh mythology features a boar-deity called Twrch Trwyth. He was once a human king who was enchanted into boar shape by means of a curse. Twrch is ferocious and dangerous, and in the *Mabinogi* stories is unsuccessfully hunted by Culhwch, Menw and Arthur. When Menw tries to steal treasures from between the ears of Twrch Trwyth, he is only able to take a single bristle. Great importance is attached to the bristles of the boar, perhaps symbolizing their strength. Supernatural boars lead hunters to the Otherworld. In the line from Aneirin's poem—*I am a ruthless boar*—we feel the strength and fertility of the Poet.

**Dogs** have been our loyal, intelligent companions since Paleolithic times. Helping with the hunt, sharing hearth and home, they are also our spiritual guardians.

Many mythical heroes have canine names, including Cúchulainn, *Hound of Culann*, who killed the great savage guard dog of Culann the Smith, and as a penance took the dog's place and also his name. In mythology, such as the medieval Welsh tales, the *Maginogi*, they run with Gwyn ap Nudd, another lord of the Otherworld, and also appear in stories with Brân and Arthur.

They accompany Herne the Hunter across the wild, stormy skies on wind-loud nights to chase the dead. Known as the Cwn Annwn, *the Dogs of the Sky*, in Wales they are known as Cwn Mamau, *Hounds of the Mothers*. They were associated with migrating geese, whose strange calls sounded like the Cwn Annwn of the night, and it was thought that their howl foretold death.

In Celtic mythology dogs often appear as shaman shape-shifters and as messengers between the worlds.

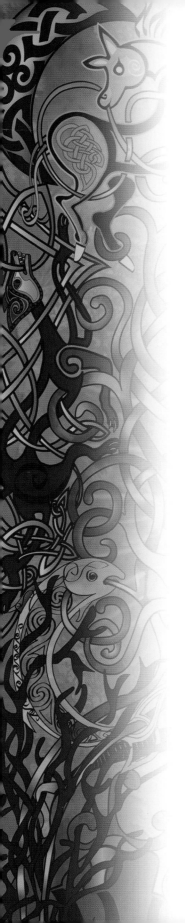

Cormac's glossary—a tenth-century encyclopedia of Irish oral tradition by Cormac mac Cuilennan, the scholarly king, priest and warrior—says: "*The fili, seer, must chew the flesh of a dog (red pig or cat) in order that his gods would show him the things which he desired they should reveal.*" Generally, though, there is a geas, *taboo,* among the Celts against eating the flesh of the dog.

**The Stag** is one of the earliest animal gods, appearing in the Paleolithic cave paintings and petroglyph rock carvings. He is the Horned God, Herne the Hunter, or Cernunnos, Lord of the Animals. The Stag represents majesty, confidence and mystical strength. In Aneirin's poem, the line *I am a stag of seven tines* represents his status and ancient power—seven points on each horn indicate a royal stag. The hunter is personified in the noble Stag, who is both his prey and the lithe Hunter Lord of the woods and forests.

**The Bull** is Hu the Mighty, a Welsh god possessing qualities of valor, strength and power. As a masculine symbol, the Bull embodies tenaciousness and vital fertility. His blood is imbued with life-renewing powers, and he is often represented as a solar deity, associated with symbols of the sun and appearing on the gold coins of the Celts. In Welsh mythology three sacred oxen pull the solar wagon.

## CREATURES OF THE AIR

**B**irds are archetypes that represent spiritual and poetic wisdom. Potent symbols, they include Cranes and Herons, Geese and Swans, the Owl, the Eagle and the humble but royal Wren.

Within the Celtic tradition birds possess supernatural powers, and divine entities frequently shape-shift between human and bird form. Birds are a powerful force that often symbolize the flight of spirits to the Otherworld—they are the carriers of souls between the worlds. Their mystical flight between earth and sky is a natural symbol of communion with spirit. Birds evoke ideas of freedom, of the human soul liberated from the body at death.

The Birds of Rhiannon are magical birds *whose songs awaken the dead and lull the living to sleep,* healing the sick and wounded with their magical songs.

**Cranes** are long-legged wading birds, usually associated with willow trees and water, mysterious as the fringed marshes along which they dwell. There are many stories in Celtic mythology of beautiful young women enchanted into Crane form by jealous rivals, and of ill-natured women transformed into the large bird with the bony toes and uncanny shriek.

**The Swan and the Goose** are important birds for the Celts. Swans appear throughout mythology—as the Children of Lir, as mysterious supernatural creatures. They are depicted by the Celtic metal-smiths with golden chains around their necks, possibly linking them with solar symbolism and with the God of Communication, Oghma, who is also imaged with chains connecting him to his people, representing language and eloquence.

The Goose is an important creature as a source of food and as a symbol of loyalty, migrating and

returning each year in great flocks with their distinctive raucous call.

## RIVERS, LAKES AND SPRINGS

Water and its subterranean entrances are the otherworldly nodes of the Folk-Soul. Rivers are alive and flowing through the land, and wells and springs are deep, mysterious connections with the Underworld.

The folk gave offerings to the water deities in gratitude and to pacify the spirits of water passing through their land. Water rises up as natural springs from the belly of the Mother Earth, giving nourishment to the world above and below.

In parched places where rain is essential, rituals to bring water are necessary. To the Celts living in northern Europe, water is plentiful, and it is at the lakes, bogs and deep wells—entrances to the world below—that offerings are given.

Rich finds of votive objects are discovered where water rises from the Underworld, showing the great importance our ancestors gave to these sacred places.

Some rivers or river goddesses in Celtic regions possess pre-Celtic names, revealing that the cult of water worship began with the early folk. The Celts adopted local customs and merged the ancient deities with their own.

The Spirit of the Waters was often represented by sacred fish, sometimes taking the form of a beautiful woman. The Goddess Boann is wife of Nechtan, a god of the water. According to legend, there was a sacred well, *Sidhe Nechtan*, that contained the source of all knowledge. Boann ignored the geas protecting the sacred well, and as her curiosity overcame her, she approached the well, violating its sanctity. The waters rose up and overflowed, transformed into a raging river, and pursuing Boann, became the river Boyne.

## FISH AND REPTILES

Rivers full of Wild Salmon once ran clear to the oceans, waters that were unrestrained and unpolluted. The salmon make profound journeys. From their humble beginnings in freshwater rivers, they journey far to the oceans, adapting to the salty waters and transforming into fish of the sea. The mature salmon then swim upstream—a heroic effort, struggling against the rugged rapids and waterfalls to spawn—and then die in the place of their birth.

The Salmon are the wise, sacred fish of the Celts, associated with the Aois Dana, the Poets of Ireland. Large, powerful and embodying the fertile golden glow of the Sun in their flesh, inspirational in their courage and knowledge, the salmon are honored as sacred symbols of wisdom. The wisest and oldest of all the animals was the salmon of Llyn Llyw. *I am a salmon in a pool*, reads Amergin's poem. In the Welsh myth Taliesin the wise Poet was fished from the salmon weir. In the Irish version, Finn acquires wisdom and the gift of prophecy from the Salmon of Knowledge.

Fish are indeed the oldest of creatures. Life came from the sea, and more species live below the water than upon the land. To swim is to navigate the mysterious depths of the below. Magical

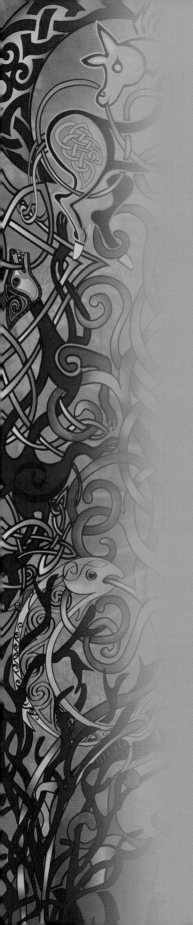

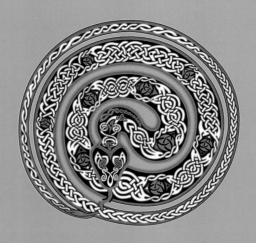

# CARMINA GADELICA

| | |
|---|---|
| Sian a chuir Bride nam buadh, | The charm put by Bride the beneficent, |
| M'a mise, m'a cire, m'a buar, | On her goats, on her sheep, on her kine, |
| M'a capuill, m'a cathmhil, m'a cual, | On her horses, on her chargers, on her herds, |
| Moch is anamach dol dachaidh is uaith. | Early and late going home, and from home. |
| Gan cumail bho chreagan, bho chleitean, | To keep them from rocks and ridges, |
| Bho ladhara's bho adhaircean a cheile, | From the heels and the horns of one another |
| Bho iana na Creige Ruaidh, | From the birds of the Red Rock, |
| Is bho Luath na Feinne. | And from Luath of the Feinne. |
| Bho lannaire liath Creag Duilionn, | From the blue peregrine hawk of Creag Duilion, |
| Bho iolaire riabhach Beinn-Ard, | From the brindled eagle of Ben-Ard, |
| Bho sheobhag luth Torr-an-Duin, | From the swift hawk of Tordun, |
| Is fitheach dur Creag-a-Bhaird. | From the surly raven of Bard's Creag. |
| Bho mhada-ruadh nan cuireid, | From the fox of the wiles, |
| Bho mhada-ulai a Mhaim, | From the wolf of the Mam, |
| Bho thaghan tocaidh na tuide, | From the foul-smelling fumart, |
| 'S bho mhaghan udail a mhais. | And from the restless great-hipped bear. |
| Bho gach ceithir-chasach spuireach, | From every hoofed of four feet, |
| Agus guireach da sgiath. | And from every hatched of two wings. |

—Alexander Carmichael,
*Carmina Gadelica—Ortha nan Gaidheal*

ocean-creatures of Celtic legend, the Selkie Seals swim like fish and also live upon the land. Playful Dolphins possess the secrets of language, breathe the air as we do, and nurse their young with mother's milk beneath the surface of the salty seas. These are the shamans of the water.

**Snakes and Reptiles** navigate into the underground places and bask upon the rocks in the warmth of the sun. This movement between the above and the below gives them special significance.

**Earth Serpent** is a symbol of rebirth, as she sloughs her old skin, renewing and becoming reborn, emerging in the Spring from the Winter's hibernation, seeming to be immortal. Many Celtic healers appear with snakes and serpents, often in association with water, rivers and springs (entrances to the Underworld). They are frequently found on torcs, the sacred neck ornaments of the Celtic kings and divinities, embodying the power of the earth and eternal life. The coiled serpent with its tail in its mouth is a circle of infinity and eternity, representing cyclical evolution and reincarnation.

# TREES AND PLANTS

**F**orests of our world help create the oxygen we breathe. They are vital to our planet's diverse ecosystem. The once-dense forests of Europe have been greatly diminished, along with many of the wild animals that once lived in them. The early folk recognized the living spirit within the trees and plants. They worked closely with their healing properties and honored their often-great age and sheer physical magnificence.

Britain was once covered in extensive oak forest, and the harvesting of wood was essential for shelter and warmth. Later, the great ships and buildings took the oldest and most royal of trees, and fertile farmland replaced the dark forests, green fields brightening the lonely valleys. The landscape changed and much of the power of the Wild was lost to us. However, the potent energy of the great forests and her creatures has infused the myths and legends of those who lived close to its source, and continues to thrive in corners of the land, of our planet, where man has not yet intruded.

## The Celtic Tree of Life.

Trees are a profound symbol of the interconnectedness of all life. The Tree of Life is an esoteric philosophy common to many cultures and mythologies.

The Ancients envisioned the entire cosmos in the form of a tree whose roots grow deep in the ground, branches reaching high into the heavens. Tree worship was at the heart of Celtic spirituality and the Druids are said to have worshipped among the ancient groves. Interestingly, the words for wood and wisdom are similar in Welsh— *gwydd* and *gwyddon*.

Illustration above: *Celtic Tree of Life*
Facing page: *Earth Serpent*

# MACHA

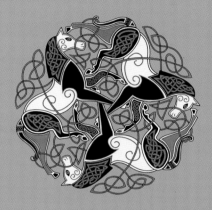

The White Mare Horse Goddess is known as Epona, Rhiannon (Wales) and Macha and Etain (Ireland). Emain Macha, *Macha's Twins*, is a sacred site from Bronze Age times that is named after the horse goddess. In mythology, Macha dies in childbed after she overtakes the swift horses of the kings in a race while pregnant.

The Welsh Rhiannon bears a child who disappears and then is found in a stable where mares have just given birth and their foals have disappeared—implying a mystical exchange or association between them. Rhiannon's husband assumes that she has harmed their son and assigns her the punishment of carrying people upon her back as a horse.

The horse symbolizes the soul's journey to the Otherworld and Underworld—the land of the dead. The ghostly grey cloud horses were the steeds of Odin's "wild hunt," made up of the souls of the dead galloping over treetops.

The Belgae, who worshipped Epona, probably carved the famous White Horse—370 feet long—into the chalk at Uffington (in Berkshire). The fertility cult of the Sacred Mare stretched from Spain to Eastern Europe and Northern Italy to Britain.

Illustration facing page: *Macha—Epona*

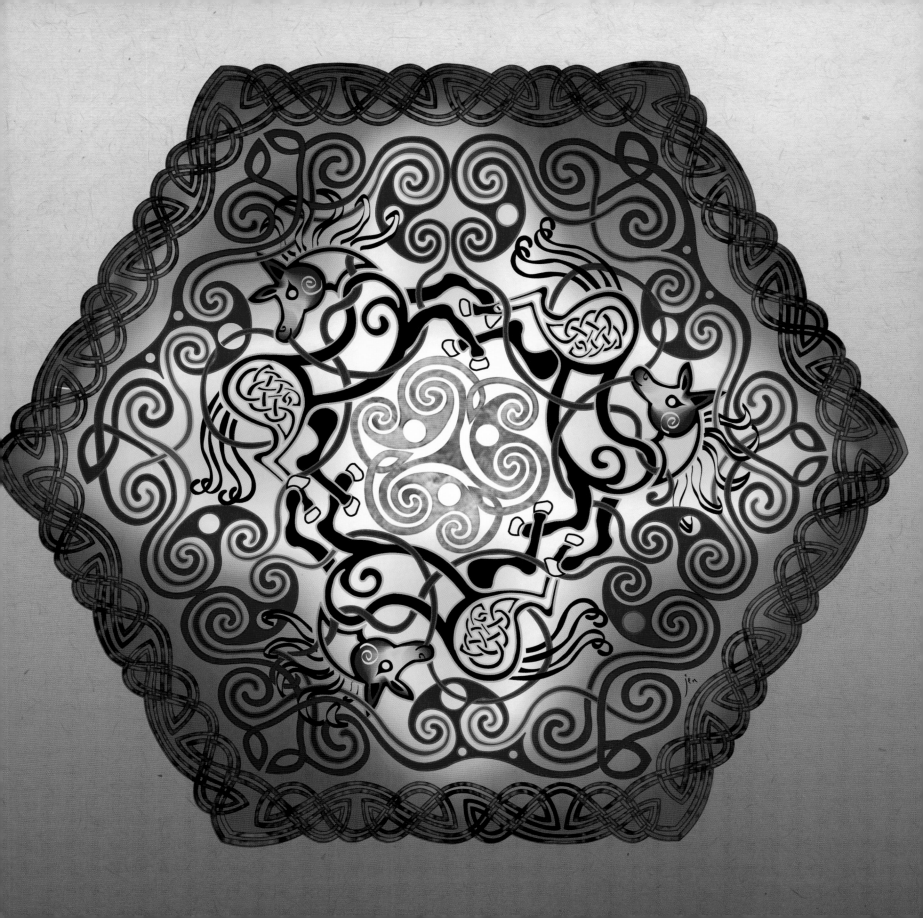

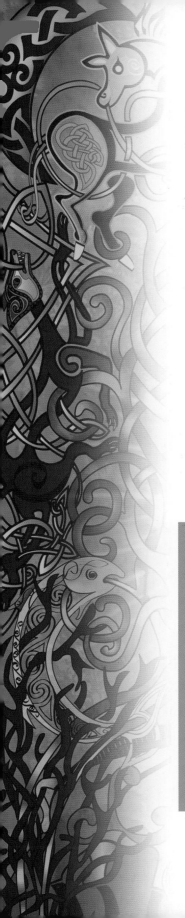

**Flowers and Plants.** The Celtic Druids, priestesses and healer-women encoded their deep knowledge of trees and herbs into an ancient cryptic Tree alphabet—an Ogham cipher: Beth Luis-Nuin. In Celtic ornament, leaves and berries of sacred plants such as mistletoe are woven among the stylistic patterns, contributing the symbolism of their healing or magical properties to the totemic images.

**M**ythic interchange between the inner world of the psyche and the fertile world around us was created by our ancestors. They lived in rhythm with the growth and decay of the earth, the migration of the birds, the potent qualities of the animals—with the green, living force within the forests, rivers and oceans of the wild, living world.

**Nature is our wealth,** our health and our future. Our mission is to continue to respect and nurture her profound beauty and vitality, to protect our inheritance for those yet to come.

Through a language of poetry, symbol and mythology, the knowledge of the power and mystery of the Wilde is the most precious gift of the Celtic Folk-Soul.

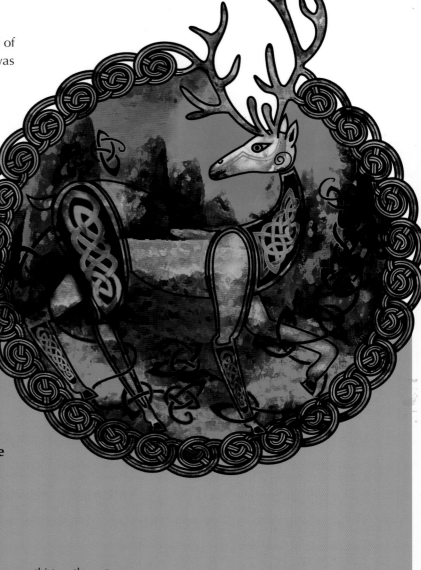

**Three times a hound's age, the age of a horse**
**Three times a horse's age, the age of a man**
**Three times a man's age, the age of a stag**
**Three times a stag's age, the age of a blackbird**
**Three times a blackbird's age, the age of an eagle**
**Three times an eagle's age, the age of a salmon**
**Three times a salmon's age, the age of the yew**
**Three lifetimes of the yew for the world**
**From its beginning to its end.**

—Arrangement of a traditional Irish proverb, *The Book of Lismore,* thirteenth century

Illustration: *Herne the Hunter*

# ARRAN

Arran of the many stags, the sea reaches to its shoulder;
island where companies were fed, ridge where blue spears are reddened.

Wanton deer upon its peaks, mellow blaeberries on its heaths,
cold water in its streams, nuts upon its brown oaks.

Hunting-dogs there, and hounds, blackberries and sloes of
the dark blackthorn, dense thorn-bushes in its woods,
stags astray among its oak-groves.

Gleaning of purple lichen on its rocks, grass without blemish on it slopes,
a sheltering cloak over its crags; gamboling of fawns, trout leaping.

Smooth is its lowland, fat its swine, pleasant its fields, a tale you may believe;
its nuts on the tips of the hazel-wood, sailing of long galleys past it.

It is delightful for them when fine weather comes, trout under the banks
of its rivers, seagulls answer each other round its white cliff;
delightful at all times is Arran.

—Author unknown, Irish, eleventh century,
translated by Professor Kenneth Jackson

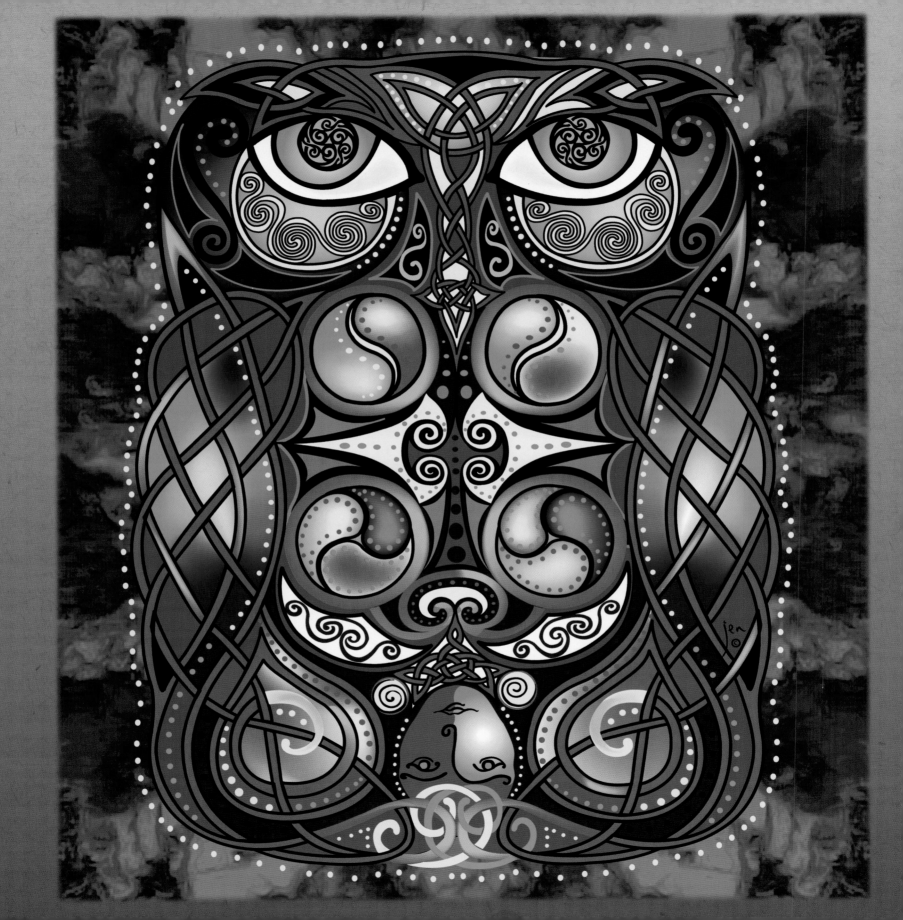

# TALE OF
# BLODEUWEDD the OWL

I n Wales, the Owl is known as Blodeuwedd, which means *flower-face*. The story of how Blodeuwedd became the large-eyed bird of the forested night is a sad and poignant tale from the *Mabinogi* stories.

This is a myth about independence, about the Wild within nature—which ultimately cannot be tamed. It is a dark, twisted tale filled with betrayal. It contains elements of shamanic shape-shifting and a beautiful young maiden who becomes a lusty woman and then transforms into the wise old crone bird, the Owl.

This medieval Welsh story begins with Lleu Llaw Gyffes, who is cursed by his mother, Arianrhod, that he shall have no human wife. He calls upon his uncles, Math fab Mathonwy and Gwydion, who are powerful magicians, to help him. After much deliberation, they decide to conjure a maiden from the flowers of oak, broom and meadowsweet. She is beautiful, fragrant as the wildflowers from which she has been sculpted, and destined to enchant and fulfill the desires of the man she has been created to serve. They name her Blodeuwedd.

Blodeuwedd is everything Lleu could have hoped for in a wife—exquisite in form and lovely in spirit. When he returns home from a long day of hunting stag and wild boar, she gives her husband a warm welcome with a plate of roasted pig meat, a bronzed horn of honeyed mead and her perfumed embrace.

One day, while Lleu is away visiting his uncle Math at Caer Dathyl, Blodeuwedd hears the blast of a hunting horn and glimpses a group of huntsmen and their dogs chasing a stag. She sends a servant lad to find out who

they are, and he returns with the news: *"It is the company of Gronw Bebyr, he who is Lord of Penllyn."* As the day declines and night draws near, Blodeuwedd offers hospitality to the chieftain and his men, who are hungry and in need of shelter.

Gronw Bebyr is a handsome, dark-eyed man who had never seen a more enchanting woman than Blodeuwedd, and she is astonished to feel flutterings in her heart as he gazes into her pale blue flower-eyes. Although Blodeuwedd knows that she has been created for her husband, she has never felt this way before, and they instantly fall in love. The spell of her making is complete when she sees Gronw, and as he caresses her cheek with his lips the flower maiden truly becomes alive.

They spend the night together, and the next, and for a few days they forget all but their joy and affection, and that Lleu Llaw Gyffes will soon be returning to his court and his lovely wife. They realize that if Lleu discovers their secret affair they will be in grave danger, so they determine to find an escape. After much sadness, and some bitterness, they resolve that only with Lleu's death will they ever be free, and they begin to plot together, deciding that Blodeuwedd must try to discover Lleu's secret weakness. Then Gronw leaves her, with reassurance that he will soon return to carry out their plan.

When Lleu arrives back home, Blodeuwedd does not look as happy as when he had left her. "What is wrong, my wife," he asks. "Are you well?" "I am troubled," she replies, her lovely eyes downcast. "I am worried about what will happen if you die before me." Lleu reassures her that he can only be killed under certain conditions,

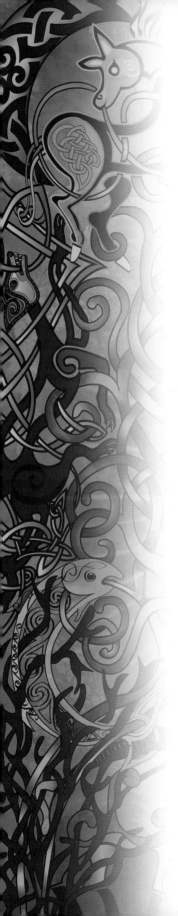

as there is a protective spell upon him. "But dear husband," she pleads in her most beguiling voice, "please explain to me how you could be killed, for my memory is better at being wary than yours." And so Lleu confides in his wife: *"I cannot be slain within a house, nor can I outside of it. I cannot be slain while on horseback, nor can I when afoot. I can only be killed by a blow from a spear that has been forged for one year by people at prayers on Sunday, and with one foot on a bathtub that is by a river, under a thatched roof shelter, and with one foot on the back of a billy-goat!"* (from the *Mabinogi*).

Over the next year, Gronw forges the sword of prayers, and Blodeuwedd continues to pressure Lleu to show her how these strange conditions may be met. She sets up a shelter by the Cynfael River, draws a bath and gathers goats. Then she persuades Lleu to come and show her exactly how it is possible that he can be killed. He climbs on the bathtub and puts one foot on the goat, and then Gronw, who has been hiding on the hill of Bryn Cyfergyr, casts the spear, which strikes Lleu in the side. Lleu gives a terrible scream, changes into an Eagle and flies wounded into the air, the spear embedded deep in his side.

Blodeuwedd and Gronw escape into the wild forests and live happily together—for a while. Although they know that they will likely be hunted for their crime, their love blossoms and Blodeuwedd is thrilled with the sense of empowerment she feels now that she has chosen her own destiny.

Math is filled with grief when he hears about his nephew's betrayal, and very worried about his condition, so he sets out with Gwydion to find the wounded Eagle Lleu. This takes them some time, but after many adventures they follow the ancient Sow, Hen Wen, to the place where an Eagle with a festering wound lives among the branches of an ancient oak tree.

Gwydion sings three englyns (a three-lined Welsh poem), and the Eagle comes down the tree a branch at a time, one for each recital. Then Gwydion strikes him with his magician's rod, and Lleu is changed into his own shape again.

He is mere skin and bone, wretched in appearance, and it takes a year and a day to heal his wounds. When he is fully recovered, Lleu decides it is time to seek justice for the man who has caused him such terrible affliction.

Math, Gwydion and Lleu begin a long journey in search of Blodeuwedd and Gronw, chasing them through forests, over mountains and across rivers, never ceasing until they find them. At last they come upon Blodeuwedd, who does not weep or ask forgiveness. Although she is sorry that Lleu has suffered, she is not ashamed of what she has done, as she was given no choice but to marry the man that she was created for.

Gwydion decides on a fitting punishment for Blodeuwedd's betrayal: *"I will not kill you, but worse. You shall never dare show your face in the light of day, and you shall fear all other birds, whose nature it will be to show hostility to you wherever they find you. You shall not lose your name, but will forever be called Blodeuwedd."* Then he changes her into an Owl and banishes her into the night.

Gronw agrees that Lleu has the right to claim justice for the dishonor done to him, and they return to the river bank where Lleu had been so cruelly struck down. Before Gronw receives his punishment—an equal blow for the one he gave—he begs one favor: that a stone be placed between himself and the spear, and so it is done. Lleu throws the spear, which splits the stone in two and pierces Gronw through and through, and he dies right there on the banks of the Cynfael River. A stone still stands there—known to this day as the Gronw Stone—which bears the mark of Lleu's fatal blow.

In this story, Blodeuwedd's wild nature cannot be suppressed, and she realizes her true being, becoming the wise all-seeing Owl whose intuitive vision peers deep into our psyche.

# CAD GODDEU

Not of father, not of mother
was my blood, was my body.
I was spellbound by Gwydion,
prime enchanter of the Britons,
When he formed me from nine blossoms,
nine buds of various kind:
From primrose of the mountain, broom,
meadow-sweet and cockle, together intertwined.

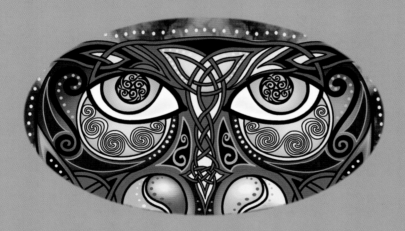

From the bean in its shade bearing
A white spectral army of earth, of earthly kind.
From blossoms of the nettle, oak, thorn
and bashful chestnut—
Nine powers of nine flowers,
Nine powers in me combined,
Nine buds of plant and tree
Long and white are my fingers
As the ninth wave, of the sea.

—Taliesin, "Cad Goddeu," sixth century, translated by Robert Graves

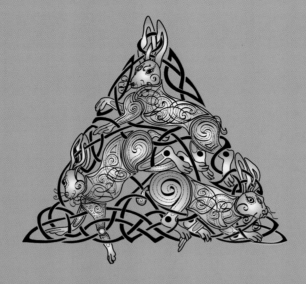

## WILDE HARES

The Hare is honored within many ancient cultures as totem of the Earth Mother.

Connected with the Spring rituals of rebirth and fertility, a single doe can bear

forty-two young in a year. The Hare is sacred to the moon goddess Andraste,

and from the earliest times people have seen the image of a hare when they

look at the full moon. Considered to be a royal animal, a Hare was released by the

warrior queen Boudicca as a good omen before battle with the Romans, and is said to

have screamed like a woman from beneath her cloak. In earliest times killing and

eating the Hare was taboo: in County Kerry it is said that eating a Hare

is like eating your grandmother! This restriction was lifted at the Celtic Festival of

Beltain. Eostre, or Ostara, an Anglo-Saxon goddess of the dawning east

and of Springtime (from whom we derive the name for Easter), was believed to

have taken the form of a rabbit, or white hare, which is her totem creature.

Illustration facing page: *Wilde Hares*

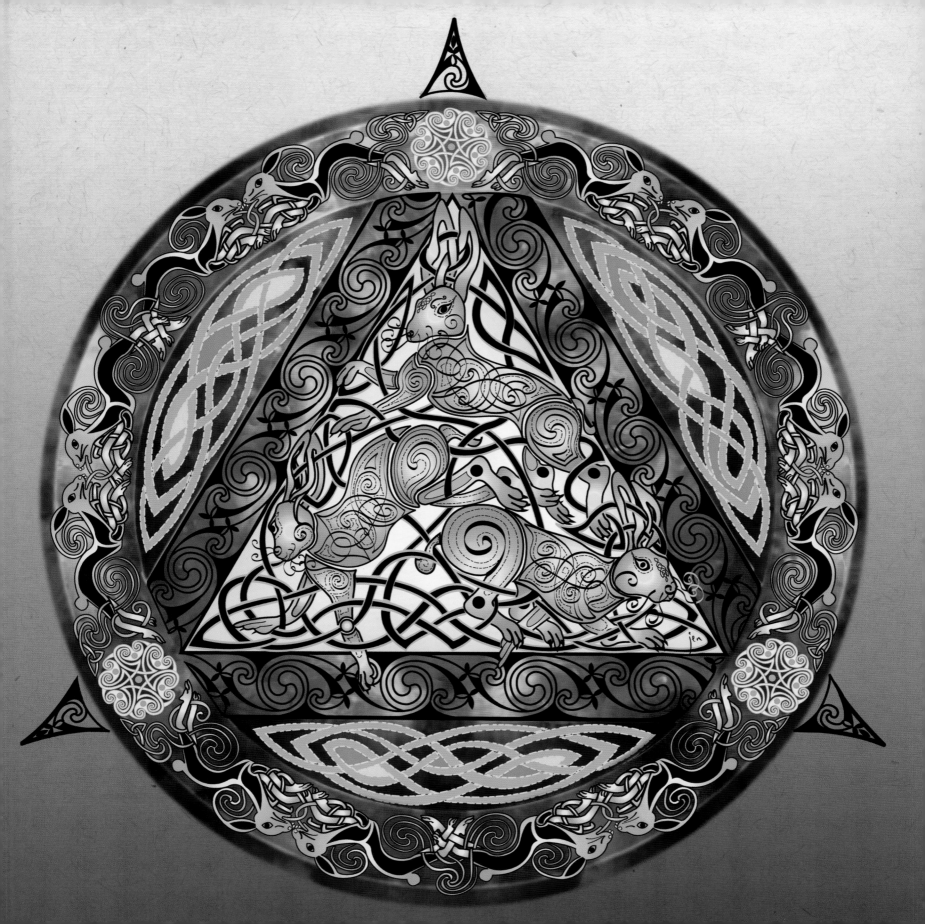

# SONG of the sea

When the wind sets from the east,

The spirit of the wave is roused,

It desires to rush past us westward

To the land where sets the sun,

To the wild and broad green sea.

—Attributed to Rumann Mac Colmain,
"Song of the Sea," eleventh century

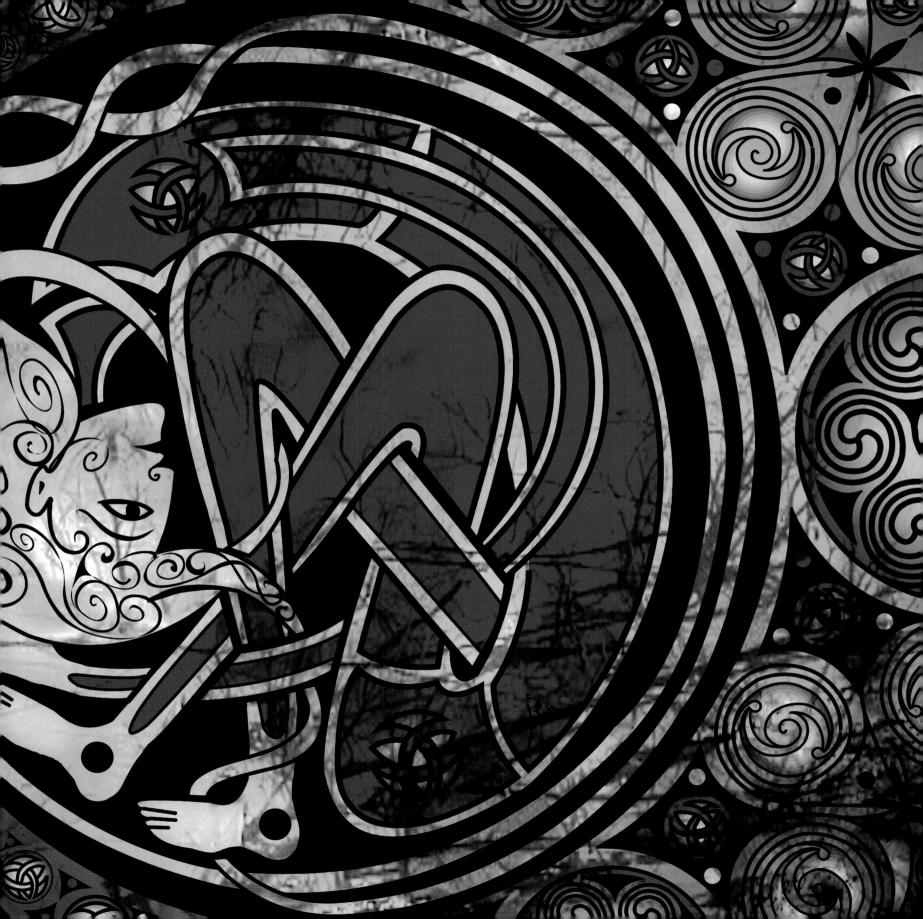

# SONG
## of the sea

**S**alty oceans are the ancient blood of the world. The primeval seas, as the waters of the womb, are the source of life. One of the most ancient archetypal elements, water is considered a powerful female symbol representing dreams and the unconscious, the intuitive aspects of our psyche.

**Water** is one of the four root elements of matter. Water flows downward to the earth, is the realm of the fish and of life beneath the surface. It cleanses our spirit and is the sea from which we are born.

**The first fishermen** wove their nets and baskets along the rocky shores. The women collected cockles and mussels from the rich estuary mudflats, gathered tangled black seaweeds to dry in the sun and made their rich lava breads as is still done in south Wales today.

Their songs, stories and blessings invoke the sea and the elements—their prayers woven throughout their everyday lives with the rhythm of the tides upon their shores.

The life of the Islander was one of faith and hardship, with spirit and prayer central to enduring a challenging existence of living with the uncertainties of the stormy elements. The Atlantic Ocean is a vast green brine of secrets. All-powerful, the waters often claim the lives of the folk, and the small settlements of the storm-battered coastline are sometimes taken back by the salty sea.

Though much has been lost, some beautiful folklore and invocations have been collected over the last centuries, drawing upon the oral memory of those whose daily lives were intrinsically connected with the ebbs and flows of the coastal seasons.

**Prayers for protection** and hope for the bounty of the ocean are deeply intertwined with everyday rituals—especially among the more isolated communities, such as the Hebridean Islands of the north of Scotland.

The wild yet sometimes gentle energies of the sea create the rhythm of life within these remote crofters, villages, and the elemental waters of the ocean are of immense significance. Their blessings are given to the ancient Manannán, Celtic King of the Sea, as well as to the Christian Lord of the Fishes. Many prayers and blessings invoke power and protection from the stormy winds and mysterious deep waters.

To the elements of water, wind and sun, the island fishermen cast their fate as they put out to sea in their hide-covered coracles and humble curragh boats. Their

> Long and white are my fingers, as
> the ninth wave of the sea.
>
> —Attributed to Taliesin,
> "Cad Goddeu"
>
>
> **Athair! a Mhic! A Spioraid Naoimh!**
> **Biodh an Tri-aon leinn, a la's a dh'oidhche;**
> **S'air, chul nan tonn, no air thaobh nam beann!**
>
> **O Father! O Son! O Holy Spirit!**
> **Be the Three-in-One with us day and night,**
> **On the crested wave, high as the mountainside!**
>
> —Old Hebridean invocation of the Faring of the Tide

often perilous journeys depended on the elements, their skills and the blessings of their gods to safely bring home the catch, or to explore the mythic lands *Beyond the Ninth Wave* as once did the Celtic monks and early explorers—who may have discovered America long before Columbus.

With much faith, some expert knowledge of the stars, winds and currents and a fair portion of luck, the early Celtic explorers navigated by the Pleiades constellation— the seven sisters—making offerings to the spirits of the sea as they journeyed westward, always westward, with the tides of their continued migration.

N inth Wave has mystical significance for Poets as the waters of rebirth and creative power, containing the qualities of the sacred triplicity. The Welsh goddess Blodeuwedd is created from the magical waters of the Ninth Wave in the sixth-century poem "Cad Goddeu" (attributed to the Welsh poet Taliesin). In some tales Arthur is born of the ninefold sea goddess. For the Celts, the Ninth Wave is the boundary of the land, of this world and the Otherworld.

Known to fishermen and sailors, the stuff of legends for modern-day surfers, the Ninth Wave is revered as the greatest wave—a powerful culmination of sea and wind, which if respected will bring you in to shore. This is the Wave of Cliodna, beautiful ruler of the waves.

C liodna's Wave. Cliodna is the shapely lady of the fair hair. Sea Queen of the Blessed Isles, she is one of the Tuatha Dé Danann—a goddess of birds and beauty who lives in Manannán's otherworldly city beneath the waves. She has the powers of the Ninth Wave, often taking the form of a sea wave or a wren. She is accompanied by her three magical birds: one blue with a crimson head, one crimson with a green head and one speckled with a gold head, whose sweet songs can heal the sick. Cliodna is loved by the people of County Cork, where a number of place names are associated with her. She is the guardian goddess of the O'Keefes and the eldest daughter of Gebhan, Ireland's last Druid.

## ISLANDER FOLKLORE

The view from Peigi's door was of the life of the island: the small figures going about their croft, the scholars crossing the hill to school, the solitary figure with a staff herding cows, the boat being dragged ashore, the brown sail on the loch, the smoke of the kelp fires on the sand dunes in the west: overhead the long approach of the flight of wild geese and swans. One watched the shore to see the state of the tide, which governed the time of work on the sea. The direction of the wind was always noted, the shape of the clouds—as that strange cloud called craobh which stretched like a narrow blanket from north to south above the hills and gave the direction of the wind to-morrow.

The spring work of the croft began in February, when seaweed, used as fertilizer, was cut with a saw-toothed sickle called a corran on the tidal islands of the loch at low water of a spring tide. It was bound together in great bundles called maoisean and towed ashore at full tide so high that it could be left on the grass verge. The crofters then carried it in creels on their backs to the field, where it was left in a heap for a fortnight before being spread on the ground. There it was left until black and dry, the new grass showing above it, when the ground would be ready to turn.

We usually journeyed to and from Lochboisdale in a sail-boat, the heavily built seventeen-foot type with a lug sail barked a red brown, which is the custom in the Hebrides. Such a pleasure on a fine day, it could be a terrifying experience on a black stormy night, tacking and threading between submerged rocks with a strong tide against a wind at gale force. But the men in the Hebrides are accustomed to using sail, and during the wars, when many ships were torpedoed and mined, crews were sometimes saved through having Hebrideans amongst them experienced in handling small craft under sail, who were able to take charge of life-boats and bring them to safety, sometimes over great distances.

—Margaret Fay Shaw, *Folksongs and Folklore of South Uist*

She often wandered the Earth as a beautiful woman—some say she lived in a marble castle on Loch Dearg, *Lake of the Red Eye*. Cliodna enchanted many lovely young men, who she lured away to the Otherworld, never to be heard of again.

Then she met the most handsome of young men, Ciabhan of the curling locks, and fell in love. They escaped away together in his curragh boat to the shores of Ireland. Then Ciabhan left Cliodna alone for a time on the shore while he went off to hunt deer. As Ciabhan was returning to join her, Manannán sent a great wave to bring Cliodna home, and they were both drowned. He brought Cliodna back to the Land under the Sea, and she was never again allowed to leave the Otherworld. The Irish landmark Tonn Cliodna, *Wave of Cliodna*, at Ross Carbery Bay is named after her.

**Flood myths** are archetypal stories created in response to ancient deluges of the land by water. These tales are often the remnants of folk-memories—sometimes reaching back many thousands of years to the times of the rising seas that occurred with the melting of the great glaciers that once covered the lands of the Hunter Gatherers.

The lost lands are a common theme in Welsh legend. Villages, towns and entire kingdoms are said to have been claimed back by the sea, or drowned in great lakes. The remains of ancient forests and geological deposits from the ending of the Ice Age have become the landmarks around which legends are woven of mythic kingdoms lost beneath the sea. A collection of large stones and boulders, known as Caer-Wyddno—*the fort, or palace of Gwyddno*—can be seen at low tide seven miles out to sea, west of Aberystwyth, and the remains of tree stumps are uncovered at low tides along the coast between Tywyn and Aberdyfi. Sarn Badrig, *St Patrick's Causeway*, is another remnant of the Ice Age, around which the folktales are created of the drowning of Cantref Gwaelod.

> To Ara of Connacht's isles,
> As I went sailing o'er the sea,
> The wind's word, the brook's word
> The wave's word, was plain to me—
> "As we are, though she is not
> As we are, shall Banba be—
> There is no King can rule the wind,
> There is no fetter for the sea."
>
> —Alice Mulligan, "Song of Freedom"

Cantref Gwaelod—*The Lowland Hundred,* Maes Gwyddno or *Gwyddno's Land*—is the legendary lost land in West Wales that has inspired many poems and songs throughout the ages.

First mentioned in *The Black Book of Carmarthen* in 1250, stories of the flooding of the Kingdom of Gwyddno were drawn from folktales centuries earlier. "Boddi Maes Gwyddno" is one of the finest examples of medieval Welsh poetry and tells how the maiden Mererid is responsible for the great deluge of the lands ruled by Gwyddno in 600 AD.

*Boed emendigaid y fachdaith a'i gollyngodd gwedi gwaith, ffynnon fynestr môr diffaith.*

*Cursed be the maiden who released it after battle—let the fountain of the waste sea be poured out.*

The theme of a beautiful woman blamed for a great flood is common in Celtic mythology. In the Breton legend of Ker-Ys, *The Fortress of the Deep*, the beautiful and seductive Dahut brings about the inundation of Ys by stealing her father's key, which had until then protected the city from the raging sea, for her lover. In the Irish legend explaining the source of the River Boyne, Boann violates the taboo, the *geiss*, on the sacred well, causing a great river to flow over the land. These stories have their roots in the Dindshenchas—the Irish poem-lore of places.

The earliest tale associated with Cantref Gwaelod tells that the land was drowned when the proud and foolish Mererid the Maiden, who was responsible for the sacred well, allowed the water to overflow after a battle she had instigated was lost.

In another myth, it is said that the land was ruled by the benevolent Gwyddno Garanhir, *Longshanks*, born in 520 AD. His wealthy and fertile kingdom of Meirionnydd stretched some twenty miles into what is now Cardigan Bay. The kingdom was kept safe by a huge stone wall and

gates that protected the land from the high tide, which were opened to allow the waters to drain at the low ebb.

It was Prince Seithennin's responsibility to control the opening and closing of the sluice gates and to manage the watchmen who were on the lookout for holes developing in the sea wall. One stormy night around 600 AD, the spring tide was particularly strong and the wind-whipped waves were battering at the sea walls. Seithennin was this evening at the king's court near Aberystwyth enjoying his fine wine and the good company. The walls had held up many a stormy night before, and Seithennin was relaxing in the generous arms of a captivating woman. A heavy drinker, he was already falling asleep as the wind was gathering force outside the keep.

The sea was relentless, and soon a hole had broken through the stone wall. The watchmen frantically rang the warning bells, but Seithennin and his company were too drunk and too tired from their carousing to hear them. The prince awoke in the small hours of the morning—but too late!—he realized his terrible neglect of the sea walls, and the land he was pledged to protect. The sea had rushed in through the breach to flood the lowlands, drowning the villages, killing many people and animals and reclaiming all for Manawyddan, Lord of the Sea.

*Seithennin, saf-di allan, ac edrychwyr-di faranres môr. Maes Gwyddnau rydöes.*

*Seithennin, stand out here, and look at the wild sea: it has covered Maes Gwyddno.*

In another version of the tale, it was the maiden Mererid who was in charge of the sluice gates. She was seduced by Seithennin at the king's feast, and so distracted by his amorous advances that she forgot to close the gates

> And sometimes, when the moon
> Brings tempest upon the deep,
> And roused Atlantic thunders from his
> caverns in the west,
> The wolfhound at her feet
> Springs up with a mighty bay,
> And chords of mystery sound from the
> wild harp at her side,
> Strung from the heart of poets.
>
> —John Todhunter, "The Banshee,"
> nineteenth century

as the tide came in and poured through, inundating the kingdom and all who were in it.

*Boed emendigaid y forwyn a'i hellyngawdd gwedi cwyn, ffynnon fynestr môr terwyn.*

*Cursed be the maiden who released it after the feast—let the fountain of the rough sea be poured out.*

It is said in Aberdyfi that if you listen closely you can hear the bells of the lost city ringing out from under the sea, especially on quiet Sunday mornings.
—Extracts are from "The Drowning of Gwyddno's Realm" from *The Black Book of Carmarthen*, 1250, translated by Dyfed Lloyd Evans

Dylan is the Child of the Waves in Welsh mythology. In the *Mabinogi* tales, we are told that his mother Arianrhod is given a test by Gwydion to discover if she is indeed a virtuous maiden, as is required if she is to serve as footholder to Math, son of Mathonwy. Gwydion bends his magician's rod and asks Arianrhod to step over it to prove her virginity; but as she does so, she magically gives birth to two children, one a big, fine, yellow-haired boy and the other a smaller one she drops just as she runs away in frustration and humiliation.

Math takes the strong boy and baptizes him. The other he quickly wraps up in a shawl and hides in a chest. The moment he is baptized, Dylan runs away and plunges into the ocean, taking on the nature of the sea and the waves, swimming like a fish and riding the backs of dolphins. He becomes known as Dylan Eil Ton, *the Prince of the Waves*, and it is said that no wave ever broke beneath him. When Dylan was later killed with a spear by his uncle Govannan (the divine metal-smith), Taliesin the poet says that the waves of Britain, Ireland, Scotland and the Manx isles wept and mourned for *(continued on page 159)*

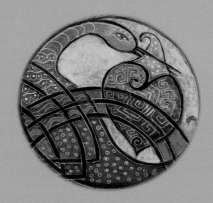

## The Strange Country

I have come from a mystical land of light
To a strange country;
The land I have left is forgotten quite
In the land I see.
The round earth rolls beneath my feet,
And the still stars glow,
The murmuring waters rise and retreat,
The winds come and go.
Like waves in the cold moon's silvern breath
They gather and roll,
Each crest of white is a birth or a death,
Each sound is a Soul.

—Robert Buchanan,
*Miscellaneous Poems and Ballads*

# MANAWYDDAN AP LLYR

The Celts have an ancient lore and wisdom
tradition reaching deep under the green waters
of the land of Manawyddan ap Llyr. Older even
than the Tuatha Dé Dannan, Manawyddan ap
Llyr (Welsh), also known as Manannán (Irish),
is Guardian of the Blessed Isles, a master of
humor, wit and wisdom, weaver of illusion
and magic. He rides upon the seas in a golden
chariot with a helmet made of flames and a
cloak that renders him invisible. Manawyddan's
horse, Enbarr of the Flowing Mane, can travel
over water as easily as land.

Manannán makes his Shaman Crane Bag from
the skin of a Crane that was once a young
woman. The Druid's Bag holds Otherworldly
treasures—spiritual power objects such as
stones and sticks for divination, herbs and
plants for healing and giving wisdom, nets and
strings for spirit traps. When the sea was full,
its treasures were visible; when it was in ebb,
the Crane Bag in turn was empty.

Illustration facing page: *Manawyddan—King of the Sea*

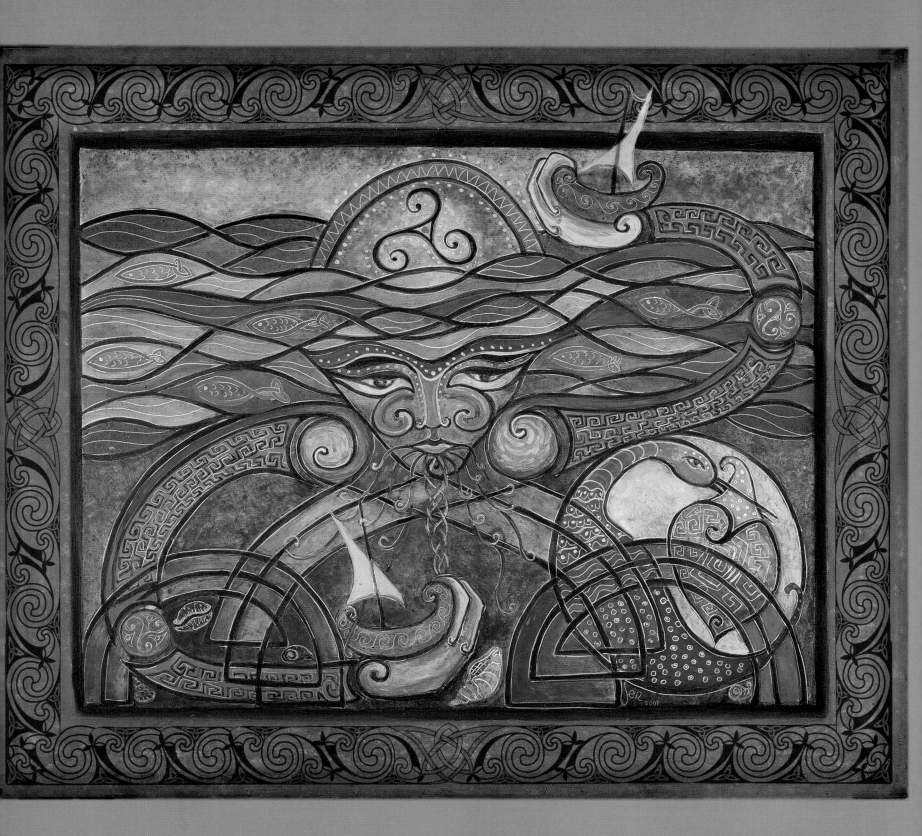

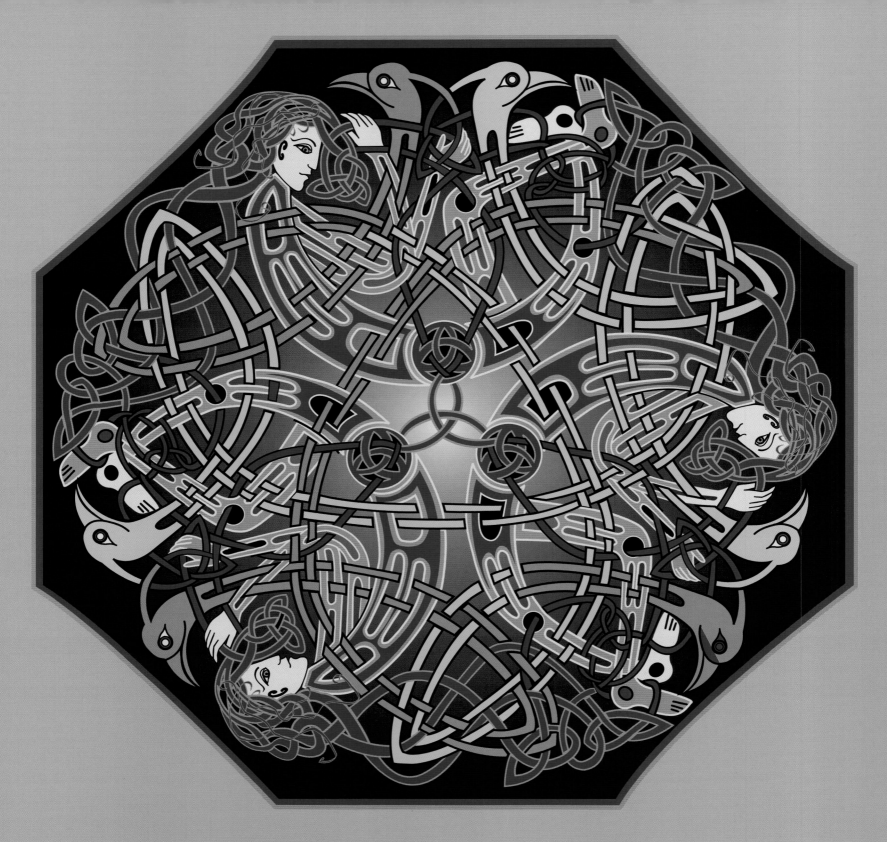

**The Welsh Goddess Rhiannon—*Great Queen*—was accompanied by totem birds whose songs could awaken the dead and lull the living to sleep.**

him. It is said that his death was one of the three ill-fated blows of Britain and that the sound of the waves is an expression of their longing for Dylan. It is known in parts of Wales as *Dylan's Death Groan.*

The other child grew up to become the hero Lleu Llaw Gyffes—*Shining One of the Skillful Hand.* Lleu represents the solar energies of the light. He is synonymous with the Irish deity Lugh Long Arm, *He of the Many Skills.* Lugh became a great warrior at the court of King Nuada of the Tuatha Dé Danann.

Lleu and Dylan represent the twins of light and darkness for the Celts, a cosmic duality of solar and lunar, active and passive, conscious and unconscious. Dylan lives in the dark, creative, watery world beneath the Sea (lunar, the realm of the subconscious and emotions). Lleu Llaw Gyffes represents the light (solar, the conscious mind, illumination). He is fostered by the great smithy Govannan, *Gobnui,* and is skilled in all the Arts. Together they represent the archetypes of moon and sun, both born of Arianrhod, who rules over the waves from her star constellation Caer Arianrhod, *Arianrhod's Castle.*

> Sea-horses glisten in summer
> As far as Brân can stretch his glance;
> Rivers pour forth a stream of honey
> In the land of Manannán, son of Ler.
>
> —"Immram Brain—The Voyage of Brân"
> seventh to eighth century,
> translated by Kuno Meyer

**M**anawyddan ap Llyr is son of the sea god Llyr, brother of Brân. He is King of the Oceans, protector lord of the Isle of Man, said to have caused great mists to rise around the Manx Isle so invaders could not find its shores. In Ireland he is known as Manannán Mac Lir, and is said to ferry souls on their sea journey to the Otherworld.

Manawyddan's ship can steer itself by thought alone, moving without wind or oar. His mysterious vessel is called *wave-sweeper,* and his chariot is drawn by two magical horses across the sea.

Manawyddan is lord of storms and predictor of the weather, and he is a master magician, possessing the fabulous Crane Bag, holder of all his treasures including language. Sometimes the wise Manawyddan can be seen as

a solitary Heron, standing watch along the frigid waters of river and shore.

Manawyddan's country is the Land Under Wave. He is Lord of Mag Mell, the otherworldly Town of the Dead in the watery plains of Tír na nÓg, and ferries souls on their sea journey through the mists to the Otherworld.

**V**oyage of Brân. Many heroes including Brân journey to the Land of Manawyddan, and some—but not all—return to tell their tales of the beautiful women of the Sidhe in the distant isles of the Lands of Promise. The Voyage of Brân Mac Febal is one of the best-known legends. Brân was charmed asleep by the strange music of the Birds of Rhiannon, whose enchanted songs *"lull the living to sleep and awaken the dead,"* according to the *Mabinogi* tale.

When he awoke, a silver branch of fragrant apple blossom lay beside him, and a beautiful Sidhe woman told him of the magical Isles of the Blessed. Brân set out to find the wondrous land, met Manannán, and found the Land of Promise that is *"Cen brôn, cen dubai, cen bás, cen nach galar—without sorrow, without death, without any sickness"*—full of treasures and riches, beauty and loveliness. —"Immram Brain—The Voyage of Brân," seventh to eighth centuries

When he and his men returned to Ireland, many years had passed, although it seemed like only a few days.

The mysterious lands under the Sea—of Manawyddan and Magh Mell, the Lost Lands of Gwyddno—are the realm of Dylan, of Cliodna, of Brân and the Selkie women. The Hebridean fishermen spend their lives tasting the salt of the oceans, and their women-folk send blessings to Manannán to protect their men and bring them home again.

The Land of Promise lies within the primeval waters of our psyche, the salty brine of our creative unconscious, our dreaming land beneath the waves. This is the birthplace of the Celtic Folk-Soul.

Illustration facing page: *Birds of Rhiannon*

# MAGH MELL

Magh Mell—the invisible world, land of the unseen—was usually
separated from human life by water, a lake or an ocean,
which by some means had to be crossed.

In Pagan days the Celt in Ireland visualized several fairy lands:
Tír na nÓg, the Country of Youth; T'r Tairngiri, the Country of Promise;
Magh Argatonél, the Silver Cloud Plain; and Magh Mell,
the Plain of Honey.

Magh Mell is conceived either as existent on an island, or islands,
or as a fair, flowery plain visible only to eyes opened under
the waves of the sea.

—Kathleen Hoagland, *1000 Years of Irish Poetry*, 1946

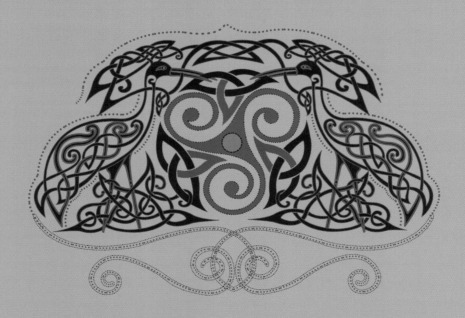

Illustration facing page: *Magh Mell*

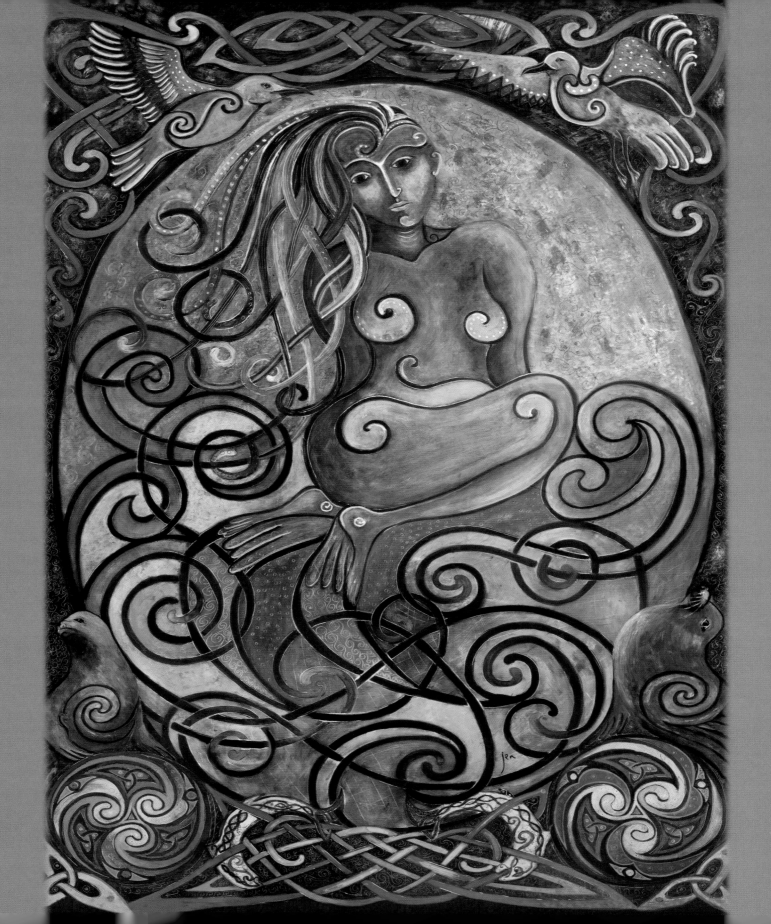

# TALE OF
# SELKIE SEAL-WOMAN

**I**n the Orkney Islands, a Selkie is a seal-woman. There are many stories of the Selkies, especially within the fishing communities of the wild and rocky islands of Scotland, where the seals are wild and free and plentiful.

Well known among the coast dwellers, Selkies are magical creatures, gentle shape-shifters who transform into beautiful humans when they cast off their seal skins. Tales are told of the half fish, half women of the sea coming upon the land to seduce the young men.

Their magical skins contain their transformative power, and the lovely fish-women leave them among the rocks while they soak up the sun on the beach. When they sense intruders, they hastily snatch up their skins and rush back to the sea, back to their home beneath the waves.

Sometimes the beautiful Selkies seek amorous encounters with unhappy human men, and they have been known to marry and have children with their human lovers. Yet it remains deep in their nature to always return to the sea, and so their seal skin is their most precious possession, the key to their primal, free and watery spirit or psyche.

In one such Selkie tale there was once a lonely young man who one day wandered farther than usual along the rocky cliffs of his island home in the Orkneys. To his amazement, down in a private rocky cove, he chanced upon some beautiful Selkie women happily enjoying the warmth of the sun upon their smooth skins.

He quickly hid from sight and watched entranced from the purple heather of the mountainside as the women hid their seal skins among the rocks and then took them up again to return to the sea.

The next day, and the next again, enchanted by the loveliness of the Selkie girls, the young man was drawn to the cove. He was seduced by the beauty of the strange women lazing in the sunshine, brushing their sisters' sea-weed locks, laughing and lounging contentedly upon the warm, flat rocks.

As the days went by, he became quite sick with love and longing, and could not eat nor drink nor work to bring fish home for his mother. He could not continue with his life as it was before his eyes set sight upon the magical fish-women of the sea.

> "Say fisher, the mermaid
> hast thou seen,
> Combing her hair by the
> sea-waves green—
> Her hair like gold in the
> sunlight sheen?"
> "I saw the white maiden of the sea,
> And I heard her chaunt her melody,
> And her song was sad as
> the wild waves be."
>
> —Breton folk song, nineteenth century,
> translated by Tom Taylor

One day, his heart bursting with fear and excitement, he crept down to the shore and snatched up one of the precious Selkie skins hidden among the rocks, stealing it away to his hiding place above. As the evening sun was beginning to dip fiery red and gold below the horizon of the green-blue ocean, the Selkies collected up their skins to return to their home beneath the waves.

Suddenly there was a terrible cry of anguish, as one of the Selkies realized that her skin was missing—nowhere to be found. The young man's heart beat fast and hard as he held the secret to her freedom in his hands.

After some time of watching her weep, searching in vain for her Selkie skin, he made his way down to the cove as the sisters quickly slipped away into the waves—all except one, who sat unhappily among the rocks.

Illustration facing page: *Selkie*

The young man wrapped his cloak around her shivering body and whispered gentle comforts, hoping to dry her tears. He felt quite sorry for her plight, but not enough to give back the magical skin he had stolen. He was in love with the beautiful Selkie, and truly believed that he could make her happy and that she would soon forget her life in the sea.

So he brought her back to his village, and soon they were married in the traditional way, although his mother was never quite at ease with the dark-eyed stranger girl that her son had found wandering, lost in the dark—or so he said.

As time passed, they made a fine crofters' home together, and she bore him three strong sons. The Selkie girl came to learn how to live among the villagers, and her love grew for the young man, who could never believe his fine luck in his beautiful wife with the dark black eyes and long black hair, shiny as the seaweeds she brought home to dry in the sun.

However, she was never really accepted among the village women, who were suspicious of her strange ways with the wild sea birds and her sadness when the fishermen brought home the catch, and no one had ever heard her laugh nor cry, not even on her wedding day. They heard her singing songs that seemed to be from some faraway place—and she never spoke of where she came from, this stranger with the dark eyes.

Although she loved her children and her husband, she often felt a sadness, a loneliness, a sense that something was missing. Slowly, she began to forget her life beneath the sea, as if it were a dream from long ago. She kept quietly to herself, weaving intricate designs into her cloth upon the loom, patterns that were not quite like those of the other women in her small fishing community.

One day, while feeling the pull of the waves, the call of the sea birds, the freedom and spice of the salty air, she wandered far from her crofters' community along the rocky shore. She had forgotten the time, and the sun had begun to plunge down into the sea, and it was growing dark. She found shelter inside a cave, and there inside she found an old wooden box. Feeling curious she opened it—and there was her beautiful Selkie pelt!

With a gasp and a cry she snatched up her old skin, and with a great longing and happiness upon her, she slipped back into the sea, back to her home beneath the waves, back to her sisters and the land of Manawyddan ap Llyr.

It is said that sometimes a child is born who is not like the others. The dark-eyed, dark-haired folk among the Orkney islanders have the secretive ways about them, and keeping to themselves, they sing strange and beautiful songs that answer the rhythm of the tides, the calling of the wild birds. It is said that they are the children of the sea, born of the Selkie women of long, long ago.

## Silochd-na-mara

**Once a man met a beautiful woman of the sea—some say a seal. The man said, "I will give you love and home and peace." The sea-woman said, "And I will bring you the homelessness of the sea and the peace of the restless wave, and love like the wandering wind." At that the man chided her, and said she could be no woman though she had his love. She laughed and slid away into the green water. He left, and married another, but he and the children he had knew by day and by night a love that was tameless and changeable as the wandering wind, and a longing that was the unquiet of the restless wave. And that is why they are called the Silochd-na-mara—the clann of the waters, or Treud-nathonn, the tribe of the sea wave.**

—Fiona MacLeod, *By Sundown Shores*, 1901

## NAOI MIANNAIN

Miann mna sithe, braon:

Miann Sluagh, gaoth;

Miann fitheach, fuil:

Miann eunarag, an fasaich:

Miann faoileag, faileagan mhara:

Miann Bard, fith-cheol-min lhuchd

nan trusganan uaine:

Miann fear, gaol bhean:

Miann mna, chlann beag:

Miann nama, ais.

## NINE DESIRES

The desire of the fairy woman, dew;

The desire of the fairy host, wind;

The desire of the raven, blood;

The desire of the snipe, the wilderness;

The desire of the seamew, the lawns of the sea;

The desire of the poet, the soft low music

of the Tribe of the Green Mantles:

The desire of man, the love of woman;

The desire of women, the little clan;

The desire of the Soul, wisdom.

—Traditional Scottish poem,
translated by Fiona MacLeod, *By Sundown Shores*, 1901

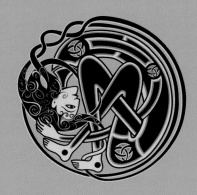

The lure of the quiet dreamy undersea...
desire to escape to sea and shells...
the seaweed tresses where at last
her bones changed into coral
and time made atolls of her arms,
pearls of her eyes in deep long sleep,
at rest in a nest of weed,
secure as feather beds...

—Nuala Ni Dhomhnaill,
"Parthenogenesis," 1952

# DYLAN–CHILD OF THE WAVES

Dylan, Child of the Waves, is the son of Arianrhod, who appears in the Fourth Branch of the medieval *Mabinogi* folktales. In the strange Welsh tale, Arianrhod is chosen for the honor of being maiden footholder to Math, her uncle the chieftain. To her great humiliation, she fails the test set by her brother, the magician Gwydion, which would prove her virginity. While stepping over his magician's rod, she magically gives birth to two boys, Dylan Eil Ton and Lleu Llaw Gyffes. Dylan is Prince of the Waves, who plunges into his native element, the sea, as soon as he is born, and Lleu Llaw Gyffes—the Bright One of the Skillful Hand— joins the Court of Nuada and becomes a great warrior.

Their mother Arianrhod is also known as a Priestess of the Moon, she who rules the tides from her chariot in the sky. Her name means Silver Wheel, and she is associated with the star constellation of Corona Borealis, named Caer Arianrhod, *Arianrhod's Castle*. Connected with the element of water through the pulling of the tides, the waxing and waning cycles, the moon is an archetypal female symbol representing womb, death and rebirth, creativity. Albion, the old name for Britain, meant *White Moon*. The Celts knew well the way of sea and stars, and counted time not by days, but by nights, and made their calendars (such as the famous Coligny Calendar) not by the sun, but by the moon.

Illustration facing page: *Arianrhod*
(inspired by figure motif by Alice Rigan)

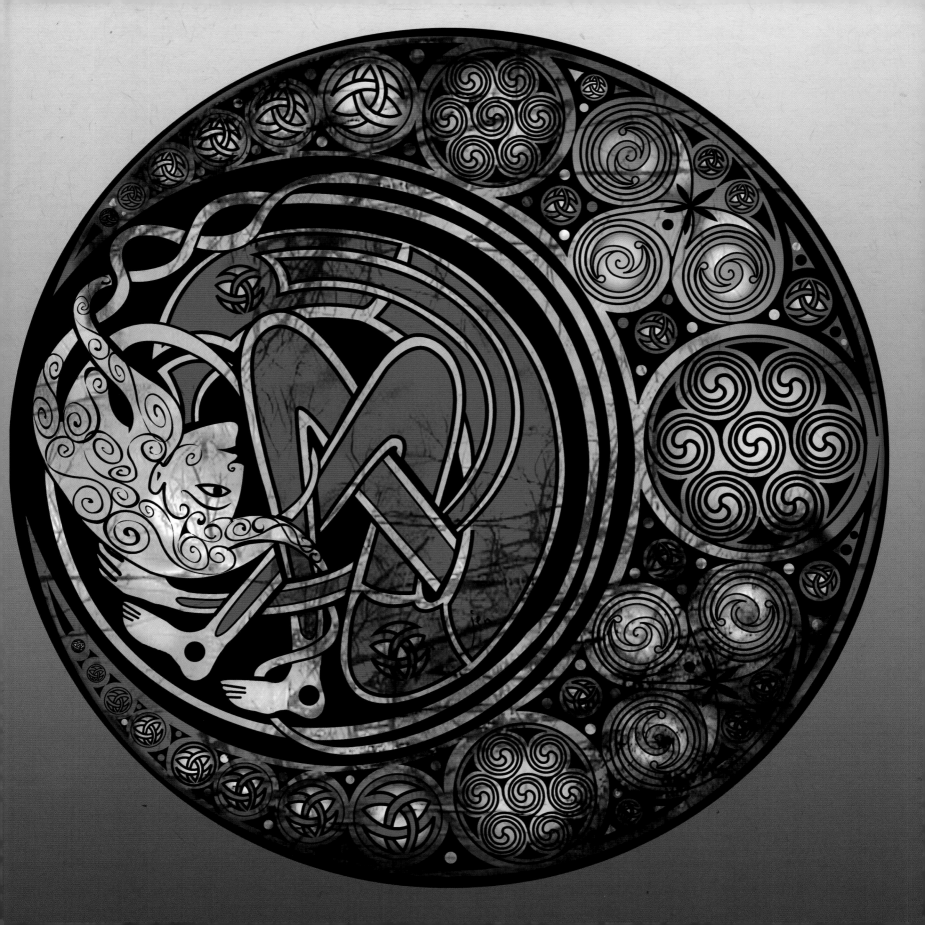

# YSBRYD
## spirit

I am the breeze that nurtures all things green.
I encourage blossoms to flourish with ripening fruits.
I am the rain coming from the dew
That causes the grasses to laugh with the joy of life.

—Hildegard of Bingen, tenth century,
translated by Gabriele Uhlein

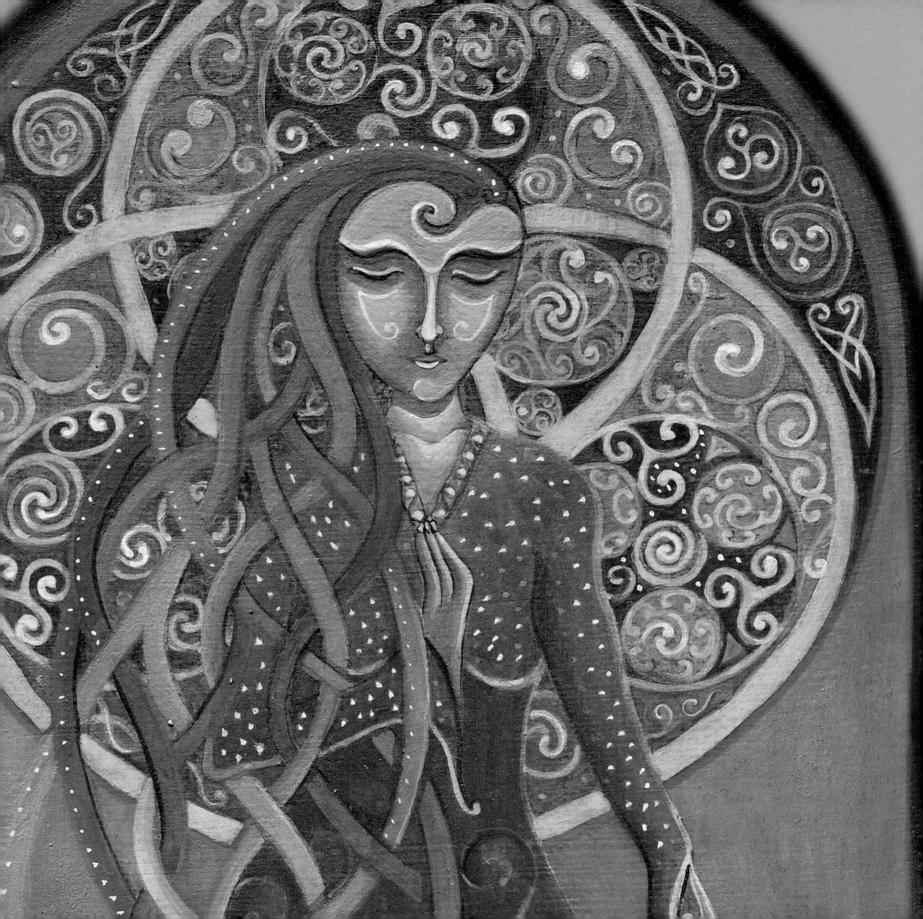

# YSBRYD
## spirit

**C**eltic Spirituality is infused with devotion for the wisdom and spirit within Nature. From the vitality of the indigenous Old Religion to the early Celtic Christian Church in Britain and Ireland, reverence for all creation is a constant thread of inspiration within the prayers, blessings and traditions of her people.

**Early Celtic Christian mystics** chose the wild, natural places to be close to their God. The hermit monks practiced a humble asceticism, often living in simple stone beehive huts or crude shelters, in the forests and the wilds of remote areas and islands. It was their sacred intention to eat and drink only what could be found in the surrounding woods—fish, nuts and berries, wild herbs, roots and honey, drinking water from the natural springs. They were inspired by the practices of the monks of the Middle East, whose desert monasticism emphasized fasting and simplicity.

The early monks created their communion with God through a life of humility, work and prayer. They renounced comfort and pleasure, adopting a life of hardship to attain spiritual purity, and wrote poetry as a form of worship and expression of their sincere experience of faith and communication with the Holy Spirit.

Their poetry and prayers are a moving testament to their love of nature and appreciation for the living spirit within the world. They had profound respect and appreciation for all of creation. They wrote poetry describing their hardships and inspirations as they sought spiritual experience within the world of nature, rather than through the world of men.

Their theology is deeply connected to the older cultures and religions that are woven through the fabric of their faith. They created a distinctive style of worship that has come to be recognized as the Celtic Church, which was often at odds with the opulent rituals, riches and hierarchical politics of the Church of Rome.

**Celtic Saints** are often transformations of legendary figures, given life by a more ancient mythology from which they emerge in the collective consciousness of the Folk-Soul. Many of the most popular Celtic saints are associated with nature spirituality, and sometimes historical figures were merged with earlier mythic characters—local divinities or aspects of them—as knowledge of their healing powers or celebrated gifts grew into legendary status.

**S**aint Cenydd is one of the early Celtic Christian figures, the local mythic saint of Llangennith, *Village of Cenydd*, in the Gower peninsula of South Wales. Llangennith is built on a brackened hill above the sweeping sands of Rhossilli Bay. The ancient village looks out over the wild sand dunes that stretch to the rocky headland where Saint Cenydd the Celtic hermit monk lived—fed only by the mouths of seagulls and the milk of a doe. In the sixth century Saint Cenydd founded a priory there, which was destroyed by the Danes in 986.

There is a beautiful and quintessential Welsh myth of a hermit Holy Man, that tells the story of communion between nature and man, spirit and healing, and is a wonderful example of a Celtic Christian myth of the early sixth century.

One telling of the story portrays Cenydd as being born in Brittany of an adulterous affair, the son of Gildas, the learned fifth-century monk. The baby was sent away to the court of King Arthur at Loughor in the Gower peninsula to escape the scandal of his ignominious birth.

Another legend declares that Cenydd was born in the sixth century—the incestuous son of King Dihocus, a Breton king who had seduced his daughter while visiting Arthur at Loughor.

The baby was born with a crippled leg, which was seen to be the mark of his mother's sin. When he was brought before King Arthur, some said that the child bore the evil sign and should be put to death. But Arthur felt that God alone should decide, and ordered that Cenydd be cast to the elements to determine his fate.

The unwanted baby was put into a wicker basket woven of osiers and cast adrift upon the waters of the Loughor estuary, which soon took him out to sea. It was a wild and stormy night, and the waves tossed the small wicker boat-basket up and down as it came ever closer to the jagged rocks of Bury Holmes Island.

Just as baby Cenydd was to be doomed upon the black rocks, a flock of seagulls came down and rescued him. Snatching up the basket in their long beaks, they flew high up to the top of a cliff and set him down in safety. The gulls kept the baby warm by making a nest with their soft feathers, and sheltered him from the driving rain. Calling out above the cold, loud wind, the gulls pleaded with the stormy elements to cease their battering of the innocent young boy.

> I have a hut in the wood,
> none knows it but my Lord;
> an ash tree this side, a hazel beyond,
> a great tree on a mound enfolds it.
>
> Two heathery door-posts for support
> and a porch of honeysuckle
> around its close the wood sheds
> its mast upon fat swine.
>
> The size of my hut, small yet not small,
> a place of familiar paths
> the she-bird in dress of blackbird colour
> sings a melodious strain from its gable.
>
> —Anonymous, Irish, "The Song of Manchin of Liath,"
> eighth to tenth century

For eight days and nights the gulls protected Cenydd from the worst of the storm. On the ninth day, some say an angel came down to the baby and placed a bell, known as the Titty Bell, in Cenydd's mouth. This miraculous breast-shaped bell gave constant nourishment to the boy, who grew tall and strong as the angel watched over him and educated him in the new faith.

Others say that a deer came out from the woods and nurtured the boy, sharing her milk and teaching him the ways of the animals, the secrets of the woods and the elements.

Cenydd lived close to the sea, collecting shellfish from the rock pools and wild herbs gathered from the local woods. He had an affinity with the ocean birds who rescued him and the gentle doe that nurtured him, and understood that God was within all living things.

Strangely, Cenydd's clothes grew as he grew, and he passed his days in prayer and contemplation, living as a hermit in a humble stone hut upon the rocky cliffs of Bury Holmes. The ruins of a small monastic cell can still be seen there today.

When he was grown to a young man, Cenydd moved from the island to the village of Llangennith, where he became known far and wide as a Holy Man, famous for his miracles and healing gifts. He founded Saint Cenydd's Priory, which was the largest parish church in Gower. Although the Danes burned the church down, it was restored, and inside, a carved slab marks the grave of the saint.

Taliesin, Lugh, Cenydd—and the bibilical Moses and Eqyptian Horus—are the Innocents, cast upon the waters

by their jealous rivals, exposed to the elements they are fated to survive, as Poets, as Prophets. This is an ancient story that repeats and dances its archetypal theme throughout the Folk-Soul, illustrating the interdependence of man and nature, the connection between spirit and the wilderness in which he must find himself and his God.

**W**ater and spirituality are interconnected with ideas of rebirth and spiritual purity. Through ritual immersion in mineral waters straight from the earth, we still find solace and curative power. Within Christianity, baptism with water is performed as a spiritual cleansing.

Water rises up as natural springs from the belly of Mother Earth, giving nourishment to the world above and below. To the Celts it is at the lakes and deep wells, the natural springs that are entrances to and from the world below, that offerings are given, myths are created and healing is bestowed upon the people who draw from its deep mystery.

There are many Celtic saints whose colorful lineage connects back to the early people who respected the sacred sources of water emerging from the ground. There are several healing wells dedicated to Bride—Saint Brighid in Ireland—including one in Kildare not far from the church where Brighid's fire is tended.

The myth of the River Boyne arises from such a well. Boann, wife of the Dagda, is a curious woman who disturbs the sacred well in defiance of the geiss that protects it. She is punished by a great river that overflows from the well and drowns her, becoming the great river Boyne of Ireland.

**Saint Winifred** became so popular that an entire town grew around her shrine. Today called Holywell, near Chester, this is perhaps the most sacred well in Britain, still visited for its healing waters. People have made the pilgrimage to bathe in Saint Winifred's Well for over 1,350 years.

Saint Winifred, whose Welsh name was Gwenfrewi, was a seventh-century Welsh nun. She was the beautiful daughter of a famous noble family. Winifred had made a private vow of chastity, deciding to become a nun, and was a spiritual student of her uncle, the monk Beuno.

One Sunday as she was alone in her house, the local chieftain, Caradog, came riding by. He was enamored of Winifred's beauty, and when she rejected his insistent advances, he roughly tried to force himself upon her. Winifred ran to the church for sanctuary, but Caradog pursued her. Angered by her religious devotion, he cut off her head in a violent rage upon the church steps. Her blood ran red down into the earth, and where her head had tumbled down the hill, a spring of healing water broke forth from the ground.

Hearing her cries, Beuno ran out—but too late! Caradog was standing over her, his sword red with blood. Beuno cursed him and Caradog was swallowed up by the earth. Beuno took Winifred's head, and praying to God for healing powers, replaced it upon her lifeless body.

Welsh scholar *Giraldus Cambrensis* offered his devotions in the thirteenth century, when he said of the well, *"She seemed still to retain her miraculous powers."*

Miraculously, she was restored to life, afterward bearing only a thread-like red mark around her throat.

Winifred became a nun, and later abbess at Gwytherin in Denbighshire. The well became famous in medieval times for its curative powers, and later the town of Holywell, *Treffynnon,* grew up around the popular site.

The legend of Winifred is based on an actual historical woman. She was related to the royal family of Powys, and although this is not recorded until the twelfth century, Winifred's brother Owain is known to have killed Caradog as revenge for a crime. Beuno was her real uncle, and her great aunt, whom she succeeded as abbess, was Saint Tenoi. A fragment of an eighth-century reliquary—the Arch Gwenfrewi, *Winifred's Casket*—is the earliest surviving evidence of any Welsh saint.

This story shows the continued importance of the older animist worship of water, and its connective thread through the Celtic myths and the new tales of the Celtic saints. The medieval belief in miracles was perhaps more vivid for the Celts, whose stories are full of strange rebirths, gruesome dismemberments and magical renewals, and water often plays an important role.

In Wales in particular, myths regarding women and water are common, and the concept of water as a healing force has been active in the psyche of the Folk-Soul since the earliest people. Stories involving water, springs and rivers are commonly associated with beautiful women, often told around the theme of a defilement at the source of the holy water. To violate purity—the spiritual nature of the feminine elements of life that are associated with the sacred water from the earth— is punished with divine retribution, as through the monk Beuno who is a messenger of God. The sovereignty of the earth and of the sacred female principle is respected.

> The woodland thicket surrounds me,
> the blackbird sings me a lay,
> praise I will not conceal;
> above my lined little booklet
> the trilling of birds sings to me.
>
> The clear cuckoo sings to me, lovely discourse,
> in its grey cloak from the crest of the bushes;
> truly—may the Lord protect me!—
> well do I write under the forest wood.
>
> —Anonymous, *The Ivy Bower Irish Poetry,*
> eighth to tenth century

The legend emphasizes that Winifred is a Celtic woman, free to choose her own destiny, and both the new Father God and the ancient Earth Mother honor this by restoring her, giving a gift of healing to the people.

## THE CELTIC CHURCH

The Church came early to the lands of the West. Only two hundred years after the death of Jesus there were signs of a Christian presence in Britain, come through the Romans and traders. The folk adopted the new ideas, sometimes as a natural extension of their own spiritual traditions.

The seeds of the New Faith brought from the deserts of the East quickly took root in the Celtic lands. Although not literally a separate entity from the Catholic Church, this distinctive branch of Christianity continued to flourish in comparative isolation, producing some of the finest art and poetry, inspired by the spirituality of the Celtic Folk-Soul.

It is important to distinguish between the sincere, genuine faith of these early Celtic Christians and the often oppressive and destructive politics later forced upon the Old Religion and its perceived superstitions by the Church itself. The powerful political movements that attempted to crush followers of other beliefs, stifled the position of women and disregarded the environment did not necessarily, or always, contradict the inspired, colorful new theology that grew—like the hawthorn staff of Joseph of Arimathea—from the roots of the Old Ways and into a new, blossoming branch of the tree.

*(continued on page 176)*

## WILDE GEESE

The early Celtic Christians adopted the Wild Goose as their symbol for
the Holy Spirit, rather than the calm, cooing Dove of surrender. Chosen for
their independence and strength, and significantly for their loyalty,
the Wild Geese represent the people who choose to worship in their own way,
close to the myth-haunted lands of the rugged western places of Britain and Ireland,
far from the wealth and decadent power centers of religion and politics.
These are large, strong-willed birds that we see flying in large flocks across the grey
winter skies. We hear their distinctive, raucous honking calls as they migrate home
each year, their constant return symbolizing loyalty and the rhythms of nature.

Although Wild Geese cannot easily be tamed or caught, a young gosling
attaches to the first large moving object it sees when born, and will
even think a human is its mother. This profound connection is both mystical
and valued as one of the earliest husbandry practices, before the domestication of
animals in Neolithic times. Once adapted to the human community,
the independent Goose is an adept scavenger, needing little care, and is
a useful food source of meat, eggs, fat and feathers. We see Goose patterns on
early pottery and bone carvings, and few birds are so important in ritual
and symbolism as the Goose and its elegant, long-necked sister—the Swan.

Illustration facing page: *Wilde Geese*

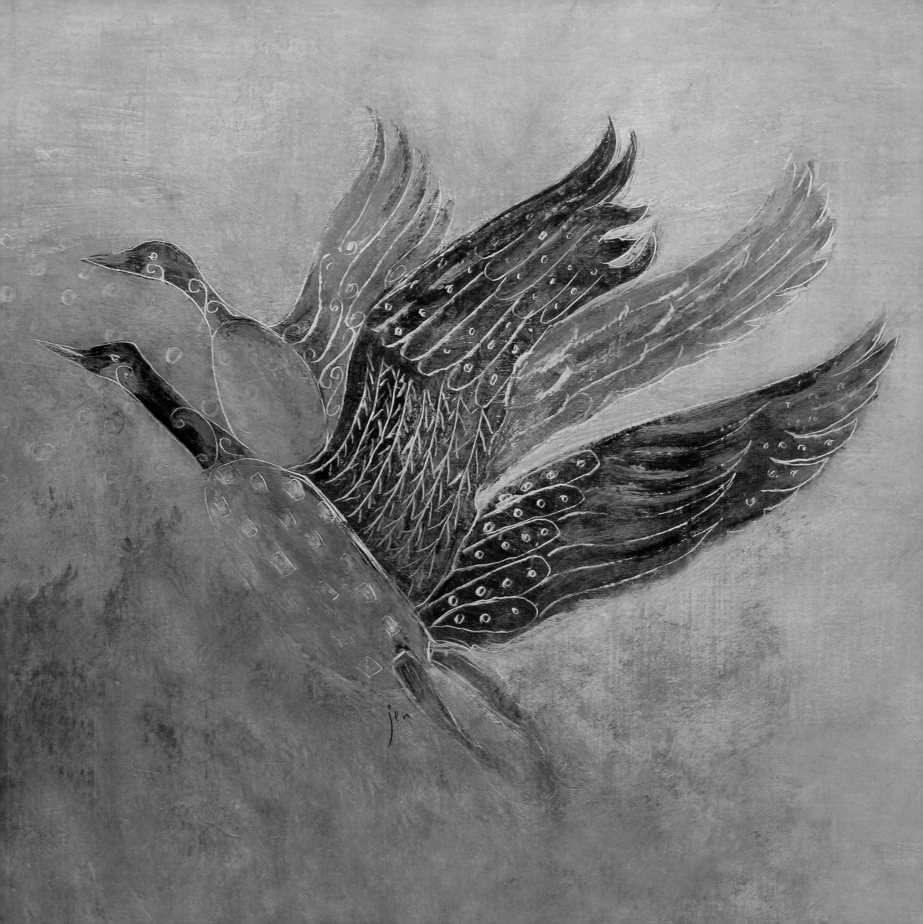

**J**oseph of Arimathea was a wealthy businessman and disciple of Jesus of Nazareth, apparently having had connections to the tin trade in Cornwall. It is written that after Jesus' crucifixion, Joseph asked Pilate for his body, took him down from the cross and with Mary Magdalene laid him to rest in Joseph's own newly built tomb.

According to medieval writings Joseph was chosen by Saint Philip the Apostle for a preaching mission to establish Christianity in the farthest corner of the Roman Empire—the island of Britain.

**Glastonbury**—*Ynis Witrin*—was where Joseph of Arimathea was said to have come around 63 AD. He was accompanied by twelve clerics and carried a hawthorn staff grown from Jesus' crown of thorns.

When he arrived at Glastonbury, Joseph stopped to rest, weary after his long journey, and thrust his thorn staff into the earth, where it miraculously took root and burst into bloom. Some say that cuttings from this tree can still be seen today, blooming only at Christmas time.

Legend reports that Arviragus, the local ruler, granted Joseph land on which to build the first monastery in Britain. Archaeological records show that there may well have been an extremely early Christian church in Glastonbury, although it was not until the thirteenth century that the legend of Joseph of Arimathea began to appear.

This story shows the close connection of the early believers to the source of the Christian Mystery Tradition, while living far from the power centers of the Church of Rome. The planting of his hawthorn staff (or

magician's shaman stick) in the mythic land of Arthur is a symbol of the integration of the Old Religion with the new theology.

The fertile Hawthorn is a wild, beautiful, gnarled and thorny little tree that can live to a great age. Known as Huath in Ogham (the alphabet of the Druids), Hawthorn represents fertility and rebirth in the Celtic tradition. Known in folklore as the May Tree, her blossoms appear at the beginning of May, the time of the Beltain festival when the folk would gather the blossoms to celebrate spring—*bringing home the May*. These stories intertwine the old and new beliefs that developed over many years and have taken root within the Folk-Soul.

**The Celtic Church** cut off from the continental ecclesiastical power centers and became insular, developing its own character and merging elements from the Old Religion of the communities into which it grew.

While there is no doubt that oppression—and often violent removal of the practices of the Old Ways and the folk who followed them—occurred frequently throughout the Celtic lands, it is important to note that this merging of religions was not always, or simply, a deliberate strategy to convert the pagan peoples.

Many of the early believers naturally adopted the new saints, prayers and stories as simply new guises of their familiar, long-practiced traditions. It was the strength of the spiritual symbols or elements at their core, rather than the specific names or figures, that was important.

The emphasis upon their profound and ancient mystical triplicity continued—now evolved into the Holy

## Deer's Cry

I arise to-day
Through the strength of heaven,
Light of sun,
Radiance of moon,
Splendor of fire,
Speed of lightning,
Swiftness of wind,
Depth of sea,
Stability of earth,
Firmness of rock

—Attributed to Saint Patrick,
seventh century

Trinity. Mother Mary and Brighid the midwife became closely associated, and many local saints grew popular, integrated with the attributes of their older divinities.

The Spring festivals of Beltain merged with Easter, and Winter Solstice was now celebrated as Christmas. Samhain—the opening of the veil between the worlds—was observed as All Hallows Day, or All Saints Day (hallows means holies or saints: Hallowe'en is the Eve of All Hallows).

Many of the early Christian places of worship were built upon ancient pagan sacred sites, but sometimes integrated the old symbols, practices and myths into the new Church. It was a slow process of conversion, a fusion of the old and new faiths, and this gives Celtic Christianity a distinctive character all its own—so interesting, inspiring and relevant for many today.

**P**elagius was a Brythonic Celt by birth, who believed in a new and controversial positive view that human nature, as given by God, could distinguish between good and evil. This heretical view implied that the individual was morally responsible and accountable through his personal relationship with God, and not necessarily through the authority of the Church. This was perceived as a threat to the Church of Rome, and began a theological split around 429 AD.

Pelagius denied the concept of original sin and believed that man could achieve grace through his own free will without the Church, its priests and all its trappings. This independent view, which sought the inherent wisdom within, was understood as being closer to the teachings of Jesus. To live life by his example and as he taught was the way to salvation.

This doctrine of free will was more acceptable to the freedom-loving Celts, and emphasized nature as a source of wisdom.

**The Romano British Church** lasted until the early fifth century when invasions from the Irish in the west, the Picts in the north and the early English in the east drove them to shelter in the Brythonic lands. In the more remote and often inaccessible terrain, Celtic resistance was greater, and the early Church thrived among the Celts, who understood on a deeply personal level the inherent philosophy of Grace within Nature.

Celtic Christianity continued to develop, especially in the more isolated areas of Wales and Scotland, Ireland and Brittany, and there was frequent travel between the important monastic centers where many of our most treasured illuminated Gospel manuscripts were created—such as the books of Lindisfarne, Kells and Durrow.

**The Celtic arts and crafts** traditions in Celtic Britain had become greatly diminished after the Romanization of the western isles. Then with the growth of Christianity began a flowering of the Celtic Arts, illuminated through the Scribes, which gave new life and brilliance to the ancient patterns and symbols. The biblical stories became interwoven with the myths and legends of the people, and were illustrated using the visual language of skilled Celtic artists. They continued to evolve their tradition, portraying the Christian stories with their vocabulary of patterns, animals, symbols and the triple form of the triskele—now, with additional interpretation, the Holy Trinity—in their vellum manuscripts.

Illustration: *Anvil Knot*

# EARLY CELTIC CHRISTIAN ART

**E**arly Christian Celts in Britain and Ireland evolved a unique and brilliant artistic tradition that blossomed in the sixth and seventh centuries. Churches and monasteries became the new patrons of the artists and craftspeople, who created manuscripts, metal-work and sculpture in monastic workshops using their native skills to combine elements of the old pagan symbolism with the new Christian iconography.

The evangelist portraits and Christian symbols, and the idea of the *codex*—the bound book—came from the Christian Mediterranean. The Celtic scribes blended these elements with their local vocabulary of ornament and mythology into a truly Celtic expression.

## Illuminated Manuscripts

of calligraphy and illumination on parchment and vellum (young lamb or calf skin) became the next evolution of the Celtic artist—the Scribe.

Materials were rare and expensive; some pigments were imported from vast distances across the known world, such as the finely ground precious stone, lapis lazuli. The artists used white or red lead; orpiment, *yellow*; verdigris, *green*; ultramarine, *blue*; folium, *blue and pink to purple*; woad, *blue*; and kermes, *red*, with ox gall as a wetting agent. Pigments were tempered with egg white, layered and glazed to create many shades.

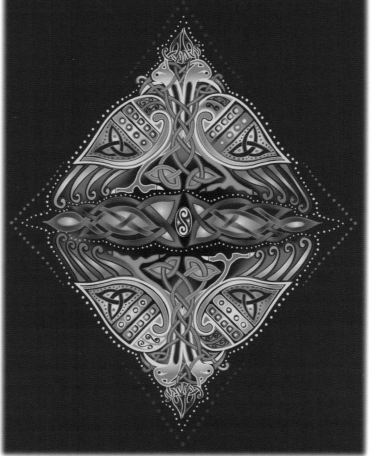

The Scribes used goose quills and brushes of fine animal hairs. The drawing compass was used extensively, with different techniques such as grids and tiny holes punched from the back of the parchment to guide the geometric designs. It is thought that some kind of magnifying glass may have been used, because some details are so tiny, it is hard to imagine how the artists created them.

Manuscripts were produced in major scriptoria attached to the monasteries. There, fine metal and enamel work, often with insets of precious stones, were worked into the Gospel book covers, chalices and valuable devotional objects commissioned by the wealthy patrons of the Church.

By the seventh century the Irish arts had achieved an incredible level of artistry and skill not seen since the pre-Roman La Tène Celts. Continuing to combine elements from the Celtic folk tradition with Christian iconography, the level of aesthetic beauty, craftsmanship and sheer technical brilliance of the Irish artists created some of the finest work of its time.

**The Book of Kells** is considered the supreme achievement and masterpiece of Celtic art. Also known as The Book of Columba, it was probably produced by Celtic monks around 800 AD.

Scribes copied the gospels in Latin with quill pens on vellum—stretched calfskin. The skins of approximately 185

calves were used to create the book, evidence of the comparative wealth of the monastic community at that time.

The four Gospels of Matthew, Mark, Luke and John are illustrated with intricate embellishments and illustration in brilliant colors tempered with egg whites. Scribes used an incredible range of pigments, from beetle wings to crushed oak apples, precious lapis lazuli and ultramarine, some of which were rare and cost more than gold.

Described by the Welshman Giraldus Cambrensis as *the work of an angel*," The Book of Kells is filled with extraordinary detail, with complex imagery of beasts and birds, interlace patterns and spiraling triskeles. The iconic images of the saints are uniquely Celtic in style, with figures creatively shape-shifting into animal forms, often humorously rendered with great style and draftsmanship.

Playful rhythms utilize both positive and negative space to create balance and completion, while remaining meandering, spiraling, free and flowing. The tiny detail and intricacy of the drawings are unmatched even today. With a magnifying glass, in a space a quarter-inch square, one may count 158 interlacements!

The Book of Kells was probably brought by monks fleeing a Viking raid from the Monastery of Columba to Kells, near Dublin, in 806 AD. After many adventures—including being buried, lost and mistreated—it has been at Trinity College since 1661.

It is the most prized object of Ireland and one of the most famous illustrated Gospels in the world. This work was created for the glory of God and Saint Columba, and illuminates the Spirit in Nature and the ancient Celtic Mysteries, integrated with the Gospel stories. It is a masterpiece of Celtic spiritual art that continues to inspire us today.

> **Fine craftsmanship is all about you, but you might not notice it. Look more keenly at it and you will penetrate to the very shrine of art. You will make out intricacies, so delicate and subtle, so exact and compact, so full of knots and links, with colors so fresh and vivid that you might say that all this was the work of an angel and not of a man.**
>
> —Giraldus Cambrensis, Welsh, thirteenth century

Lindisfarne—*Holy Island*—is in the northeast of Britain. A monastery established there was the birthplace of the illuminated Lindisfarne Gospels, another of our great artistic and religious treasures.

The Monastery of Lindisfarne was founded in 635 AD on a small outcrop of land, now known as Holy Island. It lies among the sands a mile and a half off the Northumberland coast. Saint Cuthbert was a monk who later became abbot at the monastery and then bishop of Lindisfarne; he was famous for his miracles.

The Lindisfarne Gospels, among the most celebrated illuminated books in the world, were created in the early eighth century. An illustrated Latin copy of the Gospels of Mark, Luke, Matthew and John made in honor of Saint Cuthbert, they were created by Eadfrith, the Bishop of Lindisfarne. Eadfrith was an artist of exceptional skill and innovation. He illustrated the manuscript with elaborately detailed, intricate patterns in the insular style of native Celtic and Anglo-Saxon artists, blended with Roman and Germanic elements, using a wide range of colors crafted from animal, vegetable and mineral pigments. It is unusual that he was both scribe and illuminator, which gives the manuscript a wonderfully unified artistic style.

The Lindisfarne Gospels are not only an astonishingly beautiful work of art, but have a remarkable and turbulent history, surviving attacks by northern Danes and Vikings who burned and demolished, killing abbot and monks and destroying all that they found.

# LINDISFARNE CROSS

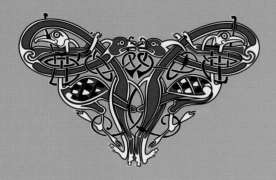

Almighty Creator,
It is you who have made
the land and the sea ...

—Anonymous,
Old Welsh, ninth century

The Lindisfarne Gospels, created at the monastery of Lindisfarne—founded in 635 AD on Holy Island in northeast England—are a masterpiece of manuscript painting, produced less than a century after the introduction there of Christianity. The Gospels illuminate the stories of the four evangelists, Matthew, Mark, Luke and John. Medieval manuscripts were usually created by more than one scribe or artist. The Lindisfarne Gospels have a unified, inspired design throughout, as both illumination and text were created by the gifted artist monk Eadfrith, who became bishop of Lindisfarne 698–721.

This design is an adaptation of a section of the cross-carpet page introducing the gospel according to Saint Mark. The highly detailed *carpet pages* consist entirely of illumination and no text, and are so named because they are reminiscent of Oriental carpets.

Although interlacing design is featured in the art of many cultures around the world, some of the finest knotwork interlacing was developed by the Celts. The imitation of the works of the Creator was commonly forbidden in many ancient cultures, and until the Christian era even vegetation was often taboo as a motif for ornament. Instead, emphasis is upon the magical weavings created by geometry, mathematics and complex patternings that were not copies of life, but rather abstractions of the world. Within the two-dimensional intricate weavings, the third dimension is the mystical element, the spiritual aspect of things. Knotwork patterns reflect the Celtic belief in the continuity of life, the interconnectedness of all things. The path of fate and the mysteries of nature are often symbolized by these elaborate designs that were regarded with awe and sometimes believed to trap evil spirits, which would become lost within their tangled twists and turns. Mandala patterns are intuitively sacred to many ancient cultures: the eye, following the interlacing meander patterns, journeys along a mystic path.

Illustration facing page: *Lindisfarne*

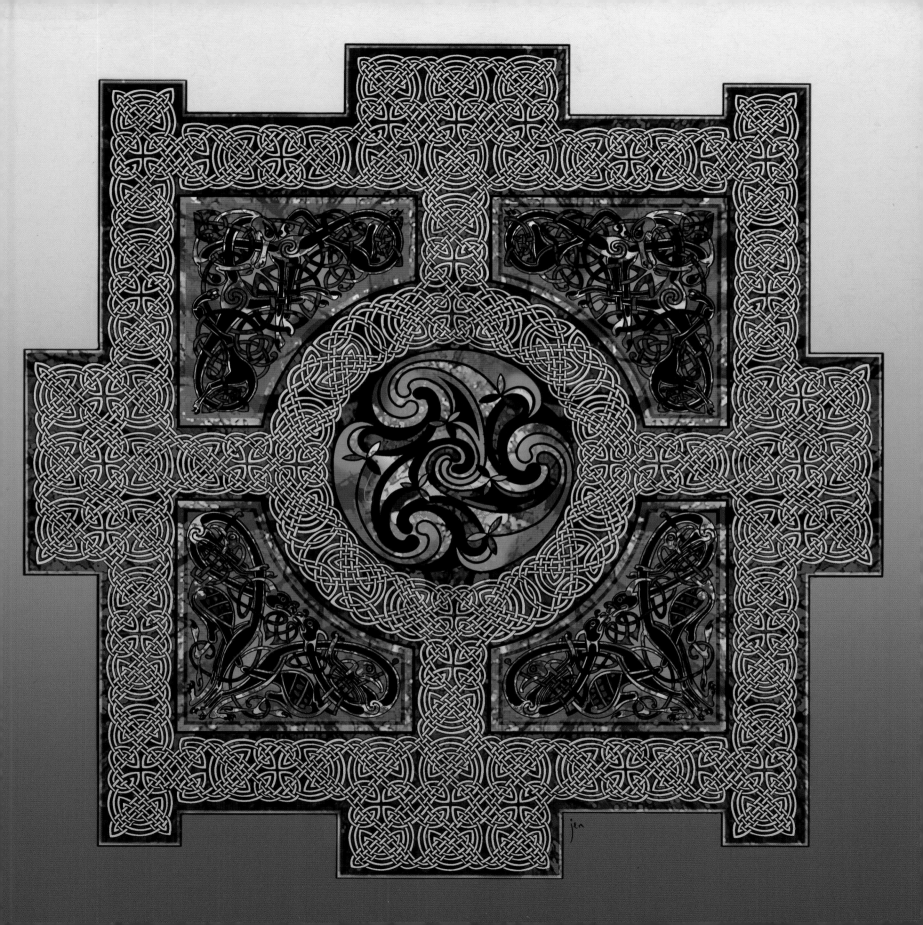

# MONASTIC TRADITION

**I**ona is known as I Chaluim Chille, *the Isle of Colm Cille,* in honor of the Irish priest who would become Saint Columba. A rugged, storm-swept tiny island in the Hebrides approximately one mile from the coast of Mull in Scotland, Iona became one of the greatest centers of Gaelic Christianity.

The island has been inhabited by Stone, Bronze and Iron Age people, and in 563 Colm Cille, exiled from his native Ireland, established a monastery there. Iona became well known throughout Europe as a place of learning and pilgrimage, and was an important Celtic Christian mission where many Scottish, Irish and Norwegian Kings chose to be buried.

In between the plundering raids by the Danes and the Vikings, Iona was once rich with treasures and artistic objects created by monks who were skilled in the working of metal, glass, wood and leather. Hundreds of beautifully carved stone Celtic crosses once graced the island, although only three remained intact after the repressive years of the Reformation. Many gospel books were written and illuminated on the island, some even surviving the Viking raids that plundered the monastery many times over the centuries.

Today there is a renewal of the spiritual creative life on Iona. Inspired by the Celtic Christian revival, in 1938 George MacLeod of Fuinary founded the Iona Community, a group of ecumenical Christian men and women. They rebuilt some of the ancient monastic buildings of Iona Abbey, creating a community to bring together work and worship, prayer and politics, the sacred and the secular.

They have chosen the Wild Goose to represent them—an independent Celtic symbol of the Holy Spirit.

**Saint Columba**—*Colm Cille*—is named for the gentle Dove of the Church. He was great-great-grandson of Niall of the Nine Hostages, an Irish king of the fifth century. He became a monk and was ordained as a priest, then exiled from his native Ireland due to a dispute over a psalter manuscript that eventually led to the bloody Battle of Cúl Dreimhne in 561.

In 563 he was granted land on the island of Iona, which became the center of his evangelizing mission to the Picts. He won the respect of the local kings and tribal leaders and became famous for performing miracles and being a wise Holy Man.

Columba founded several churches in the Hebrides and created his monastery at Iona. It became one of the most important centers of learning, probably producing the extraordinary illuminated manuscript The Book of Columba, more famously known as The Book of Kells, later named for the place in Ireland where it was moved for safety.

**Saint Aidan** is a celebrated Irish monk from Iona. Oswald, the second son of Aethelfrith, the English warrior-leader, had been converted to the Christian faith by the Irish monks from the monastery Saint Columba founded on Iona.

In 635 AD Oswald invited Aidan to establish a monastery in Northumbria. He chose the island of Lindisfarne and built a community of simple huts, workshops and a church. There the monks lived a life of prayer, study and austerity. Irish monks were well known for their skills in reading, writing and Latin. Aidan decided on a strong education for the monastic male community and created a sanctuary of learning.

**T**he Welsh Church during the early Middle Ages retained antiquated customs no longer practiced elsewhere. Monasticism was widespread, inspired by practices in fourth-century Egypt, and the monks composed poetry in Welsh, not in Latin. They considered poetry *"a requirement of a pious soul"* and thought devotional practices should include *"listening to the songs of clear-speaking poets"* (medieval Welsh text).

**The Black Book of Carmarthen** contains good examples of monastic poetry dating from the ninth or tenth centuries. This poetic tradition is a distinctive Celtic practice with roots in the bardic tradition of the Old Religion.

**Saint Brynach** was a native of Pembrokeshire who spent many years in Brittany following a pilgrimage to Rome. His

feast day is April 7th, when it is said that the first cuckoo of spring sings its first song from the top of the Nevern Cross.

The Church of Saint Brynach was founded around the fifth century. Brynach was a good friend and contemporary of Wales' patron saint, David, who died in 570 AD. The church was an important stopping place for pilgrims making the journey to the shrine of Saint David, *Ty Ddewi*—one of the most revered places of pilgrimage in Britain—from Holywell, the sacred healing spring of Saint Winifred.

**N**evern, *Nanhyfer*, is close to the powerful Pentre Ifan Cromlech, and Saint Brynach's, with its wonderful Nevern Cross and ancient Ogham Stones, is one of the earliest Celtic churches in West Wales.

Situated in a quiet, pretty little hamlet nestled in the valley of the river Nyfer of the Preseli Hills, *Mynydd Preseli*, in Pembrokeshire in west Wales, the church at Nevern was erected on one of the earliest Christian places of worship in the country.

**The Nevern Cross** is stunning, thirteen feet high and still in surprisingly good condition despite more than ten centuries of standing among the ancient Yew trees. It is a huge stone, beautifully colored with amber mosses and green lichens. Elaborately carved around 1000 AD and intricately patterned with Celtic knotwork and keyfret designs, it is one of the finest in Wales.

The gates of Saint Brynach's Church lead to an avenue of the ancient trees known as *the Bleeding Yews*. Once sacred to the Druids, many legends surround these old trees, which are evergreen and continue to grow from their extensive underground root system, representing everlasting life. The early Irish regarded the Yew—*Idho* in Ogham—as one of the most ancient beings on earth. The ninth century historian Nennius quotes from the poem "Seven Ages": *The life of a yew, the length of an age*, and the fourteenth century Book of Lismore says: *Three lifetimes of the Yew for the world from its beginning to its end.* Yews were important tribal trees for the Celts, as for the

Druids, and it is probable that these trees were established here before the first Christians worshipped in this place.

During the summer months the Nevern Yews emit a slow trickle of red sap, said by some to be the blood of the earth and thought by others to be in sympathy with the crucifixion, deepening the connection between the old and new mysticism.

A far older pagan site was first at this place and it is notable that the early Celtic Church did not always destroy the ancient symbols or the sacred trees, instead sometimes integrating them into their new buildings. This practice may be unusual, but did occur in the Celtic lands of the West. This process created spiritual growth rather than a total suppression of the Old Ways, and a powerful continuity of tradition that we can still feel reverberating today.

> On hill in hollow,
> on islands in the sea,
> everywhere you go
> before blessed Christ
> there is no place that is
> God-forsaken
>
> —"Maytime Thoughts" from *The Black Book of Carmarthen*, thirteenth century

**Ogham Stones** can also be seen in the churchyard of Saint Brynach's in Nevern. One of the oldest surviving examples of Ogham, the writing of the Druids, remains on the Vitalianus Stone, which was carved around 500 AD.

Mounted on one of the windowsills dating from the fifth century is the Maglocunus Stone, which is associated with the early Welsh King Maelgwyn Hir, referred to by the Christian writer Gildas as Maglocunus. It is extremely important, as it is one of the few existing bilingual stones—containing inscriptions in both Latin and Ogham script.

It is a privilege to touch the ancient carvings and to realize the long continuity of traditions represented by this stone, lovingly respected through the ages in this peaceful Celtic church.

**T**he Celtic Folk-Soul nurtures the wild boy, celebrates the hermit monk, reveres the saint of the people from whom he comes. Celtic spirituality draws from a language of art, myth and nature—worshipped within the ancient groves, translated through the asceticism of the monasteries—and continues to infuse both Christian and alternative spiritual expressions today.

I have a hut in the wood,
none knows it but my Lord;
an ash tree this side, a hazel beyond,
a great tree on a mound enfolds it.

—Anonymous, Irish,
"The Song of Manchin of Liath"

# Y GROES GELTAIDD—CELTIC CROSS

Often associated with the Tree of Life, the Celtic Cross predates Christianity; the oldest example is from 10,000 BC. The first cross symbols represented the sun. In the megalithic age and in the Celtic epoch, the sun was considered to be the divine center of the cosmos, the light of the world.

The sign of the sun is the circle with a center. The circle represents the whole, the encircling spirit, the sun illuminating—an all-embracing essence of light. In the Celtic Cross, it is the center where all forces come together. The central spiritual source is here represented by a triskele motif symbolizing the mystical Celtic trinity.

The cross is the cosmic wheel, representing the four seasonal positions of the sun—cosmic order—the four directions, elements, four seasons. The Wheel Crosses have round heads of large diameter and short shafts and are peculiar to Wales, Cornwall and the Isle of Man. This design is based on the great Wheel Cross of Conbelin at Margam Abbey, South Wales.

Illustration facing page: *Y Groes Geltaidd—Celtic Cross*

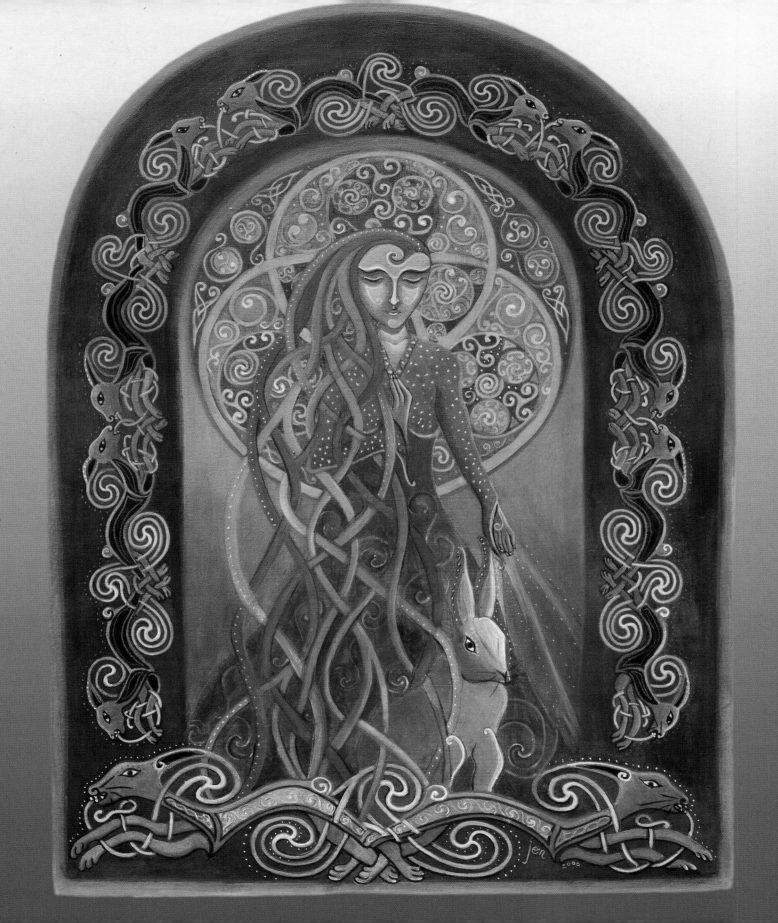

# TALE OF
# MELANGELL OF THE HARES

## Wyn Bach Melangell

**M**elangell, Protector of the Hares, is an inspirational Welsh story that illuminates the courage and spiritual devotion of Celtic women, who were honored among their people. This lovely legend also illustrates the continued theme of sacred connection between the creatures of the Wild and the folk figures or saints of both the Old and New Religions.

Saint Melangell is still honored today at her shrine in the village of Pennant Melangell in North Wales. She was an Irish princess, daughter of King Jowchel of Ireland who lived around 607 AD. Devout and religious, she was promised in marriage to a local chieftain, but she escaped in a small curragh boat to keep her virtue and her faith.

She was utterly devoted to God, and so fled across the sea to find sanctuary in the Welsh mountains, where she lived simply, sleeping on a bare rock in the woods. Melangell lived humbly, embracing the asceticism of the early Christian monks, eating the wild plants, berries and nuts, collecting honey from the hives of wild bees and drinking water from the clear streams.

She found her way to the peaceful green valley of Tenat in North Wales and made her home there, living a life of prayer and meditation among the animals and birds who kept her company.

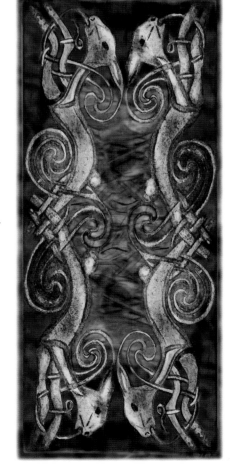

One day the local prince, Brochfael Ysgythrog, *The Tusked*, was out hunting with his hounds. They scented a wild hare, which they pursued into a dense thicket—and there, to the prince's surprise, they came upon the strange sight of red-haired Melangell praying among the brambles and thorns.

The trembling hare had found refuge among her skirts, and in the sunlit clearing the beautiful maiden continued to calmly pray as she faced the baying hounds, wild-eyed horses and impatient hunters.

"Give up that hare! He belongs to me, as all things on this land belong to me," demanded the arrogant prince, "or I shall not restrain my hounds, or my men who are hungry for their prize!"

Melangell remained calm and contemplative with whispered prayers upon her lips, and showed no fear. The wild hare remained close, seeking protection from she who lived among the animals.

The men were surprised by her serenity and courage, and again Brochfael Ysgythrog demanded that she give up the hare, although he was less certain of his threats than he had been before. "Leave this place, give us our quarry and no harm shall become you," he pleaded, but the lovely maiden remained steadfast and the hounds and men grew restless.

As Melangell continued to pray, a shining light appeared around her. The

---

Illustration facing page: *Melangell of the Hares*

**God is in the flowers**
**Sprung at the feet of Olwen, and Melangell**
**Felt his heart beating in the wild hare.**

—R. S. Thomas, "The Minister," 1953

hounds cowered to the ground with ears flattened, tails between their legs, whimpering in fear. The horses backed away, their eyes wide with uncertainty, refusing to come closer, and the hunters became quiet and wary. The prince found his horn stuck to his lips and was unable to move.

Brochfael Ysgythrog was a little ashamed to have his power thwarted by a young girl in simple rags, but he was impressed by her courage and moved by her spiritual presence. He fell humbly to his knees and knelt before her. "For your holy conviction I honor you, my lady. From this day forward, all wild creatures in this valley shall not be harmed, and I grant you this land, and its protection shall be yours."

Melangell's faith was so strong that she was not surprised, but was surely relieved to be spared the terrible fate of the hounds and the cruel lust of the hunters. The wild hare, it must be said, was also quite grateful to live to tell the tale to all other hares who live happily in the valley of Pennant Melangell still to this day. Melangell blessed

Brychwel Ysgythrog, who was later converted to her faith and helped build a church for her, and she became the abbess of the nunnery founded in her honor.

Built upon an ancient circular Bronze Age site, the Church of Pennant Melangell has continued to be a place of pilgrimage and sanctuary since the seventh century. At the Reformation, her shrine was dismantled and the stones reused in the churchyard. Her restored shrine is reputedly the earliest surviving Romanesque shrine in Northern Europe.

In Wales, Melangell—or Monacella, as she is also known—is the Patron Saint of Hares, who are still called Wyn Bach Melangell, *Melangell's Little Lambs*, and her shrine is still visited by pilgrims today. For centuries no one in her parish would kill a hare, and if seeing one chased by dogs, the folk would cry out, "God and Saint Monacella be with thee!" in hopes that the hare would escape its pursuers.

Illustration: *Leaping Hare*

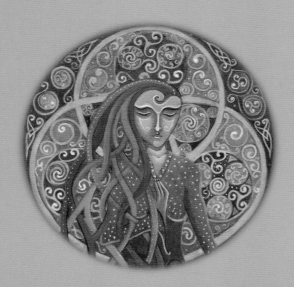

# A CLOUD OF WITNESSES

Melangell, in your box of lead, find us.
Brynach, Beuno, Tudno, Llyr.
The earth's your sleeping hare,
will jump to greet you.
Tysul, Teilo, Gwynlliw … Rain
will rub its pelt of weather hard
against blind windscreens …
Padarn, Maelog, Gwendolen …
until we feel the mountains move
towards you, Twrog, Rhystud, Llawen, Gwaur.
In company, the light grows great
around you—headlamps shine across the dark
from Cadfan, Rhydian, Sannan teg
and through the gloom of space we see
the sun take shelter in your spirit's sky
and you surrounded by the daylight stars
of other saints who shall not die—
Cynog, Padarn, Ederyn Fawr.
From time, our hunter, guard us with your prayer
Melangell, strongest steel and softest air.

—Gwyneth Lewis, excerpt from "Melangell Variations: A Cloud of Witnesses"

Here "peace on earth" is written in some of the
living languages of the Celtic Nations.

Tangnefedd ar y ddaear (Welsh)
Shee er y talloo (Manx)
Re bo cres yn nor (Cornish)
Air talamh sith (Scottish)
Peoc'h war ar bed (Breton)
S'ocháin ar talamh (Irish)

# DOVES

Irish Missionary Saint Columba, *Saint Colm Cille*, means *Dove of the Church* in Irish. Among many mythologies the dove appears as a feminine symbol of soul, wisdom, rebirth and harmony. In the ancient world the concept of harmony was close to healing. Images of doves were offered to the Celtic healer-deities of thermal springs, and multiple stone figures of doves were offered to the curative spirits presiding over shrines.

Like ravens, doves were perceived as oracular birds, perhaps on account of their distinctive call. In classical iconography and mythology, doves were attributed to Venus, Goddess of Love. Both dove and olive branch originally meant *the peace of the goddess*.

Illustration facing page: *Tangnefedd—Peace*

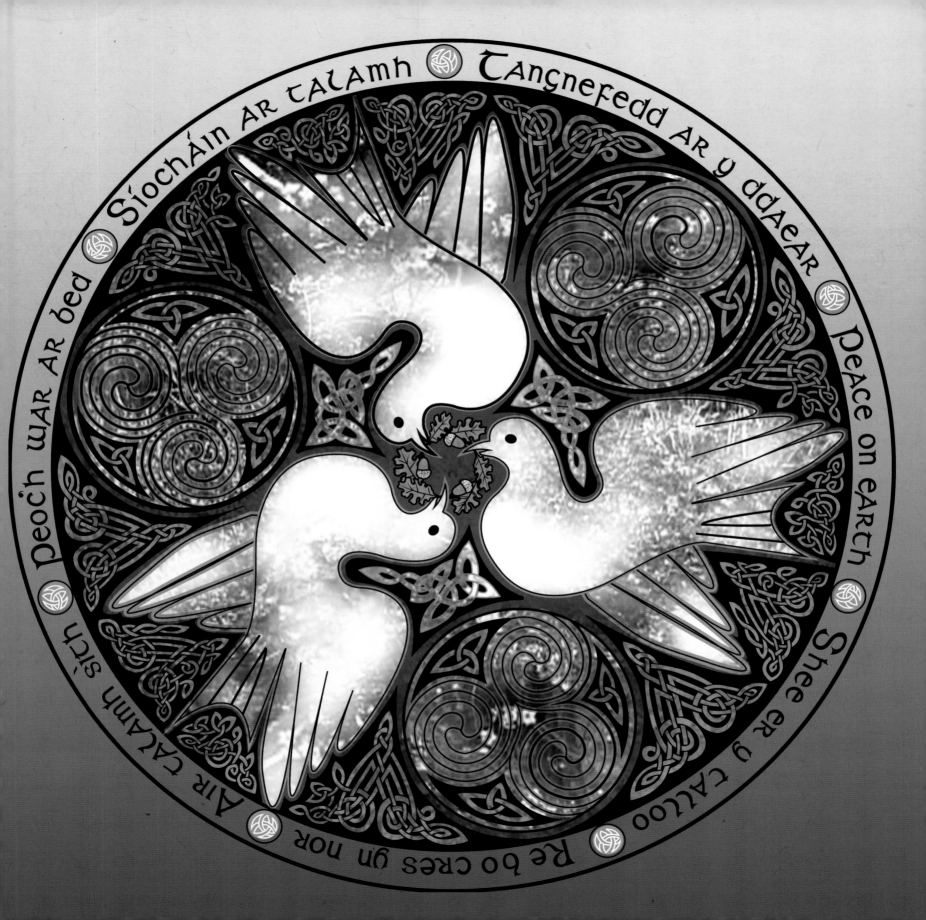

# WIND
# journey

And I will bring you the homelessness of the sea
and the peace of the restless wave,
and love like the wandering wind.

—Fiona MacLeod, *By Sundown Shores,* 1901

# WIND journey

**W**ind is sculptor of the skies, the breath of the heavens. Shifting element of journeys into the vast spaces of the above—the realm of the birds and stars—Wind crosses through the visible and invisible and is a powerful force of nature.

Wind moves through the boundaries of our perception and is the shape-shifter element. In the Celtic myths and folktales, shape-changing between human and animal form, between this world and the Otherworld, is commonplace, and the Druids believed in the transmigration of souls from one body to another. Metaphysical symbol of change and movement, Wind represents the Journey.

> **I am the breeze that nurtures all things green.**
> **I encourage blossoms to flourish with ripening fruits.**
> **I am the rain coming from the dew**
> **That causes the grasses to laugh with the joy of life.**
>
> —Hildegard of Bingen, tenth century,
> translated by Gabriele Uhlein

**The Journey** is the movement into the unknown. Heroes and monks adventure *Beyond the Ninth Wave*, and Wind represents this journey through life into the uncharted realms. The invisible force is both gentle and destructive, an often turbulent but necessary element of nature and of life itself.

**The Air element** reaches upward and outward, and is the realm of birds and flight. Air carries our prayers upon the backs of breezes, those gentle tides of the heavens. Air represents the element of mind and of consciousness, of

thought and contemplation. From the moment we leave our watery womb and take our first painful gasp in the world, air means life to us.

**Wind is the voice of Nature,** whispering soft blessings through the leaves, singing through the sharp grasses, whistling in the gullies. Wind gives life and gentle rhythm to the world; without it all would be deathly still. Wind conveys secrets, Wind rages. Sometimes frenzied, storming down mountainsides, breaking boughs of the strongest trees and destroying our shelter, the howling mistral of the heavens reminds us of the powerful force that is nature.

**Winds of Change** are the ambiguous transitions between one state and another. The wind/air element represents the shifting boundaries between earth and water, the bogs and marshes—the uncertain places. The in-between times of twilight and dawn, and the turning points of the seasons at Spring or Fall Equinox, are the liminal thresholds when, like a wind spirit, change moves through the fluid gateways between the visible and invisible, the known and the unknown.

The Celts were intensely aware of the mystical moments and places where the veil between the worlds grows thin as a shifting mist, a gentle breeze that softens the sharp edges of reality. The real and the supernatural exist side by side along a single continuum. Time is itself fluid. Like the wind, it cannot be seen, yet it shapes the everyday and Otherworld realities.

Within the faerie mounds or the shadowy circles of the ancient stones, the Fair Folk, *the Tylwyth Teg,* open a door into their immortal world where you can dance all

night to their enchanted music and feast upon banquets of delicacies, entertained by their beauty and youthful sparkle. When you wake upon the lonely, grassy hill in the cold dawn, a year or a hundred years has gone by, and you are left withered and empty.

The veil between this world and the Otherworld grows thin at Samhain, *All Hallow's Eve*, which marks the movement into the dark time. This is when the spirits come through. Even today we make entertaining ritual with trick-or-treating for the kids, and masquerades that have roots in the old traditions of Samhain.

The earth spirits are manifest in many varieties of supernatural creatures, wicked and cunning, conniving and sometimes kind. Brownies, elves, knockers, imps and leprechauns, sprites and goblins all slip through the shifting places. If you treat them badly they will sour your milk, steal your livestock or exchange a human child for a faerie changeling in the cradle. They were once familiar, feared and respected by the country folk of Wales, Cornwall, Brittany, Ireland and Scotland, and some people are still wary of their presence. They haunt the bogs and moors, the quarries and mines, the ancient woods and wild places.

**Winds of Transformation** infuse the imaginations of the Celts, like the Butterfly, who grows from her dark, internal earthbound cocoon to unfold delicate painted wings and move into the realm of the air. This fragile creature, known as *Pili-Pala* in Welsh, is our most positive and enduring symbol of magical transformation. In Wales moths were thought by some to be the souls of the Ancestors, seeking their way back home as they flew toward the light within.

Celtic myths tell of shape-shifting between animal and human forms, exchanges with time and place,

between the world of the Sidhe, the faerie folk and earth spirits. Birds were seen to have supernatural powers, and throughout Celtic mythology divine beings frequently shape-shift between human and bird form.

The cry of the Crane is the shriek of the old Hag—*the Calleach*—who was once young and beautiful. The Owl of the dark woods is Blodeuwedd, the woman of flowers changed into the bird of the night for betraying her husband. The Children of Llyr are transformed into Swans by their jealous stepmother, and the Triple Morrigan shape-changes into the Raven, ominous oracle upon the battlefield.

**Soul Journey** and the cycle of life and death lie at the heart of Celtic philosophy. The Ancient Celts believed that the soul journeys to the Otherworld, and buried their dead with ritual objects and food.

Death is inevitable, a spectre waiting in the shadows, but an essential transformative aspect of life. Folklore is filled with superstitions and signs from nature that presage the death presence upon person or home. The journey to the Otherworld begins with the call of the Geese, the howl of the Dogs, the keening of the Banshee.

In Wales it was thought that the howl of the Hounds of Annwn foretold death. The pack of the Cwn Annwn—known as Cwn Wybr, *Dogs of the Sky,* in some places and Cwm Bendith y Mamau, *Hounds of the Mother,* in others—take flight on the stormy wind-loud nights to chase the dead. The screech of an owl heard near a house, or a solitary crow or goose flying over a house, is an indication of death coming soon.

The Raven is the powerful Triple Morrigan who appears on the battlefield. She is a carrion bird, and symbolizes healing and rebirth as the eater of death.

Illustration: *Morrigan*

## The Banshee

And there, by Shannon's flowing,
In the moonlight, spectre-thin,
The spectre Erin sits.
A mother of many children,
Of children exiled and dead,
In her home, with bent head, homeless,
Clasping her knees she sits,
Keening,
And at her keening the fairy-grass
Trembles on dun and barrow;
Around the foot of her ancient crosses
The grave-grass shakes and the nettle swings;
In haunted glens the meadowsweet
Flings to the night wind
Her mystic mournful perfume;
The sad spearmint by holy wells
Breathes melancholy balm.
Sometimes she lifts her head,
With blue eyes tearless,
And gazes athwart the reek of night
Upon things long past,
Upon things to come.

—John Todhunter,
nineteenth century

## CALLEACH

The old Calleach is the *Washer at the Ford*. She is a powerful figure, standing on the boundary of the river between this life and the next. She shifts between the figure of an old woman and a beautiful young girl, between Queen of Winter and then of Spring. She is midwife of our journey to the Otherworld, the ancient Crone or Hag who delivers both life and death. In Scotland she is the *Bean Nighe*, known in many guises, each an aspect of the wisdom of the fearful old dark creature who stands at the brink of death and destruction, but also holds the wisdom of rebirth on the other side. The Calleach sits at the ford, the road through the river, washing the clothes—our material bodies, as the women ritually wash the bodies of the dead before burial.

She is *"the Woman of Tears who had her feet far down amongst the roots and trees, stars thickening her hair as they gather in the vastness and blackness of the sky on a night of frost."* —Fiona MacLeod

The Banshee is also an omen of death, a messenger from the Otherworld. She keens her sorrow and grief, brings death to the homes of those who hear her cries. She is feared, but also respected.

Illustration facing page: *Sheela-na-gig*

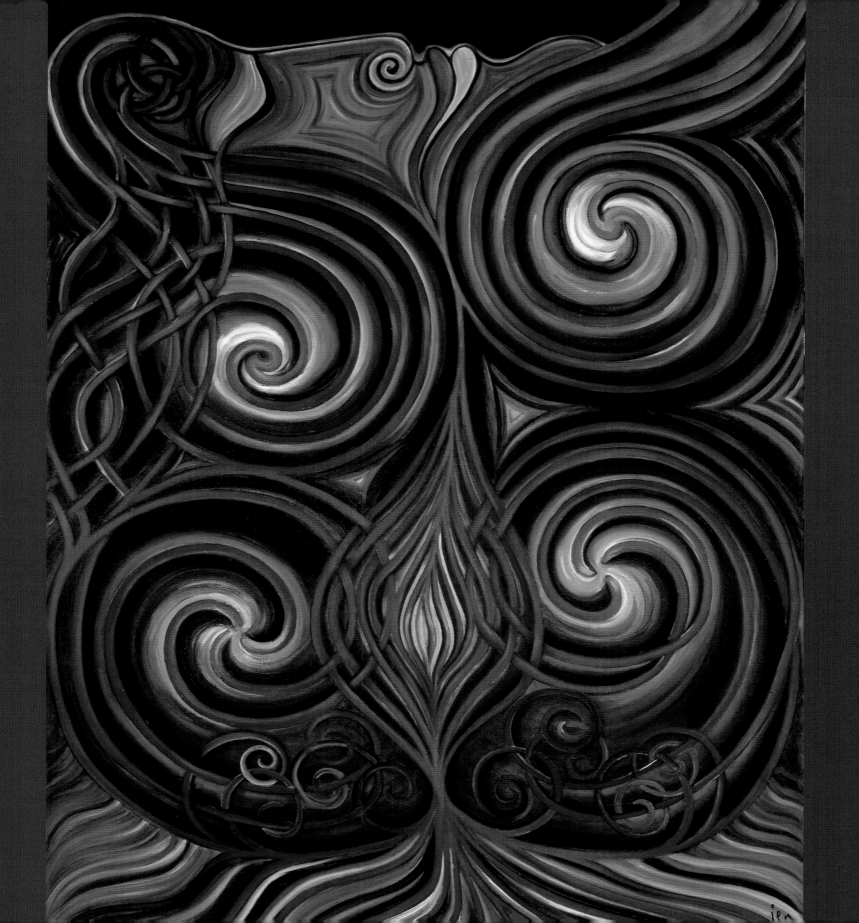

## WINDS FOLKLORE

**The god Lugh always comes in the old stories from the north-east, while the goddess Morrigan comes from the north-west. The fierce wind raising the Scottish Goddess of Spring comes from the south-west. All over Britain the fairies come from the west on eddies of wind like the Greek nereids. In Scotland the evil working giants come from the black north. It was believed that the dead went westward or south-westward towards Paradise.**

—Donald Mackenzie, *Ancient Man in Britain*, 1922

**Winds and storms take their place in Welsh lore. In the North the raising of the whirlwind was attributed to the eagles of Snowdon; in the South they said it was brought about by wicked and malicious elves and fays, and in Mid-Wales they said it was raised by the devil and his hosts when they had a meeting among the Black Mountain.**

**In the past the old people regarded the wind to be both hungry and thirsty for it was customary to throw out a handful of flour, barley-meal, or oatmeal into the wind, and it was generally followed by a bowl of water or a cup of milk. These offerings were supposed to pacify the storm. They also breathed their wishes to the balmy west and south winds, and the soft breezes of summer foretokened pleasant news.**

—Marie Trevelyan, *Folk-Lore and Folk-Stories of Wales*, 1909

**The Sow** is the ancient Goddess Ceridwen—Hen Wen, *the Old White One*. She represents fertility and will eat her young to keep the strong ones alive. Death and rebirth are connected together within nature, and within the mysticism that draws from this philosophy of interconnectedness and balance that the Celts understood as the cycle of life.

The Cauldron of Plenty also demands sacrifice. The Cauldron of the Feast consumes the dead warriors, and renews them with life. The one is balanced against the other as a deeply symbolic realization that life needs death for life again.

## WINDS OF MIGRATION

**M**igration is represented by the creatures of the air. Each spring and fall, flocks of wild birds take wing to the north or the south—to survive cold winters, or to return home to lay their eggs and nurture their young in the fertile place of their birth. Their unerring instinct for navigation was admired by the Celts, who appreciated the wisdom and loyalty of the birds who returned each year to their seasonal homes upon the winds of their journey.

Birds are natural masters of the currents of the air. Free they fly; joyful it seems, they skirt the high tops of trees, glide down mountain canyons. Undizzied, they sit upon the ledges of our tallest buildings and make their nests there. They make great sea journeys, migrating impossible distances to lands far away. Birds held the secrets of the sky before we learned to follow with our metal-winged machines, and still they keep the mystery of feathered freedom and of knowing their way home. Not so long ago we could only dream of that bird's-eye view, could only experience something of communion with the heavens from the highest mountain peaks.

Within Celtic folklore birds are messengers between the earth and the sky, carriers of the souls of the newly born and the newly dead to and from the Otherworld. Birds evoke ideas of freedom, the human soul liberated from the body at death.

**West Winds** have persistently pushed the Celtic peoples over many centuries. The tribal nomadic Celts made their homes in the mountainous and more remote western coastal areas, especially Britain, Ireland and Brittany. They came to rest in the lands of the misty ancient places and still they journey, seeking the freedom of the West Wind, to the New World.

In recent times many have left their homelands, fleeing poverty, famine, persecution—seeking a new life but with the heaviness of *hiraeth*, or longing for all that is left behind. This movement is a compelling force within the psyche of the Celtic folk. The West Wind represents this character, the adaptation and change that are essential to keeping the culture alive and renewed. The journey is both physical and spiritual, representing transformation throughout a turbulent history.

**The early Christian monks** took to the currents of the sea and the prevailing winds that filled the sails of their humble curragh boats to make great journeys into the unknown, to land upon the remote northern islands—there better to serve their God of the elements and of all things in their humble dwellings.

Saint Brendan the Navigator was the greatest traveler and voyager of the Irish saints. His mythic voyages exploring the wild, uncharted seas were also journeys into the supernatural realms of the unknown. Along with the myth of the Voyage of Brân to the Land of Manannán beneath the waves, the tales of his adventures to find the shifting mist-shrouded island of Hy Brasil, *the Isle of the Blessed*, has fueled the Celtic imagination to follow the adventuring West Winds.

## Roads

No need to wonder what heron-haunted lake
lay in the other valley,
or regret the songs in the forest
I chose not to traverse.

No need to ask where other roads
might have led,
since they led elsewhere;
for nowhere but this here and now
is my true destination.

The river is gentle in the soft evening,
and all the steps of my life
have brought me home.

—Ruth Bidgood, Welsh, "Roads"

**Madog ab Owain Gwynedd** was a twelfth-century prince from Gwynedd who sailed westward with a small fleet of ships—his was the *Gwennan Gorn*. Adventuring westward, he is said to have landed at Mobile Bay, Alabama, in 1169 over three hundred years before Christopher Columbus's voyage in 1492.

It is not entirely impossible for early Welsh settlers to have arrived in the Americas back in the early twelfth century. It is known that the Norwegian Leiv Eiriksson was the first European to set foot on the shores of North America in 1001 and that Viking explorers reached Canada around 1100.

Legends tell of the adventurers settling in the Mississippi Valley, where they connected with some of the hospitable Native American tribes-people, sharing their ancient Celtic stone fort-building skills and eventually settling together, raising families and merging some of their Welsh language and customs with those of the native people.

### Myth of the Welsh Indians.

It is said that Louisville, Kentucky, was once home to a colony of Welsh-speaking Indians. In 1669 the Reverend Morgan Jones was captured by a tribe of Tuscaroras called *the Doeg*. His life was spared when the chief heard Jones speak Welsh, a tongue that he apparently recognized. Stories of Welsh Indians were so popular that even Lewis and Clark were ordered to look out for them on their epic journey of exploration across the American continent.

At the time of the Revolutionary War, some light-skinned, bearded Mandan Indians were discovered in the area that is now North Dakota; their language and customs were said to have similarities to the Welsh. It was recorded

that they used a small round boat almost identical to the Welsh *coracle*—made from a hide stretched over a willow frame. Unlike the other nomadic tribes in the Mississippi River area, they practiced agricultural farming and lived in round huts surrounding a communal center, similar to many Celtic-style villages. Also around the Ohio River Valley are old-style Welsh hill forts and inscriptions in *Colbren*, the old Welsh alphabet.

Today this evidence is mostly refuted by scholars, but these are fascinating stories believed by many throughout history—including Queen Elizabeth I, who used the legend as justification for a war against Spain, claiming that the British had title to the empire of the Americas! The myths have survived and continue to ignite our imagination, partly due to the strong affiliation the Welsh feel for their ancient connections with America. Indeed, there are few families back home who do not have a relative who has emigrated to this country, and a cultural brotherhood extends between the two lands.

## THE CELTS TODAY

**M**odern Celts are a diverse people. Many proudly remember the enduring beauty and inspirational strength of their cultural heritage. In the New World countries that have been settled by many from the Celtic lands, the Folk-Soul finds fertile soil for the seeds of a spirit that is not dependent on time or place.

The modern Celt does not necessarily speak the ancient tongue, is most probably not of direct blood ancestry to those westward wandering Indo-Europeans and may not even live in the same lands as the tribal people of history.

Today the traditional spiritual homeland of the Celtic Folk-Soul lies in the modern Celtic countries of Wales, Ireland, Scotland and Brittany, where Celtic languages are still spoken. It also lies in Cornwall, on the Isle of Man and in parts of Galicia on the Atlantic coast of Spain where Celtic musical and folk traditions continue to be enjoyed.

Celtic culture has migrated beyond the traditional heartlands to take root in the New World as Celtic

immigrants have continued to journey westward into our times—to the Americas, Australia, New Zealand, Canada and beyond. There are strong Celtic communities today in places far from their traditional homelands, such as in Welsh Patagonia in South America, Nova Scotia in Canada, and in urban centers of North America such as New York and Chicago.

Their migration is a wandering refrain, and the songs of hiraeth and longing for the home left behind have deeply colored the Folk-Soul—they are an inherent emotional response in her people.

**The Journey to the New World** is an integral part of the modern history and mythos of the Celtic people. The Folk-Soul is permeated with the ever-changing culture of these evolving nations. Many of the early emigrants were Cornish, Irish, Scottish and Welsh farmers, miners, preachers and traders—and all those forcibly exiled from the lands of their birth on political or criminal grounds to begin a new life in the New World.

**In Nova Scotia,** *New Scotland*, on the rugged northwestern coast of Canada, in places such as Cape Breton Island, there are people who still know the Old Tongue. There are musical traditions and old Celtic songs here that have disappeared back in the depopulated Hebridean islands: so many of the young people have left the life of *crofting* behind. (Crofts are small pieces of agricultural land on which tenants build their cottages, grow some food and often graze animals on shared community areas. Crofters usually need income in addition to their small holdings to provide for their families. Until the 1886 Crofter's Act, which gave security to the tenants, many crofters were forcibly evicted from their land and their homes.)

Although some refused to leave their traditional communities, and many are now returning to the remote Scottish islands, it is remarkable that aspects of their culture took root in lands far away, continuing to resonate through the songs, dances and music that had once brightened the dark nights at the hearths of the humble croft cottages.

Illustration facing page: *Hiraeth*

# The Twilight People

It is a whisper among
the hazel bushes;
It is a long, low, whispering
voice that fills
With a sad music the bending
and swaying rushes;
It is a heart-beat deep
in the quiet hills.
Twilight people, why will
you still be crying,
Crying and calling to me
out of the trees?

For under the quiet grass
the wise are lying,
And all the strong ones are
gone over the seas.
And I am old, and in my heart
at your calling
Only the old dead dreams
a-fluttering go;
As the wind, the forest wind,
in its falling
Sets the withered leaves
fluttering to and fro.

—Seamas O'Sullivan, 1879

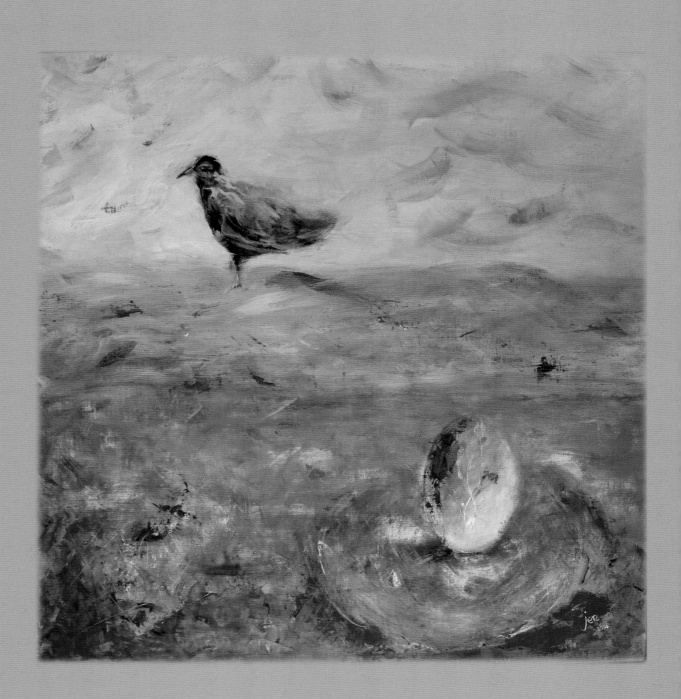

The Great Hunger, *An Gorta Mór,* is the great famine of Ireland that devastated the country between 1845 and 1849. Two million refugees left, with much suffering, to seek a new life in a new land. Over half a million Irish men, women and children died due to the failure of the potato crops. People were cruelly evicted from their tenant farms, and the Irish Diaspora depopulated the small villages and remote lands of Ireland. Her people brought their traditions and culture with them to thrive in the new homes they created. Today, Irish-Americans are a proud and strong community of people whose ancestors made the often terrible journey to the new shores. Their culture is intrinsically woven into the Australian, Canadian and especially the American landscape.

Most of the poor Irish immigrants settled in the cities. By 1850 the Irish made up a quarter of the population in Boston, New York City, Philadelphia and Baltimore. The 1851 census reported that about one third of the inhabitants of Toronto, Canada, were Irish.

## DAFFODILS

In spring the banks of many Welsh rivers and canals, hills and valleys, are incandescent with the bright yellow flower *Narcissus pseudonarcissus,* the wild daffodil, which is the national flower of Wales. Leeks or Daffodils are traditionally worn upon the lapel on March 1, marking the beginning of Spring in honor of Saint David, the patron saint of Wales.

The leek has been a symbol of Welsh identity for centuries. Leeks were also associated with health and medicine. Even today, Welsh soldiers wear leeks in their caps on Saint David's Day. Daffodils, also containing a green stem and white bulb, are often substituted for the fragrant leek by many Welsh. In fact, the Welsh name for the daffodil is cennin Pedr or cenhinen Bedr, *Peter's leek.*

The Irish have produced many well-known politicians and U.S. presidents, including the legendary dynasty of the Kennedys. Many Irish immigrants supported and became leaders of unions, understanding the plight of the workers and the power of organizing. They also became religious leaders and used their native wit and charm successfully in journalism, entertainment and sports.

The identification with Irish heritage continues, and today many people who are interested in tattoos choose Celtic patterns to decorate their skin. Celtic art, music, dance and mythology are still widely enjoyed and appreciated—not only by the Irish but by many who feel connected to this heritage that has taken root in their land. Saint Patrick's Day is celebrated in the four corners of the world with the traditional music and food, wearing of festive shamrock green and plentiful libation at the many colorful street parades and gatherings where Irish pride is honored.

Today, many Irish are returning to the native homes of their grandparents, and Ireland has created a booming economy. But the songs and tales of the sufferings of the Irish people will likely never be forgotten.

The Highland Clearances—*Fuadaich nan Gàidheal,* the expulsion of the Gael—is named for the brutal eviction of thousands of crofters from their land in the early nineteenth century, ending their ancient warrior clan subsistence farming, and forcing many to emigrate.

Most Scots left for Canada, and many came to the United States to farm and work, to create a future away from the persecution and injustices forced upon them back home. Some were exiled to Australia as criminals or political enemies of the English.

Scottish emigration began in the eighteenth century after the destruction of the clan system that followed the Battle of Culloden in 1746; prohibitive land rents drove Scottish farmers away from their beloved country in large numbers to settle in America and Canada.

By 1890 there were over two hundred fifty thousand people born in Scotland living in the United States. Many place-names reflect the surnames of the Scots and their

communities, including eight Aberdeens, eight Edinburghs and seven Glasgows! The Scots immigrated as families rather than individuals and, once settled in the New World, worked hard to bring over their relatives.

They were educated, literate people who became tutors and were active in printing and publishing. They were tradesmen, craftsmen, jewelers and shopkeepers.

The Scots were among the earliest to make the journey westward across the American continent and were some of the first non-Spanish inhabitants of California, with the gold rush of 1849 bringing many more out West. Particularly in the northwestern states of Oregon and Washington, there are many place-names beginning with *Mac* and *Mc*.

Today, groups and societies that seek to preserve interest in Scottish heritage and its traditions are popular, meeting to celebrate the *Gathering of the Clans*, with athletic games including the tossing of the caber (a large wooden pole), Scottish dancing and music, bagpipe competitions and the wearing of the tartan.

**The Welsh—Cymraeg**—emigrated from the towns and villages, valleys and hills of their green homeland due to poverty and persecution that was both cultural and religious—they left to create a better life. Often, the only employment that had been available to them was badly paid, dangerous industrial work—and this in a country where the political power was not in the hands of her people and most of the profits went into the pockets of wealthy English landowners. Children were punished for speaking their native language in schools up until recent times, and there was much disrespect toward Welsh culture in all realms of life. Poverty and everyday hardships made it almost impossible to escape a hard living with little gain, or to hope for a better future.

Miners and furnacemen left for Canada, Australia and America by the hundreds of thousands. In the 1900s a large number of Welsh immigrated to the expanding industrial centers of Pennsylvania, Ohio and New York

state. They came to farm in Wisconsin and Illinois, Iowa and Wyoming. In 1900, with over one hundred thousand folk of Welsh blood, Pennsylvania contained a third of all Welsh stock in the United States.

A major religious revival as early as the 1730s and 1740s established many small churches in rural communities. In the early 1800s the massive growth of nonconformity in Wales saw a breaking from the established Anglican Church, and large numbers of evangelizing, preaching missions left for the New World.

The preachers traveled with their enthusiastic style of oratory and rousing sermons. Their nonconformist religion, with emphasis on independence and self-reliant community, appealed especially to the Welsh workers who had suffered from years of oppression and exploitation and were determined to hear the word of God in their own language, from their own clergymen.

The preachers often spoke of political issues from the pulpit, representing the exploited and common folk, helping to galvanize workers' rights: theirs was the voice of the disenfranchised. They brought as well a great love of singing and an emotional connection with religion that was so vital within the nonconformist Welsh chapels back home. These independent churches are still a powerful political and spiritual force today, inspired by the early Welsh preachers who set fire to the souls of the New World.

**Patagonia** in Argentina was settled in 1865 by an adventurous group of Welsh immigrants whose ancestors still speak Welsh today. They were people in search of a land where they could protect their lifestyle, which had become endangered in their native Wales. They set out in their sailboat, *The Mimosa*, and 150 of them survived to found a self-sufficient colony along the Chubut River in the Punta Cuevas area, near today's city of Puerto Madryn.

They hoped to build a new Welsh nation, and after a difficult beginning with many challenges such as drought,

depression and poor quality land, they managed to build Argentina's first railway and many fine buildings and chapels, all done in native North Welsh stonework style.

Today, there are many authentic Welsh chapels and traditional teahouses along the valley, where traditional Eisteddford festivals—bardic competitions of Welsh singing and poetry—are still active, as they continue to be in Cymru, *the Land of Our Fathers*, as Wales is known. The settlers contributed to the progress and development of their adopted land, and they became Argentine without losing their Celtic roots. Welsh Patagonia has indeed fulfilled the dreams of the original settlers—to preserve their culture even in a land far from their birth.

Hiraeth is the Welsh term for longing and sadness for things lost or left behind. Many live *Beyond the Ninth Wave* of the home of their birth, especially in today's global society. Although recent emigrants may often feel the heavy heart of homesickness, we are more fortunate than the first settlers in being able to return often to our families and homes. The heart of exile keeps close the love left behind. But our roots are stretched, not broken, and interest in cultural inheritance is more keen for moving far away.

As we journey into the complexities of the modern world, with our many environmental and spiritual challenges before us, we may experience hiraeth for the time before when the rivers ran clear, the skies were unpolluted, and the earth held her gifts unravaged by the industries that we rely so heavily on today.

We are compelled to move forward by the organic nature of things. With the mythic winds at our backs we seek the shifting island of Hy Brasil—the earthly paradise which, although unreachable, yet summons us toward its vision of hope. A hope that the people to come will not forget the beauty of the old stories, songs and ways. That the Folk-Soul continues in her journey of transformation through art, poetry and mythology—always dancing with the westward wind.

# The Song of Wandering Aengus

I went out to the hazel wood,
Because a fire was in my head,
And cut and peeled a hazel wand,
And hooked a berry to a thread;
And when white moths were on the wing,
And moth-like stars were flickering out,
I dropped the berry in a stream
And caught a little silver trout.

When I had laid it on the floor
I went to blow the fire a-flame,
But something rustled on the floor,
And some one called me by my name:
It had become a glimmering girl
With apple blossom in her hair
Who called me by my name and ran
And faded through the brightening air.

Though I am old with wandering
Through hollow lands and hilly lands,
I will find out where she has gone,
And kiss her lips and take her hands;
And walk among long dappled grass,
And pluck till time and times are done
The silver apples of the moon,
The golden apples of the sun.

—W. B. Yeats,
*"The Wind Among the Reeds,"* 1899

# PILI PALA–TRANSFORMATION

The Butterfly, *Pili Pala* in Welsh, is a multicultural symbol of the beauty of Nature, and also of transformation. Emerging from her chrysalis, the Butterfly flies free, dancing in the air with painted wings. She is feminine and magical, and fairie creatures are often pictured with butterfly wings.

The Greek words for butterfly and soul are the same. Some believe a soul can become a butterfly, seeing above the surface, others that it can only become an earthbound caterpillar. In this design, Butterfly represents the symbol of freedom and transformation through the power of poetry, art and mythology. Our psyche dreams; consciousness is born and on awakening spreads its beautiful wings.

Illustration facing page: *Pili Pala*

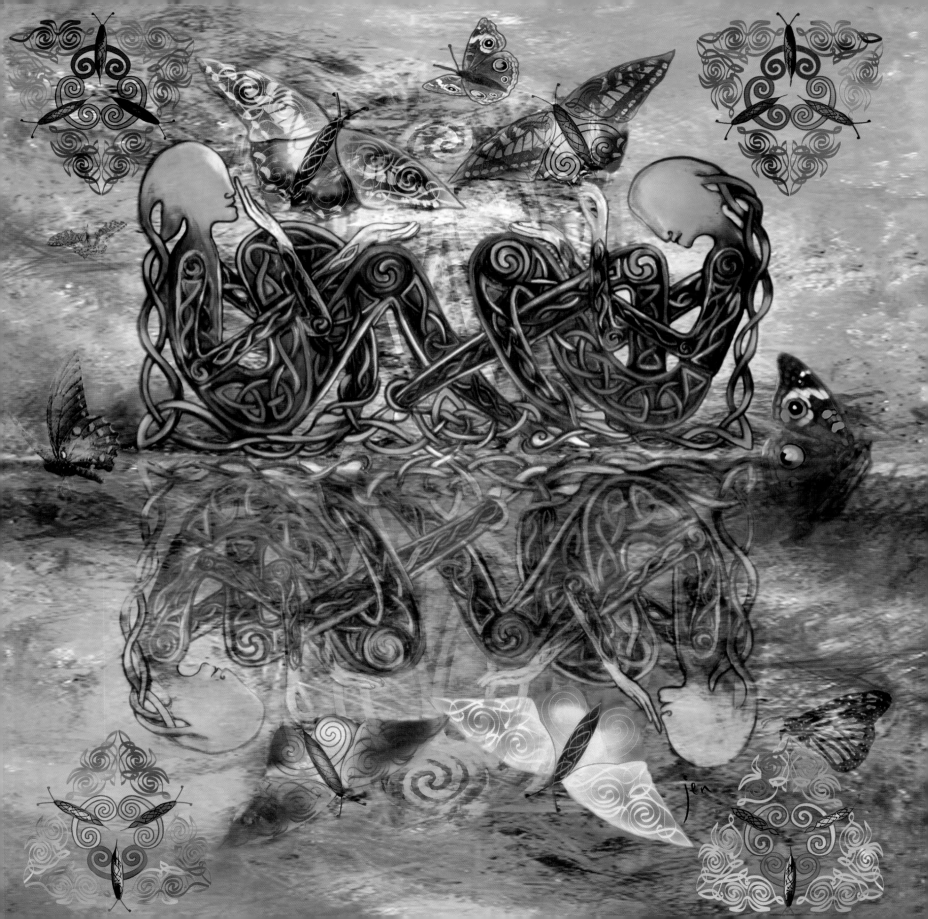

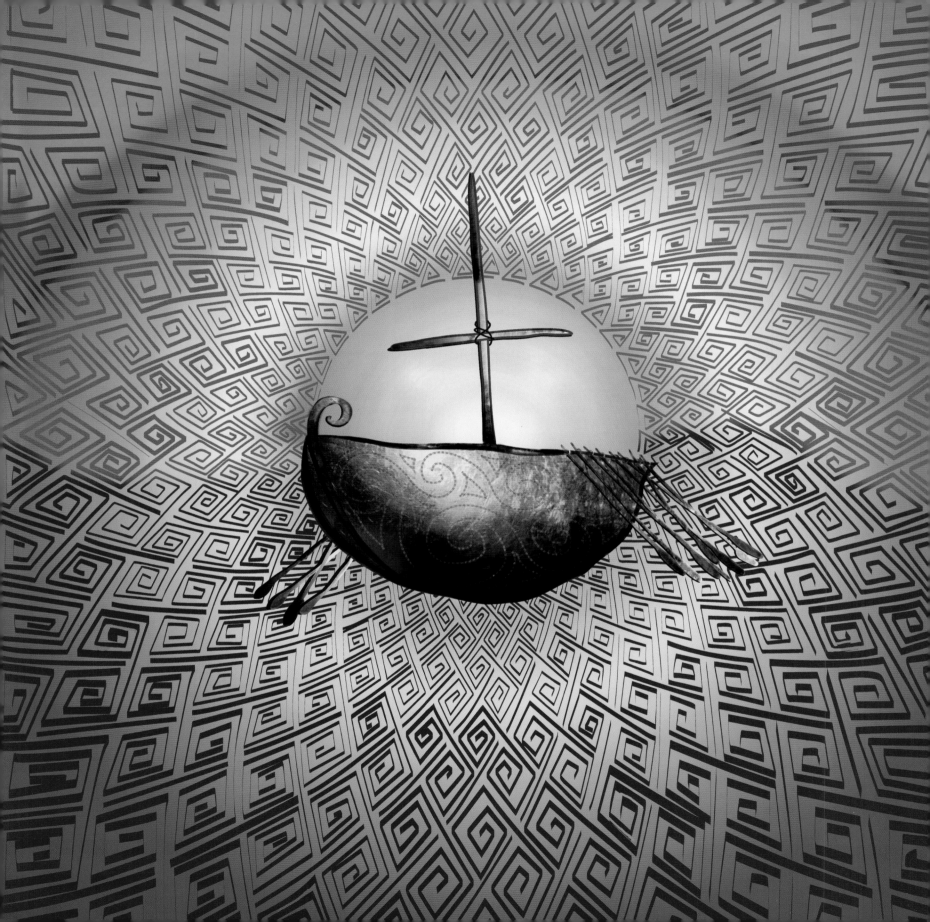

# TALE OF THE
# VOYAGE of BRENDAN

**S**aint Brendan the Navigator, also known as *Brendan the Bold* and *Brendan the Voyager*, was the greatest traveler of the Irish saints. He was both a monk and man of the sea who made many journeys, establishing monasteries wherever he landed, such as on Arran and other remote islands in the Hebrides off the west coast of Scotland. He voyaged to Brittany with Saint Malo, a Welsh monk, met with Saint Patrick and traveled extensively throughout the Celtic lands inspiring many followers and legends.

In the more remote areas of Britain and Ireland, a unique and inspirational interpretation of early Christianity flourished where the old stories and traditions merged with the new and continued to honor the spiritual elements within nature.

The stories of the Voyage of Saint Brendan are part myth and part history; the Irish epic poem *Sancti Brendani, the Voyage of Saint Brendan*, recounts his adventures. His legendary travels became entwined with the ancient tales of heroes such as Brân who journeyed to find the Land of Manannán—a mysterious Otherworld beneath the waves.

Brendan is the archetypal sea hero, meeting monsters and strange sights upon his quest for the mysterious island of Hy Brasil, which some say was the Americas. In 530 AD he climbed to the top of Sliabh Bhreandáin, *Mount Brendan*, a thirty-two hundred–foot mountain on the Dingle Peninsula in County Kerry on Ireland's west coast, where there are still the ruins of a small beehive-shaped chapel. Here Brendan had a vision of Hy Brasil— *the Isle of the Blessed*—which is known by many names:

*Tír na nÓg, the Isle of the Apples, Isle of the Living, the Isle of Truth, of Joy, of Fair Women.*

There have been many reported sightings in folklore of the unreachable mythic island, cloaked in mist except for one day every seven years, that lies off the southwest coast of Connacht in western Ireland. Elusive and shifting, the island is named after Bres, the son of Ériu, the mythical Goddess who gave her name to Eire, and whose father was a Formorian sea god, Elatha—evidence that this was one of the earliest Irish legends. Many have tried to reach the island, which appeared in maps found in the early Middle Ages, but few have ever landed there.

Brendan set out on his mythic quest upon the sea with a company of intrepid monks to find the Land of Promise, *Hy Brasil*. Sailing a simple curragh boat— a coracle of wood and leather—they set out into the unknown upon the great ocean, putting their faith in God, the elements, and their great instinct for navigation by the stars (the Celts navigated by the movements of the Pleiades). This epic journey would take seven years. Finally, they arrived at the beautiful land they called the *Promised Land of the Saints*, having had many adventures along the way. We hear details of their journey in a popular book written by a monk in the ninth century, *The Navigatio*.

Brendan and his brave seafaring monks are said to have come upon a *mountain of glass* floating in the ocean—probably an iceberg—and were *raised up on the backs of sea monsters*, which could have been encounters with friendly whales who had not yet reason to fear boats, or man. Their story was told to his contemporary,

Saint Columba, who recalled that they landed on a small island, which turned out to be a giant sea monster.

*The Book of Lismore*, an early fifteenth-century manuscript, relates: *So Brenainn, son of Finnlug, sailed then over the wave-voice of the strong-maned sea, and over the storm of the green-sided waves, and over the mouths of the marvelous, awful, bitter ocean, where they saw the multitude of the furious red-mouthed monsters, with abundance of the great sea-whales. And they found beautiful marvelous islands, and yet they tarried not therein.*

This story has its parallels in Irish mythology and other traditions, including the biblical story of Jonah and the whale: the monster of the deep ocean is an ancient archetype.

After a long voyage of seven years, they reached Terra Repromissionis, *the Isles of the Blessed*, a most beautiful land with luxuriant vegetation, thought by some to have been an early discovery of America.

Over the course of his seven-year journey Brendan probably visited Greenland, and his discovery of a new island far to the west was afterward placed on the maps. Named *Saint Brendan's Isle*, it was shown to be in the western Atlantic Ocean. This mysterious island in the west, still depicted on maps in Columbus's time, is thought to have inspired him on his journey of discovery.

In 1975 Tim Severin sailed across the Atlantic in a traditional wood and leather Irish coracle boat, *curragh*, proving that it was possible for Brendan to have discovered America. Severin believed that the prevailing winds would have taken Brendan close to Iceland and Greenland, and that he probably landed at Newfoundland.

Brendan made stops at many islands, building primitive monasteries there, and Norsemen have recorded meeting monks on the islands during their voyages.

Although Severin did not make the journey all the way to America, he realized that it was possible to achieve it in a traditional leather curragh as described in *The Navigatio*, navigating the sea currents of the North Atlantic and following the winds westward as so many have done since that time.

The story of Saint Brendan shows the Celts' fluency in sailing and natural navigation, their willingness to explore and trust to the elements of sea and wind, and their instincts to find Hy Brasil or Tír na nÓg—the Land of the Ever Young, as promised in myths and legends of a more ancient time.

Movement lies at the heart of a once-nomadic people, whose expansive view and eye on the horizon has helped them survive many challenges throughout history.

---

**When the wind sets from the east the mettle of the wave is roused;**
**it desires to pass over us westwards to the spot where the sun sets,**
**to the wild broad green sea.**

— Unknown Irish author, "A storm at sea," eleventh century,
translated by Professor Kenneth Jackson

Illustration facing page: *The Riddler*

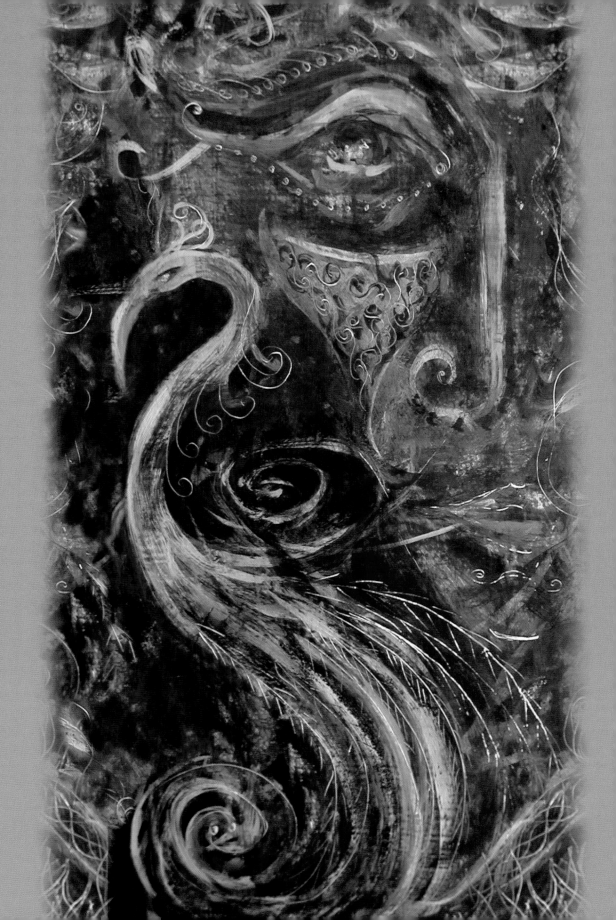

# CAN Y GWYNT–
## Song of the Wind

Unriddle me this, if you can
I was before God's flood
without flesh or vein or bone
headless, footlessly I stride
nothing's child, never born
when my breath stills, I am not dead
no older now, nor ever young
I have no need of beast or man
sea-whitener, forest-piercer
handless I touch a whole field
time's partner, youth's partaker
wide as the wide earth is wide
unequalled, masterless, never prisoner
landless, invisible and blind
solitary and brash of manner
gentle, murderous, and without sin
I am no repairer of disorder
I am wet and dry and weak and strong
what am I? that the cold moon fosters
and the ardour of the sun.

—Attributed to Taliesin, sixth century, from
*Llyfr Taliesin, The Book of Taliesin*, fourteenth
century. Translated by Robin Williamson.

"Song of the Wind" is at once an
incantation, a riddle and a song of praise.

—Robin Williamson

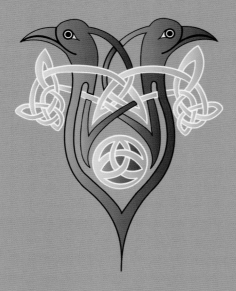

# JOURNEY TO THE OTHERWORLD

Birds are a potent force in Celtic mythology, often symbolizing the flight of spirits to the Otherworld. Herons, Cranes, Storks and Pelicans are related to the gods and goddesses that preside over the mysteries of reincarnation, acting as guides to the Underworld. Birds evoke ideas of freedom, the human soul liberated from the body at death.

Cranes are long-legged wading birds, usually associated with willow trees and water, mysterious as the fringed marshes along which they dwell. Within the Celtic tradition, birds are soul carriers between the worlds, and the White Crane is particularly associated with the spirit of the trees. There are many stories in Celtic mythology of beautiful young women enchanted into Crane form by jealous rivals, and ill-natured women transformed into the large bird with the bony toes and uncanny shriek.

These Cranes form a Brighid's Cross, traditionally woven from stalks of corn or rushes into a whirligig pattern on the eve of Saint Brighid's Feast *Imbolc, Candlemas*, February 1. The crosses were woven, blessed with prayer and ritual, and placed under the eaves of the house among the thatch, in hopes of protection and prosperity in the coming year.

If a swarm of bees enters a house
or settles on the dead boughs of
a tree near the premises, the old
people say "death will soon follow."
When there is a death
in a household the head of the
family whispers the news to the
bees, and the beehives are turned
around before the funeral.
There was an old Welsh belief
that new-born babies who died
immediately after their birth
became a new flower in the land.

—Marie Trevelyan,
*Folk-Lore and Folk-Stories of Wales*, 1909

Illustration facing page: *Tri Garan—Three Herons*

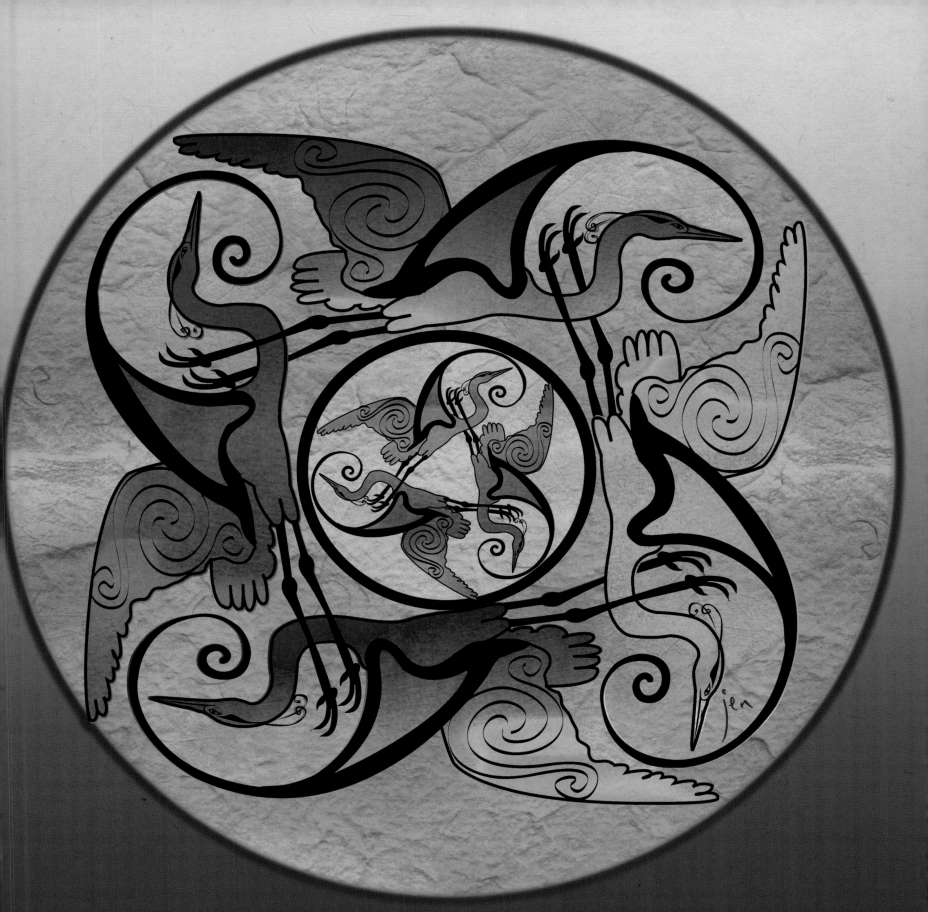

# BEYOND
## the ninth wave

The willow, whose harp hung silent

when it was withered in winter,

Now gives forth its melody—hush! Listen!

The world is alive.

—Thomas Telynog Evans, Welsh, "Winter and Summer"

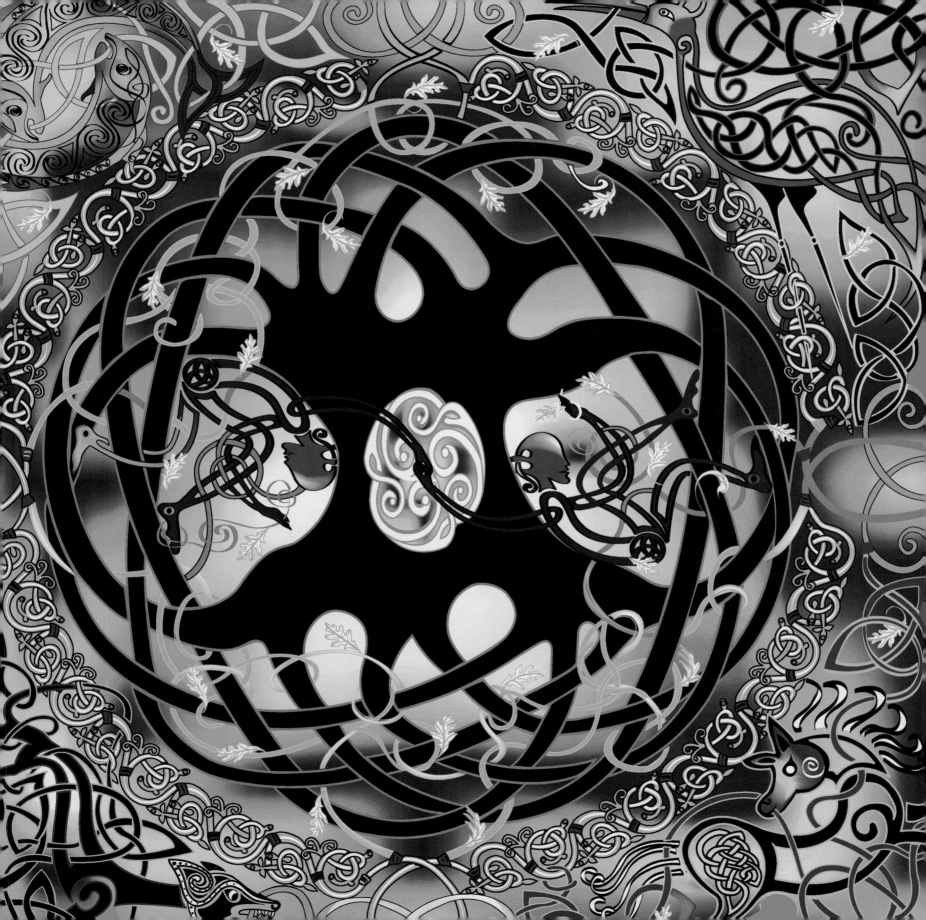

# BEYOND
## the ninth wave

**B**eyond the Ninth Wave is a metaphor for our visionary journey. The Ninth Wave contains the waters of the sacred triplicity, and is referred to by the Poets for its powers of creativity and rebirth. It represents the liminal boundaries of our perception, of the mortal and the Otherworld. This is the greatest wave that takes us out to sea, or brings us home again.

**The Ninth Wave** was also considered by the Celts to set the limit of the known world, of the land herself. To be sent into exile—*Beyond the Ninth Wave*—was considered a punishment worse than death. It is said that those who betrayed the ways of their people were sent adrift on a boat, without oars or rudder, with only a knife and some fresh water. Those who survived this test by the elements were fated to perform great deeds, and could return home as heroes, sharing their gifts of wisdom and experience.

This is a profound symbol of the journey of the Folk-Soul, of the adversity and, often, forced migration of her people. *Beyond the Ninth Wave* is also an allegory for our exile from the natural world.

**Our environment** has changed physically and psychically. The great ancient forests are nearly gone. Many creatures of power and beauty are becoming extinct and our spiritual relationship with a living, breathing cosmos grows ever thin. Much of the old knowledge has been lost, and we can perhaps never return—we are exiled from those traditions in many ways.

However, our folk memory continues, woven into the stories, artwork, songs and traditions that each generation shares with the next. Connected by this delicate thread, our Ancestors speak to us still. Symbols rooted in a world of greater balance teach us of the living spirit of the land, and respect for the fertile dynamics of nature and psyche. Using this organic language, we may create new myths, new expressions that continue our innovative inheritance.

**We carry the visions and hopes** of those who came before, for those who are yet to come, as at the beginning of the twenty-first century we move *Beyond the Ninth Wave* into the unknown—and perhaps uncertain—future.

We need to perform great deeds, to become heroes. Reaching within our heritage we find that we have brought with us on our journey greater tools than a simple knife and plain water—we have the gifts of the Aois Dana, *the Poets*, of inspiration, creativity and knowledge.

> Every nation of the world has its Soul, and every nation can find it, if it will, and the Soul of every people—whose lineaments may be found, not in the mythical Gods themselves, but in what they *represent*—is destined each to find its altar ... in the Temple of the Grail—which is the world.
>
> —Eleanor G. Merry, *The Flaming Door: The Mission of the Celtic Folk Soul,* 1936

All of nature is alive, interconnected within our mysterious, creative universe. What the Ancients knew as a profound truth, now our most brilliant scientists are confirming as cold, hard fact.

The Celtic Folk-Soul is inspired by a living tradition, forged by the spirit in Nature, illuminated through art, music and poetry. This is the language of our creative

and venture *Beyond the Ninth Wave* to seek the treasures of eternal love and youth, the land *where there is no sickness or death*. Harsh realities coexist with vision and hope. Winter is balanced by Summer, night by day, death with life—the lunar female with the solar male. By revealing the symbols and archetypes of the dark as well as the light, balance is achieved and insight and knowledge replace denial and illusion.

> All the sweetness of nature was buried in black winter's grave,
> And the wind sings a sad lament with its cold plaintive cry;
> But oh, the teeming summer will come, bringing life in its arms,
> Will strew rosy flowers on the face of hill and dale.
>
> In lovely harmony the wood has put on its green mantle,
> And summer is on its throne, playing its string-music;
> The willow, whose harp hung silent when it was withered in winter,
> Now gives forth its melody—hush! Listen! The world is alive.
>
> —Thomas Telynog Evans, Welsh, "Winter and Summer"

psyche. The Selkie finds her skin again, and returns to the sea. The radiant boy sings prophecies from his basket in the salmon weir, and the Hounds of Annwn call to us as the wild geese from stormy skies.

In Celtic Art, there is constant interplay between the negative and positive areas within a design—the background spaces can create visually meaningful patterns in loose symmetry with those of the immediate foreground. The interchange and balance between shape and form, the inner and outer, and the ever-changing center of things, are perhaps the most revealing clues to the true character of the Celts.

Forged by patterns of both darkness and light, the Folk-Soul recognizes the forces inherent in all aspects of life. Mythic figures journey through challenge and despair: rage, battle and descend into the Underworld,

Blodeuwedd must destroy her master before she can individuate, find her true self and become the wise Owl. The firstborn are sacrificed to Cromm Crúaich to ensure the plentiful harvest, and Hen Wen—the old white Sow—eats the rotten flesh of the wounded eagle Lleu before he can be reborn. The Hunter and the hunted are integrated in the dance of life and death, the one necessary for the other.

In Jungian terms the *Shadow* represents our darkest fears or mysterious (often repressed) aspects of our unconscious. In Celtic mythology the enigmatic Shadow elements are often the key to the Mystery itself. The entire range of human experience is expressed—sorrow, love, fury, lust, revenge and hope. The myths explore a wide complexity of human and animal archetypes that exist at the root of our deepest nature.

EPILOGUE 217

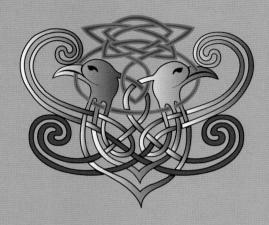

# ANU–EARTH MOTHER

Anu is the Great Mother of the ancestor gods the Danaan. An ancient figure,

venerated under many names, she is often known as Aine, or Danu.

She is the womb of life. As Aine, her name means *delight, pleasure, melody.*

She is the spark and vitality of life, she is the seed of the sun in our veins.

The Great Earth Mother is more ancient than the God of the Celtic Druids.

Her breasts are the two hills called the Paps of Anu in Ireland,

the landscape literally transformed into the body of the Earth Mother.

Her hair is the wild waves, the golden corn. Her eyes are the shining stars,

her belly the round tors, or earth barrows, from which we are born.

Like the cat, the sow, the owl, she eats her young if they are sick or dying.

She is the cycle of life, the turning of the seasons. In this design

the four elements of life are represented: air (birds), fire, earth (tree) and water.

Illustration facing page: *Anu—Earth Mother*

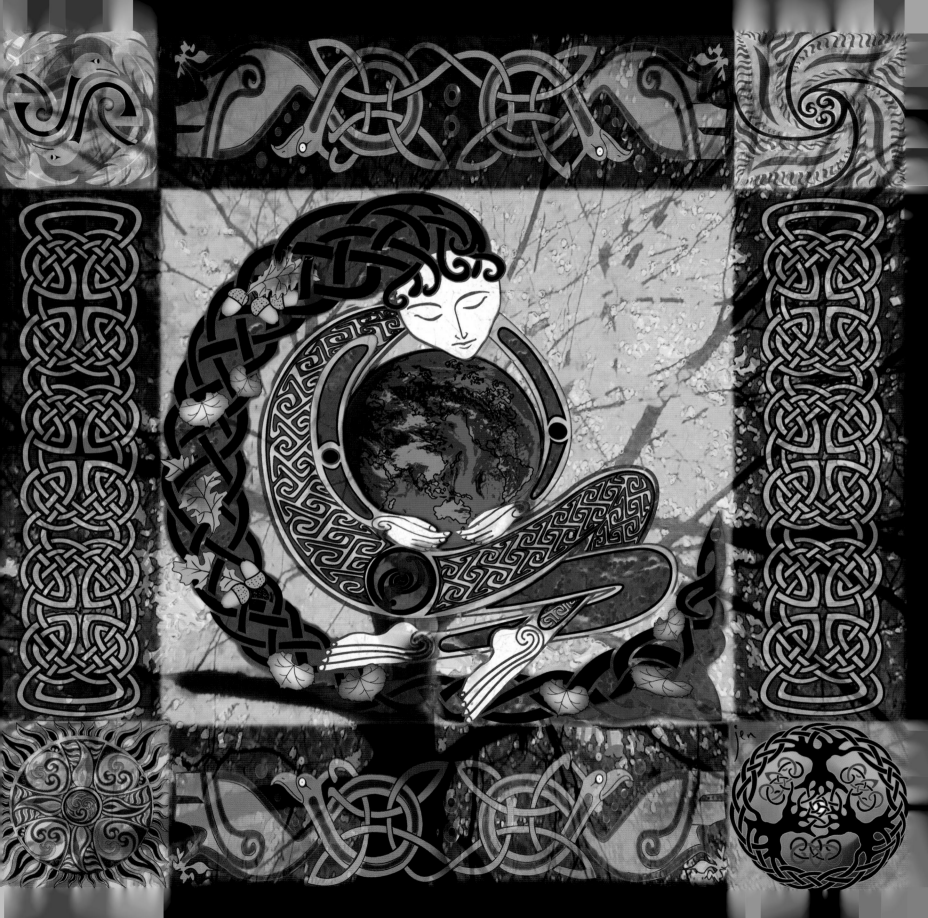

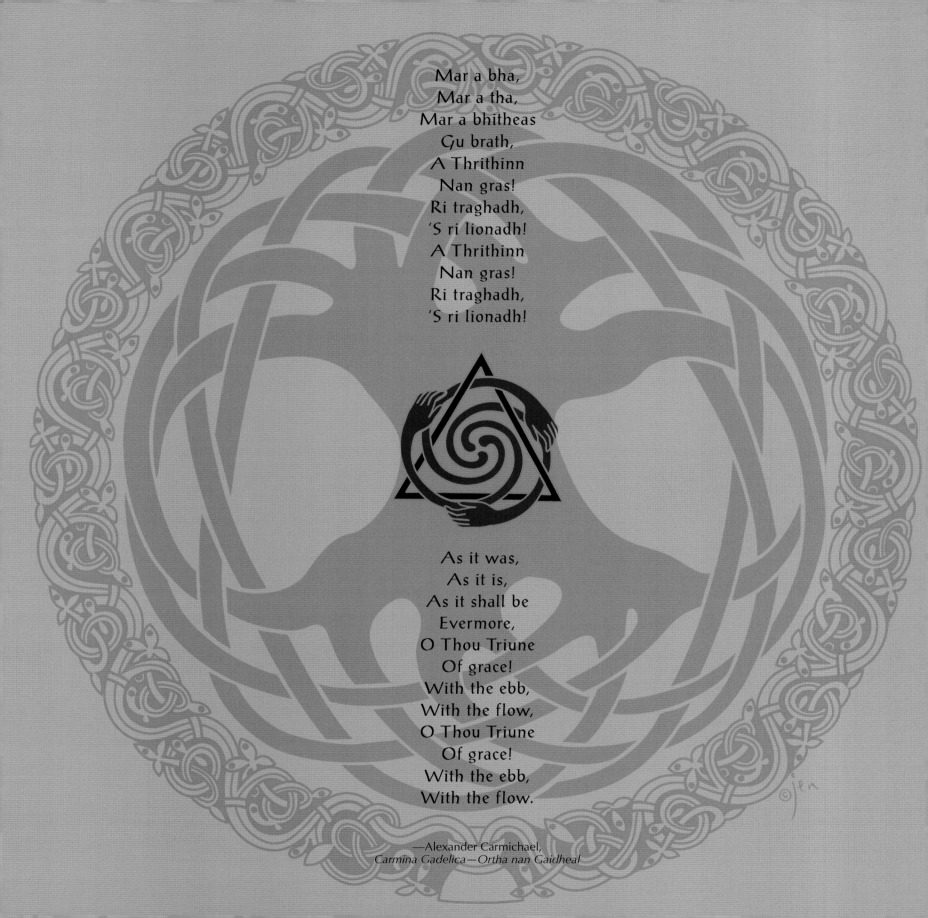

Mar a bha,
Mar a tha,
Mar a bhitheas
Gu brath,
A Thrithinn
Nan gras!
Ri traghadh,
'S ri lionadh!
A Thrithinn
Nan gras!
Ri traghadh,
'S ri lionadh!

As it was,
As it is,
As it shall be
Evermore,
O Thou Triune
Of grace!
With the ebb,
With the flow,
O Thou Triune
Of grace!
With the ebb,
With the flow.

—Alexander Carmichael,
*Carmina Gadelica—Ortha nan Gaidheal*

**C**eltic tradition presents us with an often confusing strangeness, a sometimes bizarre symbolic fusion of bird and beast, pattern and organic elements. There is an innate honesty, the sense of a key to our latent authentic nature that lies just beneath the surface.

We may have lost integration with our true, inherent power—both personal and cultural. To move confidently into our future with the skills of creativity and wisdom, we need to understand and accept our primal nature, bring our archetypes into consciousness so that they may lose some of their underlying destructive influence.

**This is our heritage.** The Western Tradition has roots reaching back to the first people. We may learn from the knowledge of many ancient cultures around the world that speak of the Mysteries of things, each in their own language and with their own mythic interpretation. In the contemporary societies of the West we sometimes forget that we have our own deep sources to draw from, and to relate to.

The Celtic tradition is particularly relevant for many today, as a powerful and profoundly beautiful expression of these Mysteries, communicated through the cadence and rhythm of our cultural inheritance.

In 1895 Fiona MacLeod writes:
*There is no law set upon beauty, it has no geography. It is the domain of the spirit. And if, of those who enter there, he is welcome for what he brings: nor do we demand if he be dark or fair, Latin or Teuton or Celt, or say of him that his tidings are lovelier or less lovely because he was born in the shadow of Gaelic hills, or nurtured by Celtic shores. It is well that each should learn the mother-song of his land at the cradle-place of his birth. … But it is not well that because of the whistling of the wind in the heather*

*one should imagine that nowhere else does the wind suddenly stir the reeds and the grasses in its incalculable hour.*
—from *Studies in the Spiritual History of the Gael*

We live—often literally, always figuratively—*Beyond the Ninth Wave* of the realm of our Ancestors. However, through the knowledge and inspiration of the Aois Dana, *the Poets*, we can heal ourselves and our world, planting the seeds from the ancient Tree of Life into the fertile furrows of our psyche.

**The Mission of the Folk-Soul** is to know beyond our seeing, and see beyond our knowing. To dance our rhythms upon the earth and sing her stories out loud. To nurture the creative spark—the Awen—looking forward as well as backward while keeping hold of the connective thread that will bring us home.

**T**his book is an offering to my green home. To the ancient place of my birth, soft and sinewed, forged by great light and deeper darkness. Haunted by the Earth, the Sky and all that lies between, her memories are forged with the mystery of beauty, kindled by the vision of the myth-makers.

For the gifts of the wise Salmon, the valor of the fierce Boar, the call of the wild Geese and the touch of Manannán's wave—and all the secrets that lie beneath the waters. For the Celtic Folk-Soul, long may she dance.

**And so a Celtic Blessing** to all our journeys into the unknown, especially those that take us *Beyond the Ninth Wave*:

*May the road rise up to meet you,*
*and the wind be always at your back.*

Illustration facing page: *Yggdrasil*
Above: *Aois Dana—the Poets*

# TREE OF LIFE–Y GOEDEN BYWYD

The *Tree of Life* is an esoteric philosophy common to many cultures and mythologies. Creatures representing the elements—the sacred Salmon, Heron, Horse, Dog and the folk figures—are entwined within the greening vines of life. Salmon is wise, and is associated with water. The Heron is also great in esoteric knowledge, and is associated with both water and air. The Horse is a solar symbol for fertility and strength, representing the Fire of the Heavens and the Earth. The Dog is loyal protector of the tribe, connected with the Earth and the underworld of Annwn. The Folk-Soul is woven within the branches and roots of the Tree of Life—figures represent the Spirit of our Ancestors, ourselves and our children not yet born.

The Celtic Tree of Life represents the mysticism of the Old Religion in which the trees, the creatures and the land are a strong and vital force, connecting the folk within a living universe. In the New Faith, the early monastic traditions of Celtic Christianity continue to celebrate the Spirit of Nature, and the Tree of Life is a powerful symbol of creation.

For many people today, with different religious beliefs throughout the world, the Tree of Life is a universal symbol expressing an ancient philosophy of the forces of nature and of spirit—of life itself. The interlacing branches symbolize Celtic belief in the Continuity of Life, with roots growing deep in the ground, branches reaching high into the heavens. The Folk-Soul is supported within the Tree of Life, which is an organic circle representing the interconnection of all living things.

Illustration above: *Dryad—Spirit of the Trees*
Facing page: *Y Goeden Bywyd—Tree of Life*

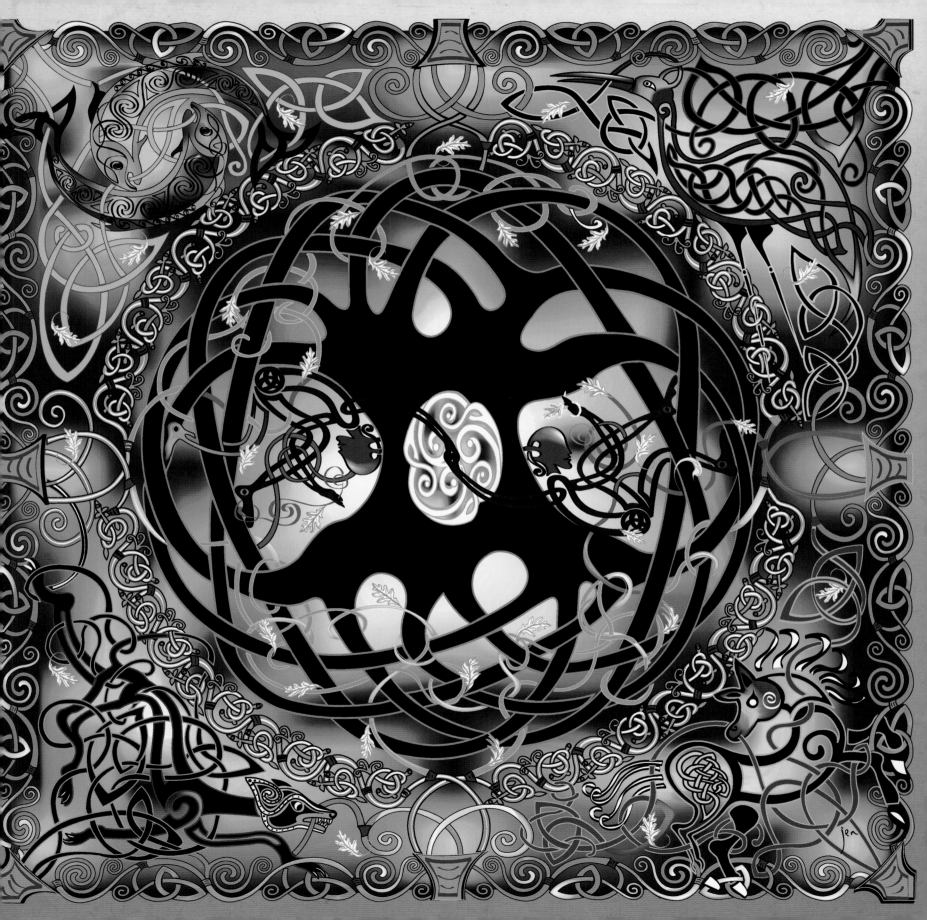

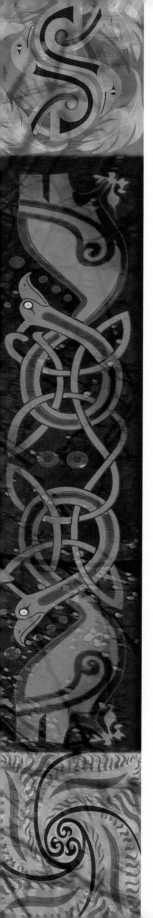

# ACKNOWLEDGMENTS

Celtic Folk-Soul is the fruition of many years of enthusiasm, challenge and hard work, inspired by my Welsh culture, and a dedicated community of artists, poets, writers and mystics of past and present who have shared their passion and knowledge with us. This work would not be possible without the encouragement of family and colleagues, supporters and friends, who helped nourish the creative process in many countless ways.

My deepest gratitude is to my parents, Mair and Fred Clough, who brought me into this world with love and support. You opened doors into a universe of learning, helped sow the seeds of imagination and opened my eyes to the beauty of nature. You taught me never to give up, and your constant encouragement and belief in my work as I stumbled along this creative path, are the most precious gifts to any child, to every one of us who dares to face our fear and doubt in order to manifest our humble vision into the world. This book is dedicated to you.

My journey is shared with dearest friend and husband, Scott, whose jazz music brought me to his country far from my home. We have danced through time, supporting each other through many years of learning and growth. You helped birth an emerging artist into the world, my ideas often refined by your own style and perspective. I am indebted to you always. From my heart, all my gratitude.

To my most cherished ally, wise and lovely sister Susan. You have constantly believed in me, always told the truth, holding my hand through trials and tribulations as only a sister can. I could not have finished this book without you being there for me. Much love to you, and to all my Sisters.

I have immense appreciation for the constant support and positivity of my publisher and valued friends Leslie, Lawson, Tim and all at Amber Lotus who helped channel this book into form. More precious still, you believed. Thank you for your generosity in giving creative freedom, for your confidence and patience during the often-overwhelming task of authoring and creating Celtic Folk-Soul together. Our vision is now manifest!

I am grateful indeed to my editor, Sheridan McCarthy, who nurtured this first-time—and often stubbornly individual—author through the challenging task of painstaking word-craft. Thank you for your careful guidance, insightful clarifications and gentle input, whilst allowing my voice to speak more clearly as a result.

Karen Finley, golden bee-keeper friend, thank you for sharing your green Oregon home and supportive ear for my early writing adventure. Folk-Soul began to form through pen and paper scribbled under the spreading branches of your beautiful black walnut tree.

Special thanks to my artist community—scattered far and wide around the world as we are. My work is infused with our shared dedication to the creative process, passion for the Celtic Arts and a mutual belief in forging individual style and expression. Particular thanks to Faith Hamilton for precious friendship and early painting inspiration. To Findhorn artist Alice Rigan for encouraging my early endeavors (and generously sharing her figure-motif as a basis for Arianrhod), to fellow Celtic artists Cindy Matyi and Chris Down, David James and Steve O'Loughlin for sharing the journey, with inestimable gratitude to George Bain, the grandfather of us all. To Welsh painter John Uzzell Edwards for challenging me to experiment with more abstract and painterly expressions, Betsy Porter for her guidance in egg tempera icon painting and my figure drawing group for keeping me fluid and connected.

We do not work alone; creativity is channeled through us. I am proud to be part of a lineage of pattern makers, icon writers and image weavers, as we sing the ancient language of myth, dancing with new cadence to rhythms beaten into our hearts long ago.

May I always heed the wisdom of Alice Rigan, who once told me, "Let your imagination be your guide."

—Jen Delyth, Spring 2008

# BIBLIOGRAPHY

Allen, J. Romilly. *Celtic Art in Pagan and Christian Times*. London: Methuan & Co., 1904.

Bingen, Hildegard of. "I am the Breeze," in *Illuminations of Hildegard of Bingen*, compiled by Matthew Fox. Bear & Company, 1985.

Campbell, Joseph. *The Hero with a Thousand Faces*. Princeton: Princeton University Press, 1972.

Carmichael, Alexander. *Carmina Gadelica—Ortha Nan Gaidheal, Vol. 1*. Edinburgh: T. and A. Constable, 1900.

Chippindale, Christopher. *Stonehenge Complete*. Ithaca: Cornell University Press, 1983.

Clottes, Jean and J. David Lewis-Williams. *The Shamans of Prehistory: Trance and Magic in the Painted Caves*. New York: Harry N. Abrams, 1998.

Cross, T. P. and C. H. Slover, eds. *Ancient Irish Tales*. New York: Harry Holt and Co., 1936.

Davies, Oliver and Fiona Bowie. *Celtic Christian Spirituality: An Anthology of Medieval and Modern Sources*. New York: Continuum International Publishing, 1995.

Evans-Wentz, W. Y. *The Fairy-Faith in Celtic Countries*. London: Oxford University Press, 1911.

Everett, David and Elaine Gill, eds. *Celtic Verse: An Inspirational Anthology of Poems, Prose, Prayers and Words of Wisdom*. Dorset: Blandford, 1998.

Farren, Robert. *The First Exile: The Story of Columcille*. London: Sheed and Ward, 1944.

Ford, David Nash. *David Nash Ford's Royal Berkshire History*. http://www.berkshirehistory.com.

Ford, Patrick K. *The Mabinogi and Other Medieval Welsh Tales*. Berkeley: University of California, 1977.

Frey, Otto, Venceslas Kruta, Sabatino Moscati, Barry Raftery, and Miklós Szabó. *The Celts*. New York: Rizzoli, 1991.

Gimbutas, Marija. *The Language of the Goddess*. San Francisco: Harper San Francisco, 1995.

Graves, Robert. *The White Goddess: A Historical Grammar of Poetic Myth*. New York: Farrar, Strauss, and Cudahy, 1948.

Green, Miranda J. *Dictionary of Celtic Myth and Legend*. London: Thames & Hudson, 1992.

Guest, Lady Charlotte, trans. *The Mabinogion*. London: J. M. Dent (Everyman's Library), 1902.

Hoagland, Kathleen. *1000 Years of Irish Poetry: The Gaelic and Anglo Irish Poets from Pagan Times to the Present*. New York: Welcome Rain Publishers, 1999.

Hull, Eleanor. *Folklore of the British Isles*. London: Methuen, 1928.

Jackson, Kenneth Hurlstone. *Studies in Early Celtic Nature Poetry*. New York: Oxford University Press, 1935.

———. *A Celtic Miscellany: Translations from the Celtic*. London: Routledge and Kegan Paul Ltd., 1951.

Jarman, A. O. H., ed. and trans. *Aneirin: Y Gododdin, Britain's Oldest Heroic Poem*. Llandysul, Wales: Gomer, 1988.

Jones, Gwynn. *Welsh Folkore and Folk-Custom*. London: Methuen, 1930.

Jung, Carl. *Man and His Symbols*. New York: Dell, 1968.

Laing, Lloyd and Jennifer Laing. *The Art of the Celts*. London: Thames & Hudson, 1992.

Lehmann, Ruth, trans. *Early Irish Verse*. Austin: University of Texas Press, 1982.

Lewis, Gwyneth. "A Cloud of Witnesses," in *The Hare That Hides Within: Poems About St. Melangell*, edited by Anne Cluysenaar and Norman Schwenk. London: Parthian, 2004.

Mackenzie, Donald. *Ancient Man in Britain*. London: Blackie & Son, 1932.

Matthews, Caitlín and John Matthews. *The Encyclopedia of Celtic Wisdom: The Celtic Shaman's Sourcebook*. Rockport, MA: Element Books, 1994.

McGee, Thomas D'Arcy. *The Poems of Thomas D'Arcy McGee: With Copious Notes*. New York: D. & J. Sadlier, 1869.

MacLeod, Fiona. *By Sundown Shores: Studies in Spiritual History*. Portland, ME: Thomas Bird Mosher, 1902.

———. *From the Hills of Dream: Threnodies, Songs and Later Poems*. London: William Heinemann, 1907.

Megaw, Ruth and Vincent Megaw. *Celtic Art: From Its Beginnings to the Book of Kells*. London: Thames & Hudson, 1989.

Merne, John G. *A Handbook of Celtic Ornament*. Douglas, Ireland: Mercier Press, 1989.

Merry, Eleanor. *Flaming Door*. Plymouth: William Brendon and Son, 1936.

Meyer, Kuno, trans. *Selections from Ancient Irish Poetry*. London: Constable and Co., 1928.

———. *The Voyage of Bran Son of Febal*. London: David Nutt in the Strand, 1895.

Owen, Elias. *Welsh Folk-Lore—A Collection of the Folk-Tales and Legends of North Wales*. Lampeter, Wales: Llanerch Press, 1996.

Pennar, Meirion, trans. *Taliesin Poems—New Translations*. Lampeter, Wales: Llanerch Press, 1988.

———. *The Black Book of Carmarthen*. Felinfach: Llanerch Press, 1989.

Raftery, Barry. *Celtic Art*. Paris: Flammarion/UNESCO, 1990.

Ross, Anne. *Pagan Celtic Britain*. New York: Columbia University Press, 1967.

Sharp, E. A. and J. Matthay, eds. *Lyra Celtica—An Anthology of the Poetry of the Celt*. Edinburgh: John Grant, 1924.

Shaw, Margaret Fay. *Folksongs and Folklore of South Uist*. London: Oxford University Press, 1977.

Skene, W. F., trans. *Four Ancient Books of Wales*. Edinburgh: Edmonston and Douglas, 1868.

Squire, Charles. *Celtic Myth and Legend, Poetry and Romance*. London: Gresham Publishing, 1905.

———. *The Mythology of the British Islands: An Introduction to the Celtic Myth, Legend, Poetry and Romance*. London: Blackie and Son, 1905.

Stokes, Margaret. *Early Christian Art in Ireland*. London: Chapman and Hall Ltd., 1887.

Stokes, Whitley. "The Prose Tales in the Rennes Dindshenchas," *Revue Celtique*, vol. 15, 1894.

Thomas, Dylan. *The Collected Poems of Dylan Thomas: A New Directions Book*. New York: New Directions, 1957.

Trevelyan, Marie. *Folk-Lore and Folk-Stories of Wales*. London: Elliot Stock, 1909.

Thomas, R. S. "The Minister," in *The Hare That Hides Within: Poems About St. Melangell*, edited by Anne Cluysenaar and Norman Schwenk. London: Parthian, 2004.

Williamson, Robin. "Five Denials on Merlin's Grave," Cardiff, Wales: Pig's Whisker Music, 1979.

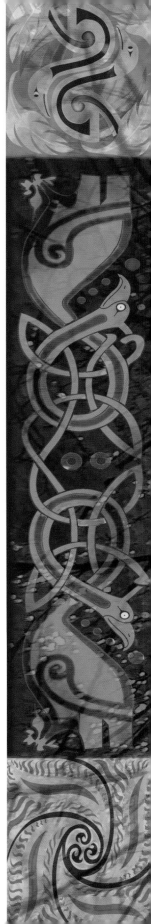

# INDEX

# PRONUNCIATION GUIDE

The following provides a basic, though not authoritative, guide to the pronunciation of some Welsh words included in this text. Peter N. Williams of Celticworld.com helped with the preparation of this section. He explains, "While there may be slight differences in the pronunciations of some words according to local dialects, in the list of Welsh characters and place names provided, these differences are so slight as to be negligible." Any errors are those of the production staff and not Williams.

KEY: a: map, ā: day, ä: bother, e: bed, ē: easy, ə: collide, ər: bird, i: tip, ī: side, ō: bone, ô: saw, th: with, th: then, u: up, ü: rule, ů: book

Aberdyfi \a-bu-'duv-ē\
Aberystwyth \a-bər-'ust-with\
Afagddu \av-'ag-thē\
Aneirin \an-'ī-rin\
Annwfn \an-'uv-ən\
Annwn \an-'ün\
Arawn \ar-'aů'n\
Arianrhod \ärē-'an-h'räd\
Awen \'ä-wen\
Beddgelert \bāth-'gel-ərt\
Beuno \bī-nō\
Blodeuwedd \blôd-'ī-weth\
Boddi \bôth-ē\
Boudicca \bü-'dik-ər\
Brân \brân\
Brochfael \bräkh-vīl\
Brychwel \brůk-wel\
Bryn \brin\
Brynach \brin-akh\
Brythonic \brith-'on-ik\
Builth in Breconshire \bilth\
Cad Goddeu \kad 'goth-ī\
Cadegr \kad-'eg-ər\
Cader Idris \'kad- ər 'id-ris\
Cadwaladr \kad-'wôl-ad-ər\
Caer \kīr\
Caer Dathyl \kīr dath-il\
Caer-Wyddno \kīr with-nō\
Cailleach \kī-lukh\
Calleach \kī-lukh\
Cantref Gwaelod \kan-trev 'gwīl-od\
Can Y Gwynt \kän u gwint\
Caradog \kär-'ad-og\
Carmarthen \kär-'märth-un\
Carn Ingli \kärn 'ing-lē\
Catraeth \'kat-reth\
Cefn \'kev'n\
Cefn Bryn \'kev'n brin\
Celyddon \'kel-ē-don\
Cenydd \'ken-ith\

Ceridwen \ke-'rid-wen\
Craig Ddu \krīg thē\
Craig-y-Dinas \krīg u 'dē-nas\
Cromlech \krom lekh\
Culhwch \kil-hůk\
Cwm Bendith y Mamau \küm 'ben-dith u 'mam-u\
Cwn Annwn \kün 'an-ün\
Cwn Mamau \kün 'mam-u\
Cwn Wybr \kün wib-bər\
Cymraeg \kum'rīg\
Cymru \'kum-rē\
Cynan \kun-an\
Cynfael \kun-vīl\
Cynfarch \kun-värkh\
Cynfawr \kun-vour\
Cynhafal \kun-'hav-al\
Cynwyd \kun-wid\
Cynwydion \kun-'wid-ē-ôn\
Ddraig Goch \thrīg gōkh\
Dewi \de-wē\
Din Eidyn \dēn ī-din\
Dinas Emrys \dē-nas em-ris\
Dôn \dôn\
Duffryn \'duf-rin\
Dyfed \'duv-ed\
Dylan \dul-an\
Eil Ton \īl tōn\
Eisteddford \est-'eth-vord\
Elinwy \el-'in-wē\
Emrys \em-ris\
Gavrinis \gō-vrē-nē\
Gilvaethwy \gil-'vīth-wē\
Glamorgan \glam-'or-gan\
Gododdin \god-'oth-in\
Goedelic \goi-'del-ik\
Gronw \gron-ü\
Gwenddolau \gwen-'thol-ā\
Gwenfrewi \gwen-'vre-wē\
Gwennan Gorn \gwen-an garn\
Gwion bach \gwē-on bakh\

Gwyddno \gwēth-nō\
Gwydion \gwid-ē-on\
Gwyn ap Nudd \gwin ap nēth\
Gwynedd \gwin-eth\
Gwytherin \gwith-er-in\
Hanes \'han-es\
Hanes Taliesin \'han-es tal-ē-'es-in\
Hen Wen \hān wen\
Hiraeth \hē-īth\
Idris Gawr \id-ris gou'r\
Ifan \ēv-an\
Kats-Sidhe \katz-shē\
Kilcoed \kil-coid\
Lir \lēr\
Llangennith \thlan-'gen-ith\
Llaw Gyffes \thl-ou 'guf-es\
Lleu \thl-ī\
Llew \thl-e-ü\
Llewellyn \thl-'ü-ethl-in\
Llwyd \thl-ü-id\
Llychlyn \thl-ukh-lin\
Llyfr Taliesin \thliv-ər tal-ē-'es-in\
Llyn Llyw \thlin thlē-ü\
Llyr \thlēr\
Llywarch ap Llywelyn \thlü-'arkh ap thlü-el-in\
Loughor \thl-uk-ər\
Mabinogi \mab-in-'og-ē\
Madog ab Owain Gwynedd \mad-og ab ou-īn gwin-eth\
Madryn \mad-rin\
Maelgwyn Hir \mīl-gwin hēr\
Maen Ceti \mīn ket-ē\
Maes Gwyddno \mīs gwith-nō\
Maes-y-Felin \mīs u vel-in\
Manawyddan \man-'ou-with-an\
Manawyddan ap Llyr \man-'ou-with-an ap thlēr\
Manerbio sul Mella \man-or-'bē-ō sil meth-la\
Mari Llwyd \mar-ē thlü-id\
Math \math\
Math fab Mathonwy \math vab math-'on-wē\
Matronae \mat-'ron-ī\
Meirion Pennar \mā-rin 'pen-är\
Meirionnydd \mā-ri-'on-ith\
Melangell \mel-'an-geth\
Mererid \mer-'ed-id\
Mynydd Preseli \mun-ith pres-'el-ē\
Mynyddoedd Preseli \mun-ith-oith pres-'el-ē\
Myrddin \mir-thin\

Nanhyfer \nan-'hē-vər\
Neath \nēth\
Nennius \nen-ē-us\
Nyfer \'niv-ər\
Ogham \og-um\
Olwen \ol-wen\
Owain \ō-wīn\
Pelagius \pel-āj-ē-us\
Pen Annwn \pen-'an-ün\
Pen Beirdd \pen bairth\
Pen Crug \pen crēg\
Penllyn \pen thlin\
Pennant \pen-'ant\
Pentre Evan Cromlech \'pen-trä e-van krom-lekh\
Pentre Ifan \'pen-trä ēv-an\
Pili Pala \pil-ē pal-'a\
Powys \'pow-is\
Pryderi \prud-'ər-ē\
Pwyll \'pü-ith\
Rhiannon \hrē-'an-on\
Rhossilli \hro-si-lē\
Sais's Ford \sīs-ez ford\
Samhain \'sou-īn\
Sarn Badrig \sarn 'bad-rig\
Sidhe \shē\
Taliesin \tal-ē-es-'in\
Tangnefedd \tāng-ne-veth\
Tan-Y-Llyn \tan u thlin\
Tre \trā\
Treffynnon \trā-'fun-on\
Tri Garan \trē gär-'on\
Twrch Trwyth \tůr'kh 'trü-with\
Ty Ddewi \tē th-e-wē\
Tylwyth Teg \til-with tāg\
Tywyn \t-'ou-in\
Wyn Bach \win bakh\
Y Ddraig Goch Ddyry Cychwyn \u thrīg gokh thur-ē cukh-win\
Y Gododdin \u god-'oth-in\
Y Goeden Bywyd \u goyd-en bow-id\
Y Groes Geltaidd \u groys gel-tāth\
Y Mab Darogan \u mab där-'og-an\
Ynis Witrin \u-nis wit-rin\
Ys \ēs\
Ysbryd \'us-brēd\
Ysgythrog \us-'guth-rog\
Y Tylwyth Teg \u til-with tāg\

228